How to Read Impressionism

James H. Rubin

How to Read Impressionism
Ways of Looking

Ludion, Antwerp
Abrams, New York

Acknowledgments

In anticipation of writing this book, I held a seminar at Stony Brook University with a combination of graduate students in art history and advanced undergraduate majors. The graduate students were: Jasnira Zuniga, Nicholas Parkinson, and Robert Diamond. The undergraduates were: Nicole Zinerco, Erin Teeple, Joanna Scala, Christina Nawabi, Maritza Meija, Mie-Yang Liang, Cristina Cruz, and Gabryelle Allnut. My thinking was that because they were closer to much of the audience for the book than I, their views on individual choices, themes, organization, and how to look at selected works would be helpful. In the end, the majority of choices were theirs, and class discussion about topics and structure were essential to the final forms I chose. I also often used information provided by their research. I am grateful for their collaboration.

In addition, I want to thank Sandrine Canac for her invaluable assistance, as well as Peter Ruyffelaere and his multi-talented staff at Ludion, especially Aline Lapeire and Sandra Darbé.

Finally, this book could not have been written without the generous and unstinting support of my wife, Liliane Rubin-Braesch, to whom I dedicate it.

Picture research
Aline Lapeire

Editing
Lise Connellan

Design and typesetting
Jirka De Preter

Production
Emiel Godefroit

Coordination
Sandra Darbé and Barbara Geenen

Colour separations and printing
DeckersSnoeck, Antwerp

Cataloging-in-Publication Data has been applied for and may be obtained from the Library of Congress.
ISBN 978-1-4197-0996-8
Copyright © 2013 Ludion and the author

Printed and bound in Belgium
10 9 8 7 6 5 4 3 2 1

THE ART OF BOOKS SINCE 1949
115 West 18th Street
New York, NY 10011
www.abramsbooks.com

On the cover
Claude Monet, *Water Lilies, Green Reflections*, c. 1918-22, Musée de l'Orangerie, Paris
Illustrations

p. 8 Claude Monet, *Impression, Sunrise*, 1873 (detail of p. 33)
p. 34 Frédéric Bazille, *The Artist's Studio in the Rue de la Condamine*, 1870 (detail of p.45)
p. 60 Édouard Manet, *The Monet Family in their Garden at Argenteuil*, 1874 (detail of p. 75)
p. 86 Armand Guillaumin, *The Seine, Rainy Weather*, 1871 (detail of p. 99)
p. 112 Berthe Morisot, *The Pink Dress*, c. 1870 (detail of p. 123)
p. 138 Gustave Caillebotte, *Le Pont de l'Europe*, 1876 (detail of p. 159)
p. 164 Edgar Degas, *Vicomte Lepic and his Daughters (Place de la Concorde)*, 1875 (detail of p. 173)
p. 190 Mary Cassatt, *Five O'Clock Tea*, c. 1880 (detail of p. 207)
p. 216 Marie Bracquemond, *On the Terrace at Sèvres*, c. 1880 (detail of p. 235)
p. 242 Pierre-Auguste Renoir, *Rocky Crags at L'Estaque*, 1882 (detail of p. 255)
p. 268 Alfred Sisley, *The Bridge at Villeneuve-la-Garenne*, 1872 (detail of p. 277)
p. 294 Paul Cézanne, *The Turn in the Road, Pontoise*, c. 1881 (detail of p. 317)
p. 320 Vincent van Gogh, *Bridges across the Seine at Asnières*, 1887 (detail of p. 325)
p. 346 Camille Pissarro, *Twilight with Haystacks*, 1879 (detail of p. 363)
p. 372 Claude Monet, *Water Lilies, Green Reflections*, c. 1918–22 (detail of p. 390)

Contents

Ways of Looking 6

Predecessors and Innovators 8
Colleagues and Patrons 34
Family and Friends 60
City Life and Urban Views 86
Fashion and Entertainment 112
Industry and Technology 138
Politics and Society 164
Interiors and Still Life 190
Gender and Sexuality 216
Promenades and Travel 242
Sport and Outdoor Leisure 268
Light and Air 294
Renewal and Revival 320
Techniques and Other Media 346
Late Work and Legacy 372

Selected Bibliography 399

Index of Proper Names 403

Photographic Credits 407

Ways of Looking

John Berger's unique and pioneering little book *Ways of Seeing* (1972) uncovered assumptions and biases that we bring to the viewing of art and, through them, to the world around us. He accomplished his masterful feat, however, not by just seeing but by looking. The distinction is between a passive, unthinking vision that takes reality for granted, and one that probes with curiosity and analytical intent, armed with historical knowledge. My title, *How to Read Impressionism, Ways of Looking,* suggests the many different approaches one may bring to art when one takes the time. Impressionism is an especially rewarding movement for study because it is so often accepted at face value, either as a record of the Impressionists' world, which it was certainly intended to be, or for its formal beauties, which led to its eventual acceptance and the success we know today. The aim of this book is, as its title says, to show by example how to read Impressionist paintings: for the stories they tell, the historical information they contain, and the often unconscious attitudes and assumptions that underlie ways of seeing – or looking – and through which their makers, their contemporaries and we ourselves have understood them.

Impressionism was the first art movement entirely devoted to representations of modern life and contemporary surroundings in a technique that itself expressed the modernity of its themes. Among its most famous artists are Édouard Manet, Claude Monet, Pierre-Auguste Renoir, Edgar Degas and Paul Cézanne. Rejecting both the classicism and nostalgia of academic painting and the conventional formulas for art taught at the official schools, these artists worked directly from observation in an ostensibly spontaneous manner. Although sketches were sometimes used for pictures done in the studio, most Impressionist pictures, especially landscapes, were painted out of doors (*en plein air*) in front of nature. Another characteristic of Impressionist painting is the role of colour. Not only are colours bright, corresponding to effects of sunlight or modern artificial lighting, pictorial forms themselves are created with colour spots or strokes. This hallmark aspect of Impressionist painting contributes to the sense that time has been seized at the instant, while at the same time it seems to express the ever-changing character of the world around.

The Impressionists are usually treated individually, as in monographs, or through exclusive themes, as in recent books and exhibitions on Impressionist women, children, landscapes, water views, urban landscapes, portraiture, geographical centres and so on. Most books that attempt a history of the movement as a whole are organised either chronologically or by artist. This new book has a very different structure. Organised

one work at a time, grouped by various themes and concepts, and by no means always chronological, it should leave the reader not only with tools to look critically and analytically, but with a sense of Impressionism as a collective enterprise. That is, these artists, most of whom knew each other well, worked, however chaotically at times, with common commitments to both thematic and technical-stylistic modernity, often conveyed through striking compositional originality. The book features a combination of close readings of pictures and many cross-references and comparisons among them, the latter intended to establish links within a broad visual culture, with other artists, and within the artists' own careers. Berger's *Ways of Seeing* depends on multiple juxtaposed illustrations, too.

I have sometimes repeated essential information on the assumption that some readers may look at single entries, or not read them in their printed order. I have deliberately placed some paintings in unexpected categories in order to elicit new dimensions of interpretation. I have varied the categories in order to mix less commonly known aspects, such as industrial views, with ones that are instantly associated with Impressionism, in order to enhance the sense of the movement's diversity and inclusiveness. The layout encourages curiosity by placing comparison pictures in positions where in order to understand their relevance it is necessary to read the text. In some cases, moreover, I have extrapolated from the announced theme of a chapter to show that it has varied consequences. In cases where circumstances have prevented illustration of a comparison, I have given the location to enable readers to look up the missing picture. The point is to encourage readers to use the book in different ways as well as in any way they like.

A whole history of Impressionism can be found within, but by looking at it in an unconventional way its history will not be simply a series of pretty pictures, beautiful though they may be. It will be a far-reaching compendium of modern life as the Impressionists intended, as well as the sense that, however individually different, their interrelations constitute them as a coherent group. I hope that through these strategies the book will appeal to every audience, from neophytes to those many scholars on whose work I have built and to whom Impressionism studies, including this one, owe so much.

— James H. Rubin, Mittelbergheim, Alsace, 2013

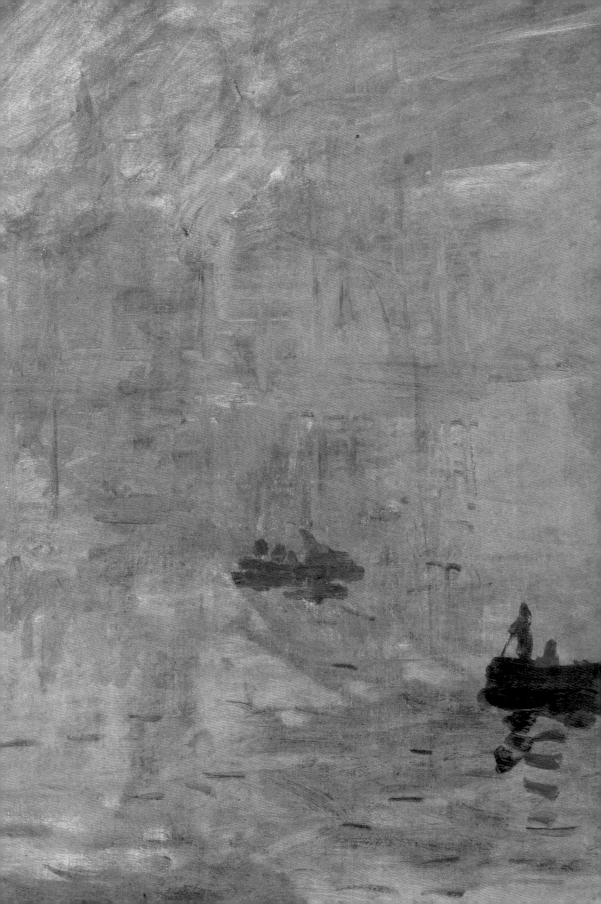

Predecessors
and Innovators

Eugène Boudin

|Fig. a| Claude Monet, *Caricature of a Man with Tobacco Pouch*, c. 1858 The Sterling and Francine Clark Art Institute, Williamstown, MA

|Fig. b| Eugène Delacroix, *Cliff at Étretat*, c. 1849, Museum Boijmans Van Beuningen, Rotterdam

The Cradle of Impressionism

Of Boudin, Claude Monet once said, 'He opened my eyes.' The proprietor of an art supply shop in Le Havre, Boudin spent much of his time painting in the open air on the nearby beaches. When Monet came to the shop hoping to display some caricatures (Fig. a), he noticed Boudin's paintings and learned about his work. Thanks to this discovery, Monet joined a well-established mode of painting out of doors (*en plein air*) that had existed at least since the first British landscape painters travelled to the Continent, landing first in Normandy. Painters such as Richard Parkes Bonington and the Fielding brothers brought with them their watercolour technique, almost always using white sketchbook paper for watercolour and doing their oil painting on canvas prepared with a white ground, called *peinture claire* (literally, 'bright painting'). Boudin employed this method, which partly explains the luminosity of his pictures. Our example was done on wood, a surface that can heighten the glow of colour. In addition, Boudin's freely brushed style, defining forms by strokes or patches, and his thin, relatively diluted paint, seem to translate watercolour style into oils.

The Normandy beaches were a favourite spot for summer sunlight and refreshing air to escape the heat that could envelop inland cities. Trouville, the first town facing the sea across the Seine delta from Le Havre, was accessible by ferry. It became especially fashionable when members of high society began to visit. Deauville, now famous for its casinos, neighbours to the west. To the east, Honfleur, another town favoured by the painters, is closer to Le Havre than Trouville but does not actually face the sea. Preceding all but the most adventurous tourists, painters chose coastal sites judged quaint for their broad sand beaches, quaint ports or amazing rock formations.

Empress Eugénie and her Suite at Trouville, 1863

oil on panel, 34.3 x 57.8 cm, The Burrell Collection, Glasgow

Jean-François Millet, a native of Cherbourg on the Cotentin peninsula, visited often, even though well established as a member of the Barbizon School of landscape painters (p. 12). Eugène Delacroix learned watercolour painting from Bonington and the Fieldings. He made spectacular sketches of the cliff at Étretat (Fig. b). This was already an attraction (see p. 318), reproduced in travel illustrations, but it was Monet who made it famous worldwide. During the 1860s and 1870s, Édouard Manet came with his family to Boulogne-sur-Mer and Berck in Pas-de-Calais, making many pictures of beaches, the harbour and the sea. Indeed, when Monet exhibited a sea piece, the similarity of his name to Manet's caused confusion.

In typical art-historical narratives the Barbizon School is given far greater importance than Normandy, and it is true that in number of painters, length of careers and market popularity, Barbizon landscapists far outstripped any others prior to Impressionism. Nonetheless, there was a luminous and spontaneous style associated with the Normandy coast, where Monet acquired assumptions about art practices, such as painting out of doors from contemporary life. Normandy can therefore claim to be the cradle of Impressionism, and Boudin its greatest predecessor.

Jean-Baptiste-Camille Corot

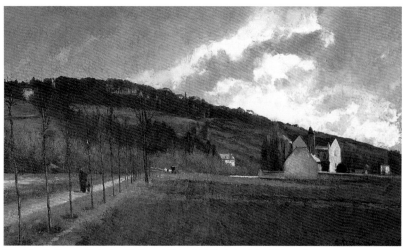

|Fig. a| Camille Pissarro, *The Banks of the Marne in Winter*, 1866, The Art Institute of Chicago, IL

Mentor of the Bright

Corot was considered the foremost landscape painter of mid-century France and the most progressive. Among Impressionists who worked directly under his tutelage were Camille Pissarro and Berthe Morisot. Corot trained in the classical tradition under the academic landscape painter Achille Etna Michallon, and his commitment to Italianate scenery, considered ideal, led him to make three trips to Italy early in his career. Conservative landscape painting had evolved to the point where Michallon's teacher, Pierre-Henri de Valenciennes, produced beautiful outdoor studies and promoted direct observation through his widely read treatise on landscape painting.

Corot was naturally sensitive to light and atmosphere, using his delicate technique and harmonising palette to create subtle moods of tranquillity. By the 1830s he was painting in the Forest of Fontainebleau, becoming one of the leaders of the Barbizon School, named after a farming village on the edge of the woods, where several landscape painters settled. As a royal hunting preserve, the forest was out of bounds for habitation and activities except for gathering dead branches, unless officially authorised. Virtually untouched at the time, ancient trees and varied topography strewn with lichen-covered rocks and many ponds left by Ice Age glaciers seemed witness to the past as well as a peaceful setting for promenades. Indeed, when Claude Monet came to Paris from Normandy, his discovery of Barbizon School paintings at the Salon drew him to the area, where he, too, made several important works (p. 14).

Certain particularities of Corot's practice would be adopted by later generations. First, in addition to large, finished landscapes with figures made for the official art exhibitions, called Salons, Corot never hesitated to show studies and sketches that provided technical inspiration. Second, he was the first prominent French landscape painter to adopt regularly the luminous British mode of *peinture claire*, using a white

The Road to Sèvres, 1858–9

oil on canvas, 34 x 49 cm, stolen from the Musée du Louvre, Paris

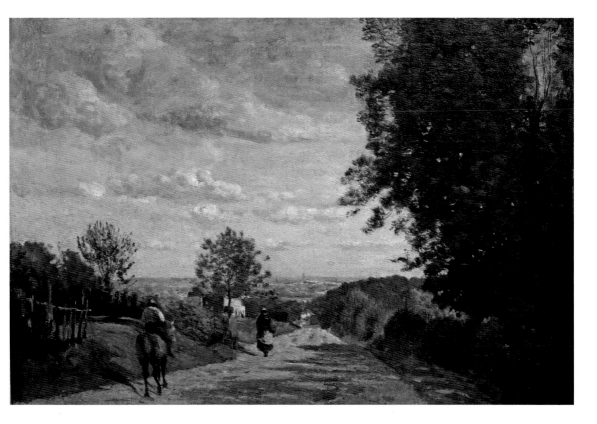

ground (p. 10). Third, Corot liked to travel. Few artists roamed the countryside as much as he, whose views, unlike the Impressionists' commitment to modernity and tourist spots, favoured rustic villages and gentle terrain.

With age and contemporary developments, Corot painted with increasing freedom and delicacy. He was especially skilled at producing a silvery atmosphere with nearly deserted roads or woods. His deft white touches suggest soft light on foliage or delicate wild flowers in grasses. Small, briefly sketched peasants seen from the side or from behind enhance the trademark sense of nostalgia that so endeared Corot to his public that forgeries abound. The French used to joke that of Corot's 500 paintings, 1,000 are in the United States. It is true that American collections are indeed rich in Corots – but authentic ones, of course.

Among the Impressionists, Pissarro owed the most to Corot. In *The Banks of the Marne in Winter* (Fig. a), the figure with the red kerchief seen from behind in the middle distance is a citation from his mentor, while the farmhouse's cubic forms and the sensitive lighting respond to Corot as well. And yet the contrasted sky and flattened, thinly painted green foreground field speak of Pissarro's more radical early Impressionist cohorts, too.

Claude Monet

|Fig. a| Claude Monet, *Woodgatherers at the Edge of the Forest*, c. 1863,
Museum of Fine Arts, Boston, MA

|Fig. b| Théodore Rousseau, *The Little Fisherman*, 1848–9,
Musée du Louvre, Paris

Near Fontainebleau Forest

Monet visited the village of Chailly-en-Bière near the Forest of Fontainebleau in autumn
1865 in the company of Gustave Courbet and Frédéric Bazille (p. 16 and p. 18). It was
at least his second visit to the village, which was two km from Barbizon, where many
of the Fontainebleau Forest painters lived. This time he may have had a major project
in mind. This early painting responds in many ways to the kind of work produced by
members of the Barbizon School, whose landscapes Monet saw at the official Salon
in Paris. Their works were numerous, popular and widely exhibited by private dealers,
such as the Galerie Durand-Ruel, before it became the home of the Impressionists.
They signalled the turn of French landscape painting towards greater naturalism, away
from classicising Italianate landscape, a development embodied by the career shifts
in the works of Camille Corot (p. 12). It should be noted as well, however, that by 1865
Monet had seen the work of Manet, in particular the latter's *Le Déjeuner sur l'herbe*
(p. 23) which caused a sensation at the Salon des Refusés (1863).

The Bodmer Oak was named after the Swiss artist Karl Bodmer, who made it famous
by exhibiting a picture of it at the Salon of 1850. The fallen leaves in this and other
canvases Monet painted in the area suggest the on-coming autumn. Another early
Monet (Fig. a) shows a typical Barbizon School theme, against a background of russet
foliage, not yet fallen from their branches. His peasants are gathering dead sticks in
preparation for the winter cold. This is a traditional way of life, quite unlike the modern
scenes Monet witnessed on the Normandy coast. Indeed, already in *The Bodmer Oak*
Monet seems more interested in the pleasures of autumn than the lives of locals.
Although the forest scene is typical of Barbizon painters such as Théodore Rousseau
(Fig. b), Monet's facture and the picture's mood are different. Monet's strokes are far
broader and more summary, and his scene is more brightly lit. Whereas Rousseau was
trying to create a sense of solitude and reflection, leading perhaps to a melancholy

The Bodmer Oak, Fontainebleau Forest, 1865

oil on canvas, 96.2 x 129.2 cm, The Metropolitan Museum of Art, New York, NY

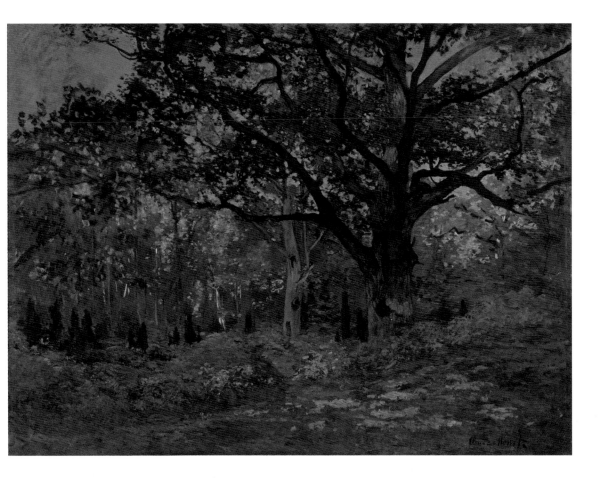

feeling of nostalgia, Monet's picture seems more celebratory, revelling in the patchwork effect of bright sunlight showing through trees. Indeed, in *Woodgatherers* Monet boldly contrasted three bands of colour, and his open brushwork, as in *The Bodmer Oak*, calls attention to the surface. In Rousseau's work one tends to be absorbed by depth and time seems suspended, whereas Monet's seems more present to immediate experience.

It is said that Monet himself made the gash in the painting's upper right-hand corner in order to discourage an irate landlord from seizing it in lieu of overdue rent.

That Monet chose this among those he damaged suggests not that it was of lesser value but, to the contrary, that he considered it worthy of being kept. It is probable that he associated it with his project to make a large painting (p. 16) to rival Manet's *Le Déjeuner sur l'herbe*.

Frédéric Bazille

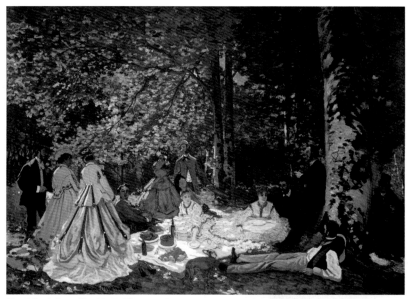

|Fig. a| Claude Monet, Sketch for *Le Déjeuner sur l'herbe*, 1865–6, The Pushkin State Museum of Fine Arts, Moscow

Students on a Country Outing

In 1863, Bazille, Claude Monet, Pierre-Auguste Renoir and Alfred Sisley visited the village of Chailly. They were students of Charles Gleyre, an academic painter who ran one of the few relatively liberal studios in Paris. Presumably they had seen works by painters of the Barbizon School and were anxious to experience the Fontainebleau Forest area for themselves. Painted in 1865, *Landscape at Chailly* dates to Bazille's third visit to Chailly and reveals the artist's characteristic embrace of free brushwork for landscape. For figure painting, he retained a greater respect for solid form (p. 62). The luminosity and patchwork-like treatment of the terrain in Bazille's landscape style can be linked to Monet, who would have been painting alongside him at Chailly (p. 14), and who had written to Bazille asking him to accompany him there. Monet's major project at the time was his own, *Le Déjeuner sur l'herbe* (Fig. a), for which Bazille posed at least twice and possibly three times as the tall standing male figures. Despite his relatively loose brushstrokes, Bazille was able to suggest weight by lowering the vantage point and stacking the rocks and trees, while packing paint into areas of sloping thickets, boulders and shrubs. The power of this bold brushwork probably also reflects Bazille's response to the work of the Realist painter Gustave Courbet. Bazille was from a well-to-do family in the southern city of Montpellier. He knew Courbet's patron,

Alfred Bruyas, a banker's son who belonged to the same social circle as his own family, and he had certainly seen the painting called *The Meeting (Bonjour Monsieur Courbet)* (p. 62). Bazille revered Courbet, in fact, but he seems to have been unable to meet the master until they both posed for Monet's *Le Déjeuner sur l'herbe* in Chailly – Courbet is the reclining figure on the right. Afterwards, Courbet visited the studio that Monet and Bazille shared in Paris. Although he cannot be counted among the Impressionists themselves, and he certainly never exhibited with them, the Impressionists were often associated with Realism, as well as with Courbet's radical politics.

Gustave Courbet

|Fig. a| Johan Barthold Jongkind, *Entrance to the Port of Honfleur*, 1864
The Art Institute of Chicago, IL

Realism Hits the Beach

One of the painters who frequented the Normandy beaches in the 1860s was the radical militant Courbet, who had made his reputation by challenging both political and artistic authority. Courbet was one of the first artists to organise a self-financed public exhibition, which he opened in a temporary pavilion called 'Realism', opposite the Paris fair grounds of the 1855 Exposition Universelle. This gesture, too, was an attention-getting challenge to convention, and it helped set the example for the Impressionists' own first independent exhibition (p. 32). Courbet was invited to Normandy by one of his collectors, the Comte de Choiseul, who had progressive artistic taste and commissioned Courbet to paint portraits of his greyhounds. Always seeking private patronage to be free from reliance on public commissions, Courbet discovered the Normandy beaches as ideal for producing numerous pictures he hoped to sell to seascape lovers. These paintings were notable for their luminosity and energetic execution, so much so that Édouard Manet called Courbet 'The Raphael of water'.

Compared to another painter of the seashore, the Dutch expatriate Johan Barthold Jongkind (Fig. a), Courbet's handling was more radically painterly. Jongkind's style is more dependent than Courbet's on drawing directly on the canvas with paint. That is, Jongkind's forms were often created with lines of dark paint applied with narrow brushes, in a Dutch tradition well known since the days of Rembrandt's ink drawings. That is not to denigrate Jongkind's formidable contribution to Normandy Coast style painting, but, rather, to distinguish Courbet's contribution from it. For Courbet applied his paints directly, often with tools other than the brush. His surfaces generally have a granular tactility that enhances the landscape's illusion of material presence and availability to direct sensuous experience while at the same time featuring their technical dexterity. Courbet displayed his legendary skill with the palette knife, for the beach, shoreline, rocks and sea, and broad brushes for the clouds. Sometimes he even applied paint with sponges.

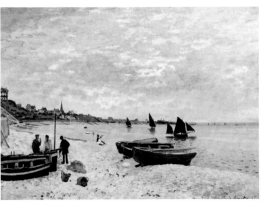

|Fig. b| Claude Monet, *The Beach at Sainte-Adresse*, 1867
The Art Institute of Chicago, IL

It is not known exactly how Claude Monet befriended Courbet, but presumably they met on beaches such as Trouville, where both Courbet and Eugène Boudin painted. Courbet and Monet were together again in Chailly-en-Bière, the village near Barbizon at the edge of the Fontainebleau Forest. In his unfinished picnic scene (p. 16), meant to rival Manet's *Le Déjeuner sur l'herbe* (p. 23) by having been prepared out of doors, Monet

Normandy Seascape, 1865–6
oil on canvas, 54 x 64 cm, Wallraf-Richartz-Museum, Cologne

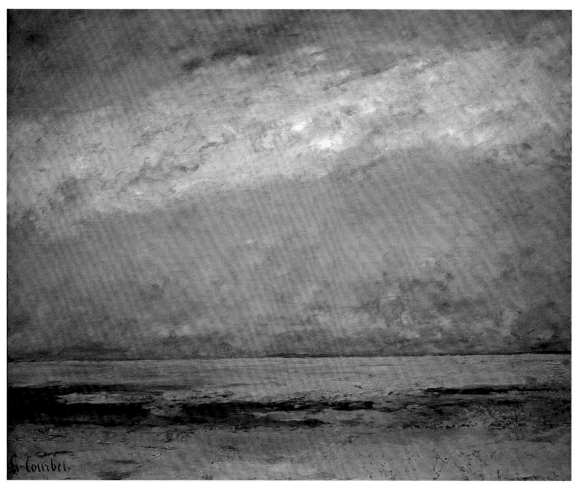

not only represented Courbet reclining (to the right), but included a canine companion reminiscent of both the Comte de Choiseul's pets and the dog by the graveside in Courbet's famous *Burial at Ornans* (1850-1, Musée d'Orsay, Paris).

Unlike Jongkind's tranquil harbour scene, and contrasting with Monet's several paintings of the beach at Sainte-Adresse (Fig. b), Courbet's views feature the immensity of sea and sky in the tradition of the Romantic sublime. Other Courbet seascapes with waves crashing on the shore or waterspouts suggest the power of nature, whereas for Monet the beach was shared by fishermen and tourists, and nature seems to offer them its perfect harmony.

Édouard Manet

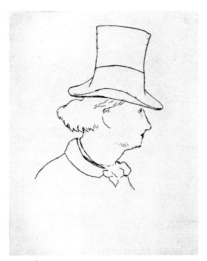

|Fig. a| Édouard Manet, *Profile Portrait of Charles Baudelaire*, 1862

|Fig. b| Édouard Manet, *The Old Musician*, 1862
The National Gallery of Art, Washington, DC

|Fig. c| Constantin Guys, *Prostitutes*, 1850s
Musée d'Orsay, Paris

Painter of Modern Life

Manet's *Music in the Tuileries Gardens* is the first major painting of modern life, as defined by his friend the poet and art critic Charles Baudelaire (Fig. a) in a famous essay entitled 'The Painter of Modern Life' (begun 1859, published 1863). Baudelaire and Manet had probably met at the Salon of Madame Lejosne, wife of an army lieutenant who was Frédéric Bazille's cousin. She sits in the foreground with a friend and her children. Bazille is recognisable by his height and bowler hat. Baudelaire and Manet became constant companions as the young painter made sketches based on their promenades in Paris and its parks. In the gardens of the Tuileries Palace (the palace was destroyed during the Paris Commune, 1871), there were twice-weekly concerts where the fashionable and cultural elite often gathered. Among the other individuals Manet portrayed is the writer Théophile Gautier, who argued in favour of 'art for art's sake' and is part of the trio that includes Baudelaire in profile standing in front of a tree to the left of centre.

This painting represents a radical shift from Manet's earlier representations of contemporary figures, who came mostly from the bohemian world of street entertainers, gypsies, and others who were more picturesque than actually part of Manet's social world. Manet's *The Old Musician* (Fig. b), exemplifying the latter stance, could be seen at the same exhibition at the cooperative Galerie Martinet, where Manet held a one-man show, as if to highlight this important shift. Manet's new orientation was certainly encouraged by Baudelaire, whose essay held that even ancient Greek art had been 'of its time', and that fashion constituted a part of 'the ideal' that revealed the ethos of its particular age. He extolled the visual experience of the *flâneur*, the often dandyish man of leisure who could stroll anonymously through crowds, sizing up people with the sure glance of a detective. This essential character of city life Baudelaire defined as modern, and its context was the constantly changing – 'ephemeral' and 'transitory' – character of Paris undergoing massive upheaval due to huge urban renewal projects of the Second Empire, directed by the city's prefect Georges-Eugène Haussmann (and called Haussmannisation, see p. 92). At the same time, waves of immigrants were coming to the industrialising capital city (p. 140) from the economically stressed agricultural countryside.

Music in the Tuileries Gardens, 1862

oil on canvas, 76.2 x 118.1 cm, The National Gallery, London

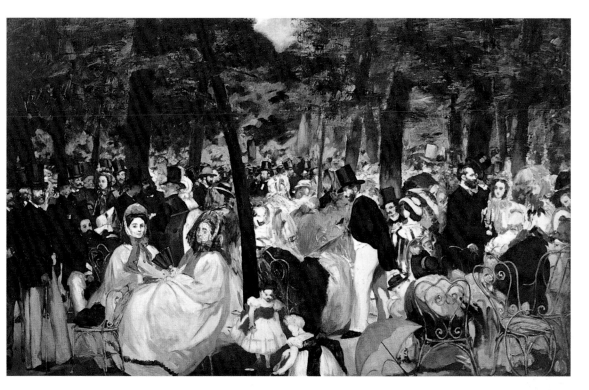

Manet was barely known when Baudelaire wrote his essay, whose focus, rather, was the illustrator Constantin Guys (Fig. c). For Baudelaire, the rapid sketch-like style of this journalistic illustrator was appropriate to the speed of movement of modern society as well as the style's economy of means, which Baudelaire equated with modern efficiency. Baudelaire also understood that by suggesting rather than slavishly copying, the artist left something to the imagination. Pictorial effects, indeed, could raise representations of the ordinary to the aesthetic, just as make-up could render a woman more seductive to the eye. Manet's loose handling and summary brushwork is a bit like Guys's watercolour style translated into oils. Not only in its subject matter, then, but in its proto-Impressionist style, Manet's picture embodied the ideals of modernity so prized by Baudelaire.

Édouard Manet

Provocation or Prophecy?

The great scandal that inspired the young Impressionists occurred in 1863 when Manet's picnic scene *Le Déjeuner sur l'herbe* appeared at the so-called Salon des Refusés. So many works were rejected by the official jury that artists' outcries led the administration to open an annex to the regular galleries for those who wished to exhibit despite being labelled as rejects. Although the gesture was to appear liberal, many expected that the public would approve of the original judgements. Among young artists, however, the future Impressionists were inspired by Manet's daring.

Originally called simply *Le Bain* (*Bathing*), the scene represented a nude woman looking out of the picture, accompanied by two clothed men and a second woman, also clothed, with her feet in the water, along a riverbank of the Seine. Bathing scenes were common, as inhabitants of Paris and its growing suburbs sought country air and sport both for pleasure and, it was believed, for health. Manet's scene combined his favourite professional model, Victorine Meurent – identified as Mlle V... by Manet's picture of her in a bullfighter's costume (1862, The Metropolitan Museum of Art, New York) hanging next to *Le Déjeuner* – and two other figures that looked like portraits of students. One was Manet's brother Eugène, the other his brother-in-law. Some critics thought the picture was meant to be a prank; others were not amused by a woman who appeared more shockingly naked than nude.

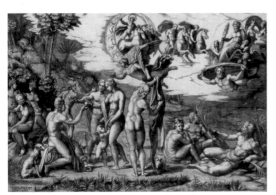

|Fig. a| Marcantonio Raimondi, after a lost Raphael sketch, *The Judgement of Paris*, c. 1517-20

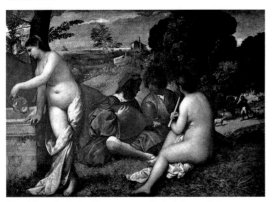

|Fig. b| Titian, *The Pastoral Concert*, c. 1509, Musée du Louvre, Paris

There is little question that Manet was being provocative – but with a point. A few connoisseurs recognised that he had updated a section of an engraving by Marcantonio Raimondi after an image by Raphael showing river gods (Fig. a), suggesting that Manet's group was the modern version. More accessible was his debt to the Venetian painter Giorgione's *Concert champêtre* (Fig. b), a well-known painting at the Louvre now thought to be by the young Titian. Manet's point seems to have been to update the classics to the present, in the spirit of Baudelaire (p. 20), and to focus on contemporary reality rather than a mythical version of the traditional artistic theme of man's relationship with nature.

The picture's two most shocking elements were, first, the model's confrontational gaze, so central to Manet's concept that his brother points the viewer towards her. Unlike the Giorgione, which preserves the allegorical fiction of art inspired by natural surroundings and whose

Le Déjeuner sur l'herbe, 1863

oil on canvas, 208 x 264,5 cm, Musée d'Orsay, Paris

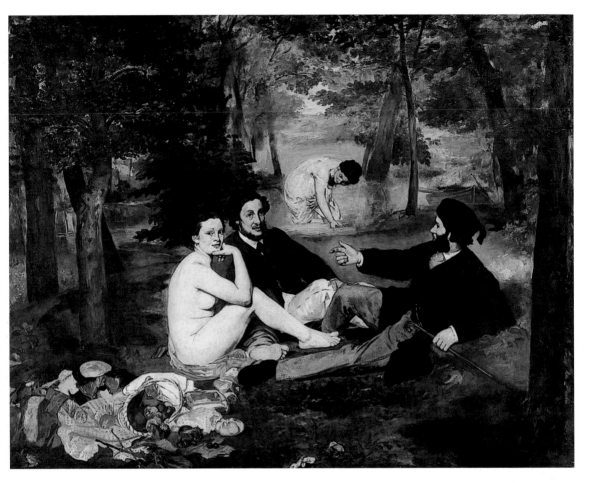

muse-like females look away, Victorine's stare shattered the fiction of art as an escape or as an ideal by linking the scene to the viewer's world. Second, Manet's deliberately varied handling, sometimes thick and vigorous, sometimes thin and flat, and other unexpected touches, such as Victorine's ugly foot and a frog (an allusion to prostitution) in the lower left corner, called attention to his wit and artifice. While demonstrating his skills with the still life of fruit, Victorine's dress and straw hat at her side, Manet seemed to insist on the idea that, in art, everything is staged by the artist and results from imagination and particular talent.

Claude Monet

|Fig. a| Claude Monet, *Port of Le Havre*, 1874
Philadelphia Museum of Art, PA

|Fig. b| Claude Monet, *Woman in a Garden*, 1867
The State Hermitage Museum, St Petersburg

Life and Leisure in Le Havre

A masterpiece of his early maturity, Monet's relatively large easel painting *Terrace at Sainte-Adresse* combines many elements of style and subject matter that characterise early Impressionism as a whole. Monet painted his father and his aunt Marie-Jeanne Lecadre from an upper storey window of the latter's villa on the cliffs of Sainte-Adresse, Le Havre's nearest suburb to the north. Next to the fence overlooking the water are Monet's cousin and her unidentified suitor, whose presence is chaperoned by the adults. Monet's distance may thus have been tactical as well as artistic. From his vantage point, Monet could survey the scene as well as watch various kinds of ships entering Le Havre's industrial harbour, said by Larousse's encyclopaedia at the time to be France's most important port. Although born in Paris, Monet's family moved to Le Havre, where his father worked in the import business with his brother-in-law. Le Havre shipping was thus the context for the family's prosperity, a fact the picture seems to imply.

Monet's commitment to modernity included industrial presences, as witnessed by a group of ten paintings of Le Havre's port (Fig. a.), including the famous *Impression, Sunrise* (p. 33). Like Monet, any local resident could have distinguished between different types of traffic, from the ocean steamer with the red and black colours of the Compagnie Générale Transatlantique, to ordinary fishing vessels and pleasure craft, the latter abundant but mostly idle on this crisp, windy, summer afternoon, as indicated by the figures' clothing, the terrace's fluttering flags and the low angle of the sun. Indeed, one of the remarkable features of the picture is the specificity of weather and season, the latter also marked by nasturtiums and gladioli, rendered as dabs or patches of red paint. In spite of its extraordinarily naturalistic effect, the painting also overtly displays its stylistic and compositional artifice. Its structure is rigorously geometric, as determined by the outlines of the terrace itself, its fencing and the circular plantings at its centre. The two verticals of the flag poles tend to flatten the picture and it is no doubt for this reason that Monet called it his first 'Chinese painting', referring to the way scrolls articulate

Terrace at Sainte-Adresse, 1867

oil on canvas, 98 x 130 cm, The Metropolitan Museum of Art, New York, NY

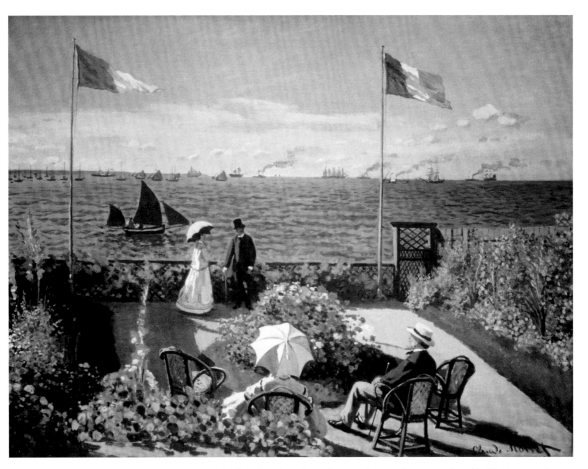

space vertically rather than through the orthogonal axes employed in Western art since the Renaissance invented mathematical perspective. One of a small group of paintings of this garden and a similar one at Sainte-Adresse (Fig. b), this painting of the terrace shows the effect in a more pronounced way than in the others. Such phenomena could be found in Japanese prints, of which Monet became an avid collector, to the extent that some scholars believe he was mixing up Chinese and Japanese art. Favouring this opinion are the bright colours that were so jarring for the time. According to Théodore Duret, the first historian of Impressionism, Japanese prints inspired these bright, natural, sunlit hues and bold juxtapositions of localised colour. In so doing, Monet was also following the example of Manet, whose influence was already noticeable in Monet's project for his own picnic scene (p. 16). The matt quality of Monet's surface and a certain feeling of stiffness echo Manet as well.

Paul Cézanne

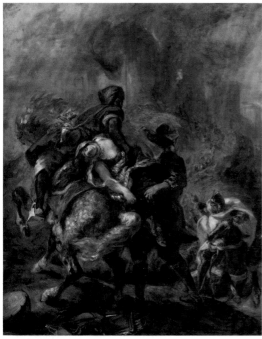

|Fig. a| Eugène Delacroix, *The Abduction of Rebecca*, 1846
The Metropolitan Museum of Art, New York, NY

Violence and Vision

Cézanne's temperament, ambition and provincial background – he was raised in the Provençal town of Aix-en-Provence – set him apart from the other young Impressionists-to-be. It is generally true that it takes time for avant-garde influences to reach the provinces. Moreover, his classical education and love of poetry made Cézanne sympathetic to Romantic themes, exemplified in painting by the great Eugène Delacroix, who was extolled by Charles Baudelaire and greatly admired by other Impressionists. He had also been an important resource for Manet, who made copies of Delacroix's work and visited the older painter in his studio. When Cézanne came to Paris, Manet was a huge presence, having created such controversy first at the Salon des Refusés and then at the 1865 Salon (p. 218). Cézanne's closest boyhood friend, Émile Zola, who had moved to Paris before the painter, took up a polemical defence of Manet, claiming on the one hand that Manet merely represented things as he saw them and on the other that he, Zola, valued an artist's temperament above all (p. 36). Cézanne's large painting of a satyr abducting a nymph somewhat awkwardly combines these strands. The exaggerated colour contrasts and classical, perhaps literary, theme take off from Delacroix, whose *Abduction of Rebecca* (Fig. a) was a masterpiece of vigorous brushwork and colouristic handling – two aspects the Impressionists much admired. However, Cézanne's virtually unprecedented choice of violent and sexual themes for this and other works (Fig. b) also responded to currents in contemporary literature, including Zola's own sensationalistic murder novel *Thérèse Raquin* (1867).

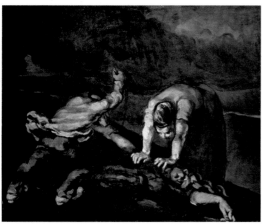

|Fig. b| Paul Cézanne, *The Murder*, c. 1867–8
Walker Art Gallery, Liverpool

In terms of colour *The Abduction* is certainly bold, but its dark, saturated values contrast with the sunlit moods of Cézanne's early Impressionist cohorts, creating an environment more suitable to his theme. His brushwork, which echoes that of the Provençal painter Adolphe Monticelli, takes Impressionist experiments to excess, becoming itself violent in keeping with the rape. The exaggerated contrast of the dark-skinned satyr and the innocent white flesh of his nymph seems a parody, perhaps one-upping Manet's bold colour juxtapositions. This and paintings like *The Murder* are executed in what

The Abduction, 1867

oil on canvas, 88 x 170 cm, The Fitzwilliam Museum, Cambridge

Cézanne himself coarsely called his 'ballsy (*couillard*)' style. The term articulates a certain pictorial masculinity and rebelliousness. The former may have been compensation for his timidity towards women, despite erotic fantasies known through drawings and early letters. The latter was surely affected by his stressful relationship with his father, a self-made banker who despite his wealth refused more than minimal support to Cézanne because he opposed his son's career.

While Cézanne was perhaps the most complex and independent member of the Impressionist group, his work was nevertheless profoundly affected by his early friendships, which flourished until he left Paris almost permanently in 1886. He was a loner by nature, who threw himself into his work with unequalled intensity, but such early bonds were essential to his formation, and once he lay aside themes of violence and literature, he would never abandon the Impressionist commitment to direct observation.

Edgar Degas

|Fig. a| Edgar Degas, *The Daughter of Jephthah*, 1859–60, Smith College Museum of Art, Northampton, MA

Stories without Words

Degas's initial training was academic, with a student of the art-conservative painter Jean-Auguste-Dominique Ingres. In that spirit, he travelled to view revered Renaissance masterpieces in Florence, where his aunt, Laura Bellelli, lived with her husband Giovanni, a Neapolitan aristocrat in political exile. Degas shows the proud Laura dressed in mourning for Degas's grandfather, whose portrait Degas put on the wall in a drawing imitating the style of Holbein – a testament to the painter's knowledge of art history. She stoically accepts her latest pregnancy, imposed on her through what some have termed a kind of marital rape, by a man she called 'boring to himself' and had come to disdain. The husband, ensconced in his armchair separate from the others, glances at his newspaper, as if avoiding eye contact with his wife. Cousin Giovanna stands stiffly by her mother, whereas the younger Giulia provides a hesitant link to Degas's uncle. The composition leads from left to right like the narrative history paintings Degas had worked on in Paris (Fig. a), yet without the emphatic gestures and expressions so common in such work. Rather, it uses subtle postures, furniture placement and objects on the mantelpiece to flesh out its psychological dramatics. Marks of the situation abound. The large Empire-style clock indicates the immeasurable passage of time, while the unlit candle implies the lack of flame to the couple's relationship. To the left of the mirror is a bell pull to summon servants. The mirror partially reflects a painting of a jockey on horseback, a reminder of aristocratic pastimes abruptly cut off, like the painting. To the right, the mirror shows a curtained window, a reminder of the cloistered life of a family in exile. Finally, a small poodle, as if sensing the tension in the room, exits to the right, partially cut off, as well.

Degas's cruel decapitation of the family pet functions more than narratively. Surgically deliberate, like the cropping produced by the mirror's frame, it suggests that the image

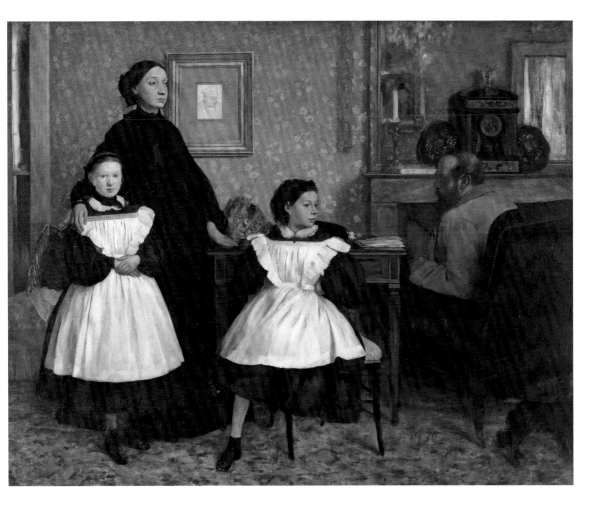

contained within the painting's frame continues beyond it. It thus enhances the picture's realism by echoing photography, implying that the picture is just a fragment cut from the broader fabric of reality. At the same time, the proliferation of such devices and their relevance to the story draw attention to the organisational decisions that have produced them. Here again is the dialogue between naturalism and artifice that often characterises Impressionism, but a very different version of it than one finds in Claude Monet's *Terrace at Sainte-Adresse* (p. 25). In calling attention to the artist's 'temperament', it is closer to Édouard Manet's *Le Déjeuner sur l'herbe* (p. 23). Indeed, as if emphasising that the painting combines intellectual rigour and handwork, the carpet is painted so freely that it appears more an agglomeration of brushstrokes than a coherent pattern. This self-conscious reference to technique and composition would become a major theme that Degas would share with other Impressionists, despite their widely divergent attitudes towards, for example, *plein-air* practice and the very different look of their paintings.

Gustave Caillebotte

|Fig. a| Carolus-Duran (Charles-Émile-Auguste Durand), *The Kiss (the artist and his young wife)*, 1868
Palais des Beaux-Arts, Lille

Labour and Light

Although not an early picture in Impressionist chronology, *The Floor Scrapers* was the first major work by Caillebotte, who joined the Impressionists in 1876 at the instigation of Auguste Renoir and Edgar Degas's friend the industrialist, amateur painter and collector Henri Rouart. Caillebotte's training was not as traditional as Degas's, but more so than the others', for he studied with the academic realist Carolus-Duran, a popular society portraitist and friend of the Impressionists (Fig. a). Carolus-Duran had adopted a dark, Realist palette under the influence of Courbet, but he gave his figures the tight, academic solidity that Caillebotte emulated for his early works. Yet, unlike his teacher, in far greater sympathy with Impressionism, Caillebotte's picture featured a modern urban subject and a remarkable sensitivity to the light emanating from outdoors that reflects on the floor. In addition, following in Degas's footsteps, Caillebotte loved unusual vantage points and spatial effects, in this case produced by the rapid recession of the floorboards and the looming proximity of the workers.

It is generally supposed that the apartment being prepared was owned by Caillebotte or his family. The workers are stripping varnish from the floor as part of a renovation. The sense of possession and authority over the space is enhanced by the artist's manipulations and perhaps by the process of stripping and recoating as a metaphor, conscious or not, for the artist's own organising labour in the construction of a composition – the sort of attitude that Degas no doubt found interesting and sympathetic. Moreover, that the workers' labour is at the artist's command is implied by their placement well below the viewer's gaze, making them seem almost like obedient slaves or automatons. The spectacular lighting effects, along with the glare of the still-varnished strips in the foreground, outline their naked backs and arms. They demonstrate the artist's power over the human anatomy, learned from his academic experience with the male model.

The Floor Scrapers, 1875
oil on canvas, 102 x 146.5 cm, Musée d'Orsay, Paris

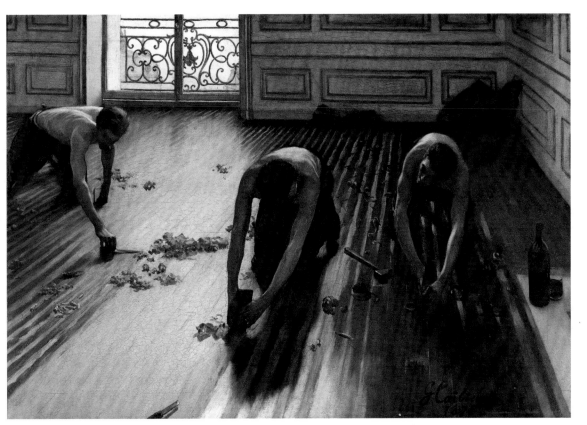

The painter's vantage point is so close to his splendid human specimens that some scholars suspect – with no proof, however – that he enjoyed their physical presence to excess. Indeed, Caillebotte's world was certainly one of men. Educated at the law faculty of the Sorbonne, he was drafted into the National Guard during the Franco-Prussian War of 1870-1 before embarking on his artistic career. He enjoyed sport, especially boating (p. 284). An anonymous photograph shows him in boxing gear (Fig. b). He did few pictures of women, and he never married, although he did have a female companion. Demonstrations of masculinity seemed important to him (p. 92).

The light also highlights the beautiful curls of shaved wood, an unusual still life that animates the space while appearing to be strewn randomly over the planks. To the right stands another still life, a bottle of wine and a half-empty glass. A similar motif can be found in Degas's *Two Women Ironing* (p. 107). Addiction to drink was thought to be an attribute of the lower classes, but its practical purpose was to make their work seem less arduous.

Claude Monet

How Impressionism Got its Name

Monet's sketch of the harbour at Le Havre at sunrise is one of history's most famous paintings as it is the one that led to naming the movement. In the 25 April 1874 issue of the satirical magazine *Le Charivari*, the critic Louis Leroy ('Louis the King', undoubtedly a pseudonym) imagined a dialogue with a fictional Monsieur Vincent. Noticing Monet's sketch at the first Impressionist exhibition, Vincent declared:

Impression? I was sure of it. I was just telling myself that, since I was impressed, there had to be some impression in it – and what freedom, what ease of workmanship! A sketch for a wallpaper is more finished than this seascape.

The reference to wallpaper was to the patches of bright colour characteristic of printed papers manufactured at the time (Fig. a). Leroy titled his review 'Exhibition of the Impressionists', and the name stuck.

The painters first called themselves the Société anonyme des Artistes Peintres, Sculpteurs, Graveurs, etc., which implied official and corporate status. It included Camille Pissarro, Claude Monet, Alfred Sisley, Edgar Degas, Pierre-Auguste Renoir, Paul Cézanne, Armand Guillaumin and Berthe Morisot. Manet did not participate because the group forbade exhibiting both with it and at the official Salon. Seen by some as rebellious associates of the exiled Realist Gustave Courbet, who had joined the Paris Commune, some writers called the group '*Les Intransigeants*'. The Impressionists' challenge to artistic authority thus acquired a political edge.

The word 'impression' had several meanings and uses. It referred to a preparatory coat of wall paint as well as being used by artists to designate sketches. Yet Monet broke with tradition by signing and dating the picture as if it were finished. (He must have done so just before the exhibition, a frequent practice of his that sometimes led to inaccuracies. Exhibited in 1874 and dated 1872, the sketch was more likely done in 1873.) On the one hand, an impression was an imprint, hence an exact replica, as in printmaking or, more recently, in photography, where the light itself leaves an accurate image. On the other hand, it referred to the very first perception, like a glance, before the perceiver actually processed the image into meaning. Monet once said he wished he could be born blind and suddenly recover sight. *Impression, Sunrise* conveys both aspects – accuracy and immediacy. Critical reception, while generally negative as to the unfinished look of this and many other pictures, was less

|Fig. a| Detail of Second Empire period wallpaper
Musée du Papier Peint, Rixheim, Mulhouse

|Fig. b| Charles-François Daubigny, *Boats on the Oise*, 1865
Musée du Louvre, Paris

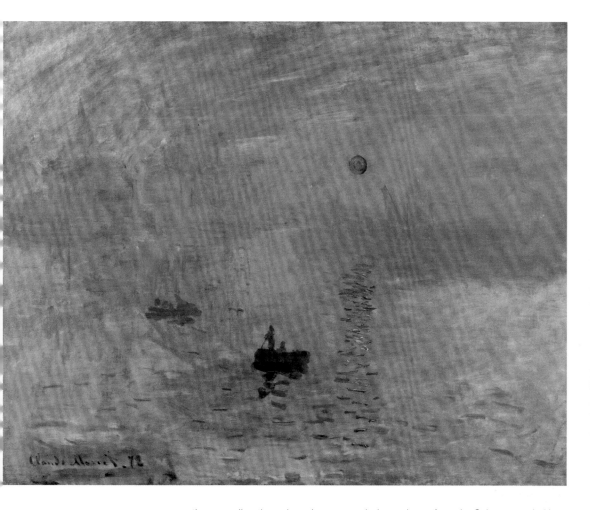

negative regarding the painters' attempt at independence from the Salon, regarded by many as moribund. Yet, in spite of its free execution and bold colour simplifications, *Impression, Sunrise* – recalling that it was smaller than Monet's other paintings and labelled a sketch – was in line with the sensitivity to light and broad handling of the painters of the Normandy beaches and, of course, the older Barbizon contemporaries such as Charles-François Daubigny (Fig. b), who befriended the younger painters. It was hardly the aberration Leroy made it out to be.

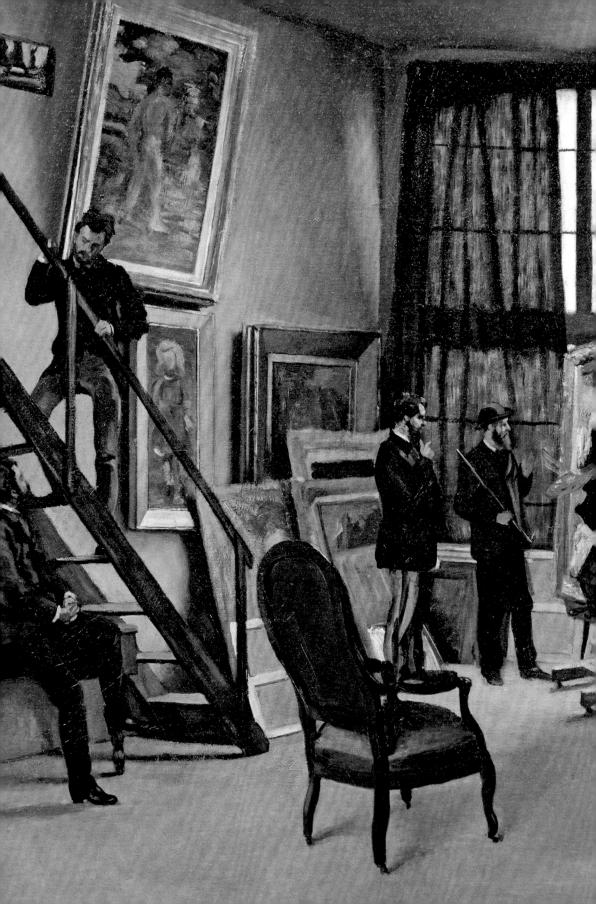

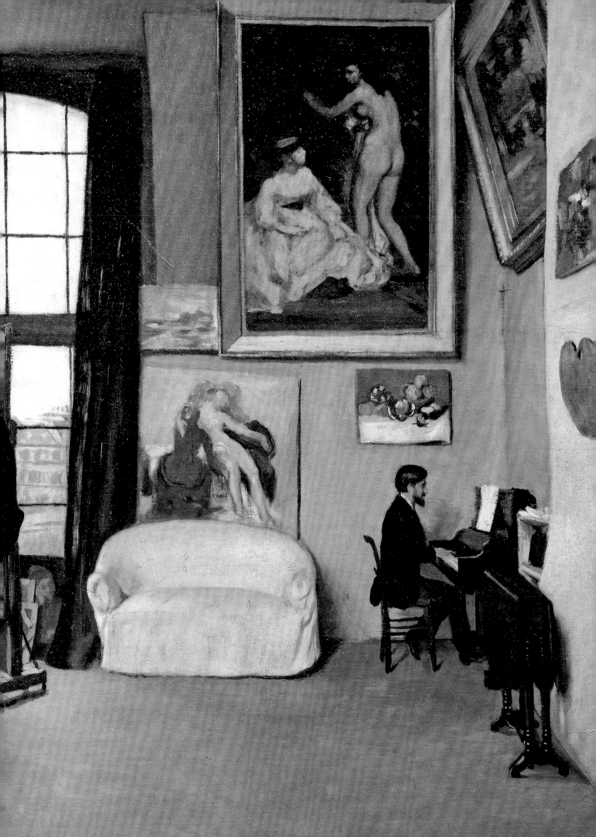

Colleagues and Patrons

Pierre-Auguste Renoir

|Fig. a| Gustave Courbet, *Self-Portrait with Black Dog*, 1842, Petit Palais, Paris

Artists in the Inn

Renoir's early painting, done in relatively dark tones, though with sharp contrasts reminiscent of Édouard Manet, places a group of artists and their friends at a popular inn and cabaret at Marlotte, south of the Fontainebleau Forest. Although not all identities are certain, the standing figure is probably Claude Monet. He is accompanied by Renoir's wealthy painter friend Jules Le Cœur, who lived nearby, often hosted Renoir, and whose sixteen-year-old niece Renoir began seeing. To the right is Alfred Sisley, wearing a straw hat. Renoir positioned himself and friends, therefore, within the practice of outdoor painting that came to be one of the several defining features of Impressionism. A waitress perhaps named Nana (*une nana* also refers simply to any young woman) clears the table, while possibly Mother Anthony herself is in the background.

The figure identified as Sisley reads the newspaper *L'Événement*, in which Émile Zola had recently vigorously defended Manet. Through this device, too, Renoir placed his cohort in sympathy with another manifestation of the avant-garde. Scrawled on the wall behind the table is a caricature of Henri Murger and a popular song, suggesting the conviviality of the place and Mother Anthony's warm-hearted tolerance of artists. Murger was widely known as the author of *Scènes de la vie de bohème* (*Scenes from Bohemian Life*), published serially in 1847–9, in which the lives of his impoverished artist friends were romanticised even though the end is tragic. (It inspired Giacomo Puccini's famous opera, *La Bohème*, first performed in 1896.)

Prominently featured in the painting's foreground is a shaggy white poodle. Although a domestic touch, and possibly the dog of the establishment, it calls to mind the tradition of artists' pets. Courbet was famously accompanied by a black spaniel, with which he showed himself posing on a hilltop, drawing portfolio at his side (Fig. a). Dogs are great companions on outdoor walks, and so were appropriate to artists who painted in the countryside or forest. Other artists, such as Manet, preferred cats, who were identified with writers such as Charles Baudelaire and Théophile Gautier for their independent nature. In all cases, the suggestion is that painting was practised in an atmosphere of sociability and domesticity, a far cry from the professionalism and institutionalism of the ever-dominant Academy.

Mother Anthony's Tavern, 1866

oil on canvas, 195 x 130 cm, Nationalmuseum, Stockholm

Henri Fantin-Latour

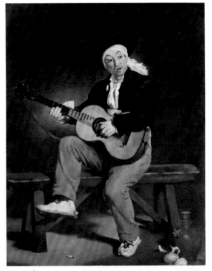

|Fig. a| Henri Fantin-Latour, *Édouard Manet*, 1867
The Art Institute of Chicago, IL

|Fig. b| Édouard Manet, *The Spanish Singer*, 1860
The Metropolitan Museum of Art, New York, NY

The Leader of the Pack

Fantin-Latour was more Realist than Impressionist – using the traditional dark palette –
but he was a close friend of the independent group, especially Édouard Manet. In 1867,
Fantin-Latour made a portrait of Manet as a well-dressed gentleman with a beautiful
blue silk tie (Fig. a), belying Manet's reputation as an unmannered bohemian renegade.
Fantin-Latour was a popular portraitist and still-life painter, specialising in flowers; but
he is perhaps most famous for group portraits of artists and musicians, all of whom
were part of the same social circle.

Fantin-Latour showed this painting of Manet's studio in 1870. Manet's space was in the
newly built-up Batignolles quarter behind the Saint-Lazare train station. Many artists
had studios there (now occupied mostly by photographers), and so it was a convenient
gathering place, from which a group might later move to a nearby café (Fig. c).

Alfred Sisley and Frédéric Bazille (p. 44) had recently moved nearby. Pictures of artists'
studios were an ancient tradition, but in the 19th century they sometimes became
group portraits with programmatic meanings. Fantin-Latour shows Manet at the centre
at his easel, carefully observing the seated critic Zacharie Astruc who is posing. Manet
had made Astruc's portrait in 1866 (p. 40). Others in the picture are, left to right: Otto
Scholderer, a German follower of Gustave Courbet with whom Fantin-Latour had a
voluminous correspondence; Pierre-Auguste Renoir, framed by the blank picture on the
wall; Émile Zola, the novelist and defender of Manet; Edmond Maître, a musician-friend
of the group (Fantin-Latour was a fanatic follower of Richard Wagner); the towering
Bazille with his fashionable trousers; and finally Claude Monet.

This new school of painters, which had already formed in the late 1860s before
exhibiting together as independents, was labelled 'Actualist', by Zola (p. 40 and p. 62).
Several, especially Manet, had a few pictures accepted by the Salon. Fantin-Latour's

|Fig. c| Édouard Manet, *Le Café Guerbois*, c. 1869, Harvard Art Museums, Cambridge, MA

composition was a sort of answer to Courbet's famous self-aggrandising allegory in *The Studio of the Painter* of 1855 (p. 202), where the painter at his easel is surrounded not by other artists but by a variety of supporters to the left, and figures to the right who symbolise the cast-off ideals of Romanticism and Second Empire politics. Fantin-Latour's picture was far more true to life and had few direct political implications. Rather, it referred through objects in Manet's studio to the dialogue with diverse traditions that had characterised Manet's work up to that time: a statue of the classical goddess Athena and a vase made in France to evoke Japanese ceramics (although using the more Chinese motif of a dragon).

Following the critical if not popular success of Manet's *Spanish Singer* (Fig. b), a group of artists and writers visited the painter. After the death of Eugène Delacroix, whom Manet and the Impressionists admired for his colour and brushwork, Fantin-Latour had painted a *Homage to Delacroix* (1864, Musée d'Orsay, Paris), showing more or less the same group as well as Manet. Hence, *A Studio in Les Batignolles* had a lineage that focused on a community with shared ideas and practices, despite stylistic diversity. It was this spirit that defined Impressionism's early years.

Édouard Manet

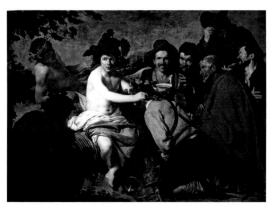

|Fig. a| Diego Velázquez, *The Triumph of Bacchus* or *The Drinkers*, 1628–9
Museo del Prado, Madrid

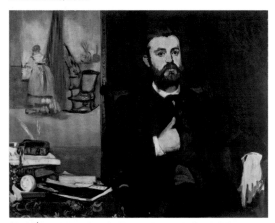

|Fig. b| Édouard Manet, *Portrait of Zacharie Astruc*, 1866, Kunsthalle Bremen

The Great Defender

Although Émile Zola grew up with Paul Cézanne, through whom he developed an interest in contemporary art, when he came to Paris the most controversial figure in the world of art was Manet. After the brouhaha over Manet's *Olympia* (p. 219), Zola, who so far had been writing book reviews, took up his verbal sword in the painter's defence. In so doing, he joined a literary genre that had been practised by major intellectuals such as Denis Diderot in the 18th century, Stendhal and Charles Baudelaire, all of whose writings Zola certainly knew. Manet placed Zola at his desk, but rather than showing him in the act of writing, he has him looking through an illustrated book or review, probably an issue of the *Gazette des Beaux-Arts*, edited by Charles Blanc, the liberal head of the Academy (officially named the École des Beaux-Arts). Blanc was also the author-editor of a multi-volume history of painters of several European schools, including of course the French, but also the Dutch and Spanish, whose characteristically realist style greatly interested Manet.

Indeed, assembled on a cork board to the upper right are three images that tell a relevant art-history story. One is a print by Goya after Diego Velázquez's *Triumph of Bacchus* (Fig. a), in which the central figure looks directly at the viewer as he offers him a coupe. Manet emulated Velázquez's realism in his *Le Déjeuner sur l'herbe* (p. 23) by breaking through the imaginary barrier between the viewer and the picture space. The second is a Japanese woodcut of a wrestler – a modern life subject from the world of entertainment with its characteristic flatness, thick contours and boldly juxtaposed colours. Prints such as those by the founder of the Edo School, Kaigetsudo Ando (Fig. c), were the rage in late 19th-century France, a phenomenon known as Japonisme. Note that behind Zola is a fashionable Japanese screen. An engraving after Manet's own *Olympia* is also displayed, but Olympia here looks down gratefully towards her defender.

Manet often played with his signatures, this one serving as the title of the pamphlet at the right edge of the picture, an allusion to Zola's more extensive essay on Manet of 1867. Near the signature is Zola's pen, a feather painted freely, as if to suggest Manet's 'signature' style and equating his forthright brushwork with Zola's journalistic style of writing.

Portrait of Émile Zola, 1868

oil on canvas, 146 x 114 cm, Musée d'Orsay, Paris

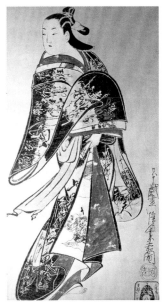

|Fig. c| Kaigetsudo Ando, *Courtesan*, early 18th century

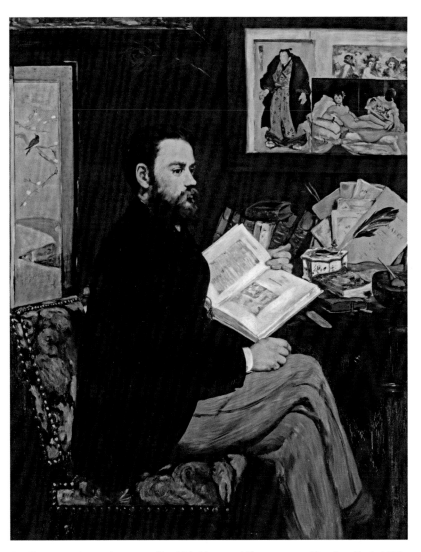

The Zola portrait was the second in which Manet paid homage to a friendly critic. In 1866 he had made a portrait of Zacharie Astruc at his desk, looking outwards (Fig. b). The latter leans against a desk piled with significant objects that, as in the Zola portrait, allude to shared preferences. Unlike the Astruc portrait, however, Manet showed Zola in profile, fully immersed in the study of art – a more active engagement and more candid view than in the earlier work. In addition, its vertical format, along with the flattening effect produced by piling up objects and placing prints on the wall, can be considered more modern because more closely emulating the effects of Japonisme that were the current rage.

Frédéric Bazille

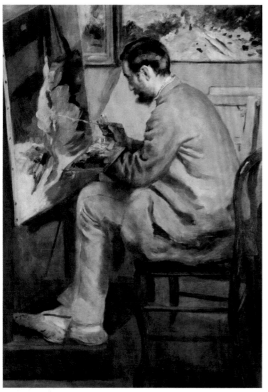

|Fig. a| Pierre-Auguste Renoir, *Frédéric Bazille*, 1867, Musée d'Orsay, Paris

Torturous Confinement

Among the indications of solidarity among the young Impressionists are numerous portraits of each other (Fig. a). Even Bazille, who could easily have afforded models, more often turned to his friends. The others, who had less money, willingly posed for one another.

Bazille was among the new generation who painted in the area of the Fontainebleau Forest (p. 16). In 1865, Claude Monet had travelled to Chailly-en-Bière, where he was making sketches for his rival version of Édouard Manet's picnic scene, *Le Déjeuner sur l'herbe* (p. 23).

He wrote repeatedly to Bazille asking him to join him. Bazille eventually did, posing for some of Monet's figures (p. 16). Unfortunately, the weather turned rainy as soon as Bazille arrived. Adding to delay was Monet's leg injury. In a letter to his parents, Bazille explained that Monet had tried to protect some children from a poorly aimed discus thrown by some English tourists. Bazille, who had studied medicine, set Monet up in a room of the Hôtel du Lion d'Or with a barrel hanging from the bedposts rigged to cool his reddened leg with slowly dripping water. It was an ironic therapy derived from a well-known torture method. The theme of the wounded man can be seen in a self-portrait by Gustave Courbet that was meant to suggest reverie and perhaps emotional rather than physical trauma (*The Wounded Man*, 1844–54, Musée d'Orsay, Paris).

In Bazille's picture, however, the pain became all too real and is represented within the physical surroundings of confinement. Monet, his injured leg bared and propped up on a folded quilt, lies in the heavy wooden bed. He is ensconced in a large pillow set on top of the long cylindrical bolster still today typical of bedding in some old-fashioned French hotels. The soft mattress bulges under his modest weight. He is framed by the bed itself, with its high bed boards, especially prominent to the left, and by the canopy and other furniture in the room – a night table and a tall dark armoire at the right-hand edge. He looks out with what seems a mixture of pathos, boredom and defiance. Even the wallpaper pattern contributes to the sense of imprisonment, and Monet's access to the outside world, through a tiny bell pull, is almost obscured by the wallpaper design

Claude Monet Wounded
(The Improvised Field Hospital), 1865

oil on canvas, 47 x 62 cm, Musée d'Orsay, Paris

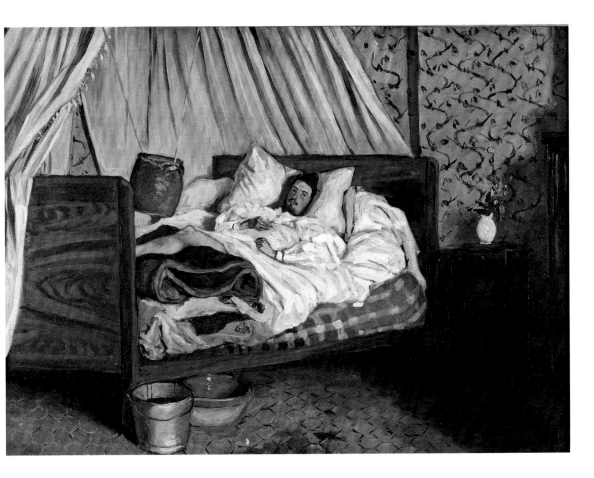

and the sorry bunch of flowers that barely remind one of the natural environment the artists had come to study. They nevertheless provide the only touch of colour in the drab, claustrophobic room. Their green leaves complement the redness of Monet's injury. Stylistically, Bazille's broad brushstrokes – for example, on the wooden end of the bed and for its starchy sheets – and the deft handling of the wallpaper and floor tiles are so completely in line with Monet's own early style that the picture can be seen as an aesthetic as well as personal sign of compassion and solidarity – indeed not just a sign of friendship but a sort of homage or spiritual collaboration.

Frédéric Bazille

Socialising in the Studio

The wealthy Bazille could afford a large studio space, which he generously shared with one artist or another from time to time, notably Claude Monet and Pierre-Auguste Renoir. It was in the Batignolles neighbourhood behind the Saint-Lazare train station, near where Édouard Manet and Alfred Sisley had their studios, and in the same street as Émile Zola's flat. Unlike Henri Fantin-Latour's group portrait of the same year (p. 39), Bazille's scene shows a working studio as a social space. Bazille was not essentially a portraitist, as was Fantin-Latour. Rather, he was at the core of the Impressionist movement in its early years, before he was killed in the Franco-Prussian War. Despite its indoor location, Bazille's luminous picture positions him within the new school, nourished to a great extent by painting *en plein air* (p. 16). In this scene, two of the largest pictures hanging on the wall are set outdoors, as is the canvas on the easel, *View of a Village* (Fig. a), painted two years earlier. In addition, there is a small landscape done at Aigues-Mortes in the South of France, near Bazille's family home in Montpellier. Still lifes complete the diverse oeuvre Bazille chose to represent.

The picture records a studio visit. Dressed in a smock over street clothes and holding a

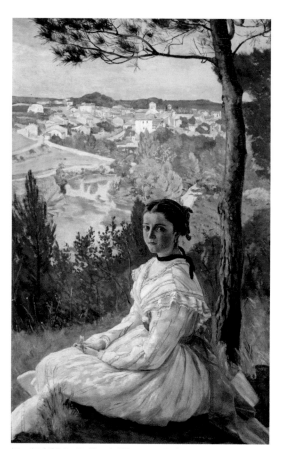

palette, Bazille has nonetheless set the picture on which he was currently working (*La Toilette*, p. 197) against the wall behind the pink sofa. He is showing his finished works to friends. Indeed, Manet, with his bowler hat and walking stick, and Zola, recognisable by his striped pants, seem to be discussing the picture. It is ironic, then, that Manet himself painted in the figure of Bazille, yet it again demonstrates the solidarity among these artists. The picture's dry, matt feel, along with its clarity, place Bazille squarely within the 'Actualist' trend described by Zola and commemorated by Fantin-Latour (p. 39).

To the right is Edmond Maître, whom Fantin included in *A Studio in Les Batignolles* (p. 39). To the left are Renoir and Sisley, having their own conversation. Although it is hard to tell which is which, I suspect Renoir is the figure on the stairs. Bazille made a quite informal portrait of him at around this time, showing him to be rather thin (*Portrait of Renoir*, c. 1870, Musée d'Orsay, Paris). The presence of Renoir's (now lost) large painting of a nude and her clothed companion on the wall to the upper right suggests that he was the artist sharing space with Bazille at the time. It might also indicate that Bazille had bought the picture, as he would do for several of his artist friends in order to help them make ends meet. That Renoir's picture alludes to Gustave Courbet's *The Bather* (1853, Musée Fabre, Montpellier) would certainly have appealed to Bazille.

|Fig. a| Frédéric Bazille, *View of a Village*, 1868, Musée Fabre, Montpellier

The Artist's Studio in the Rue de la Condamine, 1870

oil on canvas, 98 x 128.5 cm, Musée d'Orsay, Paris

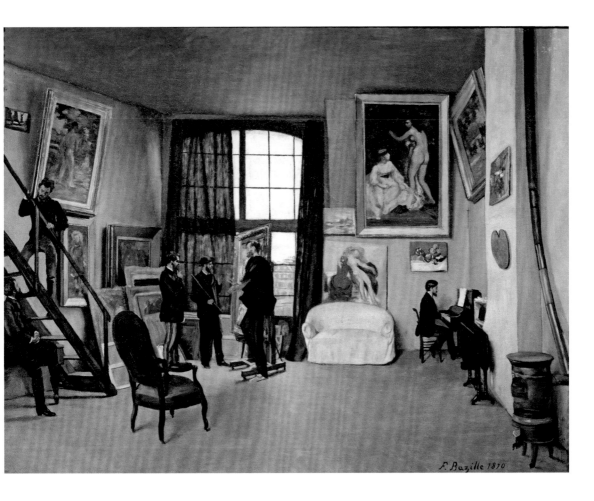

Pierre-Auguste Renoir

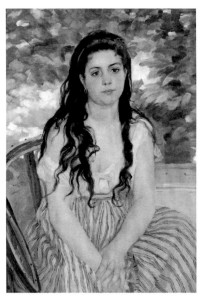

|Fig. a| Pierre-Auguste Renoir, *In Summer: Portrait of Lise*, 1868, Staatliche Museen zu Berlin

A Perfect Imaginary Couple

Long thought to represent Alfred Sisley and his wife, the woman posing with Sisley is actually Renoir's girlfriend, Lise Tréhot, as comparisons to other pictures showing her clearly demonstrate (Fig. a). Hence, Renoir's double portrait was not meant for his friends, as might be supposed if the woman were Marie Sisley, but was, rather, a Salon-sized demonstration piece through which Renoir was positioning himself artistically. As one of the Impressionists with the least financial backing in his youth, he needed to sell work in order to make money. Up until then, he had earned his living painting delicate decorative motifs on rococo-revival porcelain. That the painting was destined for public view is implied not only by its size (one m high), but by the fact that Renoir had submitted and would submit other paintings of similar dimension to the official Salon. He had sent *Diana Huntress* (p. 196), a figure in the spirit of Gustave Courbet's ample nudes, accompanied by a slain deer alluding to Courbet's hunting scenes, to the Salon of 1867. Oddly, by this time Courbet's radicalism had mellowed, and yet the *Diana* was rejected, probably because it was too obviously an unidealised portrait of Lise and because its facture was awkward in certain passages. In 1868 his more accomplished (and clothed) *Lise with a Parasol* was accepted by the Salon (p. 238).

It seems odd, then, that Renoir's next move would be to draw from more radical models than Courbet, namely Manet's *Fife Player* (Fig. b), as a cursory glance at the handling of Sisley's trousers reveals, and Monet's *Women in the Garden* (p. 115), which is clearly the main inspiration for Renoir's double portrait. Yet differences between Renoir and Monet are quite revealing. Whereas Monet used his mistress Camille Doncieux for all four figures in his painting (hence it cannot be called a portrait), Renoir's, which focuses far more on the figures than on their environment, has a relatively careful handling in the faces, where, for portraits, a convincing level of precision is required. Monet's handling is far more abstracting. Although technically, Renoir's background seems still indebted to Courbet's palette-knife work, it is far less skilled than was Courbet's, as was also the case for *Diana*. In this picture, however, the foliage and grass are blurred in a manner perhaps learned from Jean-Baptiste-Camille Corot, but also alluding to the backgrounds of photographs that sharpen their focus on their primary subjects.

Finally, but highly significant, is Renoir's devotion of about a third of his canvas's surface area to Lise's brightly coloured dress. The son of a tailor and a dressmaker, Renoir was well aware of the latest fashions and the characteristics of different materials, such as the

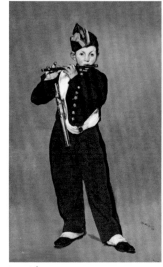

|Fig. b| Édouard Manet, *The Fife Player*, 1866 Musée d'Orsay, Paris

Alfred Sisley and Lise Tréhot in a Garden, c. 1868

oil on canvas, 105 x 75 cm, Wallraf-Richartz Museum, Cologne

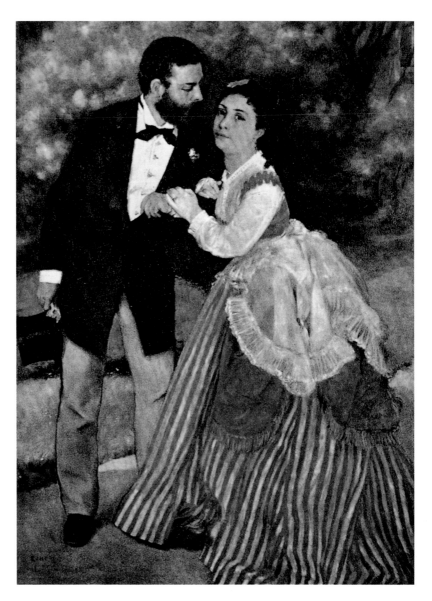

semi-transparency of Lise's ornamental apron and the gleam of her dress's red and yellow stripes. Renoir's bright reds indeed sing out against the duller green elements of his background, revelling in the spirit of Eugène Delacroix's love of complementary colours, which always reinforce each other's intensity. Thus, while revealing its many stylistic sources, Renoir's picture took a far more convincing step towards modernity than had his previous, rejected, demonstration painting of Lise as Diana.

Paul Cézanne

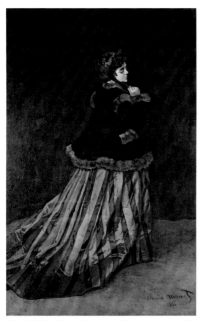

|Fig. a| Claude Monet, *The Woman in the Green Dress*, 1866
Kunsthalle Bremen

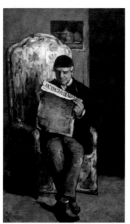

|Fig. b| Paul Cézanne, *The Artist's Father, Reading 'L'Événement'*, 1866
National Gallery of Art, Washington, DC

The Good, the Bad and the Ugly

Cézanne's portrait of his friend the painter Achille Emperaire confronts the viewer not only by its dark and heavy brushwork but through the shock of Emperaire's physical deformity – he was a dwarf. That Cézanne would choose to paint such a subject on a large scale testifies to his desire to challenge both his audience and himself. By submitting the painting to the Salon, Cézanne intended a slap in the face to the jury; for he certainly knew it would be rejected and said that was what he wanted, as if to prove how outrageous he could be. The challenge to himself was to make a powerful and coherent work based not on an elegant urban theme or female fashions, as Édouard Manet had done following the direction of Charles Baudelaire's 'Painter of Modern Life' (p. 20), but on its opposite – a coarse, provincial and thoroughly unfashionable subject. Nor would he paint in a seductive style. The picture had a political dimension, too, for its composition parodied the conservative painter Jean-Auguste-Dominique Ingres's *Portrait of Napoleon I on the Throne* (1806, Musée de l'Armée, Hôtel national des Invalides, Paris). Cézanne's satire was therefore in the same spirit of opposition as his art, since under the Second Empire, Napoleon's nephew, Napoleon III, encouraged the cult of his uncle.

In the 1860s, Manet did a number of full-length near 1.8-metre-high single figure paintings, inspired perhaps by fashionable portraits, but with which he intended a contrast. Other painters, Claude Monet and Pierre-Auguste Renoir especially, intended their large single figures to be portraits, done in their overtly modern style. A fine example is Monet's *Woman in the Green Dress* (Fig. a), which shows his girlfriend Camille Doncieux modelling a fashionable gown. Cézanne's contrarian tactic was unexpected, but makes sense in the light of his desire to impose a unique personal temperament, for better or for worse. Compared to the Monet, in which the lady's dress seems more important than her person – she is turned away from the viewer – Cézanne used a pose even more frontal than could be found in Manet's most confrontational figures (p. 46). Cézanne's earlier portrait (Fig. b) of his father reading the newspaper *L'Événement* (in which Émile Zola had published his defence of Manet) approached the subject from an angle and showed an interior decorated with one of Cézanne's early still lifes on the wall. *Achille Emperaire*, by contrast, is approached head-on, as was, so to speak, the task of painting him. Cézanne's bold, rich colours, like those of his *Abduction* (p. 27), suggest his own pictorial power rather than elegance or natural light. In an anti-picturesque exaggeration of Manet's use of black in contours, every design feature of Emperaire's house robe is indicated by heavy lines, as are the shapes of his long, sensitive hands and his spindly legs, the latter barely revealing their attachment to his torso. Framed by ample hair, Emperaire's over-sized head reaches almost out to his brawny shoulders, contrasting massively with the pleasant flower pattern of his upholstered armchair. Unlike Cézanne's portrait of his father, the space is shallow, almost airless, evoking both the dwarf's isolation and Japanese prints. And in a unique and daring gesture, Cézanne titled the painting in block letters that echo industrial stencilling, emphasising his workman-like approach.

Portrait of Achille Emperaire, 1867–8

oil on canvas, 200 x 120 cm, Musée d'Orsay, Paris

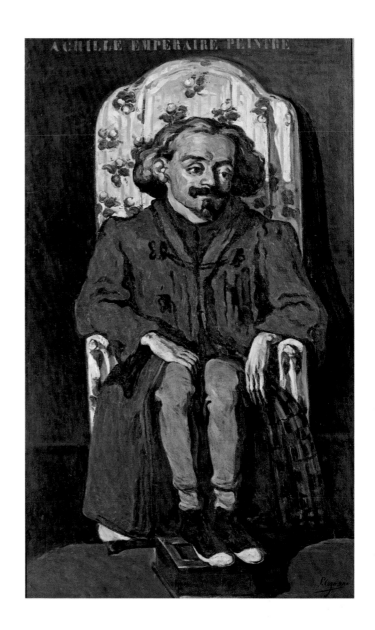

Édouard Manet

Professional Lady Friend

In 1868, Henri Fantin-Latour introduced Manet to the Morisot sisters, who had been working under the guidance of Jean-Baptiste-Camille Corot. Berthe Morisot began working with Manet, first as a student but soon as a challenging peer. They became intimate friends; it is doubtful their involvement was more than deeply psychological and professional. Not only would a secret affair have been improper, the slightest whiff of it would have ruined Morisot's chance for an appropriate suitor. An intense dialogue between the two – through eleven oils and several prints and drawings – lasted until Morisot's marriage in 1874 to Manet's brother, the kind but underachieving Eugène.

|Fig. a| Édouard Manet, *Eva Gonzalès*, 1870
The National Gallery, London

Manet never portrayed Morisot as a student or even as a painter, whereas he had shown another woman who worked with him, Eva Gonzalès, at her easel, in a picture that in many ways implied Manet's superior authority (Fig. a). By contrast, even in her own studio, as in *Le Repos*, Morisot is ostensibly relaxing on a sofa, as if the space were a living room rather than for work. Manet was known for keeping his subjects posed endlessly so he could get things just right. Apparently, Morisot got stiffness in the left leg folded under her. A close look at her pose shows both her arms stabilising her body. Her fashionable flouncy summer dress billows out to her right as most of her weight is shifted to the left. Her single exposed foot acts like the fragile fulcrum of the voluminous form above it.

In her right hand Morisot holds a fan, which may be a tool of the feminine-flirtation arts in addition to its ostensible cooling function, but is certainly not useful for the art of painting. In Manet's portraits of her, in fact, she is almost always accompanied by female accessories. In one of his most famous ones, *Berthe Morisot with a Bouquet of Violets* (Fig. b), she wears a quite extraordinary hat. In another, her face is partly hidden behind an open fan. A Japanese triptych woodcut showing *The Dragon King Pursuing the Ama with the Sacred Jewel* hangs close enough to Morisot's head to suggest an emanation of her thoughts. In Manet's painted version of it, the violent and highly detailed woodcut looks like a piece of rococo fluff with a damsel in distress. Given that it also bears Manet's signature, it leaves open the question of to whose mind the fantasy belongs. Such wit was typical of Manet's relationship to his sitters.

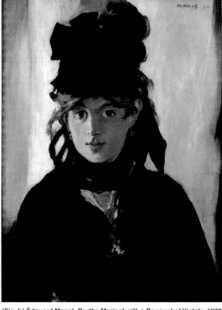

|Fig. b| Édouard Manet, *Berthe Morisot with a Bouquet of Violets*, 1872
Musée d'Orsay, Paris

Le Repos: Berthe Morisot in her Studio, c. 1870–1

oil on canvas, 150.2 x 114 cm, Museum of Art, Rhode Island School of Design, Providence, RI

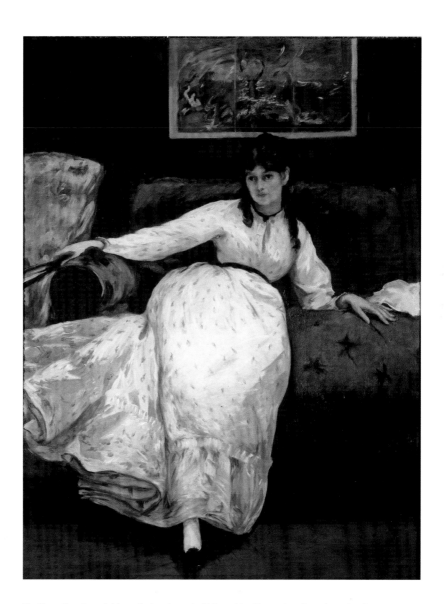

On the other hand, Manet's treatment of his subject's expression gives rise to more serious considerations. In *Berthe Morisot with a Bouquet of Violets* there appear to be two sides to Berthe's face, each with a slightly different expression, combined in a way that foreshadows what Picasso might have done. In *Le Repos* the expression is equally sensitive in its ambiguity. Is she lost in thought or simply bored? Is she tired or impatient? That so many possibilities exist enriches the painting with the mystery both of a personality and a situation.

Edgar Degas

|Fig. a| Giuseppe de Nittis, *La Parfumerie Violet*, 1880,
Musée Carnavalet, Paris

Pictorial Dialogue with a Critic

In his essay 'La Nouvelle Peinture' (The New Painting),
published in response to the second Impressionist
exhibition (1876), Edmond Duranty wrote that art must
come out from the studio into real life:

*[The artist] will no longer separate the figure from the
background of an apartment or the street … instead
surrounding him are the furniture, fireplaces, curtains
and walls that indicate a financial condition, class and
profession.*

Duranty's view was based for the most part on Degas's
work. A defender of Realism in the 1850s, having
founded a short-lived literary magazine called *Réalisme*,
Duranty's sympathies lay more with Degas's brand of
Impressionism than with the landscape painters. Indeed,
he feared that the influence of the latter would corrupt
the standards of high art by being too easily executed.
In addition, Duranty was fascinated by different artistic
techniques and methods, interests Degas also shared;
hence the complex mixture of media in this portrait
responded to Duranty's tastes and thus embodies
a dialogue between the artist and his supporter.

In a study stuffed with books, albums, manuscripts and notes, Duranty pauses to
reflect. On the shelves, contemporaries would have recognised certain paperback
series by their coloured bindings. To the left of the foreground is Duranty's presently idle
inkwell, near his right hand, which holds a blotter on the page he has just been writing.
Nearest to the viewer in the centre foreground are magnifying glasses,
references to vision and to Duranty's connoisseurship of prints.
Duranty's reflective pose is derived from representations of Romantic
poets, composers and artist geniuses inspired by imagination.
The tension in Duranty's left hand, its fingers emphasised by a line of
blue pastel, focuses attention on his concentrated gaze, implying his
focused vision of scientific observation. Duranty was among those,
including Degas, who preferred the term 'Naturalism' to 'Impressionism'.
In 1877, in fact, Degas argued unsuccessfully in favour of changing it.
Through his Italian connections, Degas also introduced painters such
as Federico Zandomeneghi and Giuseppe de Nittis (Fig. a) to the
group in order to expand its range, but their reputations as canonical
Impressionists never took because they stayed so close to academic
genre painting. He also knew the Italian art critic Diego Martelli, of
whom he made a portrait in a setting comparable to this one (National
Galleries of Scotland, Edinburgh).

One might compare Degas's portrait to that of another journalist,
Louis-François Bertin (Fig. b), painted by the great conservative
Jean-Auguste-Dominique Ingres. Although Ingres shows the power

|Fig. b| Jean-Auguste-Dominique Ingres, *Portrait of the
Publisher Louis-François Bertin*, 1832
Musée du Louvre, Paris

Portrait of Edmond Duranty, 1879

pastel and tempera, 100.9 x 100.3 cm, The Burrell Collection, Glasgow

of Bertin's personality through his physical bulk and claw-like hands, the viewer must recognise him in order to know his profession. Degas admired Ingres, especially for his technical gifts, and he had studied with one of the master's disciples. Nevertheless, by representing Duranty's tools and surroundings, he has explicitly placed his subject in a painting of modern life.

Claude Monet

Turkeys and Lives Run Amok

The format, size and unusual subject of this painting are explained by the commission from Ernest Hoschedé, a department store mogul and collector. He invited Monet to visit his estate in Montgeron, near a royal preserve between the Seine and the Yerres valleys, southeast of Paris in what are now outer suburbs. It was easily accessible by train from the Gare de Lyon, and the ride impressed Monet enough that he painted the locomotive arriving at the rather primitive station (*The Arrival of the Train at Montgeron*, 1876, private collection).

Hoschedé had just purchased the Château de Rottembourg (now a cultural centre for the town) from Baron Henri de Rottembourg, a Napoleonic general. He commissioned several decorative paintings for the house from Monet, despite the fact that his business was going broke. Another aspect of Hoschedé's downfall would be the relationship that emerged between the painter and Hoschedé's wife, Alice. No one knows exactly what it involved at the time, or if it began before Monet's visit, but when Monet's wife died in 1879 (p. 76), Alice and the painter combined households, with Alice's six children and Monet's two. Hoschedé's life had fallen apart in 1877 when he could no longer pay his debts, and he had to sell his art and property in 1878. Hence,

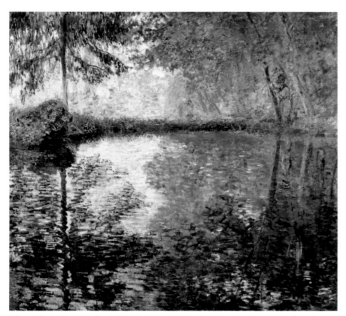

|Fig. a| Claude Monet, *The Pond at Montgeron*, c. 1876, The State Hermitage Museum, St Petersburg

the Monet–Alice Hoschedé consolidation may have had economic as well as affective benefits. They could not marry, however, until 1892, after Ernest had died. Of the decorative works Monet painted for the house (Fig. a), *Turkeys* is the most famous and unusual. It is seems obvious that Hoschedé was raising these birds, since the notoriously timid creatures would never have run wild across the terrain in numerous, paintable groups. In the background is the 18th-century château. The looming foreground and vertically stacked space evoke Japanese decorative screens and prints and in so doing declare the picture's modernity. The brushwork is considerably more gestural than in most Monets of the period, which were done not for specific patrons but for sale by the dealer Paul Durand-Ruel. The stunning mixture of colours for the turkeys' white feathers suggests reflections of the green grasses on the lower part of the bodies and the grey-blue sky on their backs. The grasses are long enough that one can barely see the turkeys' feet: they almost float on the canvas surface or seem suspended just above the ground. Placement of the birds seems random, but they clearly lead the eye to the left mid-distance where one has fanned its feathers – the only one facing the observer and

aware of an outside presence. From there, a patch of sunlight leads back past the house, towards trees that frame the composition at the upper right. Such devices, with Monet's active brushwork and complex coloration of the grasses, animate a picture that otherwise represents what in everyday life would have been perfectly banal compared to the grand efforts of Salon painters. Moreover, the commission reveals the first inkling of Monet's greatest decorative ensemble, the magnificent *Water Lilies* (p. 390).

Pierre-Auguste Renoir

The Most Fashionable Family

Renoir's large family portrait was commissioned by Georges Charpentier, the successful publisher of the Bibliothèque Charpentier, a collection that literally underwrote the Naturalist novel. His authors included Gustave Flaubert, Émile Zola and many others who became almost as famous. In 1879 he founded an illustrated journal, *La Vie moderne*, and held exhibitions in its offices, although it failed financially and was liquidated in 1883. He and his wife, Marguérite, were important collectors. She organised literary salons on Thursdays, at which Renoir was often present and through which he met important clients, such as the actress Jeanne Samary (Fig. a).

Madame Charpentier is formally and fashionably dressed, her shimmering black gown from the historic House of Worth. But rather than showing her as the head of an intellectual gathering, the scene is domestic, with her two children and the family Newfoundland dog. The pet's name, Porthos, came from *The Three Musketeers* by Alexandre Dumas. It is the picture's only literary reference. Porthos serves as the gentle guardian of the children. He calmly holds the six-year-old daughter, Georgette, on his back, but his eyes focus entirely on the viewer, as if embodying the protective virile power of the absent father. Viewers are often confused to find three-year-old Paul, next to his mother, dressed like a girl. At the time, however, that was the fashion, and it must be said that until a boy was toilet-trained it had a practical advantage. The interior is obsessively up to date, with bamboo furniture, a Japanese screen behind the flowery sofa, and a Japanese print on the wall above a

|Fig. a| Pierre-Auguste Renoir, *Portrait of the Actress Jeanne Samary*, 1878
The State Hermitage Museum, St Petersburg

table set with a sumptuous still life of fruit, flowers and beverage. All elements testify to the modernity and consumerism of bourgeois Parisian society.

Although Renoir's facture is entirely within the Impressionist range, the composition is relatively conservative. The borders of the Chinese rug provide a strong orthogonal, demonstrating a command of space rather than Japoniste flatness. Renoir's arrangement of figures is pyramidal, evoking models from the Renaissance. Indeed, in 1878, Renoir had abandoned the Impressionists for the Salon, and in 1879, thanks to Charpentier's influence, the picture was hung to advantage.

|Fig. b| Pierre-Auguste Renoir, *Victor Choquet*, c. 1875
Harvard Art Museums, Cambridge, MA

Madame Georges Charpentier and her Children, 1878

oil on canvas, 153.7 x 190.2 cm, The Metropolitan Museum of Art, New York, NY

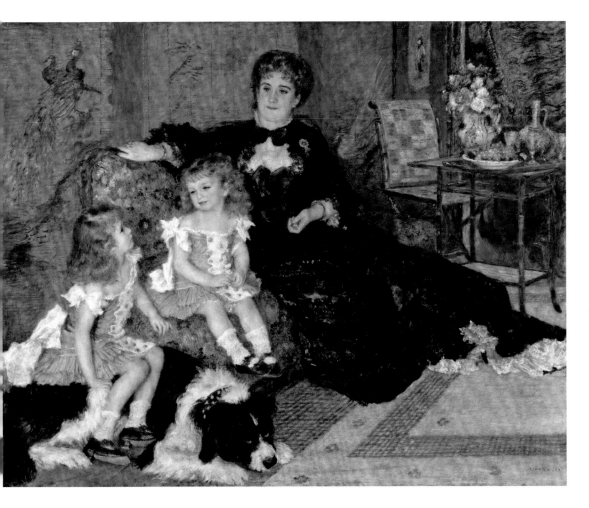

These aspects of the painting can be compared to Renoir's earlier portrait of a far less wealthy but devoted patron, the customs clerk Victor Choquet (Fig. b). For obvious financial reasons, Choquet's portrait is much smaller. But it is also more direct and the only significant indication of its setting is the painting directly behind him, a sketch by Eugène Delacroix for decorations of the Palais Bourbon. Choquet and Renoir both admired the great Romantic for his colour. (So did Paul Cézanne, whom the Choquets also patronised, in spite of the opposite look of his paintings from Renoir.) Unlike the Madame Charpentier, then, which is written all over with signs of fashionable taste – both in furniture and decor – Renoir's allusion to the Choquet home focused on their taste in art.

Édouard Manet

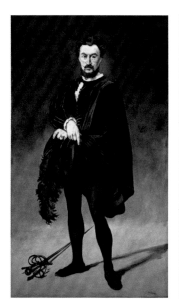

|Fig. a| Édouard Manet, *The Tragic Actor (Rouvière as Hamlet)*, 1866, National Gallery of Art, Washington, DC

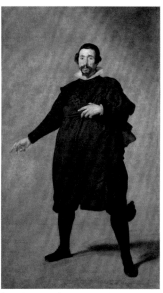

|Fig. b| Diego Velázquez, *The Buffoon Pablo de Valladolid*, c. 1635, Museo del Prado, Madrid

The Actor's Paradox and Triple Portrait

Jean-Baptiste Faure's face shines forth from the canvas, like a mask spotlighted on the stage. Its painted flesh is heavily worked in uniform tones suggesting make-up, but with a physicality that foreshadows the work of Vincent van Gogh. The expression is unexpected in portraiture, but this is a portrait of an actor acting. Faure was an operatic baritone, who sang at the Paris Opera and London's Covent Garden. He was known for many roles, including Don Giovanni in Mozart's classic, and as here, Hamlet, not in Shakespeare's play but in the opera version of 1868 by Ambroise Thomas. His role thus justifies his expression. *Hamlet*, the tragedy of tragedies, was popular in France, represented frequently in the 19th century. Eugène Delacroix made paintings as well as a celebrated series of lithographs on the theme. In the performance of the 1846 French translation by Alexandre Dumas and Paul Meurice, Hamlet had been portrayed by another actor friend of Manet, Philibert Rouvière. It was revived around the time of Manet's portrait of him (Fig. a), explaining Manet's decision to show him in the role.

Are these portraits of Rouvière and Faure as themselves, or are they pictures of Hamlet? The truth is: they are double portraits, of the actors and of the character each portrays. (In Renoir's portrait of Jeanne Samary, p. 56, by contrast, it is far less clear that she is acting.) Manet submits his actors to the roles for which they are celebrated, as if the actor-individuals are characterised by figures they portray. This is the initial paradox of Manet's actor portraits, but it is not an unfamiliar one; rather, it is the central theme in Denis Diderot's essay 'Paradoxe sur le comédien' (Paradox of acting), which although never published in his lifetime, became famous in the 19th century, when it was published repeatedly, beginning in 1830. Diderot's paradox is simple: the actor who best portrays emotion does so dispassionately, without himself sharing the emotion of his character. For Charles Baudelaire, who knew the essay, the same applied to artists. In 1863, for Delacroix's obituary, he wrote, 'Delacroix was passionately in love with passion, but coldly dedicated to expressing it through the most rational possible means.' Rouvière points to the ground, where his sword, legs and shadows produce an M that calls attention to Manet's signature. The Faure looks to Diego Velázquez's famous picture of the court jester Pablo de Valladolid (Fig. b), which Manet may have copied while in Spain (Attributed to Manet, Columbus Museum of Art, OH). In both portraits, then, Manet calls attention to himself as 'director' – the *metteur en scène* – who stages the image, which itself is a performance. In that sense, the pictures are triple portraits, for Manet is present in them too.

The Baritone Jean-Baptiste Faure as Hamlet, 1877

oil on canvas, 194 x 131.5 cm, Museum Folkwang, Essen

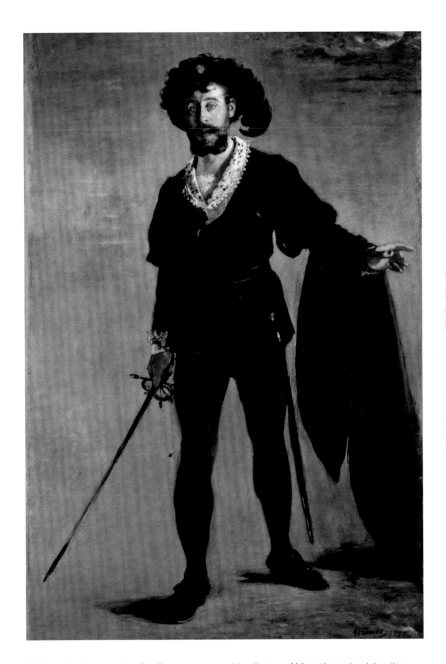

Yet there too is paradox. For Faure was an avid collector of Manet's work, giving the artist sustenance – the ability to practise his creative role – by purchasing it in volume. He was also an investor, buying and selling with Paul Durand-Ruel, helping to circulate Manet's work and raise its prices. Manet, for his part, generously introduced many other artists to Faure.

Family and Friends

Frédéric Bazille

|Fig. a| Gustave Courbet, *The Meeting (Bonjour Monsieur Courbet)*, 1854
Musée Fabre, Montpellier

A Family in Southern Light

This masterpiece suggests that Bazille would be as well known as any Impressionist had he lived to pursue a long career. (He was killed in 1870 in the Franco-Prussian War.) Magnificently coloured and flooded with the light of the Bazille family's Southern home near Montpellier, this large painting combines two stylistic streams into a coherent whole. Bazille's compact handling of the figures takes its cue from Gustave Courbet, whose work he knew through the collection of his neighbour, Alfred Bruyas, and much admired. Of special note was Courbet's *The Meeting (Bonjour Monsieur Courbet)* (Fig. a), in which Courbet represented the encounter with his patron Bruyas on the road after arriving from the city by coach (in the background).

Even within Courbet's oeuvre *The Meeting* was unusual, embodying discovery of the intense Mediterranean sunlight by a painter from land-locked Franche-Comté. The patch of sunlight on the Bazille family terrace, although its immediate source is probably Claude Monet's *Women in the Garden* of 1866 (p. 115), may look back to Courbet's picture, too. The scene is the Bazille family's large country estate, the Domaine de Méric, northeast of Montpellier's centre, overlooking the river Lez towards the picturesque village of Castelnau. (All are now part of metropolitan Montpellier.) The magnificent house, with its bright pink stucco walls, is visible in another picture, *Terrace at Méric*, taken from an opposite location (1867, Musée Fabre, Montpellier). After the latter was rejected for the Salon of 1867, *Family Reunion* was accepted for the Salon of 1868, along with works by other Impressionists, notably Monet's *Woman in the Green Dress* (p. 48) and Pierre-Auguste Renoir's *Lise with a Parasol* (p. 238). Émile Zola included *Family Reunion* in the chapter of his extensive Salon review entitled 'Actualists', whom he distinguished from landscape painters. He wrote that the picture 'bears witness to a vigorous love of truth … Each physiognomy is studied with extreme care; each figure has its individual character. One can see that he is a painter who appreciates his own times [*qui aime son temps*].' The latter was one of Zola's most important criteria.

Bazille's careful study has allowed each figure in the picture to be identified. The dominant couple, Bazille's parents, are seated together towards the left, his mother in a sumptuous blue dress, his father looking rather coldly away – his son's change of career from medicine to art cannot have pleased him. Standing behind them next to the tree are the recently married Pauline des Hours and Émile Teulon. Bazille's aunt, Madame des Hours, has a bored expression as her daughter, Thérèse, looks out towards the viewer. Bazille himself is at the far left, behind his uncle, Monsieur des Hours, a marginal position that echoes Manet's in *Music in the Tuileries Garden* (p. 21). Whereas several of these figures may appear relatively natural, those in the group to the right comprising Bazille's brother Marc and his rather stiff fiancée Suzanne Tissié are overtly posing, as for a photograph with a long exposure. The reference to photography is an ironic form of naturalism, since a painter can make his figures seem unaware of being observed, and yet the truth is, that as for photography, they need to pose. Cousin Camille des Hours stares out in youthful (she is the youngest) curiosity.

Edgar Degas

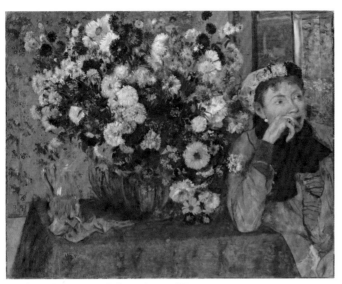

|Fig. a| Edgar Degas, *Woman with Chrysanthemums*, 1865
The Metropolitan Museum of Art, New York, NY

Calculated Candour

Supportive friends often provide the opportunity for important artistic experiments. Represented in their carriage are Monsieur and Madame Paul Valpinçon, out for a ride at Argentan's racecourse, not far from their country estate at Ménil-Hubert in Normandy.

In an earlier portrait of Mme Valpinçon, Degas had added her to the right of a still life of chrysanthemums (Fig. a), thus creating an effect of cropping far more radical than those in *The Bellelli Family* (p. 29). Her position and her gaze away from the picture's centre has the Realist effect of making the picture seem like a fragment of the reality beyond the frame.

This cropping or fragment-like effect is the most noticeable feature of *A Carriage at the Races*. The horses and the carriage wheels seem cut off as in the accidental effects of photography (p. 66). Thus, Degas evoked the latest technology, which practically since it first appeared had set a new standard for naturalism. The severing of the vehicle at the left-hand edge, however, is so conspicuous that it can hardly be accidental. Rather, it evokes the bold compositional juxtapositions of near and far, overlapping, and slicing of Japanese prints (Fig. b).

Art historians and critics have been so distracted by these pictorial effects and discussion of their sources that few have noticed the charming genre scene at the picture's centre. Within the carriage, Mme Valpinçon looks on attentively as baby Henri dozes off after gorging himself on his wet nurse's milk. The latter's dangling breast is no disgrace, for propriety among women of her station is a function of utility, not sex. It is a sign of the extent to which members of Degas and Valpinçon's social class take domestic help for granted. That the sharp corner of the parasol cuts into the nursemaid's face is another of Degas's somewhat nasty, surgical effects.

|Fig. b| Utagawa Hiroshige, *Twilight Moon at Ryogoku Bridge*, c. 1830
Art Institute of Chicago, IL

A Carriage at the Races, 1869

oil on canvas, 36.5 x 55.9 cm, Museum of Fine Arts, Boston, MA

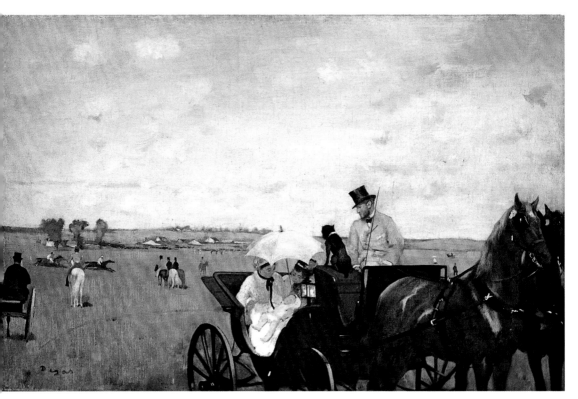

The way the riding crop cuts through Monsieur Valpinçon is far less devastating.
He looks on with guarded tenderness from his position of authority in the driver's seat,
seconded by the griffon dog, whose colour matches that of the patriarch's top hat.
Monsieur is formally dressed, as a sign that he circulates in the social world even when
on a fresh-air jaunt, while his wife and child stay in protected comfort.
Degas's outdoor scenes are rare, with the exception of racecourse locations, and
those cannot be considered primarily landscapes (p. 286). Indeed, he was known to
have disparaged the spontaneity of *plein-air* painting, claiming for his work: 'No art is
less spontaneous than mine; what I do is the result of reflection and study of the great
masters.' With its careful framing and combination of narrative and pictorial incidents,
this picture is indeed a quiet masterpiece of subtle intellect.

Mary Cassatt

|Fig. a| Anonymous, *Family in a Carriage*, c. 1860

Seizing the Reins

In 1877, Cassatt was an American spinster living in France with her parents when she met Edgar Degas, who became her lifelong friend. He had noticed Cassatt's early Spanish subject paintings at the Salon, and he introduced her to the Impressionists, with whom she began exhibiting in 1879. Cassatt was from a prosperous family of bankers in Pittsburgh, of the same social class as the more famous steelmakers Carnegie and Frick, and had studied at the Pennsylvania Academy of the Fine Arts in Philadelphia. In 1866 she left the United States to study in Paris, the same year as her compatriot, Thomas Eakins. Excluded from the École des Beaux-Arts because of her sex, she took her cues from more independent painters like, eventually, Édouard Manet. Although her association with the Impressionists and Degas quickly changed her facture and colouring, she always retained a sure sense of composition and rigorous drawing, both qualities much prized by her friend Degas.

In *The Carriage Ride* Cassatt depicted her sister Lydia driving in the Bois de Boulogne, the large park at the western edge of Paris, in the 16th arrondissement. The Bois was a fashionable place for leisure and fresh air, perfect for the bourgeois Parisian who could afford a carriage and the time. Cassatt's family could do both, benefiting as they were from a trust fund set up by brother Alexander, who inherited the stewardship of the family business. One of their first purchases on arriving in Paris was their own carriage in order to enjoy fully the city's fashionable outdoor pleasures.

The Cassatt women were an intrepid lot. Mary achieved what few women would until many years later: a successful and independent career, although she never

FAMILY AND FRIENDS

The Carriage Ride, 1881

oil on canvas, 89.7 x 130.5 cm, Philadelphia Museum of Art, PA

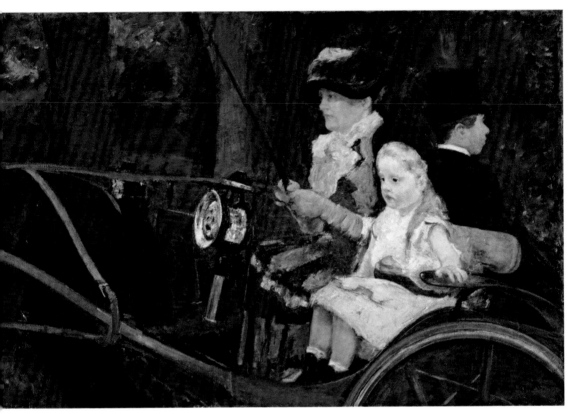

married and perhaps sacrificed a home life of her own. Her mother, an intelligent and intellectually curious woman, completely supported her daughter's ambitions (p. 68). In this picture Lydia has seized the reins and drives forwards with concentration, while her chauffeur sits in the seat facing backwards. Her face and that of her companion, Degas's niece Odile Fèvre, are sharply characterised and contrasted, as the little girl hangs on nervously to the mud guard she seems barely able to reach.

In addition to connecting to Degas through Odile, Cassatt's picture quite obviously recalls her mentor's *A Carriage at the Races* (p. 65). Cassatt's focus on the figures, to the exclusion of much of the horse and carriage, which are cropped, and background, makes it more a portrait and genre scene – as in other paintings by Degas as well as Manet – than was Degas's carriage picture, which ostentatiously displays its clever composition and thus the artist's wit behind it. The Cassatt in this respect compares better than the Degas to a photograph of a family in a carriage (Fig. a), in which cropping by the frame results from the primary interest being the figures. But that Cassatt's composition is similar to the photograph may be an effect of naturalism rather than deliberate imitation. Finally, like Degas, Cassatt had little interest in landscape. Here, the background is skilfully executed with Impressionist mixes of colour patches, but it is perfunctory in its specific rendering of detail.

Mary Cassatt

A Serious Woman

Cassatt's portrait of her mother Katherine is one of many pictures of women reading in the Impressionist oeuvre, for representations of bourgeois women in modern life generally represent them as literate creatures of leisure. This picture is exceptional, however, for Madame Cassatt holds a newspaper rather than an escapist novel, as normally befitted the reputation of women at the time – especially since Flaubert's Madame Bovary used such reading material as an escape from her boring life. The presence of the traditional newspaper *Le Figaro* suggests not only the Cassatts' conservative social position, but shows that Madame Cassatt was interested in keeping up with the latest news. She is reading the front page, perhaps the first woman in the history of art to be shown doing so. There is a sense in which the picture's composition is conservative, too, for the mother's three-quarter length, her three-quarter profile and the reflection in the mirror most certainly allude to tactics used more than once by the conservative painter Jean-Auguste-Dominique Ingres, who until his death in 1867 was the most famous and sought-after portraitist in France. One of his masterpieces was the portrait of Madame Moitessier (Fig. a). It seems significant here, however, that the mirror reflects the newspaper rather than the woman from a different angle. Even Cassatt's muted palette suggests restraint, but its reticence is accompanied by extraordinarily free and daring rendering. The picture's sweeping brushstrokes and loose, sketch-like handling are as broad as any in the Impressionism of her contemporaries, and certainly outdid Degas. The variety of tones within Cassatt's limited palette is also a *tour de force*.

|Fig. a| Jean-Auguste-Dominique Ingres, *Madame Moitessier*, 1856, The National Gallery, London

Ingres's women, with few exceptions, were represented as relatively indolent, passive or timid. Of course he was famous for the sheen and crisp linear description of his figures and their fashions, effects that Cassatt has completely transcended. But it is interesting, too, that Cassatt's images of women rarely approach the Ingresque stereotype, exemplified by Madame Moitessier's sphinx-like expression, cluttered interior and seductive negligence – her gown seems like it might slip off her shoulder. Cassatt's mother is the complete opposite: serious, concentrated and covered all the way up to her neck. Slouching would have been impossible.

It is ironic, then, that in one of only two known self-portraits (Fig. b), Cassatt showed herself not as a professional artist but as a woman of the bourgeoisie, leaning against an overstuffed sofa, dressed with a hat as if ready to go out. Only the seriousness of her expression suggests there is something more. And yet the seriousness of the portrait itself is questionable, since it was neither completely finished, nor done in oils, but in the more casual technique of gouache and watercolour. Fortunately, these are characteristics we admire today for the freshness we associate with their spontaneity.

|Fig. b| Mary Cassatt, *Self-Portrait*, 1878
The Metropolitan Museum of Art, New York, NY

Madame Cassatt Reading 'Le Figaro', 1878

oil on canvas, 104 x 84 cm, private collection

Paul Cézanne

|Fig. a| Edgar Degas, *Self-Portrait*, 1855, Musée d'Orsay, Paris

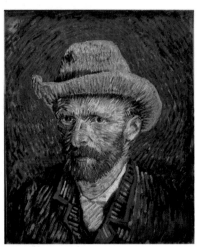

|Fig. b| Vincent van Gogh, *Self-Portrait with Felt Hat*, 1887–8 Van Gogh Museum, Amsterdam

Fashioning the Self-Image

Self-portraits are common among painters, especially towards the beginnings of their careers. First, the self is inexpensive and always available: all one has to do is look in a mirror. Second, young artists are usually reflective, concerned about their careers and how they present themselves to society. The art world is a social world, after all, in which artists must engage whether for financial reasons or for some kind of feedback. Such self-presentation includes a demonstration of pictorial style, its roots and its originality. Finally, the self-portrait can be an occasion for experimentation, as it often was for Cézanne.

Cézanne seems less concerned than others with public opinion, for most of his poses tend to focus on the face. Compared to an early self-portrait by Edgar Degas (Fig. a), which was modelled on one by Jean-Auguste-Dominique Ingres (1804, Musée Condé, Chantilly), Cézanne was not interested in calling forth previous models. Nor did he present himself with the psychological ambiguity of Degas's character study, which seems to combine (or hover between) the arrogance of Degas's social class and his self-conscious thoughtfulness as an artist. In Cézanne's picture, rather, the head dominates the composition, with the artist's shoulders, coat and the background produced through far more summary sketching than the face. The eyes are concentrated, but not with a mysterious inner vision, as in the all-too-familiar trope of genius portraiture, popular among Romantic artists and perpetuated by Vincent van Gogh (Fig. b). Rather, Cézanne's scrutiny really seems aimed at the painted image presumably in front of him as he worked, for its technique and powerful but ostensibly dispassionate execution exemplified an important step in his development.

Having left behind his violent and heavy *couillard* style (pp. 26, 48), Cézanne nonetheless retained the intensity of purpose and effort his early paintings revealed. The variations in the brushstrokes of his face are studied in order to bend the Impressionist technique to the as yet unfamiliar goal of producing a sculptural effect, rather than the flattening and fragmentation so often observed in the 1870s. The subtle relationships of colour within the unusually limited palette and the individual shape of each brushstroke require the viewer's scrutiny in response to the artist's. It is worth noticing especially how Cézanne tries to dissimulate line – that is, traditional draughtsmanship – by making certain prominent contours such as the outline of his nose seem the result of shadows – or one might say, the trace of a form's absence beyond its edge. And yet Cézanne is entirely faithful to the Impressionist method of direct observation and painting with patches of colour. It is the sense of spontaneity that he eschews, in order to achieve something greater than the effect of the passing moment. And rather than the colourful decorative surfaces of his prominent colleagues, he uses closely related colours to produce a new version of the traditional practice of three-dimensional modelling.

Paul Cézanne

|Fig. a| Paul Cézanne, *Madame Cézanne in a Yellow Chair*, 1888–90, private collection

Locking in the Model

This brightly coloured picture is dated to the late 1870s or early 1880s because of its experimental style and the wallpaper pattern found in other pictures of the period (p. 316). Cézanne rarely signed or dated unless he was exhibiting or selling. Both were rare since he was indifferent to making money, and after his father's death in 1886, did not need to. He participated in only two Impressionist exhibitions – the first and third, 1874 and 1877 – after which he never showed until 1895, when invited for a one-man retrospective by the dealer Ambroise Vollard.

Cézanne met Hortense Fiquet in 1869 when she was modelling at the Académie Suisse, an inexpensive studio run by a former artist's model by that name. She became Cézanne's mistress, and in 1886 they married, against his father's objections. Cézanne made twenty-seven portraits of his wife, even though in the same year as his father's death the couple separated, with Cézanne moving out to live with his mother and sister at the family estate, the Jas de Bouffan in Aix-en-Provence. Their relationship had been tense, caused by what Cézanne felt were Hortense's excessive demands. In his will he left her nothing, settling everything on his son, whom he named after himself, but whose birth in 1872 he kept secret from his father until 1886.

The picture's composition is a wonderful jigsaw of juxtaposed shapes, notably of the elements of Hortense's body within the forms of the armchair, then framed by the wallpaper and inexplicable flooring. The geometric interlock is enhanced by the rectangle at the upper left (a window?), which secondarily extends the leftward diagonal axis that balances the rightward weight of the armchair. Although Cézanne would not extensively pursue such explicit shape patterning – perhaps there were underlying gender and control issues in this case – this aspect would be taken up extensively and wittily by Paul Gauguin, who greatly admired the Aixois master (p. 258 and p.326). Yet coherent geometry was often a concern for Cézanne in other ways. For example, the curves of armchair, shoulders and Hortense's expensive dress echo one another; the horizontal rib above the dress's ruffle continues what might be the skirting board or moulding at its left.

Madame Cézanne in a Red Armchair, c. 1877

oil on canvas, 72.5 x 58 cm, Museum of Fine Arts, Boston, MA

With greater economy of means, Impressionist colour, and flattening than his *Self-Portrait* of c. 1878-80 (p. 71), Cézanne here showed that he could compete with Impressionist aesthetics while continuing his fascination with two- and three-dimensional geometries. The juxtaposed patchwork of brushstrokes calls attention both to their own physicality, as if he were modelling in clay, and to the surface, especially in areas of the dress where the canvas shows through. Yet despite the sheen of vertical stripes that also tend to flatten it, the silk dress, the model's knees hardly hinted at underneath, protrudes with massive volume. Cézanne would follow through with even more egregious devices in later work: for example, his *Madame Cézanne in a Yellow Chair* (Fig. a), in which the hands seem carved or formed in clay to the point of being misshapen.

Édouard Manet

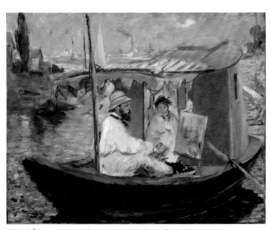

|Fig. a| Édouard Manet, *Monet and his Wife in the Studio Boat*, 1874
Neue Pinakothek, Munich

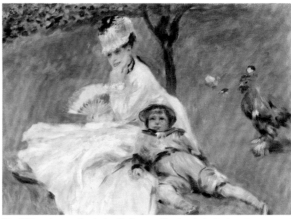

|Fig. b| Pierre-Auguste Renoir, *Camille Monet and Son Jean in the Garden*, 1874
National Gallery of Art, Washington, DC

Plein-Air Practices

After being encouraged to paint outdoors by Berthe Morisot and through his increasing friendship with Claude Monet in the early 1870s, Manet made *plein-air* painting a major practice. With his own family estate across the Seine at Gennevilliers, a visit to Argenteuil was both natural and easy. In this portrait of Monet, Manet shows his friend and colleague tending flowers rather than at the easel. Monet's devotion to gardening is undoubtedly why he lived in a suburb rather than in Paris itself.

Painting freely in a style not far from Monet's own, Manet shows Monet's wife Camille and their son Jean relaxing while the painter waters his garden. Monet was not content just to depict plantings, as he had in *Terrace at Sainte-Adresse* (p. 25); he loved to cultivate them too, as we know from the extraordinary plantings at the house he eventually owned in Giverny. Indeed, outdoor painting and gardening can be considered parallel activities in which both a love of nature and dominance over it are combined.

For Monet, domestic life and painting overlapped, as revealed by Camille's presence in the studio boat (Fig. a), painted by Manet at the time of the same visit recorded here. In the garden picture

|Fig. c| Pierre-Auguste Renoir, *Monet Painting in his Garden at Argenteuil*, 1873
Wadsworth Atheneum Museum of Art, Hartford, CT

FAMILY AND FRIENDS

The Monet Family in their Garden at Argenteuil, 1874

oil on canvas, 61 x 99.7 cm, The Metropolitan Museum of Art, New York, NY

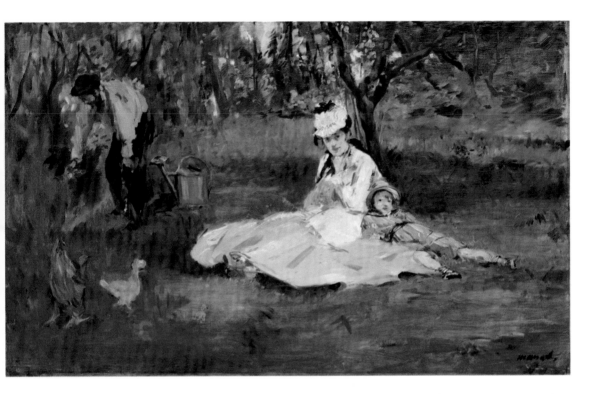

Manet includes a rooster and a white hen, a family of sorts sometimes used by previous painters as a sign that home, family life and fidelity are ordained by nature (p. 230). While Manet was painting, Pierre-Auguste Renoir stopped in for a visit. Seeing Manet at the easel, he asked to borrow equipment from Monet for himself. In 1924, Monet recalled that after setting up alongside Manet, who surveyed Renoir from the corner of his eye, Manet went over to whisper discreetly to Monet with typical irony, 'He has no talent, that boy! Since you are his friend, tell him to give up painting!' The self-deprecating joke was that while Manet's style was inspired by Monet, Renoir's picture is closer to Manet's style than was usually the case for him (Fig. b).

That Renoir's picture focuses only on Camille and her son might suggest his interest in women and children rather than the activities of men. In a better-known painting done a year earlier than these (Fig. c), however, Renoir depicted Monet alone at the easel in his garden, surrounded by flowering bushes. And it is this painting, rather than either of Manet's, that has become the standard representation of Monet's *plein-air* practice.

Claude Monet

In the Winter of a Life

However touching a deathbed scene may appear, Monet himself was surprised at his lack of emotion. He recalled guiltily:

I caught myself watching her tragic forehead, observing the sequence of changing colours that death was imposing on her rigid face. Blue, yellow, grey and so on. … my reflexes compelled me to take unconscious action in spite of myself.

Yet Camille's thin features, her ashen face and Monet's limited palette, in spite of his responses to changing colours, nonetheless produce feelings associated with the passing of someone dear. His broad, open brushwork and the painting's unfinished state imply that his focus on anything but her person was comparatively slight. Wrapped in nightclothes and enveloped by her bedding, Camille seems already in a funeral shroud.

Although Monet had met Alice Hoschedé three years earlier (p. 54), it was she who nursed Camille and tended the couple's two children. It may well have been her unselfishness that endeared her to Monet rather than an illicit attraction. There can be no question regarding the sincerity of either Monet's remarks or the picture itself.

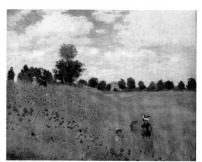

|Fig. a| Claude Monet, *The Poppy Field, Promenade*, 1873
Musée d'Orsay, Paris

|Fig. b| Claude Monet, *The Red Shawl: Portrait of Camille*,
1869–70, Cleveland Museum of Art, OH

The painting can be placed within an ancient tradition of deathbed imagery and death masks, which serve as recollections of and homages to the deceased. Although unique in the oeuvre of Impressionist painters, it testifies again to the presence of family and friends in their repertory. Although present in so many of Monet's pictures, Camille was rarely the subject of what one would call an actual portrait. Her features are usually simplified and she is more a model than a specific individual. That was certainly the case in Monet's projects for a *Le Déjeuner sur l'herbe* (p. 16) and his monumental *Women in the Garden* (p. 115), even though he could certainly have particularised her features more. In other pictures, such as *The Poppy Field* (Fig. a), she is but a passer-by, floating anonymously across the picture, accompanied by a child that only a close friend or art expert would recognise as their son.

A possible exception to this impersonality is a moving work that shows Camille outside the windows of their house in winter (Fig. b). She gazes towards the painter with a forlorn look that suggests she is either locked out or lonely, as if the physical barrier might be emblematic of the relationship with her workaholic husband. It must be cold, and snow seems to be falling. But, in fact, Camille may be modelling, wearing a bright red shawl to provide a brilliant contrast, intensified by juxtaposition to green foliage, to an otherwise dull and relatively colourless day. That she would render such a service testifies to her loyalty, and from it Monet made a masterpiece. It is thus entirely appropriate that someone

Camille Monet on her Deathbed, 1879

oil on canvas, 90 x 68 cm, Musée d'Orsay, Paris

so closely associated with the artist's development be remembered through a solemn deathbed testimonial. It remained in Monet's possession for the rest of his life.
(The signature is a stamp made by Monet's son Michel in order to authenticate unsigned paintings that had remained in the master's studio.)

Mary Cassatt

|Fig. a| Edgar Degas, *The Rehearsal*, 1878–9, The Frick Collection, New York, NY

A Girl's Best Friend

After a long and probably tedious day at school – as indicated by her uniform – a little girl, aged about seven, flops down unselfconsciously on a comfortable armchair, presumably in the living room of her family's posh apartment. In her innocence she has not noticed the unladylike position of her skirt, pushed up to reveal her bloomers. Almost a bit dejected, she gazes blankly off to her right, leading the viewer to discover the griffon terrier, so at ease in its pillows that it seems to be snoozing off. Yet a closer look suggests that at any hint of a disturbance, the tiny guardian would be up in a nanosecond, ferociously challenging any intruder. This situation is the reverse of those used sometimes by Edgar Degas (p. 198), in which the interruption has already taken place. Here it is anticipated. Hence, Cassatt acknowledges her mentor while distinguishing her strategy from his.

Cassatt, a master at pictures of families and children, captures the innocence of childhood in her own playful manner – one that tilts space upwards and compresses it in a Japanese effect and renders upholstery patterns with brushstrokes as bold as any of her contemporaries. The blue colour that dominates the picture is stunning, unlike anything shown by other painters at the fourth Impressionist exhibition (1879). It was Cassatt's first exhibition as a member of the group, a powerful début with eleven paintings in all. And yet when she submitted the picture to the American section of the 1879 Exposition Universelle, it was rejected.

Cassatt recalled that the child was the daughter of friends of Degas, and that Degas not only liked the picture but helped her with it – perhaps for the

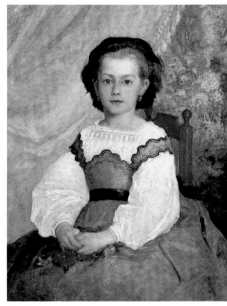

|Fig. b| Pierre-Auguste Renoir, *Portrait of Mademoiselle Romaine Lacaux*, 1864, Cleveland Museum of Art, OH

Little Girl in a Blue Armchair, 1878

oil on canvas, 89.5 x 129.8 cm, National Gallery of Art, Washington, DC

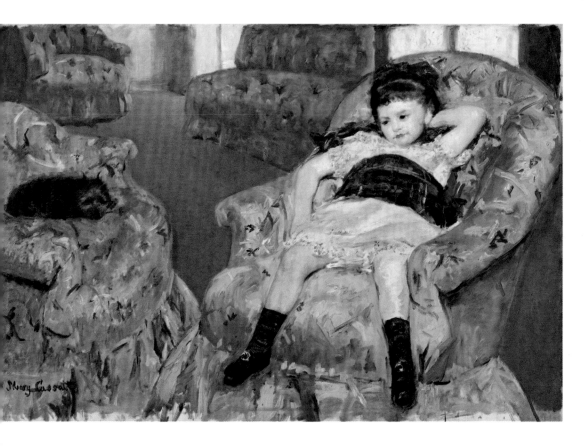

dramatic vantage point that was certainly set up in the studio. In that respect it closely resembles Degas's *Rehearsal* (Fig. a), painted around the same time. Yet Cassatt was certainly not imitating Degas, and her attitude towards children was the complete opposite of Degas's disdain. To the contrary, she was far closer to Pierre-Auguste Renoir in her ability to render the fragility of childhood and the delicacy of children's hair and skin. Compare Renoir's skills in his *Portrait of Mademoiselle Romaine Lacaux* (Fig. b), in which the child poses stiffly and yet her body seems so absent behind her dress that the result is doll-like. Indeed, no one could match Renoir's rendering of a child's hairline or the moisture in her eyes. In comparison to Renoir, however, Cassatt's attitudes were far less permeated by convention, as this unusual picture shows.

Édouard Manet

|Fig. a| Édouard Manet, Illustration to Stéphane Mallarmé, *Le Corbeau*, 1875

|Fig. b| Édouard Manet, Illustrations to Stéphane Mallarmé, *L'Après-midi d'un faune*, 1876

Smoking Permitted

On returning to Paris in 1873 to take up a position as an English teacher at a nearby *lycée*, Stéphane Mallarmé began to drop in at Manet's studio nearly every day. The two had long discussions about literature and the arts, and became collaborators. In 1875, Manet contributed illustrations (Fig. a) to Mallarmé's translation of *The Raven* by Edgar Allan Poe, who had become popular in France thanks to essays by Charles Baudelaire. In 1876, Manet contributed some delicate woodcuts (Fig. b) to Mallarmé's first edition of his poem *L'Après-midi d'un faune* (*The Afternoon of a Faun*). In the same year, Mallarmé wrote an extended essay about Manet and the Impressionists called 'The Impressionists and Édouard Manet' (known only in its English published version). In it, he portrayed Manet as the leader of the movement, even though Manet had never exhibited with them. In Mallarmé's view it was thanks to Manet that the Impressionists developed their characteristic treatment of light and air. Unlike Émile Zola, who had focused on defending Manet's style of the 1860s, Mallarmé knew Manet's work primarily from his more Impressionist pictures of the 1870s.

Manet's small portrait of his friend exemplifies for an interior scene the style he developed through his *plein-air* experiences (p. 74). At the same time, it conveys the poet's delicacy and stylistic sophistication by paralleling them in paint. Manet's treatment of the wallpaper, so simple and generalised through mere random-seeming touches and a squiggle or two, is especially effective. Mallarmé's casual pose suggests

Stéphane Mallarmé, 1876
oil on canvas, 27.5 x 36 cm, Musée d'Orsay, Paris

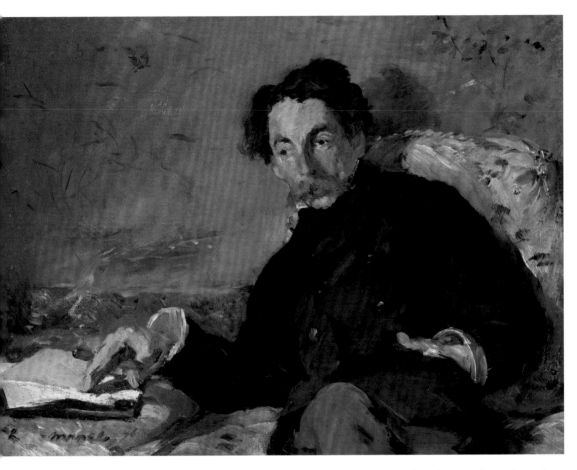

a candid view, such as that of a friend rather than the formal poses of portraits made for public consumption. The poet's rumpled hair and outsized moustache suggest something of the metropolitan dandy-bohemian. He leans back in a soft armchair with his left hand in the pocket of his coat. His right hand, resting on a manuscript or pile of papers, holds a cigar, a favourite attribute of fashionable gentlemen. Of course the smoker theme has a long history in art since its appearance in Dutch genre painting of the seventeenth century. There it often signified the vanity of idle pastimes and the fragility of life. In this case it is used ironically, for these were extremely productive years for both the artist and the poet. Mallarmé treasured the image, which stayed in his family until its purchase by the French museums in 1928.

Berthe Morisot

|Fig. a| Berthe Morisot, *The Mother and Sister of the Artist*, 1869-70, National Gallery of Art, Washington, DC

Protective Custody

Morisot's sister, Edma, married Adolphe Pontillon, a friend of Édouard Manet's from their naval training days. She had trained along with Berthe under Jean-Baptiste-Camille Corot and produced some charmingly delicate landscapes, but when she married and had children she gave up any career ambitions she might have harboured. Berthe shows Edma seated in the light of an open window, dressed in a frothy summer housedress that demonstrates the artist's ability to paint subtle gradations of white, as had other Impressionist painters. As in most of Morisot's paintings, there is the subtle tonal harmony with which Corot's mentorship imbued her. After meeting Manet the year before, however, her handling considerably broadened and her compositional arrangements became boldly naturalistic. In a contemporaneous picture, showing mother and sister together (Fig. a), Manet had actually thought to help his new tutee by retouching certain areas. Berthe was furious because it was forbidden to exhibit a picture at the Salon if it was not entirely by the person who submitted it.

In the tender portrait at the window, the lovely sister (Berthe herself was more homely) absent-mindedly fondles a Japanese fan. She has announced her pregnancy and, as was the custom for proper ladies, has moved back to her mother's house, situated in the peaceful neighbourhood of Passy, in what is now Paris's 16th arrondissement. Her gesture and expression might suggest the boredom one supposes in such a situation. On the other hand, they might indicate Edma's continuing interest in art, at least vicariously through the charm of an exotic object. One can only know that her maternal state required discretion. Moving to her mother's she withdrew temporarily from her husband's social circle. She even sits back from the window rather than on the balcony, away from the view of apartments across the street.

By contrast Manet had portrayed Berthe the previous year on a balcony boldly looking outwards (p. 223). From the other side of the railing, she is an object of both visual consumption and mysterious elegance. That world is far distant in Morisot's own picture, as Edma's remove becomes a measure of her confinement. Through the window one observes a maid watering flowers and a gentleman either eyeing the maid or gazing at the street. An extraordinary picture by Gustave Caillebotte echoes the man's position: brother Martial Caillebotte is shown from the rear staring from his window at a solitary woman at the foot of a starkly modern block (p. 93).

The emphasis on vision found in so many Impressionist paintings results from many factors. In a crowded city the issue of private versus public spaces is sharpened by their increasing overlap. Individual appearance becomes more important in order to stand out in an increasingly anonymous world. Visual spectacle, not just in entertainment but in everyday life, becomes a medium of communication, with attentiveness to such appearances the result. In her portrait of Edma, Morisot explores this tension, which is at the heart of her sister's situation.

Berthe Morisot

Almost Grown Up

This late painting by Morisot, who married Édouard Manet's brother Eugène, shows their daughter Julie, born in 1878, as an adolescent. Her companion is a greyhound, given by the poet Stéphane Mallarmé, a family friend (p. 80). Its name, Laertes, after the character from *Hamlet*, emphasised Mallarmé's knowledge of British literary classics. The portrait is one of many Morisot made of her daughter, often accompanied by her husband when Julie was younger (p. 180). Although unfinished, this work is done in Morisot's late style, in which brushwork is smoother than in the more freely worked pictures of the 1880s. Morisot was in close touch with other artists, especially Pierre-Auguste Renoir, with whom she became close after her brother-in-law's death. Such continuing contacts explain her shift away from the style she helped to pioneer towards handling based on longer, softer brushstrokes that follow shapes and trace contours more than her earlier, less conventional, choppy patchwork.

As in the later work of Renoir, who became interested in the paintings of Jean-Auguste-Dominique Ingres in the mid 1880s, as well as those of Paul Gauguin, Edvard Munch and a few others, Morisot began to rely more on simple shapes than fragmentation. When in 1887 she and Eugène commissioned a portrait of Julie from Renoir (Fig. a), the latter was in his so-called 'sour' or Ingresque period, in which he sought to recover from an Impressionism that placed him too far away from the great masters of the past. Morisot never went that far, but her admiration for Renoir's rounded forms is obvious in this portrait. Julie's pose is unconventional, compared to formal treatments of the subject in so many commissioned portraits, as well as even in Morisot's own studies of her, with the exception of those she made outdoors. Julie steadies her pet with her right hand: the fingers under Laertes's jaw are articulated more than those of the left, which steadies Julie as she leans on the seat of the family couch. She is dressed in black, mourning the death of her father the previous year, also signified by the empty chair to her right. Her expression combines sadness and boredom at – again – posing for her mother. Compare Morisot's sensitivity to her daughter to her husband's rather distracted and less nurturing attitude. Yet Eugène was an essential resource for Berthe's career. Merely tolerating it was more than expected from the conventional bourgeois male. He, however, took a major role in promoting Berthe's work. Even though she exhibited regularly with the Impressionists, she would do nothing more. Eugène took on other necessary roles; it was he who dealt with sales and finances. The only sign that Morisot was a professional was that she continued painting. A large Japanese print behind Julie is a reminder, for example, that Morisot rarely hung her own works in the house, preferring those of others, especially those by friends and colleagues.

|Fig. a| Pierre-Auguste Renoir, *Julie Manet (Child with Cat)*, 1887
Musée d'Orsay, Paris

Julie Manet and her Greyhound Laertes, 1893

oil on canvas, 73 x 80 cm, Musée Marmottan Monet, Paris

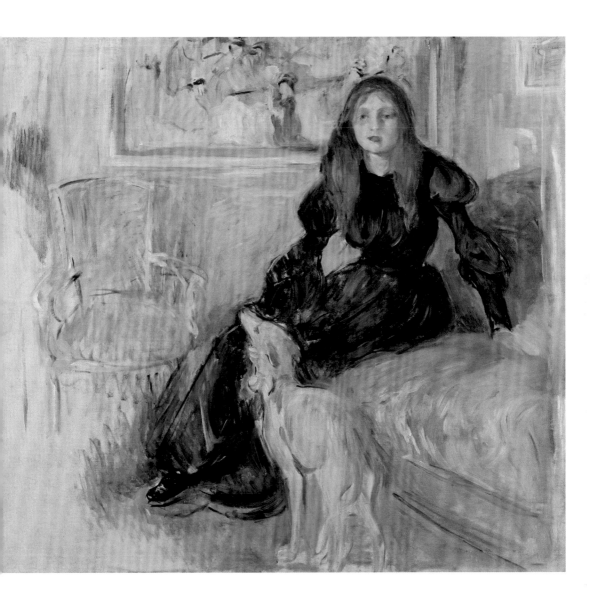

City Life and Urban Views

Claude Monet

|Fig. a| Claude Monet, *The Church of Saint-Germain l'Auxerrois*, 1867
Alte Nationalgalerie, Staatliche Museen zu Berlin

|Fig. b| Charles Soulier, *Panorama of Paris taken from the Colonnade of the Louvre*, c. 1865
Bibliothèque nationale de France, Paris

View from the Colonnade

During the 1860s many of Monet's colleagues still visited the Louvre with easels and palettes to copy the museum's world-renowned masterpieces. No one would have suspected that when Monet brought his equipment, it was to make a group of pictures looking away from the galleries out onto the modern city. His vantage point was the famous 17th-century colonnade designed by Claude Perrault for the Louvre's eastern façade, high enough to offer panoramic views. Although urban panoramas were not a novelty in art, Monet's featured a newly modernised area of Paris. Before the urban renewal projects directed by Baron Haussmann (p. 20), buildings like the Louvre and the Church of Saint-Germain l'Auxerrois (Fig. a) were crowded in by often insalubrious shops and houses overpopulated with poor workers.

This view of Saint-Germain l'Auxerrois from the same position shows a newly minted square. Such renovations allowed for smoother circulation of vehicles and pedestrians, and fresh air as well as social cleansing. Haussmann's designs set ancient monuments apart from their surroundings so that they could be appreciated on their own by tourists, who already contributed significantly to the French economy. Streets were widened, too, in order that they were proportionate to the newly built-up embankments now suitable for promenades. In the skyline of *Garden of the Princess* one sees the cupola of the Panthéon together with the Church of Sainte-Geneviève to its left on their hill and the Val-de-Grâce on the skyline to the right.

The Princess's Garden was a private green space adjacent to the Louvre that had originally been created for the Spanish Infanta who came to France in 1721 to be betrothed to Louis XV. The garden has a smooth lawn, manicured flowerbeds and newly planted trees. In Monet's paintings one sees coaches and crowds of people, dressed in the black uniform of the bourgeoisie. They are milling about like Charles Baudelaire's *flâneurs* in the intense light of a partly cloudy day, a breeze blowing from the west, as suggested by the tricolour to the picture's right. As a sign of national pride, the flag celebrates modern France, and implies that Monet considers his modern cityscape as its appropriate representational genre.

In addition to his view of Saint-Germain l'Auxerrois, a third painting from the same vantage point used the horizontal format, which is most characteristic period of landscapes that aim to capture the greatest sweep. Compare a photograph from the same period taken from the nearby collonade of the Louvre (Fig. b). By contrast, *Garden of the Princess* uses a vertical format that corresponds to a window view as well as to the format associated with portraits. Since most early cameras were set to vertical format, such views abound in urban photography; and many were taken from studios whose main commerce was portraiture. Was Monet deliberately imitating photography? It would be more accurate to say that he was using a vantage point and format current in visual culture and which through its association with photography had set a standard for naturalism. He was simply using forms that were associated with modernity and were thus appropriate for an image of the modern city.

Garden of the Princess, Louvre, 1867

oil on canvas, 91.8 x 61.9 cm, Allen Memorial Art Museum, Oberlin College, OH

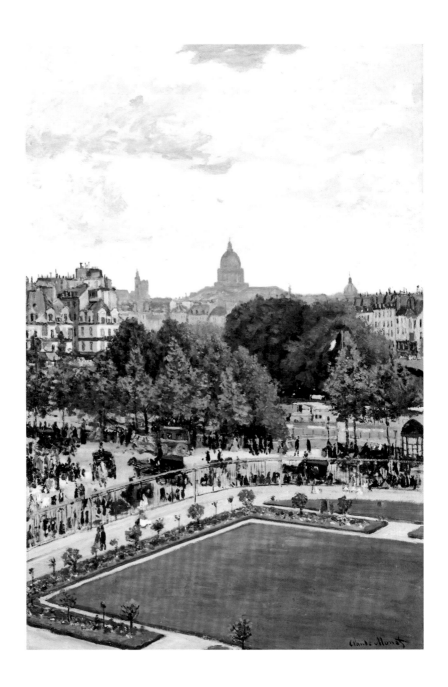

Claude Monet

|Fig. a| Hyacinthe-César Delmaet and Louis-Émile Durandelle, *The Construction of the Opéra Garnier*, 1860s, Musée Carnavalet, Paris

Filthy Tongue-Lickings on the Street

Monet made a second group of cityscapes, one vertical, one horizontal (*Boulevard des Capucines*, 1873–4, The Pushkin State Museum of Fine Arts, Moscow). Both were painted from the window of the studio of the photographer Nadar (Félix Tournachon) at 35 Boulevard des Capucines. Nadar was moving and rented it to the Impressionists for their first exhibition. Monet's views were done the winter just before the opening, as shown by the bare trees and, in the vertical version, a light coating of snow on the ground.

Contrasting to *Garden of the Princess, Louvre* (p. 89), the Grands Boulevards were in the commercial heart of Paris, along thoroughfares that were once medieval fortifications but had been converted into grand residential avenues in the 17th century. Under Haussmann most of the older structures were levelled in order to make way for what are now considered typical Paris buildings, six or seven storeys high, with shops at street level. Unlike in today's high-rises equipped with lifts, the best apartments were on the first and second floors. Contrary to their avant-garde artist colleagues, whose studios were mostly around Saint-Lazare station, Batignolles or Montmartre, most photographers congregated in this area more accessible to visitors and businesses. In Monet's picture, across the boulevard is the recently constructed Grand Hôtel, owned by the Péreire brothers, railway magnates whose companies brought in tourists. In the undefined area behind the tallest trees on the right side of the boulevard lies the Place de l'Opéra, where the city's biggest public project, the Opéra de Paris designed by the young architect Charles Garnier, was being built (Fig. a). It would assure the district's lasting commercial centrality and cultural significance.

To the right on a shallow balcony above the awnings of a shop are gentlemen in top hats looking down at the crowded scene. (Such views would become favourites of Gustave Caillebotte; see p. 92 and p. 94) They are stationary *flâneurs* of sorts, figures with whom the artist's vision is in sympathy, at the edge of the picture like Édouard Manet's self-portraits in *Music in the Tuileries* (p. 21) and Bazille's in *Family Reunion* (p. 63). The street is jammed with traffic, as are the wide pavements with shoppers and families out for a stroll. A vendor, whose orange balloons stand out near the picture's centre, caters for children's tastes and emphasises the street as a realm of commerce, spectacle and entertainment.

Monet's sketchy rendering of figures and his kaleidoscope of colours, branches and architectural features create a far more dynamic scene than his earlier group of cityscapes (p. 88). When faced with the picture at the Impressionist exhibition, the satirical critic Louis Leroy referred with mock disgust to the figures as 'black tongue-lickings': 'So is that what I look like when I'm walking along the Boulevard des Capucines? Blood and thunder!' Yet in contemporary photographs unable as yet to freeze motion to a standstill, moving forms would be blurred. It might be suggested that Monet's sketchy handling indicates rapid 'impressions', which could be interpreted as naturalist effects.

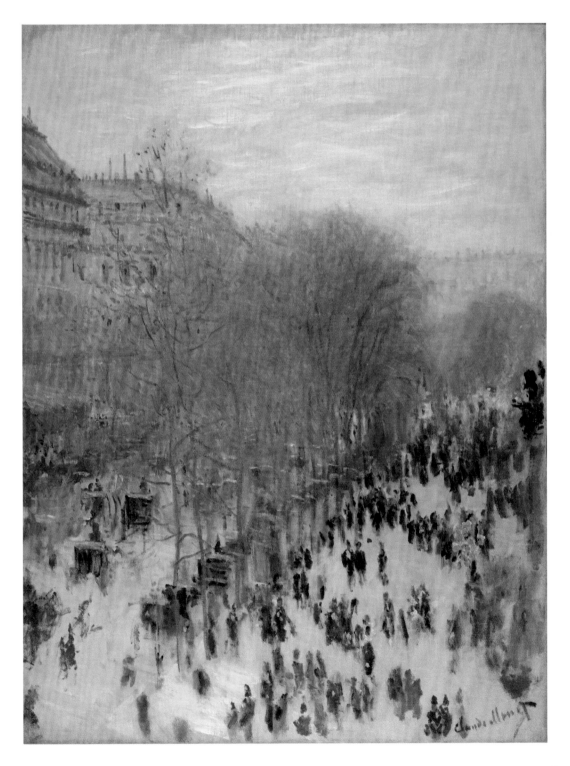

Gustave Caillebotte

|Fig. a| Gustave Caillebotte, *View through a Balcony Railing*, 1880, Van Gogh Museum, Amsterdam

Remote Target

Caillebotte lived with his mother and brothers in a new apartment at 77 Rue de Miromesnil on the corner of the Rue de Lisbonne, in the same general area near the Gare Saint-Lazare as Claude Monet and Frédéric Bazille. Caillebotte's father, a successful textile manufacturer, had purchased it in 1868; he died in 1874, leaving behind a fortune for his heirs. From what seems to be the living room, brother René gazes out on his practically deserted block. Other than the unseen occupants of a carriage, if there are any, a solitary woman is the only living creature. She is crossing onto the slightly busier Boulevard Malesherbes, although only a determined viewer will notice activity there, the effect of which is to emphasise the absence of activity nearer by. Bright sunlight, strong shadows, closed shutters and unfurled awnings indicate the summer's heat, when many Parisians flee for cool northern beaches or verdant countryside. The architectural uniformity of the neighbourhood, its shallow balconies, if any, and sparse ornamentation indicate the profit-driven economics of such more or less anonymous ensembles.

Caillebotte exhibited the painting at the second Impressionist exhibition (1876), which his friend Degas had invited him to join (p. 30). It represents the urban space as spectacle, even when sparsely occupied. Trained as an engineer, Caillebotte certainly appreciated its spare geometry. Dramatic vantage point, rigorous perspective and the natural tendency to identify with the figure whose back is turned maintain concentration on the sense of sight. Dominance and control of one's environment, as in Caillebotte's calculation of both his composition and the viewer's experience of it, are hallmarks of his style. They are also attributes of his possibly insecure masculinity, as conveyed by the tension between the target of René's remote vision and the hulking brother himself, whose phallic puissance is enhanced by vertical thrusts of the perfectly cast balustrade shapes (p. 236).

That the woman had entered the public space ostensibly unescorted made her fair game for curiosity. René has stood up to get a closer look. Hence, there is an allusion to Impressionist immediacy even though the image itself is static and fixed by Caillebotte's still relatively conservative handling. The interest in lighting effects so ostentatious in his *The Floor Scrapers* (p. 31) is more subtle here. The contrast between indoors and outdoors is obvious, as is the shadow cast by the building across from René onto the street. Caillebotte was interested in reflections, too, like that of René in the window at his right.

When Gustave and his younger brother Martial later moved to a higher floor near the Boulevard Haussmann the see-though/cutting-off effect of the balustrade would become one of his most innovative themes, as in *View through a Balcony Railing* (Fig. a). It is worth comparing these late experiments to the crisply defined simplicity of the railing in the window of *The Floor Scrapers* in order to understand the progression of such effects, with *Young Man at his Window* representing a mid-stage of the development.

Young Man at his Window, 1875

oil on canvas, 117 x 82 cm, private collection

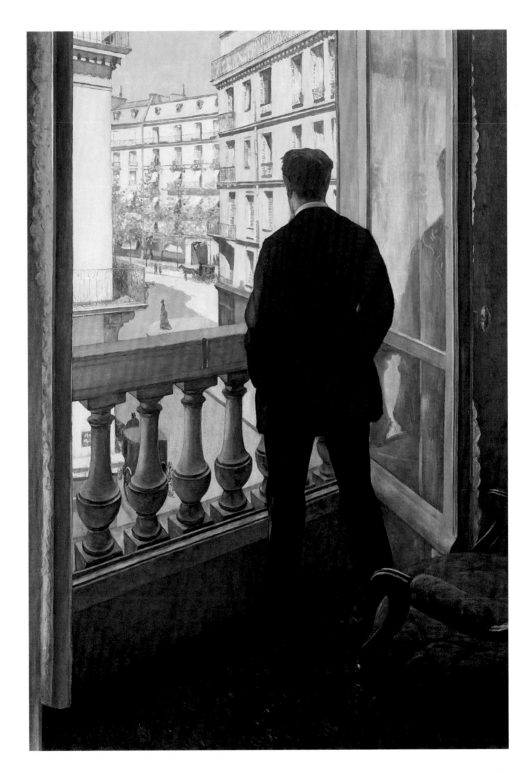

Gustave Caillebotte

|Fig. a| Hippolyte Jouvin, *Place des Victoires*, c. 1865

Vertiginous Variations

Following the death of his brother René in 1876 and his mother in 1878, Gustave and his younger brother Martial sold off their properties and moved to a third-floor apartment on the Boulevard Haussmann, just behind the new Opéra. It was from there or from an even higher floor just below the roof – Paris apartments often came with servants' quarters on the top floor – that the painter executed most of his other highly varied and often daring urban views. The view of a traffic island is one of the most unusual for its geometry, besides reminding the viewer of photography, with its seemingly random cutting off of figures.

Martial was an amateur photographer, and certain of his brother's views evoke the camera viewfinder, among other optical interests. Yet a comparison of *Traffic Island* to a photograph of the Place des Victoires taken by Hippolyte Jouvin (Fig. a), which is often cited as an influence, reveals more through its differences than its similarities. For one thing, the Place des Victoires was an example of 17th-century urbanism, designed to display at its centre a statue of Louis XIV. (Destroyed during the Revolution, the statue was replaced by an equestrian statue by François-Joseph Bosio in the 19th century.) Hence, Jouvin's aim was to photograph a historic monument and its classic architectural setting. By contrast, the traffic circle is a utilitarian convenience, guiding circulation and functioning as a refuge for pedestrians, as Caillebotte's painting clearly shows. These are modern concepts. Finally, Caillebotte's far more radically plunging view suggests strangeness rather than the neutral so-called objectivity of the photograph. One also notices that by this date Caillebotte's facture has loosened up to align more closely with his Impressionist cohorts. It cannot be mistaken for a coloured photograph.

Even more radical than *Traffic Island* is Caillebotte's *Boulevard Seen from Above* (Fig. b), which is hard to imagine without having been prompted by an optical device such as the movable viewfinder of the camera or binoculars. In this picture there is less emphasis on the street and flow of traffic than on the pavement, and in particular the design of the iron grates that protect the roots of relatively young trees. Its round shape is

|Fig. b| Gustave Caillebotte, *A Boulevard Seen from Above*, 1880
Private collection

A Traffic Island, Boulevard Haussmann, 1880

oil on canvas, 81 x 101 cm, private collection

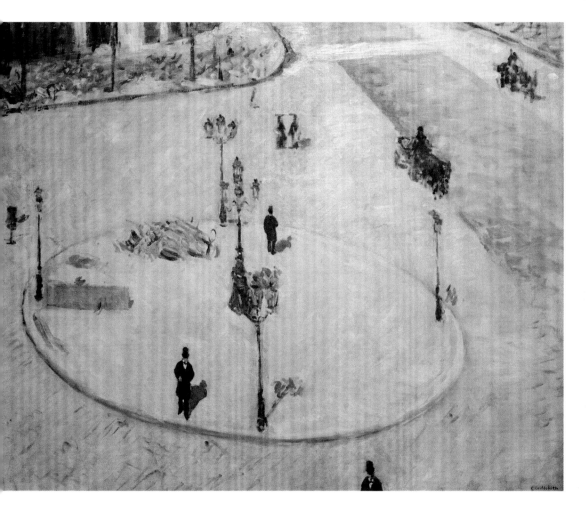

complemented by the rectangle of a bench seen from above; and there is the curious phenomenon of pedestrians' foreshortened anatomy from the bird's-eye view. Although photography seems essential to such conceptions, the motif of tree branches crossing back and forth over the composition can be found in Japanese prints. The effect is so concentrated at one point that it virtually obscures a fiacre waiting at the curb. Other pictures that Caillebotte made from similar perches are views of the boulevard itself or the adjacent Rue Halévy (p. 96). And looking from the same upper floor but towards the inner side of the block, he painted the rooftops of older buildings, distinguished by their lesser height (p. 326).

Pierre-Auguste Renoir

Shop 'til You Drop

Renoir hated what he called the military look of Haussmannian boulevards (Fig. a). As can be seen from Claude Monet's views of the Boulevard des Capucines (p. 91), however, shoppers and tourists made them a huge success. Renoir's painting blurs the buildings, which are in the background, while – typically for him – focusing on the figures and their activities.

Then, as still now, although habits are changing, shopping was primarily a female occupation and part of a new stereotype engendered by consumer society. In earlier times women went to market as part of their household duties. In the 19th century an additional ritual developed, which the luxury stores along the Grands Boulevards institutionalised. Émile Zola's novel *Au Bonheur des Dames* (1883) is set in a department store. The title translates literally as 'at the place of women's pleasures', thereby underlining the relationship.

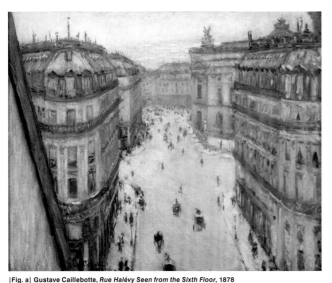

|Fig. a| Gustave Caillebotte, *Rue Halévy Seen from the Sixth Floor*, 1878
Private collection

The author of a popular Paris guidebook, *Paris illustré* (1867), maintained that great cities are known by their gardens, public spaces and promenades. London had its squares, St Petersburg its vistas; but Paris had, above all, its boulevards. Under the Second Empire, stores like Les Grands Magasins du Louvre, La Maison de Blanc, Aux Trois Quartiers, La Maison Alphonse Giroux and Auguste Klein de Vienne offered their extraordinary arrays. During the Third Republic, which took over in 1870, the Boulevard des Capucines, Boulevard des Italiens and Rue de la Paix were part of an area called the Golden Triangle.

Despite its marvellously free execution, typical of mainstream Impressionism, Renoir's picture has enough detail to engage the viewer in a charming narrative. Staged between trees and street lamps on both sides – the elegant three-branch *lampadaire* to the right being the type for which Paris was famous – the story tells of the enhanced conveniences, mobility and dangers of the modern widened street. At the left edge, next to a kiosk, a man sits on a bench reading the daily paper. Set back and immediately to the right of the lamp post a gentleman engages two ladies in conversation. Men may wander the streets alone, but ladies without male escorts must travel in pairs or with their families. Although Charles Baudelaire's *flâneur* was presumed to be a man, women could stroll about in pairs and use shopping as excuses for promenades. Next, in front of two men who

The Grands Boulevards, 1875
oil on canvas, 52.1 x 63.5 cm, Philadelphia Museum of Art, PA

are in conversation, one notices a fashionable lady waiting to cross the street with her two children. Her dress is enhanced by a big red bow and matching chapeau; her son wears a jaunty straw boatman's canotier and knickers; her daughter, the younger child, is already being trained in appearances, for she, too, wears a hat and her short white jumper is garnished by a red ribbon echoing her mother's. *Ombrelle* in one hand, daughter in the other, the mother waits for a break in traffic to cross over to the shops. A carriage with a fashionable couple dominates the street. To its right and dangerously close is a nun who, protected by her habit, her status, and certainly by God, will make her own way through, like the Israelites crossing the Red Sea.

Armand Guillaumin

The Industrial Impressionist

Guillaumin was among the first avant-garde painters to represent factories of heavy industry as a primary subject (p. 140). *The Seine, Rainy Weather* was shown at the first Impressionist exhibition, its prominence enhanced by its relatively large size and its careful handling. It confirms that Impressionism was committed to a modernity that included scenes of industry and labour in addition to leisure. In the picture, workers look across to the Quai d'Austerlitz from the Quai Henri IV – not Quai de la Rapée as once thought. Across to the right can be seen the Île Saint-Louis, where Guillaumin had his studio on the Quai d'Anjou.

The apse of Notre-Dame cathedral, on the Île de la Cité, is at centre background. Linking the left bank of the Seine to the Île Saint-Louis is the pedestrian Passerelle de Constantine, which after its collapse was replaced by the vehicular Pont de Sully (1876). A tug steams towards it from the rear. To its right is a wooden walkway, the Passerelle de Damiette, which linked the Île Saint-Louis to the right bank and was replaced by the second span of the Pont de Sully (1878), finally allowing crowded river traffic to pass on the northern side of both islands. At their moorings across the river are barges delivering wine to the wine market nearby at Jussieu. Barrels lie in rows on the shore behind them. Two horse-drawn carts used for hauling them are also visible. Paul Cézanne, who became a close friend of Guillaumin and painted as a guest in the latter's studio (p. 186), depicted the market itself when he lived directly across the street (Fig a).

Four men are at the railing, in groups of two, wearing mariner's garb and hats. A woman holding a child looks over the railing, perhaps awaiting her husband. Two of the men

|Fig. a| Paul Cézanne, *The Wine Market at Jussieu*, 1871–2, Portland Art Museum, OR

CITY LIFE AND URBAN VIEWS

The Seine, Rainy Weather, 1871

oil on canvas, 126.4 x 181.3 cm, The Museum of Fine Arts, Houston, TX

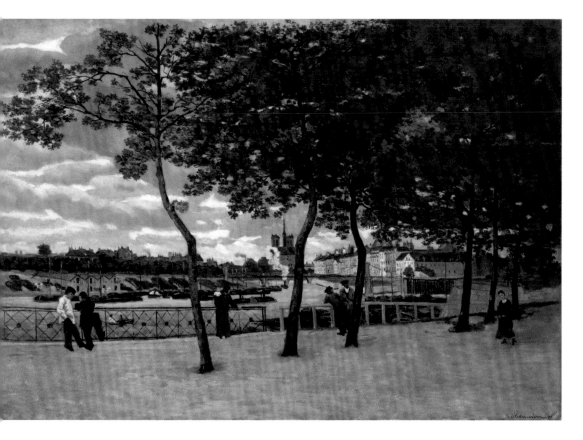

eye a second woman who is approaching. This is not a place where crowds casually congregate or the bourgeois promenade. Although many boats are tied up near the railing, there is no indication that they are pleasure craft. The overcast sky and the title *Rainy Weather* suggest that Guillaumin was more interested in an ordinary, workday reality than in the carefree pleasures of sunny times.

The artist knew the area across the river well, since he had worked as a ticket clerk nearby at the Orléans rail company, which used the Gare d'Orléans (now Austerlitz) station behind the Quai d'Austerlitz. In 1868, five years after meeting the Impressionists at the Académie Suisse (p. 72), Guillaumin took a job at the City Hall in the Department of Roads and Bridges, working three nights per week for higher pay. The new position allowed him to paint during the daytime and gave him access to public works projects such as the Quai de l'Hôtel de Ville (p. 177). As the painting by Cézanne demonstrates, Guillaumin's interest in the industrial and labouring side of modernity was shared at least for a while by Cézanne and Camille Pissarro (p. 149), who became a sort of trio in the early 1870s.

Gustave Caillebotte

|Fig. a| Street plan of the neighbourhood

|Fig. b| Gustave Caillebotte, *Perspective Study of Streets*, 1877
Private collection

Rigours of the Season

Looking past the rain on a chilly Paris day, the rigours of the built environment may provide some comfort, or at least Caillebotte, with his engineering background, may have felt that to be the case. At the star intersection of eight streets (Fig. a) near his family apartment on the Rue de Miromesnil (p. 72), the couple in this large painting exhibited at the third Impressionist exhibition make their way through the dreary weather under the protection of a large umbrella. The neighbourhood was similar to Caillebotte's. Its streets were named after foreign cities in order to suggest the worldliness of those who would choose to inhabit them. (Until 1878, the Caillebottes lived near the corner of the Rue de Lisbonne.) The streets intersecting in the painting were named after St Petersburg (Manet lived at no. 49 in 1877), Moscow, Turin and Bucharest. The couple is walking south on the Rue de Moscou, which with the Rue de Saint-Pétersbourg is one of the two through streets that cross at right angles. City streets based on focal points were one of the principles of Haussmannian urban planning. The most famous is the Place de l'Étoile, now Place Charles de Gaulle, at the centre of which stands the Arc de Triomphe. Its twelve avenues, the most famous of which is the Champs-Élysées, are like the spokes of a wheel. Caillebotte's interest in modern urbanism can be found in many of his works (see p. 92, p. 94 and p. 158). Allied to his fascination with its rigorous geometries were his visualisations produced with the aid, most likely, of photography. A study for *Paris Street* (Fig. b) shows a rectangle superimposed on a sketch that extends beyond it, in the manner of a movable frame. Moreover, several of Caillebotte's preparatory drawings on tracing paper correspond to photographic plate sizes used by his brother Martial (see p. 358), or to other common photographic formats.

More important than Caillebotte's actual use of photography, however, are not only his acceptance but his self-conscious display of photographic vision as a basis for his art. That is, his paintings systematically embody and legitimise a way of seeing made possible through technology; hence, his vision of the world is wilfully stamped and proffered as modern.

Other aspects of studied opticality in *Paris Street* complement Caillebotte's calculated *tour de force*. The lamppost accurately slices the picture in half, each side of which corresponds approximately to a golden section rectangle (see p. 374). Even in inclement weather, light reflects off the wet cobblestones and the puddles that gather in their graphic pattern of crevices and joints. As if to emphasise the act of visual attention, the foreground couple look to the right as a man approaches from the opposite direction. Are they planning to cross, as others do quite randomly in the space behind them? (No pedestrian crossings then.) Or are they making sure no speeding carriage will splash them as they move closer to the pavement edge in order to accommodate the oncomer's umbrella? Such mysteries will for ever animate masterworks like this.

Pierre-Auguste Renoir

The View from the Bridge

The Pont des Arts (Bridge of the Arts) was built by Napoleon ɪ to link France's two most venerable art institutions, the Louvre on the right bank (to the left) and the École des Beaux-Arts, commonly known as the Academy. It was a cast-iron footbridge that facilitated the commute for professors and students between their most important educational locales. Yet in Renoir's picture, which is also at the heart of tourist Paris, neither institution can be seen (Fig. a). It is as if, like Claude Monet at the Louvre (p. 88), he turned away from the institutions the Impressionists were challenging by painting *en plein air*.

Responding further to Monet, Renoir's picture is framed at the bottom by a bold shadow, reminiscent of that in Monet's *Women in the Garden* (p. 115), painted the previous year. Vivid contrasts of light and shade became a trademark of the new 'Actualist' school, as Émile Zola called it (p. 38 and p.62). Moreover, the shadow's form cleverly suggests a painter at his easel, with curious *flâneurs* looking over his shoulder. Thus, while the painter records his presence, he is even more marginal than Manet's in *Music in the Tuileries Gardens* (p. 21). Yet the device has the realistic advantage of appearing to be based on direct observation. The slightly raised perspective indicates that Renoir was working from the ramp of the neighbouring Pont du Carrousel, although he foreshortened the space in order to accommodate the shadow to a close enough view of the scene's details.

One looks down the recently cleared Quai Malaquais towards the Académie Française, housed in the august 17th-century Palais Mazarin with its elegant cupola. In the foreground are tourist *navettes* at the little Port des Saints-Pères. The skyline is delicately detailed, more like an engraved illustration than Monet's abstracting generalisations. Like Monet in *Garden of the Princess* (p. 89), he has raised it slightly to make recognisable monuments more visible. At the left are two large theatre buildings, one of which is the Théâtre du Châtelet. Further on, one distinguishes the little turret of the city hall, beyond which is the Church of Saint-Gervais, with its gothic nave and classical 17th-century façade. The trees at the centre indicate the point of the Île de la Cité, where the bulky medieval Conciergerie had held Louis xvɪ and Marie

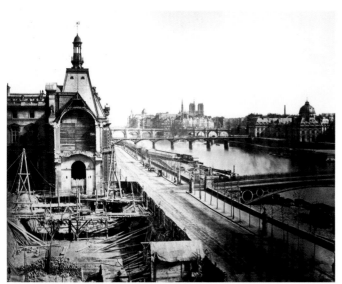

|Fig. a| Édouard Baldus, *Demolition of the Grande Galerie of the Louvre*, c. 1865
Musée d'Orsay, Paris

The Pont des Arts, Paris, 1867–8

oil on canvas, 60.9 x 100.3 cm, Norton Simon Museum, Pasadena, CA

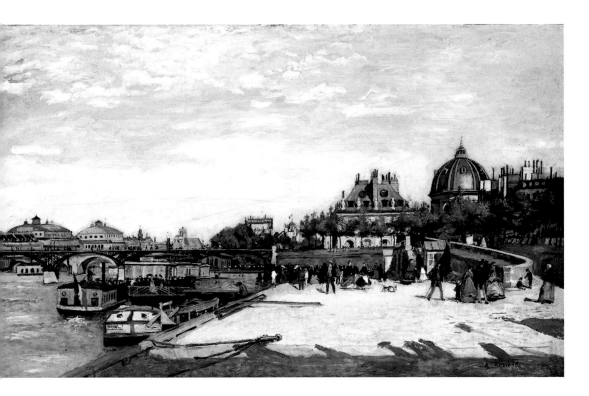

Antoinette prisoner. Here they seem devoid of political significance. Finally, the viewer might guess that topped by the French flag are the courts of the Palais de Justice.

A freely painted sky and foreground provide the setting for these details that are part of the tourist vision. Indeed, Renoir is attentive to the tourists themselves, who wait to board their excursion boat. Fashionable families and even playful dogs pass the time in the middle ground. There is little sign of the lower classes other than a man wearing worker's blue sitting idly to the left on the protective railing at the water's edge and probably a mother (rather than a nanny) watching two scruffy boys at the foot of the access ramp's curved wall.

Alfred Sisley

Paris by Inland Waterway

The British-born Sisley's reputation is more as a follower than a leader, but in the early years of Impressionism he was definitely at the cutting edge. His group of paintings of the Canal Saint-Martin compare to Claude Monet's harbours of Le Havre, Camille Pissarro's gasworks and factories at Pontoise, Armand Guillaumin's labourers along the Seine, and Paul Cézanne's early industrial scenes. Although this trend barely lasted beyond the 1870s it was a serious part of Impressionist modernity during its formative years. Sisley, with this work and others dating to 1870, was at its forefront.

The most remarkable aspect of Sisley's picture is its plainness. This working-class part of Paris north of the Seine was and still is urbanistically undistinguished, even though it is now fashionable to live along the canal, which was opened in 1825. The waterway's purpose was to shortcut the loops of the Seine, saving twelve km. It joined the Canal Saint-Denis at La Villette, bringing cargo to the Port de l'Arsenal, near the Bastille, where it emptied into the Seine behind the Île Saint-Louis. Although one now thinks of canals for lazy walks, back in time, through unspoiled countryside and villages, in Sisley's time they were important elements of infrastructure supported by state investment as both a parallel and competitive counterweight to the growing power of the railways. The Saint-Martin canal was especially expensive, due to its nine locks to accommodate a twenty-five-metre drop, its five stone bridges,

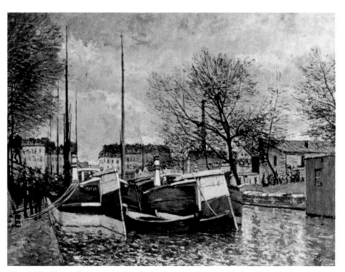

|Fig. a| Alfred Sisley, *Barges on the Canal Saint-Martin*, 1870, Museum Oskar Reinhart, Winterthur

two pedestrian overpasses and seven turntable bridges. With a little guardhouse to the left, one of the turntable passages seems to be allowing pedestrians to cross, temporarily closing off the water traffic and explaining the relative lack of activity in Sisley's picture.

In another composition, barges are the focus (Fig. a). Workers unload while the supplier and client discuss business standing at the water's edge. In the first picture one barely notices the tiny figures, and what barges can be seen are at a distance. That left Sisley the opportunity to focus on the cold light of winter. He looks south toward central Paris, with the sun relatively low and barely showing through the clouds in the eastern sky. The picture's palette is limited, like the drab houses and trees bereft of foliage. Yet light nevertheless gleams off the water.

The Canal Saint-Martin, 1870

oil on canvas, 50 x 65 cm, Musée d'Orsay, Paris

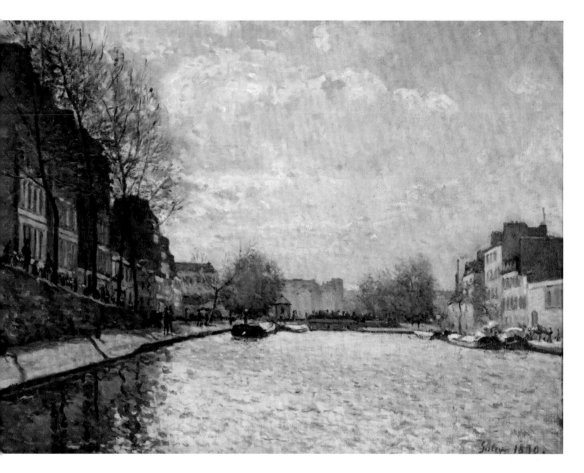

Guillaumin had been the first to concentrate on barge traffic (*Barges on the Seine at Bercy*, c. 1865, Musée Carnavalet, Paris), but it became one of Sisley's favourite themes. He also painted at the opposite end of the Seine from Guillaumin's territory, producing many views of the light industrial areas near Grenelle (p. 302) and Boulogne-Billancourt, where the Seine exits the city on its way towards Rouen, Le Havre and the Channel. The homely scenes Sisley often chose were the sites for a new kind of painting one might call anti-picturesque, another element of the Impressionist commitment to document inclusively their contemporary surroundings.

Edgar Degas

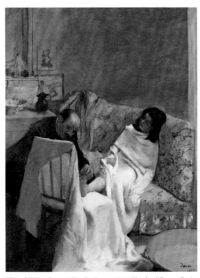

|Fig. a| Edgar Degas, *The Pedicure*, 1873, Musée d'Orsay, Paris

|Fig. c| Jean-Baptiste Greuze, *The Lazy Kitchen Maid*, 1757
Wadsworth Atheneum Museum of Art, Hartford, CT

Clean as a Whistle; Stiff as a Board

Laundry was a fact of daily life among those who could afford to bathe frequently and dress fashionably. One could find a *blanchisserie* – from the verb *blanchir*, to whiten – on the ground floor of almost every residential block. Without even going slightly out of his way, Degas would certainly have encountered girls ironing in the front room of their shops. Artistically, however, his more than two dozen works show considerable effort in carefully studying them. There are single ironers, different vantage points, and mixes of different media and technique.

Certainly, Degas's theme has to do with appearances, with men and women dressing and grooming (Fig. a) for a visual society, which Charles Baudelaire described in his *Salon of 1846* as 'the spectacle of the elegant life'. But another spectacle Degas enjoyed was that of young working women, whether ballet dancers, laundresses or prostitutes (p. 108). Female models were a traditional subject in the history of art, which generally represented them as ideals of beauty. Degas sought them in their natural state, and, ideal or not, they had the beauty of the real. He recorded his models as such but at the same time transformed them into objects of beauty called art. That is, his manipulations infused the ordinary with aesthetic properties, raising his images above mere copies of banality, while demonstrating his mastery over both nature and man.

|Fig. b| Anonymous, Photograph of bare-breasted ironer
Musée d'Orsay, Paris

The finished batch of pressed and starched shirts are a still life at the centre of the composition. They signify that the artifice of gentlemanly dress, which both presents a persona and hides human imperfection, is the result, like art, of effort and skill. The girl to the right uses her shoulders, upper body and both hands to press down on the hot flat iron with which she moulds a recalcitrant cuff. Her companion to the left, barely sixteen, yawns and stretches, a bottle of wine in her hand

CITY LIFE AND URBAN VIEWS

Two Women Ironing, or Laundresses, c. 1884

oil on canvas, 81.5 x 76 cm, Norton Simon Museum, Pasadena, CA

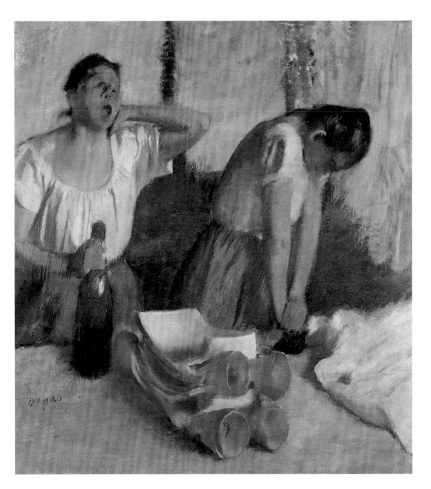

to help the work go more easily. Her low-cut blouse, necessary in the hot boutique, is on the cusp of slipping off her shoulder. It reveals the smooth skin of her young neck, enough to attract any virile gaze. Indeed, in proper society, even uncovered arms were considered risqué. Perhaps she is inured to alcohol, or naive. Or perhaps she seeks an exit from her working life on the arm of an interested client.

One art historian has discovered a photograph of an ironer posing with bare breasts (Fig. b). Was it really that hot, or was she soliciting? Compare the Degas's erotic potential to an 18th-century picture by Jean-Baptiste Greuze (Fig. c). His kitchen maid is so lazy that pots and pans fall on the floor, one of her shoes is off, and her décolletage reveals too much cleavage. Is Greuze's picture a lesson in morality, showing others how shameful negligence can be, or a titillating feast for the connoisseur's eye? And if it is both, is that hypocritical? By contrast, the erotic charge in Degas is more subtle, and the questions it raises are more difficult. But that is surely the nature of reality.

Edgar Degas

|Fig. a| Édouard Manet, *The Artist, Portrait of Marcellin Desboutin*, 1875, Museu de Arte de São Paolo

Morning Chaser: a Performance

From his seat at the Café de la Nouvelle-Athènes, where he seems to have been reading a newspaper, Degas notices a couple still in the stupor of last night's partying. The lady seems half asleep as she gazes at her glass of absinthe, a drink so noxious it is the only beverage ever to have been banned in France. She is dressed in clothing one suspects she slept in or hasn't changed, judging from its rumpled look. Her companion looks blankly out at the street, a tall coffee-based chaser on his side of the table. Maybe they've been up all night…

But wait! I recognise the woman: she's Ellen Andrée, an actress who often posed for her artist friends, and might well have been known to most of the picture's viewers when it was shown at the Impressionist exhibition of 1876. And isn't the man Marcellin Desboutin, a printmaker friend of the Impressionists? Édouard Manet represented him in a portrait called *The Artist* (Fig. a), where he still has his walking stick under his arm while he opens his tobacco pouch and his dog takes a drink as if they've just returned from a walk. So if Desboutin defined the genre of artist as *flâneur*, in *L'Absinthe* he is a stationary one, gazing from his protected space behind the café window at those few who might be on their way to work at this early hour.

Degas here has pulled off one of his best performances – a representation of the reality of modern bohemianism and alienation, as both characters seem alone in their thoughts in spite of the social setting. The empty tables at the café suggest their loneliness and isolation. The newspapers allude not only to the morning hour, but to Degas's documentary approach, enhanced by an angled composition that obviously references photography. At the same time, his unmistakable facture, combining sketch lines and suggestive patches of colour, underlines its artifice.

La Nouvelle-Athènes, at 9 Place Pigalle, was a favourite Impressionist hangout, pioneered by Degas and Manet themselves, for whom the Café Guerbois had become too dark, crowded and downscale. A print by Jean-Louis Forain (Fig. b), done in the lightly suggestive style of Manet, shows its high ceiling, bright lamps and tall mirrors. Named after a neighbourhood to which many artists and bohemians had moved, the café looked out onto the populous and popular Boulevard de Clichy. It had a somewhat seedy nature, too, as seen in Degas's pastel of *Women on a Café Terrace, Evening* (p. 364), where some undistinguished ladies congregate. One notices a male passer-by who has perhaps ignored them, as the woman in blue's vulgar reaction might suggest. The crowded, brightly lit terrace across the street records the dazzle of Parisian nightlife. As to *L'Absinthe*'s initial reception, the artist's Irish friend the novelist George Moore exclaimed 'What a whore!'

|Fig. b| Jean-Louis Forain, *Le Café de la Nouvelle-Athènes*, c. 1877 National Gallery of Canada, Ottawa

Édouard Manet

Will She or Won't She?

Cafés, bars and restaurants were places of everyday socialising for the bourgeoisie and artists who catered for them. Manet discovered Père Lathuille's through its proximity to Hennequin's art supplies, itself near the Café Guerbois, which was the Impressionists' early gathering place. Despite being off the Place de Clichy, down the boulevard from Pigalle, its enclosed garden continued to attract customers, a remnant of the area's suburban days before Parisian construction engulfed it. It afforded Manet a *plein-air* setting for a charming episode with figures that might normally be located indoors. Its brilliant colours are appropriate in sunshine, and its loose handling suggests the spontaneity of the Impressionist mainstream.

Compared to Degas's *L'Absinthe* (p. 109), where only minor elements are left to imagination, Manet tells a story the viewer must complete. A fashionable lady,

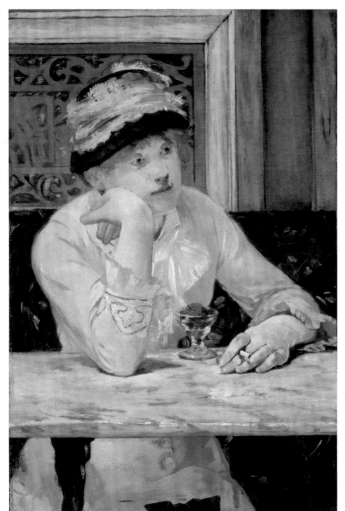

independent enough to lunch alone, is finishing off her meal with a coupe of champagne. A handsome young man approaches her, daring to place his arm on the back of her chair and his hand on her drinking glass. Leaning forwards to avoid his arm, she is forced closer to his face. Her expression, mostly hidden, could be amusement, caution or coyness. The problem Manet poses was obvious in his time, for the man's inferior social status is indicated by his moustache, sideburns and casual, hatless outfit. Still, places of leisure and entertainment were frequented by many different types, with as many different intentions.

The young man, it happens, was the son of Père Lathuille. Was he simply Manet's model, or was he playing himself? The lady was posed by Ellen Andrée, who had played a down-and-out part for *L'Absinthe*. She is not entirely recognisable, however, because she abandoned her role for Manet and had to be replaced.

The restaurant's midday service has ended. In the background a maid cleans up. The waiter to the right, holding a pitcher of hot coffee, waits to see if he is needed, but looks out at the viewer as if asking what's going on. Indeed, it's

|Fig. a| Édouard Manet, *Plum Brandy*, c. 1877, National Gallery of Art, Washington, DC

Luncheon at the Restaurant of Père Lathuille, 1879

oil on canvas, 92 x 112 cm, Musée des Beaux-Arts, Tournai

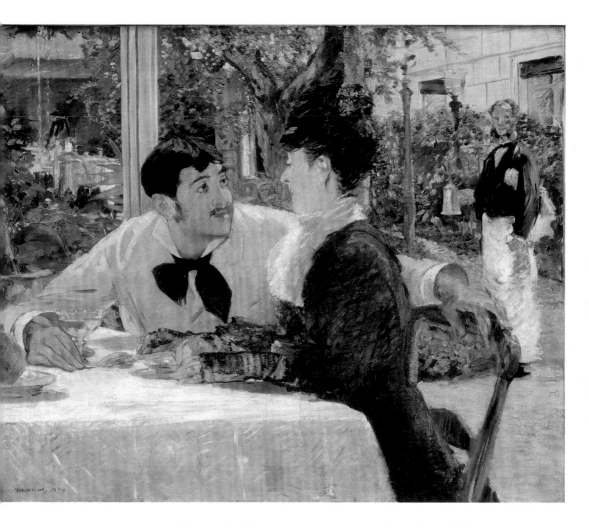

not the event itself that requires explanation, but the outcome. Will the boy succeed in getting a date with the older lady? Is she freethinking enough to consider it?

A related conundrum of the sort Manet loved is in his contemporaneous painting, *The Plum* (Fig. a). A young woman dressed as a shop girl sits alone at a brasserie. In front of her, as yet untouched, is a plum preserved in brandy. Tired and bored, after a long day on her feet, she holds an unlit cigarette, the enjoyment of which in public signified modern independence, a serious challenge to conventional manners. Is she waiting for someone to light her fire (an expression with similar implications in French)? The only way to judge is to imagine what one would do oneself. Similarly, in Père Lathuille's restaurant the final outcome will be imagined by the viewer, bringing to bear both his or her prejudices and habits.

Fashion and
Entertainment

Claude Monet

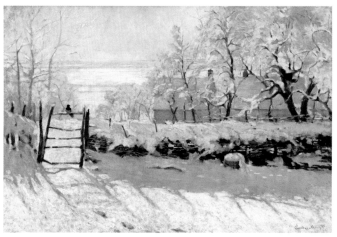

|Fig. a| Claude Monet, *The Magpie*, 1868–9, Musée d'Orsay, Paris

Happiness is a Gown

In the garden of a rented house at Sèvres, southwest of Paris, Monet set up a 2.5-m (about eight feet) canvas in order to produce a Salon-sized picture executed entirely out of doors. His first response to Édouard Manet's *Le Déjeuner sur l'herbe* (p. 23) had been to prepare a sketch of his own composition based on observation (p. 16), but he had begun the final version – never finished, and cut up into fragments – in the studio at the time. With *Women in the Garden* the process would take place entirely outdoors and on the spot. The canvas was too high for him to reach the top with ease. In such cases artists usually used ladders or scaffolding, with accompanying constraints on movement. Monet's solution, impossible inside a studio, was to dig a trench and rig a pulley so that in its lowered position the upper part of the picture could be painted as spontaneously as the rest. The marks of his patchy and summary brushwork are therefore visible all over. In addition, the line of shadow in the foreground and the bluish reflections of the sky from Camille's dress to her jaw graphically declare that he understood the effects of sunlight. In some snow scenes of the 1860s he rendered such phenomena so emphatically that they verge on abstraction (Fig. a).

With the exception of the seated figure, the women's faces are sufficiently hidden to obscure their identity. Even the seated woman's face is simplified, but recognisable as Monet's girlfriend and future wife, Camille Doncieux. She posed for all four women, in fact, to whom Monet gave different-coloured hair. When the couple was living in relative poverty for a young man used to bourgeois comforts, they could hardly have afforded luxurious gowns. Monet's letters show him complaining about money. Yet as a mark of precise contemporaneity, rendering the latest fashions was important, as in Monet's early single figure paintings *Woman in the Green Dress* (p. 48) and *Madame Gaudibert* (1868, Musée d'Orsay, Paris).

The solution was to copy fashion plates (Fig. b). But doing so was not just a practical matter. Such illustrations had recently acquired philosophical importance not just as barometers of taste but as manifestations of a national ethos, of 'the morality and the aesthetics' of their time, according to the first chapter, entitled 'Beauty, Fashion and Happiness', of Charles Baudelaire's famous essay 'The Painter of Modern Life' (1863). Baudelaire reasoned that beauty has both eternal and variable – that is, traditional and

|Fig. b| Adèle Anaïs Toudouze, *Le Follet*, May 1869, New York Public Library, NY

FASHION AND ENTERTAINMENT

Women in the Garden, c. 1866

oil on canvas, 255 x 205 cm, Musée d'Orsay, Paris

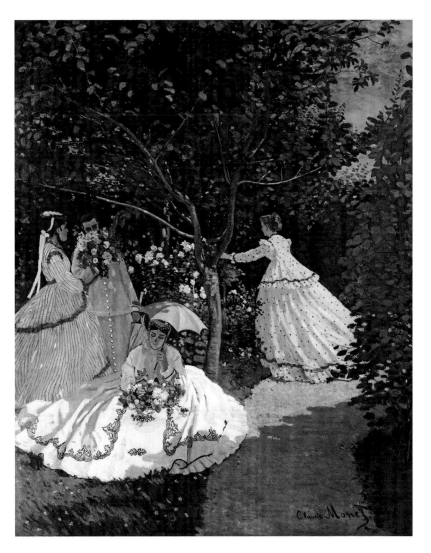

contemporary – components. There is not one single ideal, as Classicists would have it, but classical beauty itself was the modern beauty of its time. Baudelaire's combination of metaphysics and positivism defined beauty as the aesthetic quality that provides the greatest pleasure at a particular time and place. He related it therefore to desire, a motivating force in early 19th-century utilitarianism and in psychoanalysis later on.

Monet was no philosopher, but he knew how to appropriate contemporary trends. As such, the picture was so ahead of the Salon's official jury that it was rejected two years in a row. It nonetheless acquired a reputation among Monet's friends and colleagues, many of whom, including Manet, were able to see it in his studio.

Édouard Manet

Mirror, Mirror, Who's the Fairest?

Modern Paris inverted the Cinderella story. Woman could be magically transformed by make-up, and after midnight she was usually at her best. Such could be said of Nana, whose prince patiently endures the make-up ritual, which, before the result, is not just a prelude but an integral part of the seduction.

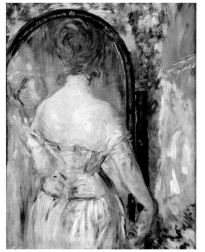

|Fig. a| Édouard Manet, *Before the Mirror*, 1876
Solomon R. Guggenheim Museum, New York, NY

|Fig. b| Édouard Manet, Illustrated letter to Mme Jules
Guillemet, 1880, Musée du Louvre, Cabinet des Dessins, Paris

Nana was a character from *L'Assommoir*, Émile Zola's novel of the year before Manet's painting, and his first to immerse readers in the miseries of working-class life. Nana's mother, the protagonist Gervaise, was abandoned by Nana's father and must resume her occupation as a laundress (p. 106), slipping into alcoholism. Manet must have known Zola would make Nana a successful courtesan in his eponymous novel of 1880. Years earlier Manet had done a lithograph advertising poster for his friend Champfleury's book about cats. Here was what might be called advance publicity in oils, much *avant la lettre*. But for whom, Zola or Manet himself?

In an earlier, less finished painting (Fig. a), Manet brought the traditional theme of woman's *toilette* into the present. In *Nana* he elaborates on the theme of masquerade and seduction with a play of gazes as complex as in his early works. Nana embellishes her appeal to others as an object of vision and desire, looking to the viewer as if acknowledging her performance rather than to her elderly suitor (Count Muffat in the novel). Her petticoat is transparent enough to glimpse a leg elegantly stockinged up to her bloomers. (A drawing, Fig. b, shows Manet's fascination with ladies' legs.)

With its brilliant sheen, the painting stages aesthetic experiences paralleling Nana's feminine seductions. Her exquisite torso is framed by a large, enticing pillow, while the lower part of her body gleams against its darker background and the rococo-style furniture echoes its curves. From the shoulders upwards, the portrait, enhanced by freshly applied lipstick, is framed by Manet's studio wallpaper, which just happens to show an exotic bird. The bird's name in French – *grue* (crane) – meant 'prostitute' in slang. Other visual effects and puns enhance the picture's pleasures.

The poor Count is cut off at the right-hand edge. His clenched teeth and powerfully gripped walking stick may suggest frustration. His left foot seems ready to kick the lady – or is this an allusion to the recent slang expression *prendre son pied*, meaning 'to get one's fill' (including sexually)? The mirror stand has an anthropomorphic but cyclopean look, emphasising the act of vision. Its outstretched arms with unlit candles suggest the relationship's lack of passion.

Posing for Nana was the young 'boulevard theatre' actress Henriette Hauser, the very public mistress of the Prince of Orange. Nicknamed

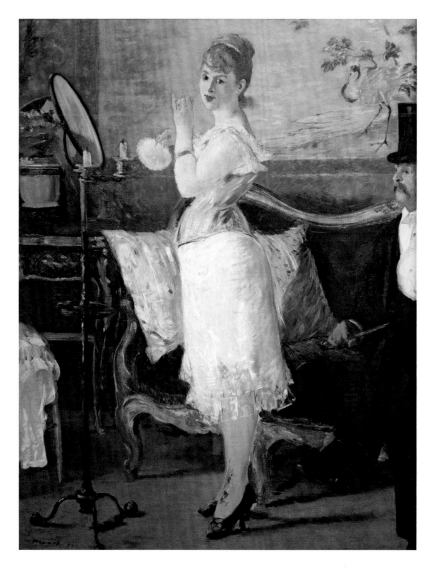

'Citron', she is reputed to have been the model for Zola's novel, too. As both courtesan and actress in real life, her profession was to seduce her audience. Therefore, Hauser's real-life connection, as much as her outrageous appearance in undergarments, may explain the picture's refusal by the Salon. So Manet showed it in a fashionable shop window on the Boulevard des Capucines, where it caused a sensation: crowds gathered and business boomed. There's nothing like bad press to attract curiosity and fame.

Pierre-Auguste Renoir

|Fig. a| Eugène Delacroix, *Women of Algiers in their Harem*, 1834
Musée du Louvre, Paris

Exotic poses

With Napoleon's invasions of North Africa and French colonisation of Morocco and Algeria, Arab culture and motifs became objects of fascination and fashion in metropolitan France. Renoir's picture, posed by Lise Tréhot, reveals two sides of what is now called Orientalism: that is, a set of attitudes towards the cultures of the East – in this case the Arab and Ottoman regions of the Middle East, as opposed to the Far East (i.e. Japan). Even though North Africa was due south from France, the centres of Islamic culture were east; among the first places Western artists visited was Constantinople (now Istanbul), capital of the Ottoman Empire.

Lise's supine pose suggests the assumed indolence and sexual submissiveness of Arab women, who were, after all, kept on call in harems several at a time for the male master, the number depending on his wealth. With her diaphanous blouse, her partly opened legs and her sultry gaze, she is the very image of seduction. Or is this the gaze of a model's boredom? For Renoir seems equally if not more interested in the other side of Orientalism – a fascination with its local colour, its ornaments, its fashions, from the dyed ostrich feather and tiara made of golden coins, to the embroidered silky pantaloons and festooned slippers. The son of a tailor, Renoir experienced a variety of fabrics and fashions in his home life and once declared, 'I love beautiful materials, rich brocades, diamonds flashing in the light [and] I would just as soon paint glass trinkets and cotton goods.' The canvas seems but a surface for the artist's visual pyrotechnics, almost like a still life for which Lise is merely the support. Renoir eventually visited Algeria, but his picture was based on assumptions and previous imagery, such as paintings by both the opposed masters of the mid 19th

|Fig. b| Henri Regnault, *Salomé*, 1870
The Metropolitan Museum of Art, New York, NY

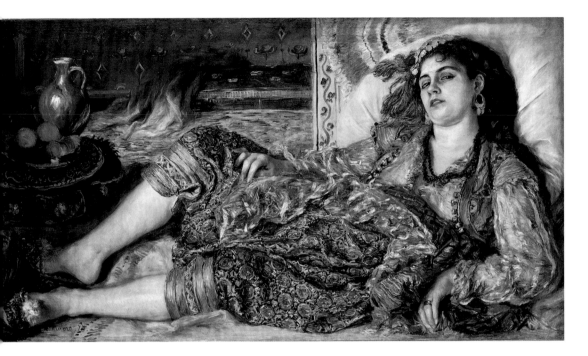

century: Eugène Delacroix and Jean-Auguste-Dominique Ingres. In the early part of his career, like many of his colleagues, Renoir admired Delacroix's use of colour, as in the latter's famous *Women of Algiers* (Fig. a). One may wonder if Lise's pose is based on the reverse of Delacroix's melancholic woman to the left. On the other hand, Ingres's odalisques had mastered the transfer of the classical nude to the Orient (see p. 196). Renoir would take up similar themes later in his career, but already in common with Ingres was his fascination with oriental paraphernalia.

Delacroix's painting was based on sketches made while peeking into a harem through a window in the door, a privilege accorded by his Arab host. Ingres's setting, by contrast, was drawn from imagination. A picture of 1870 entitled *Salomé* (Fig. b) by the young and very talented academic painter Henri Regnault is closest to Renoir's spirit. A stunning Italian model with a full head of wavy jet-black hair poses in a revealing exotic dress. She looks alluringly at the viewer. As in Renoir's picture, there is no doubt that *Salomé* is about visual seduction, produced by exotic fashions and pictorial flair.

Édouard Manet

Fanning the Flame of Freedom

One of art history's most scintillating representations of the ever popular theme of the reclining woman, Manet's picture of Nina de Callias shows one of Paris's best-known liberated women in a relaxing, self-confident pose. Nina de Villard, born Anne-Marie Gaillard, married the sophisticated journalist-about-town Hector de Callias in 1864 at the age of twenty-one. By the time of Manet's portrait, however, she had divorced him. An actress, poet and gifted pianist, since 1862 she and her mother had been holding a literary salon, to which they invited painters, poets and musicians, regardless of social or economic status. Sexually liberated since her youth, one of her early lovers was Manet's first biographer, Edmond Bazire.

Nina's pose is a variant on the reclining Venus Manet had already parodied in his *Olympia* (p. 219). It also appeared in his painting of the photographer Nadar's mistress wearing Spanish toreador pants (Fig. a) at a time when it was daring for women to show off their legs and hips even if they were clothed. This early picture was itself a riff on Francisco de Goya's *Clothed Maja* (Fig. b), an important milestone in the realistic representation of a courtesan, even if she is less popular today than Goya's earlier and controversial naked version, in which, possibly for the first time, pubic hair is visible in a painting. In *Woman with Fans*, Nina seems amused and contented by the act of posing, accompanied by the adoring exotic Pekinese at her feet and a brilliantly painted bouquet at her shoulder. Or is the bouquet part of the Japanese-style triptych that hangs above her a fabrication unlike anyone might have found in Japan? In it is the telltale crane or *grue*, which alludes to prostitution even before the picture Manet made of Émile Zola's courtesan, Nana (p. 117). Ironically, the dog is often a sign of fidelity, in contrast to the cat's wily promiscuity, as in *Olympia* and *Woman Reclining in a Spanish Costume*. In this

|Fig. a| Édouard Manet, *Woman Reclining in a Spanish Costume*, 1862–3
Yale University Art Gallery, New Haven, CT

|Fig. b| Francisco de Goya, *The Clothed Maja*, 1807–8, Museo del Prado, Madrid

FASHION AND ENTERTAINMENT

Woman with Fans: Portrait of Nina de Callias, 1873

oil on canvas, 113.5 x 166.5 cm, Musée d'Orsay, Paris

picture, Nina's pet is of a breed kept as lapdogs and known as *petits chiens de dames* – little dogs for ladies. Ironic or just cute, its presence enhances the notion that this woman hardly suffers from being single.

Like Renoir's *Loge* (p. 125) and numerous other paintings of the time, Manet's Impressionist facture aligns with the revived popularity of 18th-century rococo style, recently extolled by the Goncourt brothers in their collection of essays called *Art of the Eighteenth Century*. The writers spoke wondrously of the brushwork magic able to call forth illusions of reality as if effortlessly. Rococo painters such as François Boucher were associated with upper-class luxury and refined taste, which the prosperous 19th-century bourgeois lifestyle sought to emulate at a time when a growing segment of French society was benefiting from industrialisation and accumulation of surplus capital.

Berthe Morisot

|Fig. a| Pierre-Auguste Renoir, *Mademoiselle Sicot*, 1865
National Gallery of Art, Washington, DC

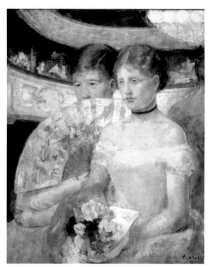

|Fig. b| Mary Cassatt, *Young Ladies in a Loge*, 1882
National Gallery of Art, Washington, DC

Fit to Tie the Knot

Morisot painted the eighteen-year-old Albertie-Marguerite Carré from life in her own apartment. She will soon marry a duke (Ferdinand-Henri Himmes), and her engagement ring sparkles on her left hand, prominently propped upon a pillow. She is seated on a two-person settee, known in English as a love seat. It is as if she awaits the moment when her fiancé will be officially authorised to share it. Behind her is an expensive Japanese vase stuffed with red roses from her future partner. Next to it a fashionable Japanese fan, no longer needed for flirtations. It has accomplished its purpose and can be displayed as a relic still life or collector's item.

The picture was executed under the stylistic spell of Édouard Manet, whorn Morisot knew since 1868, but with brighter, more stereotypically feminine colours and more delicate touches than her mentor. Although it is one in a long line of 'portraits' of fashionable dresses – which happen to have women wearing them – this particularly beautiful one pulls out all the stops. Its unified pink offers no other respite to the eye but runs the full range from occasional touches of red, at the lower left, for example, to the white of its collar and moulded cuffs. Only at the neckline does a black choker with its modest golden pendant intervene. Such neckwear was the fashion of the times, as seen in many pictures, from Manet's *Olympia* (p. 219) to the contrast it provides in Pierre-Auguste Renoir's early portrait of *Mademoiselle Sicot* (Fig. a). The comparison with Renoir is worth considering, for while Mlle Sicot's dress is far more colouristically saturated than Mlle Carré's, the latter's complexity makes it a far greater challenge for a painter.

With amazing dexterity, Morisot recreates every bow and ruffle in paint. Her brush-strokes not only echo their shapes, but they seem to perform the tactile pleasures that the sight of them suggests. While the expression of her subject's youthful face is

The Pink Dress, c. 1870

oil on canvas, 54.6 x 67.3 cm, The Metropolitan Museum of Art, New York, NY

reserved and grave, contemplating her future, Morisot's representation is ebullient and celebratory, embodying the joys the social world predicts will be her destiny. Compare the picture to that by fellow female Impressionist Mary Cassatt of two young friends on their first formal outing to the opera (Fig. b). Fashion is up front there as well, with Geneviève Mallarmé's off-the-shoulder gown painted with pastel-like delicacy and thinness, and Mary Ellison's fan unfurled to compare its painted flowers with those of Geneviève's bouquet. And yet Cassatt's contours are more precise than Morisot's, indicating her traditional training and her sympathy with Edgar Degas's methods. They underscore the teenagers' faces in particular, recording Geneviève's stiff formality and Mary's combination of timidity and awe at the spectacle before them with more sensitivity to psychology than Morisot's portrait. Yet both pictures certainly exemplify what Charles Baudelaire called the 'spectacle of fashion'.

Pierre-Auguste Renoir

|Fig. a| Edgar Degas, *Woman with Field Glasses*, c. 1875–6
Staatliche Kunstsammlungen Dresden

Icing on the Cake

One of Impressionism's most stunning pictures, *La Loge* was shown at the first Impressionist exhibition. It was intended as a demonstration of Renoir's awesome gift for representing women and their fashions. Like his *Alfred Sisley and Lise Tréhot in a Garden* (p. 47), it was not a commissioned portrait, given that it was posed by a model, Nini Lopez, and Renoir's brother. Dressed as sumptuously as any young woman in an Impressionist work, the model reads as a confection, made for visual delectation. The deft handling of the striped gown, white gloves, gold bracelet, flowers and almost excessive string of pearls is so generous it feels like cake decoration, as it appeals directly to visual appetite. The creamy make-up on Nini's face almost seems applied to her throat and breasts as well, while their subtle juxtaposition to the only slightly whiter necklace and the pinkish-red flower calls attention to the delicate shadow above it. The result is – as Renoir's idol Eugène Delacroix once held that art should be – 'a feast for the eyes'.

The thick soft collar that outlines Nini's neck and bosom in black enhances the picture's appeal to erotic appetite as well. Woman was traditionally a not-so-subliminal selling point for goods other than sex, such as drinks at a bar, clothes in a boutique and, in this case, paintings. For the picture's seductive pictorial properties parallel those of its subject. It is as much a luxury object as its referent: desire for the painting and the woman converge.

The opera and theatre were among the few public venues available to respectable bourgeois women and their families (p. 122), where they might also rub shoulders with courtesans and men of the world. Dressing up was part of the ritual, through which not only women but their partners could show off their status and their wealth. As Renoir's brother demonstrates by aiming his binoculars high up, he has paid for one of the more luxurious lower boxes.

The point of view, seeming to be taken from mid-air outside the opera box, is a sign of the picture's artifice. But perhaps it corresponds to the kind of view the male escort has through field glasses, which are bigger and more powerful than those held by Miss Lopez, more like those one takes to the *hippodrome*, as in Edgar Degas's sketch of a woman at the races (Fig. a). The composition's angle makes the painting seem informal and spontaneous, like such a fleeting view, and yet it is cleverly organised along the axis determined by both optical devices, thereby framing it with the signs of modern vision focused on spectacle, whether outdoor sport or indoor entertainment. Indeed, Nini's companion emphasises the ever searching, testosterone-driven gaze of Parisian male virility; having won the lady in his box, he already seeks new challenges. In this, Renoir's brother's gaze is a projection of his own.

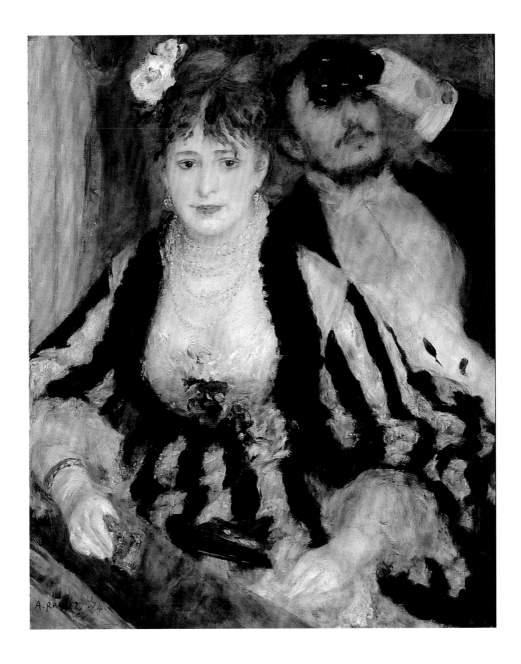

Mary Cassatt

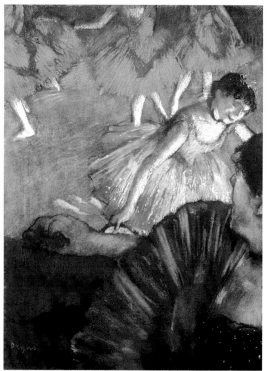

|Fig. a| Edgar Degas, *Ballet from an Opera Box*, c. 1884
Philadelphia Museum of Art, PA

Lady Spy

Cassatt's picture of a woman in black looking across the theatre with her opera glasses is one of her most unusual pictures, almost out of character with the main body of her work. Most of her models were known and her pictures commissioned or done for friends, but this figure is unidentified. Dressed in black, she is probably a widow, not at this time to be mistaken for an object of desire. Being looked at is less important in the picture than the act of looking. Equipped with her instrument for spying, indeed, the lady is empowered by her position in a private box.

Ironically, in the background three boxes over and on her level, is someone equally curious about her. It is a man, this time, ostentatiously leaning at the very edge, as if to mock the lady, unless he knows who she is. This facetious interplay of gazes is more characteristic of Édouard Manet or Edgar Degas, but here Cassatt angles for the upper hand by handing the voyeur's tool to a member of her sex. The fan is folded, unused, almost like a baton or club, suggesting masculine determination more than feminine flirting or discretion.

One wonders whether Degas's *Ballet from an Opera Box* (Fig. a) might be responding to Cassatt's composition of 1878. Degas depicts a woman from the side, sitting practically on top of the stage in a corner box, as indicated by the tension in her body and the turn of her head to the right to get the best view of the dancers. Of what use are the opera glasses she holds so prominently on the velvet rail? Is she so interested in the young ladies, or are they for social spying, as in the Cassatt? In her case, the fan is open, partly obscuring the view of the stage. Whose gaze is she deflecting? Given that Cassatt's woman aims her glasses too high for the ballerinas, might it be from someone like her?

Degas calls attention to the act of vision through his brilliant colours, jarring vantage point, heightening the comparison between the fan and the dancers' tutus, and featuring his bold pastel technique. By contrast, the opera glasses at the centre of the picture are idle, in shadow and coloured relatively dull. Cassatt's attention is more narrative and specific, but her method of painting can be equally spectacular.

The generalisation of her background, sketched with verve and subtlety, emphasises her female protagonist. Yet at the same time it hits home when tracing the form of her visual interlocutor across the way. Thus Cassatt asserts her own personality and that of female vision, distinguishing both it and her style from Degas, despite his role as the artist most influential on her career. This was the first of Cassatt's works to be shown in the United States, where it was found 'striking' and as good as the work of men.

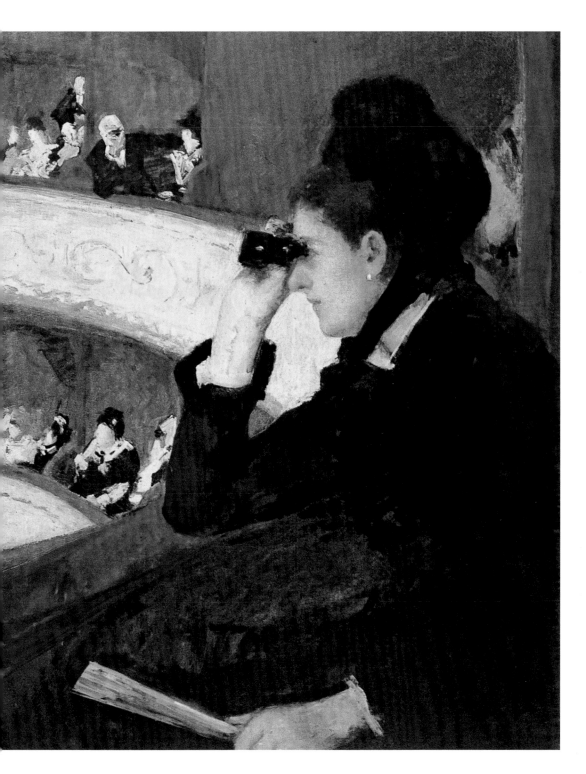

Edgar Degas

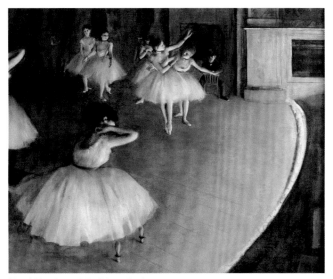

|Fig. a| Edgar Degas, *Ballet Rehearsal on Stage*, 1874
Musée d'Orsay, Paris

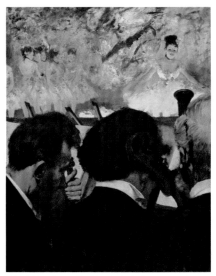

|Fig. b| Edgar Degas, *Musicians in the Orchestra*, c. 1870
Städel Museum, Frankfurt

The Artist as Performer

Degas viewed his compositions as highly orchestrated, and so his representation of a dance master with his baton is a metaphorical self-portrait. While many of Degas's pictures focus on the concept of vision, his ballet scenes of the 1870s are more broadly about artistic process – how artists stage spatial effects, produce environments with scenery and manipulate forms that populate it. Experimental versions of this very scene show the artist placing and displacing figures, similar to human 'pawns' in a ballet.

For example, the Musée d'Orsay has a more simple, quasi-monochrome, oil-painted version (Fig. a) of this complex composition. Comparing them shows that in both there are several changes, including the double bass scrolls in the foreground and the ballet master. In the oil there are more dancers and one of the gentlemen watching the rehearsal has been rubbed out.

Degas's ballet pictures were done in the old opera house on the Rue le Peletier before Garnier's famous building was completed on the Place de l'Opéra. Admission to rehearsals and dance classes was limited to members of the exclusive Jockey Club. Hence Degas's work implies his social status and helps explain why ballet scenes and racecourses were his most common themes. It is well documented that since ballerinas were working-class girls, men of rank might be interested in them for sexual favours as well as entertainment. Some mothers shared those ambitions for their daughters, for despite this being the back entrance to society it was nevertheless a way in. Degas's boyhood friend Ludovic Halévy wrote stories about such adventures, entitled *La Famille Cardinal* (1883). Degas's presence in brothels suggests he might have had direct experience, too (p. 364).

Ballet Rehearsal on the Stage, c. 1874

oil on canvas, 54 x 73 cm, The Metropolitan Museum of Art, New York, NY

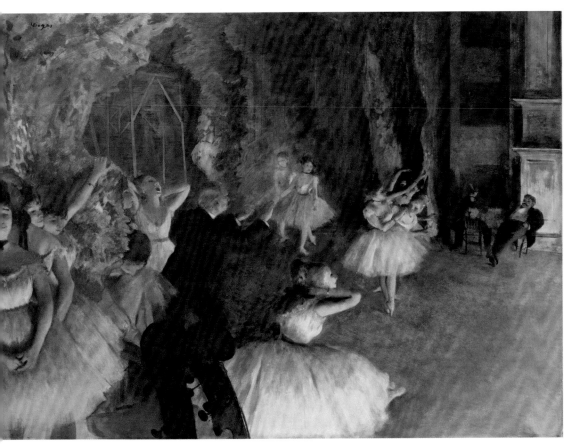

A hallmark of Impressionism was, so to speak, to create gold from dross. Dancers are not always pretty, but their skills transform their bodies from the commonplace to art. Many have said that Degas was misogynistic, and although he was in all sorts of ways a snob and a racist, a combination of such attitudes and visual reality explains the homeliness of so many of his dancers (p. 130 and p. 352). In this composition girls appear as their natural selves in the foreground – yawning, stretching, slipper-tying and back-scratching. Compare them to the precision and sequential poses of those in the distance, at whom the dance master directs his and the viewer's attention. The foremost one is on the tips of her point shoes.

Behind them the scenery flats look like the skeleton of the theatre's anatomy. Indeed, Degas's aim seems exactly that: to reveal the craft and internal workings of the dance medium, in much the same way as his technical and compositional skills show off those underlying fine art. In a picture of *Musicians in the Orchestra* (Fig. b) he went even further. The musicians have finished playing and the prima ballerina comes forwards, out of character, against harsh footlights, to take her bow. What her performance produced was a beautiful illusion, comparable to those of Degas's visual performances.

Edgar Degas

|Fig. a| Edgar Degas, *Café-Concert at Les Ambassadeurs*, 1876–7, Musée des Beaux-Arts, Lyon

|Fig. b| Edgar Degas, Notebook page with sketches for *The Song of the Dog*, c. 1877, private collection

The Ascent of Dog

At the other end of the social spectrum in musical entertainments from ballets and operas were open-air cabaret acts in the green spaces along the Champs-Élysées, as at the Alcazar d'Été and Les Ambassadeurs (Fig. a). The public they attracted was more diverse and the entertainment far less highbrow than at the Opéra, as the relatively middle-class audience in the foreground of Degas's rendering of the *Café-Concert* reveals. Yet, just as at the opera, the spectacle was not solely on the stage – notice the man at the left edge looking at the woman in the green hat, who seems to nod towards him for reasons one can only guess. And just as at the opera, the production had to be lavish and the performance amazing to keep the audience's attention.

In *The Song of the Dog* Degas shows an instance where the entertainer seems to have the upper hand. She has been identified as the chanteuse Thérésa, which was the stage name of Emma Valladon (Fig. c), according to her gravestone at Père Lachaise Cemetery. She performs one of her celebrated numbers at the Alcazar d'Été, a nearby rival to Les Ambassadeurs. Her act includes satirical lyrics and showy miming: for *The Song of the Dog* her arms imitate the front paws of a mutt begging on its haunches. Even with Degas's reputation as both an elitist and a keen observer, it is surprising to discover studies for Thérésa in one of his notebooks that represent her with animalistic attributes (Fig. b). Along with his friend Edmond Duranty, Degas was deeply interested in scientific studies of human psychology and expression. Leonardo da Vinci and, in France, Charles Le Brun had made drawings and engravings that compared human faces with those of various animals. Charles Darwin's theories on evolution were widely known by Degas's time (*The Origin of Species*, 1859, and *The Descent of Man*, 1871), but in a sense he merely developed a theory to explain what famous artists had already observed. As early as 1843 the caricaturist J.J. Grandville had parodied such notions with a woodcut illustration, *Man Descending towards the Brute* (p. 348).

The Song of the Dog, c. 1878

gouache and pastel on paper, 51.8 x 42.6 cm, private collection

Fig. c| Anonymous, Photograph of Emma Valladon, probably in her forties, c. 1880

Thérésa identified with the lower classes. One ironic admirer said she had 'a modest proletarian chic' (*un petit chic canaille*). In what passed for science in the 19th century the theory of evolution could be applied to the human species to explain both racial and social differences. On the lower rungs of both ladders, physiognomies were more bestial. From there, of course, it was an easy step to racism, but Degas probably believed he was simply making his observations more legible. In any case, not only did he produce a good likeness of Thérésa, he created a stunning work of modern art, with a spare, right-angled geometry as a foil for Thérésa's ample middle-age torso and a pattern of gas lamp globes that seem festively suspended among the trees. Moreover, its composition is as loosely executed as it is tautly designed.

Edgar Degas

|Fig. a| Pierre-Auguste Renoir, *Acrobats at the Cirque Fernando*, 1879, The Art Institute of Chicago, IL

|Fig. b| Georges Seurat, *The Circus*, 1891
Musée d'Orsay, Paris

By the Skin of her Teeth

Among the spectacular entertainments available in 19th-century Paris was the circus, several of which had permanent spaces in the city. The Cirque Fernando was in Montmartre, not far from the cafés and studios where artists spent their time. In *Miss La La* Degas's vantage point and colouring are actually more daring in his domain than the acrobat's stunt in hers, for she practised and performed it many times over so that her chances of failure were slim. By contrast, Degas's picture comes as a surprise even from him and is unique among his varied works. Indeed, for those used to plunging views of the ballet, it is a shock to wrench the neck around in order to stare up at the ceiling. As popular as the circus was, Impressionist pictures on this theme are fairly rare. Yet for the artists who tried it, the results were masterpieces. It is amusing to compare Pierre-Auguste Renoir's picture taken from the same circus in the same year as Degas painted *Miss La La* (Fig. a). *Acrobats* is a close-up, too, possibly aided by opera glasses or imitating their effect, as was certainly the case for Degas, though not as dramatically and less for its own sake. The girls are identifiable as Francisca and Angelina Wartenberg, seventeen and fourteen respectively. They were part of a travelling acrobatic troupe from Germany. One of the few things they share with Miss La La are their shoes and costumes, which Renoir has rendered with more detail than Degas, and with more subdued reflections and less glare from the indoor lighting. Only their white cotton stockings are a different colour from Miss Lala's, which are darker and thicker, perhaps in case of a fall. Renoir shows his girls after their performance, so they have natural postures as they retrieve gifts of oranges tossed by children in the audience. Degas concentrates on the acrobatics: Miss La La's hair is flying and her body taut in order to steady her pose. Renoir is more anecdotal and seductive; the sisters are charming and the oranges provide an opportunity for still life.

Renoir's architectural setting is just enough to indicate the location, but mostly the girls are seen against the ground, which is empty except for a few stray pieces of fruit. In the Degas, however, the structure is emphasised by contrasting colours and ornamental carvings and is a major feature of the organising geometry. In Georges Seurat's somewhat later *Circus* (Fig. b), in the Neo-Impressionist style, the architecture plays a major role as well. But it flattens his composition to abstraction, imitating advertising posters designed to catch the popular eye. The cartoon-like figures and clown's cut-off body are humorous, expressing the child-like joy of watching people who can stand on horseback on one foot or the skills of the tumbler behind her. Its daft simplifications share with Degas the spirit of parody, and with Renoir the charm of childhood. But while Seurat's pointillism feigns an impersonal record of the performance, Degas's handling has the opposite effect, calling attention not just to Miss La La's but certainly to his own as well.

Miss La La at the Cirque Fernando, 1879

oil on canvas, 117 x 77 cm, The National Gallery, London

Pierre-Auguste Renoir

|Fig. a| Vincent van Gogh, *Le Moulin de la Galette*, 1886
Neue Nationalgalerie, Berlin

|Fig. b| Antoine Watteau, *The Pleasures of the Ball*, c. 1715–7
Dulwich Picture Gallery, London

Having a Ball

Renoir was one of the first artists to move his studio up the hill to Montmartre, where he found cheaper space and lots of lively working-class activity. The Moulin de la Galette, literally 'the cake mill', was a former windmill for cake flour. It became a site for drinks and dancing, especially on warm Sundays, when locals dressed up and came to enjoy outdoor tables and the dance area behind the converted mill. In the background, painted green, is the covered dancing floor. In good weather the orchestra moved outdoors. Renoir was a lover of working-class women because, he claimed, they were more natural as models than professionals. Of artisanal origins himself – his father was a tailor, his mother a dressmaker – Renoir was more at ease with seamstresses than proper ladies who wore their latest fashions.

His most ambitious effort to date, *Dance at Le Moulin de la Galette* was shown at the third Impressionist exhibition, where it attracted the attention of the publisher Georges Charpentier (p. 56). In it, Renoir assembled a number of his friends. The only precedent so far for such an ostensibly spontaneous grouping of cohorts was Édouard Manet's *Music in the Tuileries Gardens* (p. 21), done many years earlier, and which assembled members of the upper bourgeoisie and Parisian intelligentsia in a place where working girls and bohemian men would have seemed out of place and possibly suspect. Renoir's is a very different crowd. His friend the writer Georges Rivière smokes a pipe to the right. He recalled sitting next to the painter Norbert Goeneutte, across from whom, with his back turned, is the painter and illustrator Pierre Franc-Lamy. Both were younger than Renoir and more oriented towards genre painting. Neither really joined the Impressionist group or attained as much stature. They are having a grenadine while chatting with a seamstress, Jeanne, who had modelled for Renoir. She leans over her younger sister. Although other names are known, it is hard to associate them with specific figures. It may be that Paul Lhote and Suzanne Valadon are the couple in the middle-ground centre – they later appear in full-length portraits of them as a

Dance at Le Moulin de la Galette, 1876

oil on canvas, 131 x 176 cm, Musée d'Orsay, Paris

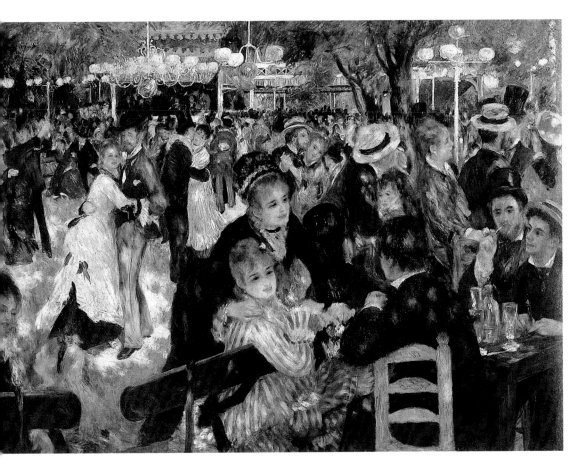

dancing couple (p. 292). Further back, on a bench to their left, and true to his love of anecdote, Renoir has sneaked in a couple in which a young lady is tired either of dancing or of her suitor.

With its patchwork of sunlight filtering through the trees, trellises and hanging lamps, its active and feathery brushwork, and its crowd of moving figures, Renoir's technique converted what in Van Gogh's early morning image of the Moulin (Fig. a) seems a dull and dilapidated place in a deserted neighbourhood to a fairyland of festive energy, charming courtship and elegant fashion. The painting's realm of pleasure with its delicate pictorial effects recalls Antoine Watteau's exquisite repertory of gatherings in parks or the gardens of aristocratic country houses (Fig. b). While the scene is more urban and more proletarian than those of Manet and Degas, the Sunday finery and Renoir's tendency to prettify erase the social distinctions often made by those two painters. Renoir's is an ideal world where such concerns are forgotten, a utopian fantasy of liberty and disinterested love.

Édouard Manet

|Fig. a| Édouard Manet, Study for *A Bar at the Folies-Bergère*, 1881
Private collection

|Fig. b| Gustave Caillebotte, *In a Café*, 1880
Musée des Beaux-Arts, Rouen

Mirroring Eye Appetite

In art the mirror often stands for art's reflection of nature, of the world around it.
Manet was already ill when he finished this painting, his last large work and a kind of
testament, as well as the culmination of a group of café scenes. The Folies-Bergère
was a popular cabaret built in a converted department store; it was thus quite literally
an emporium of pleasures. A large stage was on the ground floor, with bars, tables
and promenades along its ample balconies. A barmaid is centred against a brilliantly
lit background of spectacular entertainments and matching brushwork. Yet when one
notices the reflections of her back and her client's profile, a feeling of uncertainty creeps
in. The gentleman presumably stands directly before her, as normally would the viewer,
so his reflection should be mostly blocked by the barmaid's body. Yet both reflections
are clearly visible. It is as if the eye has been displaced to the right, a literal instance of
Manet's characteristic detachment.

The sketch for the painting was straight on (Fig. a), like Gustave Caillebotte's composition
of a man standing before a café mirror simply looking out (Fig. b). So Manet's optical
anomaly is deliberate, a reminder of the artist's control, but also a challenge to one's sure
footing that parallels the modern experience in which classes mix in places such as the
bar and enjoyments are matched by feelings of solitude and alienation. The barmaid,
posed in Manet's studio by a waitress named Suzon, seems wooden. Can she herself
be an object of consumption, like Edgar Degas's ballerinas available for more than
choreography? A cartoon (Fig. c) showing an embarrassed customer might suggest this.
Is she an ironic object of worship, like a modern mocking Virgin Mary behind the altar?
Whether the expression signals discreet availability or the tedium of a working woman's
endless day is an undecidable mystery.

Manet's name on a bottle of ale to the left signs the most scintillating still life of his career.
He often played with signatures in other pictures and here implies that the picture itself,

A Bar at the Folies-Bergère, 1881–2

oil on canvas, 96 x 130 cm, The Courtauld Gallery, London

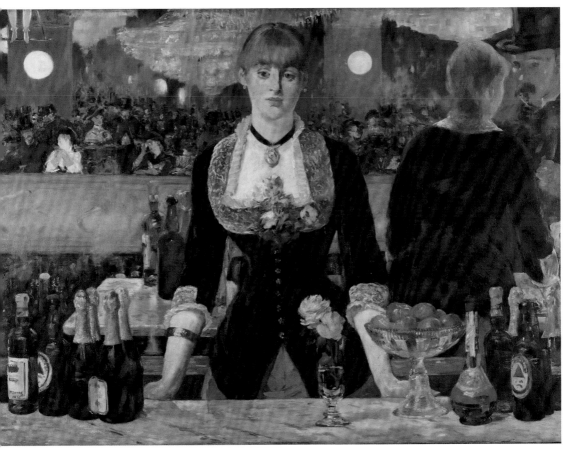

Fig. c| Georges Lafosse,
t the Folies-Bergère, 1878

like the display of aperitifs, champagnes, cordials and various brews, is food for what one might call 'eye appetite'. The scopic gaze, as described by French psychoanalyst Jacques Lacan, is one in which the desire for objects is merged with erotic impulse. As in pictures such as Pierre-Auguste Renoir's *Loge* (p. 125) and Édouard Manet's *Nana* (p. 117) and *Woman with Fans* (p. 121), Manet's own version of this combination seduces the eye through a parallel strategy of contemporary themes and bold displays of craft. To the left of Suzon's shoulder a woman looks through opera glasses, calling attention to the concept of voyeuristic vision found in paintings by Degas and Cassatt (p. 126). To her left, Manet's friend Jeanne de Marsy holds a fan, while at the left of the waitress attending her is Méry Laurent, looking towards her companion. The ladies' gloves contrast with Suzon's hands, reddened by dishwashing. Finally, in the upper left-hand corner are the cut-off legs of a trapeze performer – Manet's homage to Degas, with whom he shared a love of visual acrobatics.

Industry and Technology

Armand Guillaumin

The True Landscape of Modernity

Impressionism is so often characterised as an art of bourgeois leisure that the important role of modern industrial scenes in the Impressionist repertory is frequently overlooked. In their formative years of the late 1860s and the 1870s, however, several members of the group painted industrial landscapes. Claude Monet's views of the commercial harbour at Le Havre were among them (p. 24), but no artist was as consistently devoted to the representation of factories and other labour-oriented activities as Guillaumin. *Setting Sun at Ivry* was one of two industrial landscapes along the Seine he exhibited at the first Impressionist exhibition (p. 98). Ivry was a heavily industrialised suburb where the river Marne joins the Seine and flows towards Paris. The following description is from a Paris guide:

For approximately 30 years the incessant backwash of Paris has covered Ivry with factories … In all the suburbs there is no more productive town. It has factories that produce pigments and varnishes, fertiliser, oils, fats, glue, gelatin, albumin, candles, waxed papers, chemicals, hardware … [S]ome discharge suffocating odours, fortunately carried away and diluted by the lively and salubrious regional air … The municipality is prosperous …

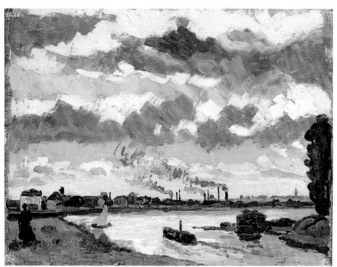

|Fig. a| Armand Guillaumin, *The Seine at Ivry*, 1869
Musée du Petit Palais, Geneva

Guillaumin's painting transposes sunset *effects* of the sort found in Barbizon landscapes (p. 14) into a modern context. The vantage point looking west is from the banks of the Marne's junction with the Seine, opposite Charenton, where Guillaumin also painted many views. This composition was clearly planned over a longer period. Drawings, complementary views and an oil sketch (Fig. a) exist, the latter rivalling Monet's *Impression, Sunrise* (p. 33). Unlike Monet's, however, Guillaumin's sketch was a prelude to a more finished version of the same composition. The sketch's existence proves that the subject was important enough for him that he did not approach it casually. In fact, despite appearances, few Impressionist paintings are really spontaneous events. Even Monet left a notebook full of sketches for his series on the Saint-Lazare train station (pp. 154-5).

Several critics associated with the young artists of the 1860s called for representations of industry in the new school of modern life painting that was emerging. One, a politically

liberal lawyer named Jules-Antoine Castagnary, who had defended Gustave Courbet's militant Realism, claimed as early as 1863 that art should document the society of its times, and that to do so it must include both industry and rural life. The latter was traditionally favoured by painters, for whom art was to be a spiritual relief from the everyday. That concept lay behind the popularity of the Barbizon School. For the new generation, however, authentic art should be based on observation of the present world from the artist's personal point of view. In 1868 Émile Zola wrote that one could no longer deny the importance of modern subjects in art.

Paul Cézanne

|Fig. a| Paul Cézanne, *Train and Factories at L'Estaque*, 1869, Musée Granet, Aix-en-Provence

Railroaded Through!

One of Cézanne's best-known early landscapes, *The Railway Cutting* is a large painting for which he made drawings and a preparatory sketch. It shows a dramatic gash through a Provençal foothill, made for a line heading west from Aix-en-Provence that also appears in the foreground of better-known views of the Montagne Sainte-Victoire (p. 382). Here, the mountain is visible in the background. The site was at the southern limit of the Cézanne family estate, Jas de Bouffan. The abruptness with which the right of way implacably slices through its mound suggests the relentlessness of modernisation, while evoking the modern traveller as indifferent to and isolated from the topography through which he hurtles at unprecedented speeds. At the same time these characteristics are related to other early paintings by Cézanne in which such feelings are embodied by violent and/or erotic content. One can therefore see this picture as an early step in Cézanne's effort to reorient his impulses towards the modern themes of Impressionism.

Among those who most forcefully advocated modern subjects was Cézanne's childhood friend Émile Zola. For Zola's wife, Cézanne made one of his most radical industrial compositions, a watercolour and chalk drawing of a train and factories on the steep terrain at the Mediterranean port of L'Estaque (Fig. a). Just outside Marseille at the time and now an inner suburb, L'Estaque was where Cézanne hid in order to avoid being drafted into the Franco-Prussian War. Zola visited him there. Cézanne is said to have made the composition to decorate the top of Madame Zola's sewing box, perhaps as a joke of some sort. The body of the train is hidden behind a barrier, but its funnel is visible thanks to telltale vapours that hint at the engine's speed against the prevailing wind, as indicated by factory smoke.

INDUSTRY AND TECHNOLOGY

The Railway Cutting, 1869–70

oil on canvas, 80 x 129 cm, Neue Pinakothek, Munich

There are two types of railway pictures in Impressionism. One focuses on the trains and passengers themselves; the other represents their interaction with the landscape. *The Railway Cutting* illustrates the latter and contrasts sharply with Monet's *Train in the Countryside* (p. 153), despite sharing honours with it as one of the two earliest Impressionist railway scenes. Monet's picture conveys a satisfying harmony that Cézanne's hard geometric focus denies. Despite its absence from Cézanne's picture, the machine's presence in nature is marked through topographical features such as the right of way, the track, fences to keep out stray animals, a signal on its post and attendant buildings like the small utility shed in the composition's centre, highlighted against the cutting's shadow. The painting thus focuses on human intervention in the landscape rather than beneficent co-existence, as in the Monet. Both approaches help one to gauge not only different effects of the railroad revolution on people's lives and environment, but a range of different attitudes towards them. Commonplace as trains may have been in the landscape and in the public consciousness, their presence was rarely a matter of indifference.

Alfred Sisley

|Fig. a| Armand Guillaumin, *The Road to Clamart at Issy*, 1873–5, Birmingham City Museum and Art Gallery

Roads of the Future

Sisley often painted around Louveciennes and Marly, the latter just inland from a small port on the Seine, notable for the proximity of a great pump, the wondrous Machine of Marly (Sisley, *The Machine at Marly*, 1873, Ny Carlsberg Glyptotek, Copenhagen). The mechanism was built by Louis xiv to supply water to his Château de Marly perched up on the heights. The port also served as a shipping point for Marly's plaster mines and its production of lime (*blanc de Marly*), as well as for timber cut in nearby forests. The recently modernised stretch of road thus fulfilled the ideal combination of both economic and touristic functions.

A comparison to Jean-Baptiste-Camille Corot's more picturesque *Road to Sèvres* (p. 13) highlights the new thoroughfare's modernity. The rustic fence along Corot's road and his peasants suggest that life has little changed outside the city, which is present in the background but suffused in mist. His figure riding on a donkey hardly exemplifies a modern form of transportation. By contrast, Sisley's highway is notable for its straight, wide stretch, with newly laid kerbstones lending crispness to its geometry, as opposed to the uneven, natural border in the Corot. Whether brand new or a renovation, Sisley's capacious corridor is emphasised by its ostensible emptiness, allowing for speedy coaches and considerable traffic. Unlike Corot's nostalgic focus on country folk, Sisley's figures are little noticed in the row of freshly planted trees. Their series of vertical lines, like railway ties, emphasise standardisation and efficiency.

Even Armand Guillaumin's winding *Road to Clamart at Issy* (Fig. a) has the specificity of the modern. Its carefully graded S-curve is counterpointed by bordering saplings, evenly spaced. From near Issy-les-Moulineaux, where he occasionally painted with Paul Cézanne, Guillaumin was looking northeast. Western Paris – as yet not fully developed – lies in the distance, identifiable by the dome of Les Invalides.

INDUSTRY AND TECHNOLOGY

The Road to the Machine, Louveciennes, 1873

oil on canvas, 54 x 73 cm, Musée d'Orsay, Paris

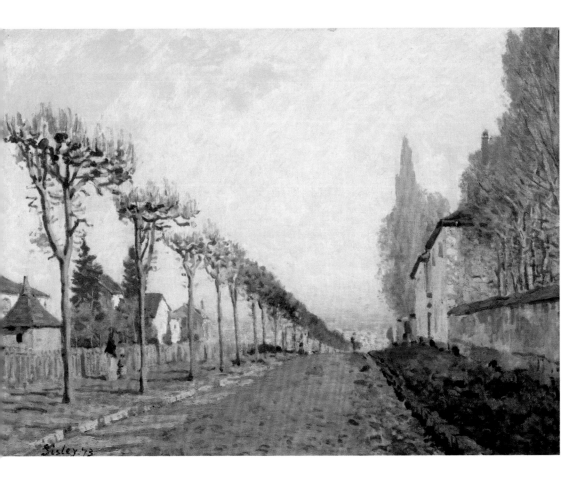

Unlike Corot's view in *Road to Sèvres*, Guillaumin's contains specific elements of
modernity. A new house is at the centre and a train on the Orléans line heading to
Montparnasse Station crosses from left to right behind it in the middle distance.
These road scenes contrast markedly with the previous generation of landscapes,
located in solitary woodlands, away from all but the most primitive and rustic lanes.
For painters of earlier generations, the road, when present at all, was secondary
to the picturesque experience of an outlying village, country estate or geological
curiosity. In Impressionism, suburban roads and city streets are themselves places
of meaningful activity; far from the banality with which they appear to us today, they
signified modernity to the 19th-century viewer. Even when empty, the road implies the
potential for mobility and access that are at the heart of the modern economy. Like the
train, roads imply the freedom to travel and to expand the range of one's existence.
By focusing attention on man-made elements in the landscape, they also imply the
extension of human control over nature through the creation of a national infrastructure.

Alfred Sisley

Plain Beautiful

One of Sisley's loveliest paintings, with its bright blue water, puffy clouds and sunlit piles of sand, represents as banal a subject as one could have imagined at the time: workers bringing silt up from the bottom of a river. To the left is a man with a sieve used to eliminate rocks, so the sand could serve as a reasonably uniform base for cement. Raw materials were in high demand because of the construction boom during the Third Republic that followed the destruction of buildings, bridges and roads caused by the Franco-Prussian War and the Paris Commune. Dredging sand from the riverbed also helped keep channels open for navigation. The Seine was notorious for its shallow bottom. Its islands in the middle, on which Paris was first built or like La Grande Jatte, were the result of silt build-up.

A major project of the third quarter of the 19th century, called 'Paris Seaport', was to bring shipping all the way up the Seine from the Normandy coast into the city. Although ultimately impractical because of the efficiency of the railways, the extension of the Canal Saint-Denis into Paris via the Canal Saint-Martin was related to this goal. Sisley perhaps more than any other painter, including Armand Guillaumin was interested in waterway traffic. Although Claude Monet is more identified with pictures of the Seine than Sisley, his orientation was mainly towards sailing or pleasure boating, with just a few significant exceptions (p. 156). Guillaumin (*The Seine at Bercy*, 1874, Hamburger Kunsthalle, Hamburg) and Sisley were more drawn to the river as a place for productivity and labour. Sisley's style in the early 1870s, however, was closely related to Monet's. Not only could his brushwork and lighting be compared to the latter, but also compositional devices such as the monumental presence of the sand piles to one side of the foreground. The cutting off and cutting through of forms are features that are both realistic and Japoniste. The scene is peopled with workers, whose functions are

|Fig. a| Pierre-Auguste Renoir, *Barges along the Seine*, 1869, Musée d'Orsay, Paris

INDUSTRY AND TECHNOLOGY

Piles of Sand along the Seine at Marly, 1875

oil on canvas, 54.5 x 73.7 cm, The Art Institute of Chicago, IL

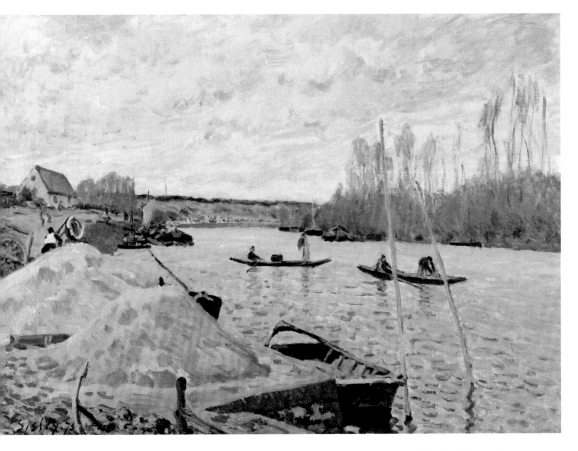

carefully particularised even though the figures are small. Each of the two boats has an oarsman, who steadies the small craft while his partner performs the task of dredging or, in the boat to the left, emptying a bag of sand into the boat.

One of Pierre-Auguste Renoir's rare views of industrial river traffic (Fig. a) offers an enlightening comparison. Although brightly lit and painted more or less in the prevailing style, his view is from the heights overlooking a string of barges, which, unlike Guillaumin's and Sisley's, offer little information about their particulars. A fashionable lady much closer to the riverbank in the centre of the composition is lost in her reading and seems to ignore them. It is as if Renoir needed her as an excuse for choosing the scene in the first place, and for her the environment is bucolic. Sisley's workaday scenes in this early part of his career are by contrast deliberately plain, but plainness has its beauty too.

Camille Pissarro

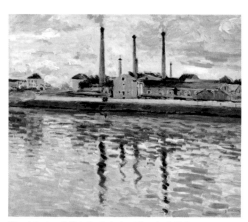

|Fig. a| Gustave Caillebotte, *Factories at Argenteuil*, 1878
Private collection

|Fig. b| John Constable, *Salisbury Cathedral from Lower Marsh Close*, 1820
National Gallery of Art, Washington, DC

Cathedrals of Modernity

Like Claude Monet with his group of paintings of the harbour of Le Havre and Armand Guillaumin with his group depicting factories around Ivry, Pissarro took up industrial subject matter in the early 1870s with a number of paintings of factory buildings near Pontoise, where he was living at the time. Pissarro preferred a more rural environment to the Parisian locations of most of the Impressionists, or even the suburban residences of Monet. Pontoise was a market town northwest of Paris, overlooking the river Oise, not far from its confluence with the Seine. It was linked to Paris by the railway, it had a gasworks and a paint factory, and a company named Chalon and Co. built a cluster of starch plants on the outskirts.

Unlike Guillaumin's Ivry (p. 141) and Gustave Caillebotte's image of factories at Argenteuil (Fig. a), Pissarro's Chalon and Co. buildings are located in otherwise not yet urbanised territory and are surrounded by grass that looks almost like a park. Their harmonious integration with nature is suggested by the continuity of the axis going from the tallest chimney to the treetops at the right. In another view, taken from a greater distance (*The River Oise near Pontoise*, 1873, The Sterling and Francine Clark Art Institute, Williamstown, MA), this effect is even greater. In both, the factory smoke merges as if naturally with the clouds in the sky. Caillebotte's picture really focuses on the Argenteuil factory complex of the Joly Ironworks, as if their surroundings are incidental. In Monet's paintings suburban Argenteuil is primarily a place for sailing, promenades and gardens (p. 282). However, industry had moved to the riverbank upstream from the sailing basin nearer to the railway line, which opened in 1851. In contrast to Monet's innumerable images of Argenteuil painted while he lived there, Caillebotte's only picture of the town featured its industry rather than its leisure. Contrary to Caillebotte, Pissarro creates a unity of the whole. But contrary to Monet, who kept Argenteuil's factories in the distant background when he recorded them at all, Pissarro's work while living in Pontoise was more inclusive. For him, it is obvious

Factory near Pontoise, 1873

oil on canvas, 46 x 55 cm, Museum of Fine Arts, Springfield, MA

therefore that modernity, even in more rural territory than Argenteuil or Paris, is both acceptable and, at the very worst, benign. More than once in contemporary writings one could have read that railway stations or factories were 'cathedrals of modernity'. A comparison of Pissarro's painting to one by John Constable of Salisbury Cathedral (Fig. b) makes one wonder if Pissarro was taking the comment literally. Pissarro had found refuge in a suburb of London during the Franco-Prussian War. Along with Monet, he saw works by J.M.W. Turner, and so certainly saw works by Constable as well. Direct influence, however, is not necessary to demonstrate the point that Pissarro's faith in modernity led him to make many industrial landscapes, of which his group of factory buildings at Pontoise was among the first.

Claude Monet

Bridge over Untroubled Waters

In this relatively stark picture of the railway bridge that crossed the Seine from Gennevilliers to Argenteuil, Monet represents the modern lifeline that fed Argenteuil's expansion from a genteel village raising asparagus and grapes, to an industrial suburb like so many that ringed Paris. The train also carried commuters to Paris, like Monet himself on days when he met his friends, saw dealers or bought supplies. Especially on holidays it carried Parisians in the reverse direction. The river widened out into a basin, which was long established as an ideal place for sailing. With weekenders arriving, boat renting became profitable. In Monet's painting two sailing boats navigate among the bridge's columns, as if the structure provides a bit of sport.

The bridge itself was brand new, having been rebuilt after the Franco-Prussian War. Its lines are clean and streamlined, and the simple geometry of its powerful supports barely recalls the post and lintel system of classical architecture. Their cylindrical shape is neither decorated nor varied in width, and their functional capitals are undisguised by any allusion to the ancient orders. The day is sunny and the bright light not only makes a pattern of reflections in the water but projects them onto the columns of the bridge itself, which reflects the blue sky.

Two men observe the scene, one dressed in a blue suit with straw hat, the other in more utilitarian, probably worker's clothing. Might they suggest the divided opinions regarding the bridge's aesthetics? While one newspaper celebrated the structure as a feat of economy and engineering, an object of local pride built by Argenteuil's own Joly Ironworks (p. 252), another felt it was a brutal intrusion on the environment that blocked an otherwise open view.

This painting is one of the least ambiguous pictures in Impressionism of the railway's effect on its surroundings. Another version by Monet himself (Fig. a) shows the bridge at a greater angle, thus decreasing its impact on the composition. Its near end is obscured by vegetation that cushions its impact. A sailing boat lazily glides by even as a freight train rumbles across

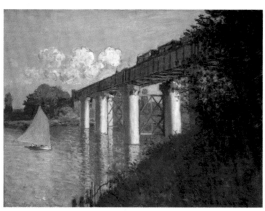

|Fig. a| Claude Monet, *The Railway Bridge at Argenteuil*, 1874
Philadelphia Museum of Art, PA

|Fig. b| Armand Guillaumin, *The Railway Bridge at Nogent-sur-Marne*, 1871
The Metropolitan Museum of Art, New York, NY

The Railway Bridge at Argenteuil, 1873

oil on canvas, 60 x 98.4 cm, Nahmad Gallery, New York, NY

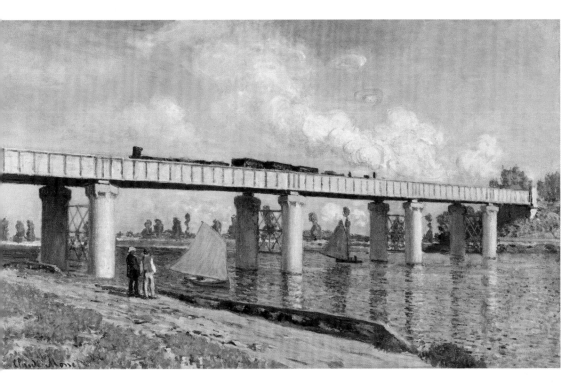

the trestle. A picture by Armand Guillaumin representing one of the longest viaduct-bridge ensembles built up to his time (Fig. b) is more straightforward in its celebration of a recent span. But it exemplifies efforts to build in a more traditional mode, since its supports were arches faced with brick in imitation of ancient Roman predecessors.

In virtually all pictures of railway bridges, Impressionist artists included a train crossing over it, even though there would often be no more than one per hour. Not only was the structure itself of interest, but also the train that gave it identity and purpose. It was even more unusual to include two trains, as in Monet's near right-angle view done downstream. And in all three pictures discussed here the vapour exhausting from the engine seems to merge naturally with the clouds, as if making a pleasant and innocent contribution to the air.

Claude Monet

|Fig. a| Gustave Doré, Title page to *Histoire des environs du nouveau Paris* by Émile de La Bédollière, 1861

Train and Country

Along with Paul Cézanne's *Railway Cutting* (p. 143), Monet's picture was one of the first in Impressionism to take up the modern theme of railways. The first passenger line in France, from Paris to Saint-Germain-en-Laye, opened in 1837. From 400 km in 1840, French track grew to 23,600 km by 1880. Despite this ubiquity, serious interest in painting trains emerged only with the Impressionists' commitment to modernity. It is worth noting that although Monet kept factories in the distance while in Argenteuil – his truest industrial scenes were always located elsewhere – the same was not true for trains. They were part of his direct experience as a frequent commuter, and they served the bourgeoisie directly by linking the city and the countryside. An illustration by Gustave Doré (Fig. a) clearly establishes this relationship, while humorously suggesting the disruption it caused to rural folk.

In Monet's painting, the small double-decker carriages of the Saint-Germain line trundle toy-like across the bridge over the Seine at Chatou. In the foreground, ladies with parasols stroll across a bright green field; they, rather than the train itself, seem to be the picture's focus, despite its title. Partly hidden among the trees and confounded with the tree line, the railway and its structure seem a benign and almost incidental presence in this lush and sun-drenched suburban paradise. Yet the truth is that the train provided access to the countryside for such people; it was the condition for their being there and a marker of modernity. More subtly than Doré's caricature, Monet implied a link between the leisure-seekers and the train by rendering passengers visible on the open third-class deck, above the enclosed compartments for second-class passengers. Neither Monet nor other painters took the trouble to do so in other works.

What a contrast between this picture and another pioneering train image by Monet, *The Cargo Convoy* (Fig. b)! Against the background of a thicket of factories (including one run by his brother) on the hill of Déville, Rouen's main industrial suburb, a freight train speeds across the landscape. It spews huge plumes of smoke that add their pollution to that of factories to the left and right. In the foreground are three figures watching it. As indicated by the ladies' parasols, they are bourgeois taking fresh air along the riverbank just below them. They stop and stare at the sight, like tiny figures in mountain scenes

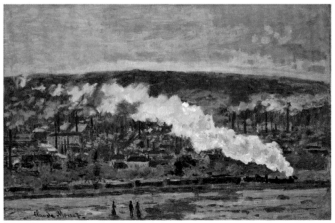

|Fig. b| Claude Monet, *The Cargo Convoy*, 1872, The Pola Museum of Art, Mt. Hakone, Japan

Train in the Countryside, c. 1870

oil on canvas, 50 x 65 cm, Musée d'Orsay, Paris

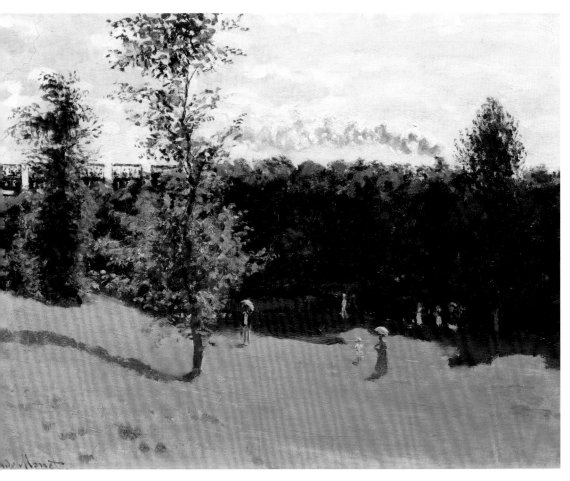

or at the seaside gazing in awe at nature's grandeur (p. 318). In *Cargo Convoy*, Monet deploys this trope for a man-made spectacle, in what might be called 'the industrial sublime'. What it shares with *Train in the Countryside* is not simply the presence of the train in a landscape, but its articulation of the relationship between the train's presence and those who benefit from it, whether directly or indirectly. Rouen was a prosperous railway crossing point, and even with competition from Le Havre it was an important site for shipping (p. 162). Deliberately or not, these two train paintings exemplify the relationship in modern society between the industrial revolution and leisure.

Claude Monet

|Fig. a| Claude Monet, *Railway Yards at Argenteuil Station*, c. 1875
Château de la Motte, Luzarches

|Fig. b| Claude Monet, *Train Signals and Tracks at Saint-Lazare*, 1877
Landesgalerie, Niedersächsisches Landesmuseum, Hannover

Steaming Monsters

Saint-Lazare railway station was designed in the modern cast-iron mode by the
engineer Eugène Flachat, whose reconstruction of the original 1837 structure opened
in 1853. It handled approximately 40 per cent of Parisian passenger traffic at the time.
It was there that Monet arrived from Argenteuil or Normandy. In 1877, with Gustave
Caillebotte's help, Monet rented a flat across from the station. The previous year,
Caillebotte had painted the extraordinary Pont de l'Europe (p. 159), which crosses the
railway yards behind the station.

Monet had already made more paintings of trains than any other painter at the time.
He portrayed them in different seasons and from different viewpoints but always in
Argenteuil – except for *The Cargo Convoy*, done while visiting his brother in Rouen
(p. 152). One is especially sketch-like (Fig. a), a sort of equivalent to *Impression, Sunrise*
done in railway yards. The decision to paint the Saint-Lazare station in Paris was thus a
calculation; he even sold some of the works before he showed them.

While awaiting permission to paint inside, Monet made some free-handed compositional
sketches in a notebook (Musée Marmottan Monet, Paris). Once admitted in January, he
worked intensively until the third Impressionist exhibition opened in April. He produced
eleven paintings with different train configurations or from a variety of vantage points
(Fig. b). In the painting of the station from head on seen here, a train arrives, still steaming,
while a worker in the foreground awaits it. To the left, passengers are about to board
outbound coaches. The locomotives' emissions obscure the iron and glass structure, and
the residual mist seems to dissolve the massive apartment blocks behind it.

Georges Rivière, a friend of Pierre-Auguste Renoir and publisher of the short-lived
journal *L'Impressionniste* – a sort of in-house publicity organ – wrote what is still today
the freshest and most authentic account of this painting:

*… the locomotive is about to depart. Like a furious and impatient beast, energised rather
than fatigued by the long haul it has just provided, it shakes its mane of smoke …*

The Gare Saint-Lazare: Arrival of a Train, 1877

oil on canvas, 75 x 104 cm, Harvard Art Museums, Cambridge, MA

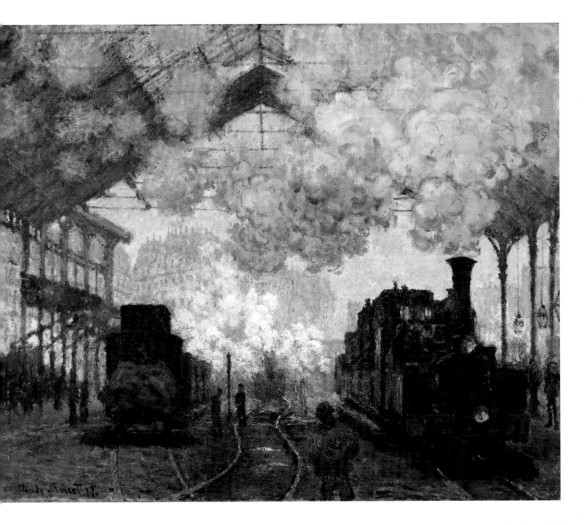

All around the monster, men scurry along the track like pygmies at the foot of a giant. [...] One hears the shouts of the workers, the sharp whistles of the machines sounding their warnings from a distance, the constant sound of iron on iron and the formidable and breathless respiration of the steam. ... One sees the grandiose and crazed movements of a station in which the ground trembles at each turn of wheels. [...]

There is drama both in Monet's portrayal and in what he portrays. This is the essence of Impressionism – that an artwork simultaneously enacts and describes its subject through a unity between its theme and pictorial form. In the image of steam as near abstractions indexed by the artist's proactive brush, the viewer finds Monet's evanescent merger of industrial and aesthetic productivity – a convincing performance of the spirit of his times.

Claude Monet

|Fig. a| Claude Monet, *Barges at Asnières*, 1875, The State Hermitage Museum, St Petersburg

An Industrial Ballet

Paintings depicting industrial workers are rare in Impressionism until the new generation of the 1880s, but this one is a bold exception. Even in pictures of the Gare Saint-Lazare there is less emphasis on human labour than on machines. Here, against a background of factories in Clichy, an inner suburb one loop of the Seine closer to Paris than Argenteuil, workers unload coal from barges to power the factories in the background.

The composition is dramatically framed by the bridge that crosses from Clichy to Asnières. The latter was a fashionable place for luminaries and leisure; bathing and boating were among its popular activities. A picture called *Barges at Asnières*, painted at the same time, places the barges against a view of this more residential neighbour (Fig. a). But the title is misleading, for they are actually docked on the Clichy side, filled with coal as in the picture of unloading.

Monet's subdued colours and generalisation of the workers' features tend to render the men anonymous and uniform, as if robotic in their labour. Yet they are enlivened by their activity, which reads as rhythmic and syncopated thanks to Monet's positioning of them, like an industrial ballet. The shadowy light effects are the result of early morning and a smoky sky on a cloudy day as well as coal ash eyewitnesses say covered the place. One writer, named La Bédollière, celebrated Clichy's industrial complex as 'a city of business' rather than pleasure:

The buildings [...] spread majestically along the banks of the Seine. They cover a surface of two hectares [about five acres], on which function three steam engines with 130 horsepower. They drive powerful hydraulic presses and distribute with remarkable harmony, in every part of the factory, a perfectly regulated energy ...

A massive multi-year, multi-volume publication titled *The Great Factories of France* was filled with illustrations, including one of Clichy (Fig. b). But another witness disparaged the place as a 'dried up riverbank, full of the coal dust spread by the workers unloading the barges,

|Fig. b| H. Linton, *View of the Candle Factory at Clichy taken from Asnières*, 1860

Men Unloading Coal, c. 1875

oil on canvas, 54 x 65 cm, Musée d'Orsay, Paris

bordered by factories covered by soot' compared to Asnières, 'gay, carefree, lazy and green as its facing neighbours are arid, dull, sombre and laborious'.

In *Men Unloading Coal* one has the feeling of labour as effort performed over time, although the performance itself seems more like a ritualistic procession than a back-breaking slog. The planks are spaced and Monet has staggered the coal carriers contrapuntally so that they look like pawns lacking agency against their backdrop of smoking chimneys. At least their juxtaposition to the factories that burn the fuel gives their labour an ostensibly progressive purpose.

Gustave Caillebotte

|Fig. a| Auguste Lamy, *Paris, Bridge at the Place de l'Europe*, 1868, Musée Carnavalet, Paris

|Fig. b| Édouard Manet, *The Railway*, 1873, National Gallery of Art, Washington, DC

A Chance Encounter in the New Europe

Along with *Paris Street, Rainy Day* (p. 101), this large painting is Caillebotte's masterpiece of geometry and anecdote, celebrating both modern engineering and the ways of city life. As shown in an illustration made shortly after its completion (Fig. a), the Pont de l'Europe was a daring project conceived in order to link the new neighbourhoods on either side of the Gare Saint-Lazare's sunken railway yard (Fig. b). Its star arrangement typical of Haussmannian planning has six half-spans meeting at the centre. The visionary concept was not just to connect the two sides but to make the new Place de l'Europe intersection a focal point.

The painting's glaring light on a sunny day heightens the sense of ruthless geometric rigor underlying both the cast-iron trestlework and the streets that run across it. The rapidly foreshortened perspective pulls the viewer inwards, suggesting through spatial dynamism rather than sketchy brushstrokes the rush and movement of modern life. In the background are imposing new housing blocks characteristic of the neighbourhood, like the one in which the painter, his mother and his brothers lived (p. 92). A soldier, identified by the red trousers of his uniform, crosses the street between the passage of two carriages in the background to the left. The picture's rapid recession quickly dwarfs him. Caillebotte's representation of the built environment thus embodies the bold lines of engineering design and mass construction, while suggesting their dehumanising effect as well.

The scene overlooks the railway yards. A man in a worker's smock directs his (and our) gaze towards the station, which is off to the right beyond the painting's edge. He seems to be looking at a shed, behind which is parked an idle locomotive. In the distance at the edge, close to the man's eye level, is a tiny engine heading out. Through the girders, one can see the southern span of the eastern side of the bridge. Rising up from the yards below is a cloud of steam that obscures the building above and cannot be mistaken for a natural atmospheric one.

Le Pont de l'Europe, 1876

oil on canvas 125 x 180 cm, Musée du Petit Palais, Geneva

The man walking towards the viewer is a self-portrait. The artist should be heading home to the Rue de Miromesnil (p. 92), but the picture has him making a detour. Rather than the direct route of the Rue de Lisbonne (he lived at the corner) on the middle span, he has taken the Rue de Vienne, the bridge's southern span. The viewer is given the position of a *flâneur* walking his dog. Caillebotte turns to glance at a woman whom he has just passed, suggesting that her pace is slower. Perhaps she is soliciting, since she is alone and yet in fancy clothing. At this borderline between a residential area and a railway station one encounters a mix of individuals, including workers in their smocks, clerks in bowler hats and women of the world. Away from the direct surveillance of closely overlooking buildings, the Place de l'Europe could be used as a rendez-vous without offending neighbours. The dog, with its hunting instinct, points the way.

Armand Guillaumin

Crossing the Line

Guillaumin and his friend Paul Cézanne (p. 98 and p. 186) took walks together making sketches and paintings in the southern suburbs of Paris. A drawing by Cézanne (Fig. a) from a similar viewpoint to Guillaumin's implies the uniqueness of this special point where the Aqueduc de la Vanne crosses the Sceaux railway and turns northwards. Compared to Cézanne's rapid unpopulated sketch, Guillaumin's painting reveals passengers waiting at a primitive train stop under the aqueduct's shelter.

The Sceaux railway was run by Guillaumin's former employer the Orléans train line and linked Paris to the posh suburb of Sceaux, with its château and magnificent park. It is still a desirable place to live that has not been completely overrun by public housing. The Aqueduc de la Vanne was a major project, started many years earlier but recently extended to bring water from sources in Burgundy to the southern side of Paris. Its grand scale made it the subject of illustrations and photographs (Fig. b).

Guillaumin's picture is rendered in a relatively limited palette dominated by the lush green vegetation and light of the sunny sky. Touches of other hues here and there make sure the eye notices the figures, even though they are secondary to the bays of the aqueduct and the parallels of the rails. Playing contrapuntally against the arches are vertical forms representing a signal pole near the foreground and, to the right of the track, telegraph poles, from one of which runs a little mark might that suggest a wire.

Guillaumin and Cézanne often joined Camille Pissarro, with whom they formed a sort of trio, and they experimented together with prints at the press of Dr Paul Gachet, a homeopathic physician and amateur painter-printmaker. Gachet lived in Auvers, north of Paris. Pissarro, like Cézanne and Claude Monet, was among the first to treat the railway theme, his earliest picture of which was done while he was in England during the Franco-Prussian War, living with relatives in the south London suburb of Upper Norwood. One of his most interesting pictures shows a train leaving Lordship

|Fig. a| Paul Cézanne, *The Aqueduct and Sceaux Railway at Arcueil*, c. 1874

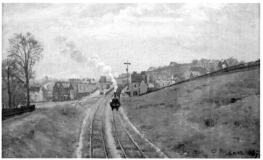

|Fig. b| Hippolyte Collard, *Deviation of the Vanne Waters*, c. 1867
Musée Carnavalet, Paris

|Fig. c| Camille Pissarro, *Lordship Lane Station, Upper Norwood*, 1871
The Courtauld Gallery, London

The Aqueduct and Sceaux Railway at Arcueil, 1874

oil on canvas, 51.5 x 65 cm, The Art Institute of Chicago, IL

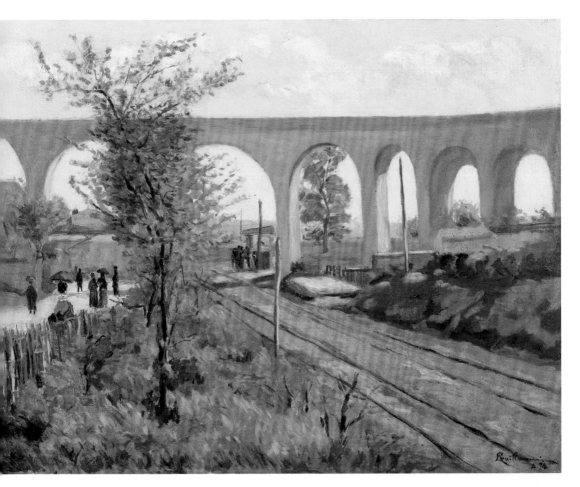

Lane station, approaching the bridge at Fox Hill, from which Pissarro seems to be observing it (Fig. c). The line was a spur meant to bring visitors to the nearby Crystal Palace, where Great Britain had its famous first Universal Exhibition, showing off its industrial products. Pissarro shows the British-designed locomotive, more squat and rounded than its French cousins, entering a gentle curve that has been cut and sunken into a wide trench in the side of a slope. Unlike the Guillaumin, for which the crossing of the lines is most important, Pissarro seems fixated on the cat-like engine creeping towards the viewer.

Camille Pissarro

Harbour Series

Like Claude Monet, Pissarro painted a great deal in Normandy. Rouen is its capital, famous for its medieval core crowned by the magnificent late-gothic cathedral so often depicted in tourist guides, national monument compendia and, most famously, in Monet's series of 1894 (p. 380). In spite of its economic importance, however, until Impressionism the port at Rouen attracted little attention. Monet was the first to take it seriously, in a group of works he did while visiting his brother Léon in 1872 (p. 380), well before he contemplated the idea for the series of cathedrals. Pissarro visited the city several times, too, beginning in 1883 when he produced a group of riverside port scenes, then culminating in the 1890s with a major series of industrial views (Fig. a). Pissarro was invited to Rouen by Eugène Murer, a former pastry cook who owned a hotel, overlooking the Seine, at Place de la République. Guillaumin had introduced him to the Impressionists, for whom he became a collector and friend. Since Monet's visit in the 1870s there had been major investments, spurred on by competition with Le Havre, the increasing draft of ocean-going vessels and competition with the railways. A major import from North America was cotton for Rouen's textile and dye industry, the largest in France since Alsace had been lost to the Prussians. Some fifty cranes were added, piers were renovated, channels deepened and warehouses were built for storage. From 1871 to 1880 tonnage doubled.

Place Lafayette is in Rouen's industrial zone of Saint-Sever, across the river from the city's centre. Pissarro would have crossed over on the Pont Pierre Corneille, which began at the foot of his hotel. His vantage point was the intersection at the bridge's landing, which is to the left beyond the picture's edge. Along the near riverbank, sail and steam barges are anchored, with the nearest one raising its small loading crane. Horse-drawn carts shuttle cargo. Across the river is the heavily industrialised Île Lacroix, at the tip of which the Pierre Corneille Bridge's first span touches down before the second span continues. Perched on the Côte Sainte-Catherine in the distance is the church of Notre-Dame de Bon-Secours, built during the 1840s in neo-gothic style. In 1883 Pissarro made several drawings and a print of the Île Lacroix, but it was not until 1886–8 that he painted it (Fig. b), using the pointillist style developed by the Neo-Impressionists Paul Signac and Georges Seurat.

|Fig. a| Camille Pissarro, *The Pont Boieldieu in Rouen, Rainy Weather*, 1896
Art Gallery of Ontario, Toronto

|Fig. b| Camille Pissarro, *L'Île Lacroix, Rouen (The Effect of Fog)*, 1888
Philadelphia Museum of Art, PA

Place Lafayette, Rouen, 1883

oil on canvas, 46.3 x 55.7 cm, The Courtauld Gallery, London

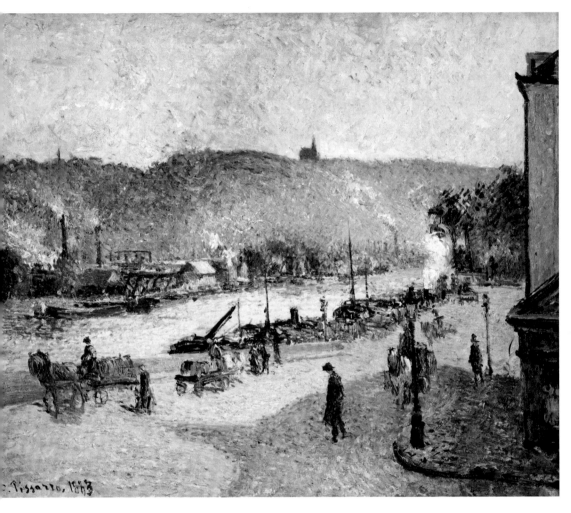

In *Place Lafayette*, however, one can see that Pissarro himself had already arrived at a technique based on small, relatively dry brushstrokes whose pasty quality avoided what he denigrated as the overly pleasing 'romantic' touches of his colleagues Monet and Pierre-Auguste Renoir. Yet his heavy use of blues in shadow had been Monet's idea first, and the painting is remarkable for its subtle colour transitions. Combined with the fragmentation produced by brushstrokes, Pissarro was responding to Rouen's typically humid, foggy weather, which in his painting *L'Île Lacroix* overwhelms most forms while also poeticising the scene.

Politics and Society

Édouard Manet

|Fig. a| Édouard Manet, Sketch for *The Execution of Emperor Maximilian*, 1867
Museum of Fine Arts, Boston, MA

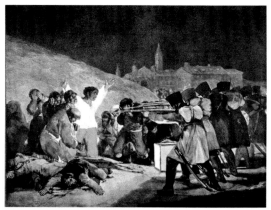

|Fig. b| Francisco de Goya, *The Executions of 3 May 1808 in Madrid*, 1814
Museo del Prado, Madrid

Hand Holding Under Fire

When the reformist party led by Benito Juárez was elected to govern Mexico in 1861, it almost immediately ceased debt payments to the European powers. Napoleon III, anxious to retain a base in North America – Louisiana having been sold by his uncle to America – used the loan default as an excuse for military intervention. With its European allies, France placed the thirty-two-year-old brother of the Austrian emperor on the throne. With French overconfidence and eventual reductions in French troops demanded by domestic opinion, however, the emboldened juaristas attacked and overwhelmed the French at Querétaro. Emperor Maximilian and two loyal generals were executed for treason on 19 June 1867. When Manet heard the news he saw an opportunity to express disdain for Second Empire politics more explicitly than in earlier work.

Manet transformed his first conception (Fig. a), inspired by Goya's famous *Executions of 3 May 1808* (Fig. b), thanks to a widely circulated photograph of the firing squad (Fig. c). Yet he altered certain features of their uniform to bring it closer to that of the French. Their spats and ceremonial gendarme swords led his friend Émile Zola to quip: 'Such a cruel irony – France executing Maximilian!' Indeed, that was precisely the point: it was French imperialism in the first place that had led to the loss of life, especially of a naive young puppet who, holding hands with his subalterns and wearing a sombrero like a halo, wanted nothing more than to identify with his subjects and do them good.

Manet's composition forgoes Goya's dramatics for ostensibly journalistic neutrality in order to allow the viewer to judge innocence or guilt. The first shot seems to be followed by silence. Yet the irony of the situation is underlined by figures looking over the wall, who are adaptations of a Goya bullfight etching. Whether their reaction is horror or boredom, the reference suggests that this political ritual barely differs from the predetermined outcome of the matador's victory over a captive bull. The reference is all the more piquant because Napoleon III's wife, the Spanish-born aristocrat Eugénie de Montejo, had introduced bullfighting to France, over the objections of those who

The Execution of Emperor Maximilian, 1868–9
oil on canvas, 252 x 302 cm, Kunsthalle Mannheim

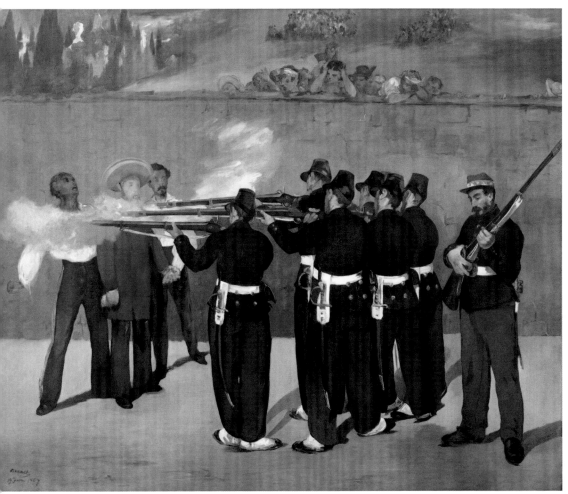

Fig. c| Anonymous, Photograph of Emperor Maximilian's firing squad, 1867

disdained her influence and her husband's encouragement of public spectacles to distract from his autocracy, as well as those opposed to cruelty to animals.

The matter-of-fact expression of the soldiers, the even lighting – contrasting with Goya's dramatics – and the victims' dazed looks create a deadpan effect that implies that Manet merely recorded visual facts. As Zola noted, however, while appearing not to tip the scales, nor to moralise, Manet provided clues to his opinion for those with the knowledge and time to look more closely. He was warned not to exhibit the picture publicly, and a lithograph version he made was barred from circulation. Ten years later he sent the picture for exhibition in New York and Boston through the singer Émilie Ambre, who was travelling there to play her famous role of Carmen. Manet dated the picture at bottom left, not with the year he painted it but with the exact day of Maximilian's death.

Édouard Manet

A Life Surrendered

Following defeat by Prussia and the abdication of Napoleon III, the government that remained hastily organised a Third Republic to sue for peace. Paris liberals and workers, however, saw an opportunity for genuine change, inspired by socialist theories and exploiting the vacuum caused by the parliament's exile at Bordeaux and the flight of residents with the means to avoid the Prussian siege. They elected a Paris Commune and declared a Marxist state, enraging the official government, which had moved to Versailles – a place charged with obvious symbolism. It controlled the army, and assigned the royalist Maréchal Patrice de Mac-Mahon to retake the city. He did so, making thousands more victims than the total killed by Prussians. The Communards in turn destroyed buildings and tore up cobblestones for barricades (p. 170). They burned the Tuileries Palace, another symbol of royalty, which once enclosed the Louvre. Manet returned as the rebellion's final days, The Bloody Week, unfolded. Profoundly shocked and depressed by what he saw, he was well aware that history was being repeated. *Civil War* alludes directly to two famous predecessors: the first by Eugène Delacroix, whose *Liberty Leading the People* (Fig. a) celebrates the consensus

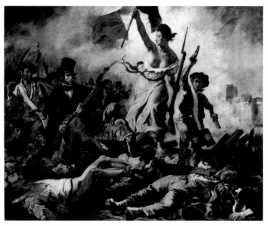

|Fig. a| Eugène Delacroix, *28 July: Liberty Leading the People*, 1831
Musée du Louvre, Paris

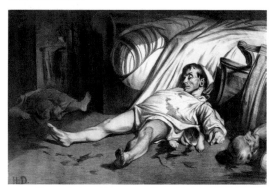

|Fig. b| Honoré Daumier, *Rue Transnonain, 15 April 1834*, Bibliothèque nationale de France, Département des Estampes et de la Photographie, Paris

underlying the July 1830 revolution; the second by Honoré Daumier, who ruefully recorded the massacre of innocent civilians by the new monarchy's soldiers in 1834 (Fig. b). The latter put an end to any illusions of national unity the former might have optimistically implied. Manet's victim lies with his right arm still clutching a white banner of surrender, which was unable save him from the ruthless vengeance of the Versaillais troops. As in Daumier's lithograph, bodies lying partly within the picture suggest countless others beyond it. And following Daumier's example, Manet echoed figures in Delacroix's foreground who gave their lives for political change but were later disinherited. Daumier and Manet understood that class conflict and contempt were at the root of dehumanising violence. The wine barrel next to the body was material for the barricade and supplied what many believed necessary to give the rebels courage. Alcoholism was considered an attribute of the lower classes and was used to explain social protest without taking other factors seriously.

Like his *Execution of Emperor Maximilian* (p. 167), Manet's *Civil War* was censored. It was published three years later, when discontent with Mac-Mahon's government had

grown enough to allow sympathy for the Commune's victims. It may have been aided by ambiguity, too. Unlike *Rue Transnonain* and his own *Maximilian*, *Civil War* avoids pointed accusation by bearing no specific date or portrait. Nor is its central figure a worker: he wears a military cap and a uniform rendered indistinct by rapid execution. He is probably a civilian national guardsman, like the figure lying to the right in Delacroix's foreground in reverse (*Civil War* being a print). This militia often stood with the people against the aristocrat-led professional army and had vigorously defended Paris against the Prussians while the army was being defeated in Lorraine. Lying at a barricade he was certainly defending, with the support of the nearby victim in civilian trousers, the guardsman's corpse has been abandoned, his destiny an anonymous mass grave.

Claude Monet

|Fig. a| Anonymous, Photograph of the ruins in the Rue de Rivoli after the Commune, 1872

|Fig. b| Anonymous, Photograph of a collapsed bridge, 1870

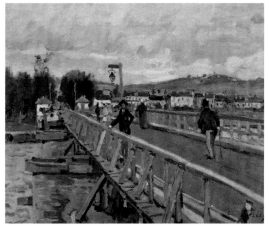

|Fig. c| Alfred Sisley, *The Footbridge at Argenteuil*, 1872
Musée d'Orsay, Paris

Economic Stimulus Plan

Not all self-inflicted destruction in France was the result of the Paris Commune (Fig. a). In order to slow or prevent the Prussian advance on Paris, the French themselves blew up bridges in order to deny the enemy access (Fig. b). Monet had spent his time in London during these conflicts. When he settled in Argenteuil in December 1871 one of the first scenes he encountered would have been the reconstruction of the road bridge.

Economic recovery was an important national preoccupation as well as a distraction from the humiliating defeat of 1870 and the civil war that had ensued. It was also an important element of rhetoric, with consequences for art, which artists sought to revolutionise as much as politics. In *Les Merveilles de l'industrie* (1873–6) Louis Figuier predicted that, in spite of being defeated by the Prussians, 'a people whose industry is flourishing can serenely anticipate that the future will bring about their moral vindication'. The engineer Paul Poiré wrote in *La France industrielle* (1873):

'If France today, still under the shock of the terrible blows it received [from the Prussians], can look to its future without too much worry ... it is because her people, with their exquisite taste and their free inventive spirit, truly possess the industrial genius.'

His implication was that French talent in artistic taste and creativity would carry over into industry.

Monet's modern landscapes – images of trains, modern infrastructure and even occasional workers – fit directly into this rhetoric. On the one hand, the rebuilding of a bridge recalls its destruction; but it also looks ahead to recovery, especially since a temporary span is already in place and open to traffic (Fig. c) – an omnibus coach and pedestrians are crossing over. The specificity of the scene, Argenteuil at a precise point in history rather than viewed through activities that characterise it generally, corresponds to the Impressionist commitment to documenting contemporary life by preserving the individual moment. It also shows the industriousness and complexity of reconstruction, which seems rendered in relative objectivity without excessive celebration through bright colour.

Reconstruction of the Argenteuil Highway Bridge, 1872

oil on canvas, 54 x 73 cm, Fondation Rau pour le Tiers-Monde, Zurich

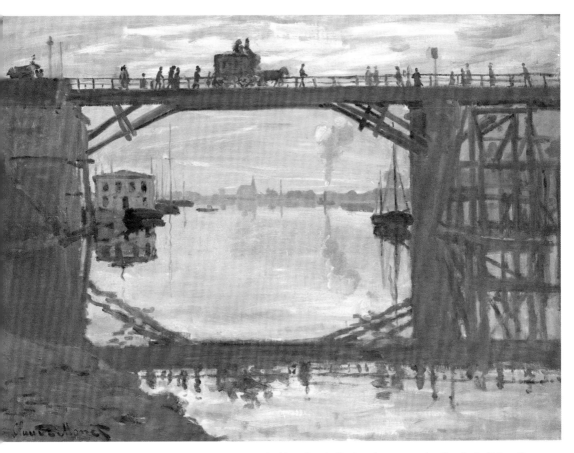

The picture is executed with a sketch-like freedom approximating that of Monet's *Impression, Sunrise* (p. 33) and *Railway Yards at Argenteuil Station* (p. 154). It has been a somewhat cloudy day, and there are long shadows at sunset. But these may also suggest the end of a gruelling experience and the new dawn on its way. The calm water affords a beautiful reflection, enhancing the picture's symmetry and balance, producing a beneficent sense of peace and tranquillity. It is a reassuring and optimistic image, implying a look forwards to normality re-established after traumas of an earlier time. One's only afterthought might be that Monet was not really working from direct experience of that past, since he was far away in London while those disasters were taking place. And yet might that not be a significant point, too? That is, as a painter working solely from direct observation, without the depressing baggage of violence such as Édouard Manet had witnessed on his return, Monet was able to produce a more optimistic vision of the future.

Edgar Degas

Gone Missing

Ludovic Napoléon Lepic was a watercolourist and printmaker whom Degas introduced to the Impressionists and who exhibited with them once. He was also a dog breeder and the father of two daughters, with whom he is wandering, seemingly absent-mindedly, in Paris's most splendid public space. The glorious Champs-Élysées, the world's most famous avenue, is to the viewer's back. The Tuileries Garden and, to the left, the entrance to the Rue de Rivoli form the picture's background. The viscount chomps on his cheroot, his umbrella jauntily clamped under his left arm. With the right arm at his side he must be holding his prize greyhound's leash while his daughters look the other way. Degas was no lover of children, and his interest in physiognomy (p. 52 and p. 130) led him to compare their features to the dog's.

The composition cuts off the figures' footing, as if they are floating across the picture. (In fact, the bottom was cut down further, but it is not known when.) The passer-by at the left, looking towards the group, is a framing element. The whole repeats the cropping pattern of *A Carriage at the Races* (p. 65), done at roughly the same time. The effect suggests the passing glance of the *flâneur* and the accidents of photography's movable viewfinder. The obviousness with which these devices were deployed, however, makes clear that they were deliberate.

Degas is said to have bragged that 'a picture requires as much cunning and vice as the commission of a crime'. Omission can be a criminal act as well, but since in art absences are the result of choice, in this case they were a political act. The Place de la Concorde was built to honour Louis XV, after whom it was first named. It was later at the centre of revolutionary politics when, after removing the king's statue, public festivals were organised and executions by guillotine were held. It was redesigned under the July Monarchy, when an obelisk, a gift from Egypt, was placed at its centre, inevitably suggesting France's colonial conquests. The design

|Fig. a| Anonymous, Photograph taken in the 1870s of the Strasbourg statue with wreaths

Vicomte Lepic and his Daughters (Place de la Concorde), 1875

oil on canvas, 78.4 x 117.5 cm, The State Hermitage Museum, St Petersburg

of the Place commemorated the unification of France as a single nation from its main provinces via statues of their capital cities, such as Nantes for Brittany and Strasbourg for Alsace.

It happens that Vicomte Lepic's hat blocks out the statue of Strasbourg. Alsace had been ceded, along with part of Lorraine, to the Prussians following the French defeat. The spot of red on the breast of Lepic's coat is probably a *cocarde*, a patriotic ribbon. Lepic, whose middle name was Napoléon, was an avowed Bonapartist. The picture alludes to the Third Republic's cession of France's eastern provinces in a treaty many regarded as cowardly and far too generous. The hidden, hence absent statue was a site of mourning and protest, as well as flowers and wreaths (Fig. a). To show them in an ostensibly innocent picture of family *flâneurs* would have been too obvious. Degas's game, both political and artistic, was subterfuge, of which this painting is a fine example.

Claude Monet

Compromise Flagging

The biggest hits at the fourth Impressionist exhibition (1879) were Monet's bright and patriotic pictures of the Festival of the Republic. In *Rue Saint-Denis*, he included the words 'Vive la France', making them seem like a banner suspended across the street, though without visible signs of support. Among the many flags, one in particular stands out against the sky in the upper centre, as if to tell the story by itself. More integrated to the cacophonous colour clashes of the foreground, a large one, nearest to the viewer, has 'Vive la Rep …' in yellow lettering. Boutiques festooned with red bunting and a tricolour parasol probably indicate businesses profiting from public enthusiasm. The street throngs with men in bourgeois black, painted with the kind of energy that conveys movement and excitement. The Rue Saint-Denis was a commercial street in a central, working-class neighbourhood. It would have been important for the Third Republic to target such areas in its effort to appear inclusive. In 1876, Republicans gained a majority in the parliament. They represented liberal and democratic principles in contrast to monarchists, Bonapartists and the Church. Yet the royalist Patrice de Mac-Mahon retained his presidency. The choice of 30 June for a Fête de la Paix (Peace Festival) was a compromise meant to avoid 14 July, which marked the storming of the Bastille and the bloody beginnings of Revolution.

|Fig. a| Édouard Manet, *Rue Mosnier with Flags*, 1878
The J. Paul Getty Museum, Malibu, CA

Not all artists appeared so enthusiastic about the festival as Monet. Édouard Manet in particular was a diehard republican. Through his lawyer brother Gustave, who was directly involved in politics, the painter became a close friend of Léon Gambetta, the Republican Party leader, who advocated Bastille Day. Confirmed republicans like Manet's friends wanted the French National Day to be 14 July – which it now is – in celebration of the Bastille. They were forced to compromise on the arbitrary date of 30 June, which coincided with the closing of France's third Exposition Universelle. (14 July was re-established in 1880.) So Manet's painting, by contrast, implies that he stayed home. His studio on the Rue de Saint-Pétersbourg looked down the Rue Mosnier (now the Rue de Berne; Fig. a) at considerable distance from the festive city centre. It was a newly paved residential street, next to the railway yards behind the fence to the left, where a passing train has left a cloud of vapour. It was isolated even within its own neighbourhood but, as the ladder indicates, city workers had mounted flags even there. In Manet's view, however, the flags are almost incidental; and that was surely his point. For there is far more emphasis in the foreground on a one-legged man on crutches who will never make it to the main event or, for that matter, ever be able to climb a ladder. Presumably a victim of foreign campaigns or civil war, he is Manet's cynical reminder of the costs of past regimes, and a typically Manetesque riposte to Monet's optimistic celebration.

Rue Saint-Denis, Festival of 30 June 1878, 1878

oil on canvas, 81 x 50 cm, Musée des Beaux-Arts, Rouen

Armand Guillaumin

|Fig. a| Hippolyte Collard, *The Pont de Grenelle from Below*, 1874, Bibliothèque nationale de France, Département des Estampes et de la Photographie, Paris

|Fig. b| Philippe Benoist, *View of the Hôtel de Ville, Église Saint-Gervais and Pont d'Arcole*, 1863

Bigger, Faster, Wider

Momentum for urban renovation grew during the Second Empire and continued under the Third Republic, especially since the depressed economies of the 1870s required sustained investment and improved efficiency. Renewing the bridges over the Seine and the embankments along the river were as important to the efficient flow of Paris commerce as were widened streets and new boulevards. Long before John Maynard Keynes, governments understood the value of public works as an economic stimulus. For Guillaumin, who lived along the Seine at Quai d'Anjou, on the Île Saint-Louis, many renovation projects were taking place practically next door. With his penchant for rendering industry and workers, activities along the river were part of the everyday life he wanted to paint. Art for him was not limited to scenes of pleasure; indeed, he was the sole Impressionist who rarely represented the bourgeois. Framed by a modern gas lamp to the right and with the single span of the Pont d'Arcole in the background, Guillaumin's picture shows the efficient organisation and team effort required to dredge the Seine and build up its embankment. Carts and loaders are lined up and work in unison to redistribute and haul away the silt.

The Pont d'Arcole was built in 1854–5 under Haussmann. It exemplified the daring use of cast-iron beams. So dramatic was this feat of engineering that Hippolyte Collard made photographs of it and similar bridges from their undersides (Fig. a). Guillaumin, by contrast, had no interest in visual dramatics. His fascination with labour was enough. However, images of the Paris renovations were widespread in visual culture (Fig. b), and like those painters inspired by fashion illustrations or Japanese prints, Guillaumin introduced new themes and perspectives that coincided with his more unusual interests.

France was in part driven by its rivalry with Great Britain. Defeated by Germany, it could at least claim the mantle of consumerism and creativity in the arts and industry. Great Britain may have invented the train, but France claimed the invention of photography through Louis Daguerre's registry of his device in 1839 and his gift of its patent to the nation. Government commissions for photo albums were the means through which infrastructure improvements were most publicised. In 1859 the government opened a Salon of Photography, adjacent to that for fine arts but with a separate entrance.

The Pont d'Arcole from the Quai de l'Hôtel de Ville, c. 1878

oil on canvas, 59.2 x 72.5 cm, Musée du Petit Palais, Geneva

Seen in these contexts Guillaumin's picture of the Pont d'Arcole viewed from the Hôtel de Ville embankment cannot be too surprising, even though few other artists brought their easels to such places, given the location of their studios in northern Paris and their interest in other aspects of modernity. Without Guillaumin's efforts, this aspect of everyday Parisian life would have been entirely absent from Impressionism. Perhaps he felt a responsibility to include them, even though his choice seemed to go against the grain. While it surely affected his sales and reputation, it certainly freed him to experiment with colour in ways still not fully appreciated (p. 344).

Edgar Degas

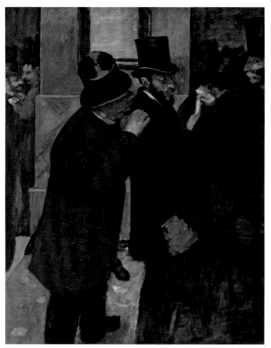

|Fig. a| Edgar Degas, *Portraits at the Stock Exchange*, c. 1878–9
Musée d'Orsay, Paris

Business as Usual

Degas's uncle Michel Musson examines a cotton sample in the foreground. His partners, James Prestidge (seated on the high stool unwrapping a package) and John Livaudais (to the right, checking the ledger), are present with Degas's two brothers, Achille (leaning against the window to the left) and René (reading the newspaper in the middle ground). Degas had crossed the ocean to visit them. Note that the brothers seem idle, distant and indifferent, while the partners are engaged in productive activity. Degas senior had sent his two sons to help in the New Orleans company, in which the family bank had a considerable stake. But like the young aristocrats they claimed to be, they seem to have found work distasteful. It was Edgar who changed his family's aristocratic De Gas in order to appear more common, and whose calling made him a workaholic, as long as his labour was an expression of the higher enterprise of art.

In the end, the cotton business engulfed a good deal of the Degas fortune, as banks and businesses collapsed all over Europe and the United States. Looking always for scapegoats, many blamed the disaster on the Jews.

Degas's *Portraits at the Stock Exchange* (Fig. a) seems, like the *Cotton Office*, to be another place of business, but like the *Cotton Office* it was filled with commentary, in this case more troubling. On this occasion, as on others, Degas the 'physiognomist' seemed to relish the long-nosed profile of the Jewish stereotype. In *Stock Exchange*, a man whispers conspiratorially into the long ear of stockbroker Ernest May. Another hook-nosed figure is at the edge to the far left. Stereotypes of Jews in finance were common, as in Émile Zola's novel *L'Argent* (1890–1), in which he confronted them for the first time. Were it not for historical evidence and the eyeglasses, one could hardly distinguish May's profile from the one Degas gave his boyhood friend Halévy (Fig. b). Degas's rabid anti-Semitism emerged only during the Dreyfus Affair at the very end of the century, when he distanced himself from his old chum. Before then, one could pass off his attitude as stereotyping, since he had numerous Jewish acquaintances and patrons whose money he didn't mind taking. And, as demonstrated by *Cotton Office*, Degas didn't mind reflecting negatively on his own family, either.

Although Degas needed no money until the collapse of his late father's bank soon after the beginning of the so-called Long

|Fig. b| Edgar Degas, *Ludovic Halévy finds Mme Cardinal in her Dressing Room*, 1876–7, Staatsgalerie Stuttgart

Portraits in a Cotton Office, New Orleans, 1873

oil on canvas, 74 x 92 cm, Musée des Beaux-Arts, Pau

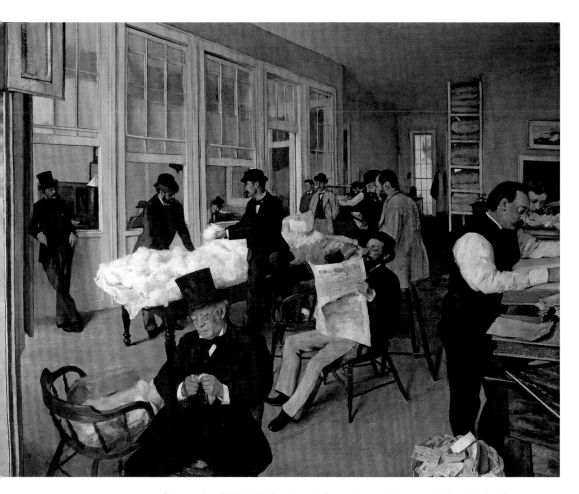

Depression (1873–96), he shared the modern entrepreneurial spirit of colleagues like Claude Monet and Pierre-Auguste Renoir. *Portraits in a Cotton Office* was in fact conceived with the idea of a sale. The picture's optically arresting perspective, and amusingly appropriate details, such as the basket filled with discarded envelopes in the foreground and the open cabinet door at the upper left, would seem to appeal in their modernity to a certain British collector he had targeted. When that scheme failed to materialise, Degas's school pal, the copper tubing manufacturer Henri Rouart (whose son married Julie, the daughter of Berthe Morisot and Eugène Manet), convinced the progressive Pyrenees resort town of Pau, where he summered, to acquire it for its newly founded museum. It was the first Impressionist painting to enter a public collection.

Berthe Morisot

|Fig. a| Berthe Morisot, *Eugène Manet and his Daughter at Bougival*, 1881, private collection

A Worker Views Another

Professional wet nurse Angèle breastfeeds Julie Manet, daughter of Berthe Morisot and her husband Eugène Manet (p. 84), in the garden of the couple's home. It was common for bourgeois women to delegate this inconvenient service, and wet nursing was a growing profession. Most of its practitioners were girls from the countryside, whose recent motherhood left them laden with milk plentiful enough for more than one but who were led by economic necessity to prefer someone else's infant to their own.

How the complex relationship between mother, child and wet nurse is expressed in Morisot's picture is at the heart of its pictorial character. Women of Morisot's class traditionally hired outside help, as did the Valpinçons in Degas's *A Carriage at the Races* (p. 65). But to the sensitive mother whose bond to the child is obviously physical, giving baby up to another's nurturing could lead to conflicting feelings, since in the early stages a mother's own tumid breasts are telling her the situation is unnatural.

It has been suggested that Morisot's mixed feelings are conveyed through brushstrokes that make plain her viewpoint. Compensating for the guilt one must assume is unconsciously driving her, she displays herself as a working woman through evidence on the canvas surface. The picture's manual production is undisguised by blending or glazing that would cover up its gestural traces. Hence labour, rather than class tradition, necessitated the exchange. One should also note that this was a private image, like those of her husband tending to Julie (Fig. a), which are equally freely painted.

Many Impressionist paintings reveal similar techniques, of course, although Morisot's are among those most loosely painted. Yet in many cases the public reaction was that the pictures were not laboured *enough* since they were not brought to a fully sheeny finish. There is ambiguity in Impressionist paintings between reading them as expressions of manual process – denigrated by conservative critics who felt such evidence should be suppressed – and those who believed them celebrations of individuality and spontaneity, hence more authentic than work laboured over by academics. This apparent contradiction of opinion is more the result of duality than conflict. The paintings harbour both the display of labour and spontaneity, and therefore embody the modern economic value system in which labour and innovation are allied.

For others, Morisot's technique expressed her femininity. Its delicacy and high-keyed colours recalled pastels and 18th-century painting,

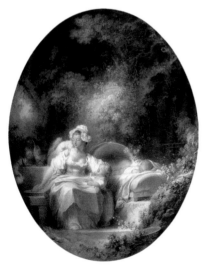

|Fig. b| Jean-Honoré Fragonard, *The Good Mother*, c. 1773
Private collection

typically associated with women. For example, the rococo painter François Boucher (p. 224) worked not for King Louis xv but for his official mistress, Madame de Pompadour. He and Jean-Honoré Fragonard often painted children (Fig. b). For some, Morisot's qualities were characteristic of all Impressionists, of whom Morisot could therefore be considered the best representative. Ironic or not, such opinions signify that she was mainstream within Impressionism, even though her sex limited choices of subject matter and travel. She in fact exhibited at all the Impressionist exhibitions except for 1879, when she was pregnant. Only Camille Pissarro exhibited at all eight.

Camille Pissarro

|Fig. a| Armand Guillaumin, *The Pont Louis-Philippe*, 1875
National Gallery of Art, Washington, DC

House of Hygiene

A bit like works by Armand Guillaumin, but with a far more rural flavour, Pissarro's paintings often show figures from the lower rungs of society. In this picture a washerwoman, standing pensively on a dull winter day, anchors the composition at the left. She seems to be waiting her turn at the crowded country wash house at the picture's centre. In the foreground are piles of sand, probably dredged from the river's bottom (p. 146). That is probably the activity of the men on the boat just above the wash house. In the background are buildings and a factory with barges moored at Port-Marly. The location was around the bend in the river from Bougival, where La Grenouillère was located (p. 272).

Concern for health and hygiene grew in the 19th century. Paris's renowned sewer system was part of Haussmann's project. Wash houses and their workers became serious subjects, in both the city and the country. In prior centuries, laundresses were often represented as young girls, whose lower status and exposed limbs were the stuff of rococo fantasies. With medical science and the elimination of gutters that sent sewage running down the middle of alleys, cleanliness became a sign of the superior knowledge and propriety of a bourgeois city. Wash houses floated on the Seine, where public swimming pools have now taken their places. They can be seen in the background of various Paris views, including Claude Monet's *Garden of the Princess, Louvre* (p. 89). Guillaumin's picture of the Pont Louis-Philippe is more about a wash house than about the bridge (Fig. a). His floating constructions seem not yet permanently installed, since a woman must access the structure on a flimsy plank.

One of the most remarkable aspects of Pissarro's work is its social inclusiveness. For him, the mixing of classes where it occurred was worth illustrating, even if his interest was primarily in the landscape.

In another picture from the Port-Marly group painted in autumn 1871 to winter 1872 (Fig. b), he shows a steam barge chugging up the river against the current, workers on another barge to the left, a fisherman in the foreground no doubt

|Fig. b| Camille Pissarro, *The Seine at Port-Marly*, 1871–2
Private collection, Switzerland

The Seine at Port-Marly, the Wash House, 1872

oil on canvas, 46.5 x 56 cm, Musée d'Orsay, Paris

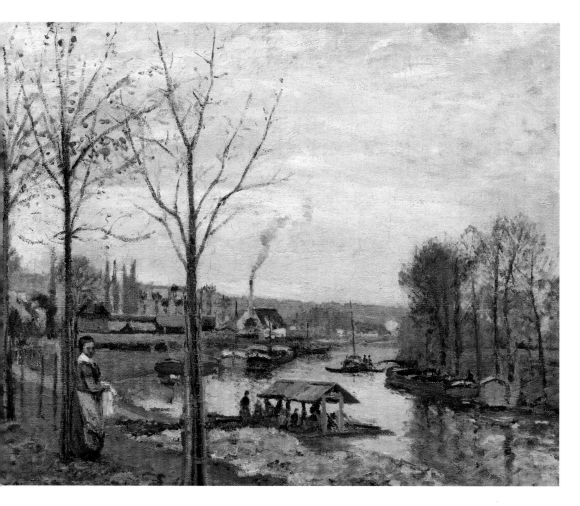

expecting to catch his supper, and a bourgeois couple strolling along what, judging by the horses in the background, may double as a towpath. The vantage point is from the same side of the river but the other side of town and closer to it than the *Wash House*. The mixture of activities and classes was typical of the overlap of expanding industry, bourgeois leisure and on-going traditions of the countryside. Le Port-Marly exemplified this phenomenon (p. 144), to which Pissarro was probably attracted for personal as well as artistic reasons. As a Jew born on a Danish island in the Caribbean who married his family's Catholic maid, Pissarro was anything but typical. An inclusive, democratic society such as was emerging in France might be a place where he could feel at home.

Camille Pissarro

Making Hay while the Sun Shines

Pissarro's penchant for rural life and labour placed him closer than his Impressionist colleagues to the Barbizon School. Yet, unlike the latter's, his imagery was not overtly nostalgic, and it could even be political. *Harvest at Montfoucault* was painted while Pissarro was on one of his annual trips to visit Ludovic Piette, a gentleman farmer from a family of notables and an amateur painter who exhibited briefly with the Impressionists. Montfoucault was several hours from Pontoise, the smallholding market town in which Pissarro was living. It was in the French 'breadbasket' region of Mayenne, where sunny weather and rolling plains facilitated growing wheat in quantity.

At the hamlet of Hermitage, next to Pontoise, Pissarro complained of lack of models. Farms were smaller and more private. By contrast, as the guest of the local squire in Montfoucault, he probably felt authorised to study workers more closely than at home where they were neighbours. He made many drawings of individuals engaged in various tasks as well as landscapes. He exhibited *Harvest at Montfoucault* at the third Impressionist exhibition in 1877.

The figure in the foreground poses matter-of-factly, as if she has briefly paused in her work, carrying a bunch of wheat under her left arm. Behind her to the left, several other workers continue undisturbed. The stacks are formed by leaning harvested sheaves against one another and gradually expanding the structure until it is sufficiently stable. This unfinished stack is then covered by bunches radiating out from the centre on a slant to act as a kind of roof, draining away rain so that the insides will not rot. Pissarro's point, unlike so many images of finished grainstacks, is to show the work in progress.

With its team of workers, the farm at Montfoucault is clearly a large operation. Piette even owned a threshing machine. Although agricultural labour was an age-old occupation, and the grainstack forms were the result of wisdom gained over centuries, Pissarro's paintings eschew the conservative aura of Barbizon painting. For example, although well aware of Jean-François Millet, called the 'rustic Michelangelo' by admiring

|Fig. a| Jean-François Millet, *Going to Work*, 1851–3
Cincinnati Art Museum, OH

|Fig. b| Camille Pissarro, *Poultry Market at Pontoise*, 1882
Private collection

POLITICS AND SOCIETY

Harvest at Montfoucault, 1876

oil on canvas, 65 x 93 cm, Musée d'Orsay, Paris

contemporaries, Pissarro was wary of the moralising overtones of pictures such as *Going to Work* (Fig. a), which was modelled on Masaccio's painting *The Expulsion from Paradise*. He hated sentimentality and found Millet too 'biblical', wryly remarking that 'For a Hebrew, there's not much of that in me' – that is, he had little use for religion. In contrast to field labourers at Montfoucault, Pissarro was able to sketch in Pontoise on market days, when he could get close to people, his anonymity protected by the bustling of the crowd. As a sort of country *flâneur* he achieved a group of remarkable paintings full of figures, some of whom are closely characterised (Fig. b). With their cutting-off effects and complex technique, they were surely done in emulation of Degas, but with rural themes. Pissarro was always interested in new and different ways of looking, and for this group he put the small market town of Pontoise to his advantage.

Camille Pissarro

Comrades in Arms and Art

Few friendships among the Impressionists were closer than between Pissarro, Paul Cézanne and Armand Guillaumin, whose visions of modernity were less pleasure-oriented than their cohorts Claude Monet and Pierre-Auguste Renoir. In the early years of their relationship the trio was joined by Dr Paul Gachet, a specialist in homeopathy and nervous disorders who also painted. He encouraged his friends to use his etching press at Auvers-sur-Oise and purchased a number of their works, most of which are now at the Musée d'Orsay.

Dressed as a rustic in a scarf and winter coat, Cézanne sports a beard that echoes that of Gustave Courbet, who is shown in the background as a caricature with his palette and a raised glass of beer. Cézanne is set against three images which, as in Édouard Manet's *Émile Zola* (p. 41), provide a commentary. To the lower right is a landscape by Pissarro himself, a sign of pictorial exchange or collaboration, like the presence of Guillaumin's *The Seine, Rainy Weather* (p. 99) as the background to Cézanne's self-portrait (Fig. a) done around the same time. Cézanne's collaboration with Pissarro was particularly fruitful, and it is generally understood that as the oldest of the three, Pissarro was a mentor to him. He certainly helped Cézanne's conversion from figure painting to landscape and still life for the majority of his future works.

The cartoon to the left shows Adolphe Thiers, President of the Third Republic after Napoleon III's abdication, handing over sacks of gold to Prussia. It implied that France was sold out by moneyed interests in a rush to get back to business as usual. Pissarro's politics were leftist, and although he, like Monet, sat out the conflicts in London, he had strong political opinions. Like the anarchist he was, he favoured internationalism.

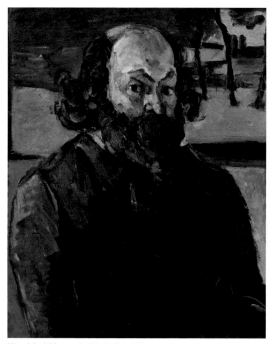

The first background image a viewer would have noticed would have been Courbet's, whose association with the anarchist Pierre-Joseph Proudhon was well known. The famed militant Realist painter was in exile in Switzerland after being released from prison for participation in the Commune. He was still menaced by heavy fines, which he avoided by fleeing France. Sympathy for Courbet was therefore a political as well as aesthetic attitude, but the latter was no less important. Courbet's handling of paint had been perceived as coarse and rustic, like the labour of an artisan or worker rather than a sophisticated artist. For those critics who opposed challenges to authority both pictorial and political, the Impressionists were at once Realists and communists.

Monet and Renoir, but especially Pissarro and Cézanne, looked to Courbet in their early years. Both understood

|Fig. a| Paul Cézanne, *Self-Portrait*, c. 1875
Musée d'Orsay, Paris

Portrait of Paul Cézanne, 1874

oil on canvas, 73 x 59.7 cm, private collection, London

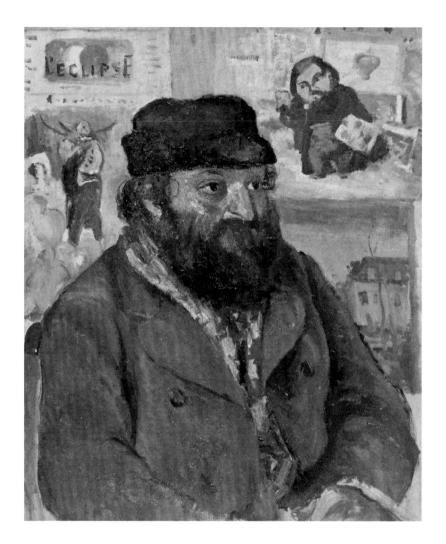

how their predecessor seemed literally to ground his vision in a process that combined physical and perceptual effort. Until the Commune made it inopportune to refer to the proletariat, Zola and others had called the new artists 'workers'. For Zola, Pissarro in particular was an 'honest man', a 'worker' and 'a true painter'. Pissarro himself had anarchist leanings and regarded the Impressionist organisation as a kind of worker cooperative. In this portrait, then, he displays not only his solidarity with Cézanne, but with Realism and its utopian, at times collectivist ideals.

Georges Seurat

Seize the Moment

Seurat's first formally exhibited painting was *Bathers at Asnières*, which he showed at the inaugural Société des Artistes Indépendants exhibition in a post office across from the Louvre after it was rejected by the Salon of 1884. The show was an alternative to the Impressionists, who seemed to have been taken over by fancy art dealers. Georges Petit in particular, Paul Durand-Ruel's most serious rival, was showing some Impressionist pictures in his Exposition Internationale, and the Impressionists had not had a group exhibition since 1882.

The new group joined by Seurat represented artists with progressive politics and reformist ideas on art. Seurat himself came from a professional family, his father a prosperous engineer. It was natural for someone with his background to choose the Academy for artistic training. His discovery of Impressionism, however, made him realise that there was another way of painting. *Bathers at Asnières* was his first major effort to combine Impressionism and tradition.

Asnières was a popular spot for bathing and boating, and no one seemed to mind its location across the river from factories at Clichy, as seen in the background of Seurat's picture and others painted at more or less the same location (Fig. a). Workers, perhaps from those factories, are enjoying leisure on their Monday off. (In France today there are still some businesses that close on Mondays to compensate for working on Saturdays.) On Sunday, as Seurat's *La Grande Jatte* shows (p. 331), the bourgeois reigned supreme. Here, the mix is less elegant or familial.

Seurat certainly had previous Impressionist scenes of bathing in mind. For example, the clothes and straw hat of the central bather reference Édouard Manet's path-breaking *Le Déjeuner sur l'herbe* (p. 23). While Seurat retained the classical interest in volume and clear outline, he emulated Impressionist colour and a version of its technique for his luminous surfaces. His brushwork is more systematic than what one normally associates with Impressionism, yet it is not far from the developments in the brushwork of Pissarro. Both the latter and Cézanne had been experimenting with methodical, anti-spontaneous paint application, though, since Cézanne rarely exhibited, Pissarro would have been Seurat's source. It was Seurat, however, who would develop the system further into pointillism, which he used two years later. In addition, Seurat was experimenting with colour effects, as had the Impressionists with their shadows.

|Fig. a| Claude Monet, *Springtime on La Grande Jatte*, 1878
Nasjonalgalleriet, Oslo

|Fig. b| Pierre Puvis de Chavannes, *The Pleasant Land*, 1882
Musée Bonnat, Bayonne

POLITICS AND SOCIETY

Bathers at Asnières, 1884

oil on canvas, 201 x 300 cm, The National Gallery, London

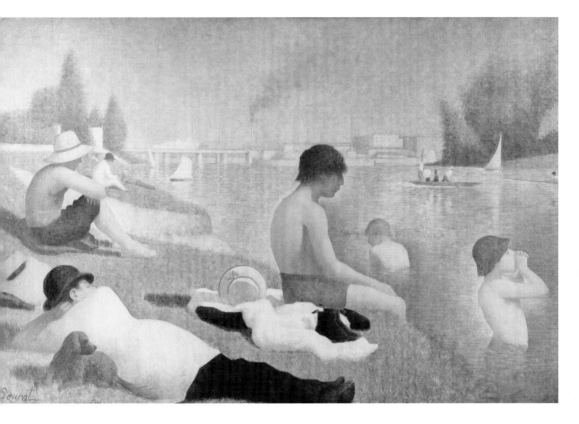

Here, too, Seurat became systematic, interspersing complementary colours with their primaries, as if he had been reading books about colour reflections by Michel-Eugène Chevreul and optics by Odgen Rood.

Seurat's simplified forms look back not only to classical art but also to the recent work of the highly praised modernist classicism developed by Pierre Puvis de Chavannes, who at the time was regarded as the master who would renew the classical tradition. His *The Pleasant Land* (Fig. b), a theme of bathing, sport and boating, like so many in Impressionism, is set in a timeless environment or perhaps Antiquity, judging by the figures' semi-nudity, draperies and statuesque poses. Puvis's simplifications would be fodder for the abstracted figures Seurat produced and the so-called primitivising forms of later artists such as Paul Gauguin and the Nabis. For Seurat, however, they afforded the look of duration or frozen time, which was another antidote to the Impressionist focus on the moment. The result was a sort of paradise in which the modern worker could relish the moment rather than see it fleeting by.

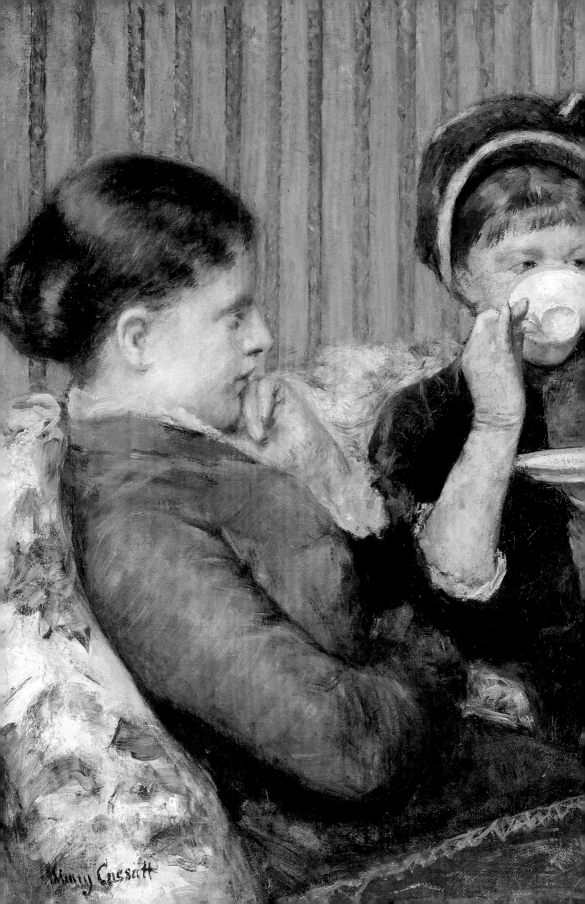

Interiors and Still Life

Paul Cézanne

|Fig. a| Willem Claesz. Heda, *Still Life with a Ham and a Roemer*, c. 1631-4, Philadelphia Museum of Art, PA

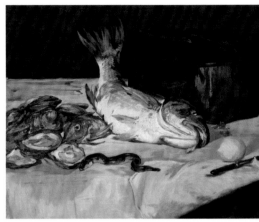

|Fig. b| Édouard Manet, *Still Life with Fish*, 1864, The Art Institute of Chicago, IL

Primal Time

Still life can be considered the most primal form of art for it begins with the artist setting up or imagining objects whose arrangements are artistic compositions even before he paints them. The double process of organising and representing thus exemplifies a convergence of realism on the one hand and the artist's creative process and control over nature on the other. In addition, still-life painting is generally a private activity: indoors and alone, Cézanne before his easel and his objects is isolated from the vicissitudes of modern life his colleagues so often sought to portray. No accidental phenomena disturb his concentration. Yet one should not forget that Cézanne was a child of the modernity from which he so often took shelter. His father's income, no matter how stingily allocated, insulated him from market demands, allowing him to practise what in the hierarchy of the subjects of art was lowest on the rung. These circumstances gave Cézanne the freedom to transform painting's humblest genre into a paradigm for the modern.

The collection of objects in *Black Clock* is unique in the history of art. It seems to embody an attempt to transfer and sublimate into pure artistic practice the ambition and angst expressed in Cézanne's figure painting of the same time (p. 26). Yet with its extraordinary seashell, like a living fossil with its voracious, red-lipped mouth and sardonic smirk, the composition hardly seems inanimate. The shell is balanced by a handless modern clock, presumably belonging to Cézanne's oldest friend Émile Zola (p. 40), for whom the painting was made. Time seems stopped and the mysterious and menacing atmosphere created by the unprecedented juxtaposition is inescapable. Given Impressionism's obsession with the moment, the picture seems like a rebuke. Contributing to the precarious effect is the composition's placement, poised at the end of a mantelpiece. The mirror above it reflects the clock, making its body seem twice its size. Only the reflection of the vase on top of the clock gives away that the

Still Life with Black Clock, c. 1870

oil on canvas, 55.2 x 74.3 cm, private collection

effect is an illusion. The teacup, glass vase and ash tray for Zola's pipe seem almost to float, because the powerful sculptural effect of the tablecloth detaches it from the background. These more everyday objects between the clock and shell evoke traditions of Dutch still life (Fig. a), half-hidden here, in which the lemon so frequently appears. But there is no question that the folds and forms of the tablecloth look directly to Édouard Manet (Fig. b). They are far more arbitrary in their arrangement and more coarsely painted in comparison with Manet's refinement, so, like Cézanne's *Achille Emperaire*'s commentary on Manet's figures (p. 49), *Still Life with Black Clock* reflects influence cum rivalry. The black gash of the bold shadow that pierces the composition at the centre is a not-so-subtle act of visual violence that Cézanne would often repeat (p. 316). Such displays of decision and power are what make Cézanne's still lifes riveting and their playfulness so rich that he produced more of them through his career than any of his cohorts. Today they are among his most highly prized creations.

Berthe Morisot

Mourning Patience

Morisot's father passed away in 1874. She and her sister, Edma Pontillon, wore black for the period of mourning, as was the custom. Édouard Manet painted a frightening picture of the devastated Berthe at the time (Fig. a); in *Interior*, Berthe's picture of her sister is more conventional but is sensitive to the situation as well. Edma's taffeta gown is fashionable but not exuberant, painted loosely in the brilliant blacks Berthe's friend and mentor Manet loved so much (p. 58). Her body, placed in the foreground, is cut off, as is the body in many pictures by Edgar Degas (p. 172). Whether Morisot painted from memory, reality or fashion prints is impossible to determine but, except for the allusion to a death in the family, the pose is of a type such prints might use. With Edma are her first daughter, Jeanne, about four years old, and her governess, perhaps a foreigner with her red hair worn in braids. The latter is well dressed for the occasion, too, but not in mourning. She and her charge stand at the window awaiting visitors to the bereaved. Morisot represents her pretty sister's expression as sad and pensive, patiently waiting for the sympathy call, which seems to have been scheduled in advance. The apartment glows in morning light coming through the muslin curtains. Its delicacy is well worthy of the tonal sensitivity of her first teacher, Jean-Baptiste-Camille Corot. The interior provides an opportunity for an artist to comment on her subject's status and taste. The chairs are simple but comfortably cushioned and are of the relatively lightweight variety one might bring out of the corners for receptions. On the other hand, the planter behind Edma is quite extraordinary, part of a carved console table unless it is actually built into the wall. Note the sculpted vase with flowers below it.

This women's world contrasts quite frankly with interiors represented by men. A good example is Claude Monet's *Breakfast* (Fig. b), from which the man is absent, but whose abandoned table setting clearly implies his point of view. Contrasting with domestic interiors in previous art, those in Impressionism are usually specific to the moment. Monet has pushed back his chair from the table and his place is indicated by the newspaper, a male attribute. The maid stands back at an open cabinet, ready to serve, but in the background. A friend dressed in

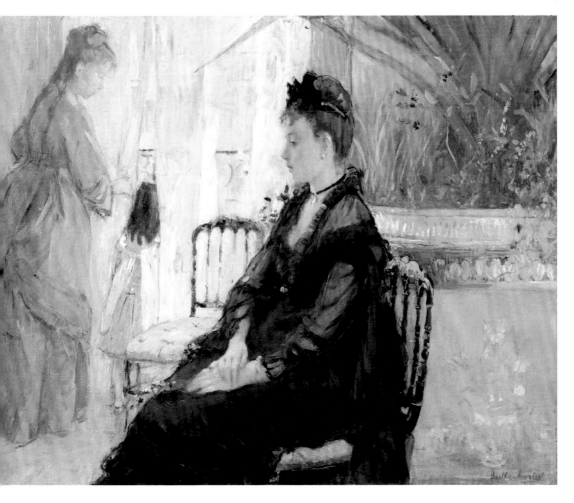

black with a veil has also stood up. It is the end of the meal, with only son Jean needing encouragement from Maman to finish. Morisot's *Interior* is similarly specific, however different the circumstances.

Manet had discouraged Morisot from exhibiting with the Impressionists in 1874, since her earlier work had been accepted by the Salon. She went against his advice, however, and exhibited in all but one of their exhibitions. In lieu of an exhibition the following year, they held an auction of their works at the Hôtel Drouot. Morisot's *Interior* fetched the highest price, going to Monet's future patron, the department store owner Ernest Hoschedé (p. 54).

Frédéric Bazille

Odalisque and Company

Fascination with and stereotypes of foreign places combine to produce exoticism, which is an attitude characteristic less of the object of the gaze than of the beholder from within his or her own society and position. Bazille is not usually associated with Pierre-Auguste Renoir, except for briefly sharing his studio with him. Yet during that time, he at least temporarily shared Renoir's interest in the Orient and the associated attitudes called Orientalism. Indeed it may well be at the same time as Renoir was posing Lise Tréhot for *A Woman of Algiers* (p. 119) that Lise posed for Bazille as lady-in-waiting to a nude studio model posing as a harem woman. An African slave, echoing those in pictures such as Eugène Delacroix's *Women of Algiers* (p. 119) and Jean-Auguste-Dominique Ingres's *Odalisque with Slave* (Fig. a), helps the model with her slippers.

Bazille's picture was intended for the Salon, as might be guessed from its large size, strong contours and high finish. Given that Renoir's accepted picture was far more loosely painted, it must have been the sensuous nudity of Bazille's model that led the jurors to reject it. Renoir's own *Diana Huntress* (Fig. b) had been rejected when he came too close to Courbet's brazen challenges to propriety. It seems as if the problem for both Renoir and Bazille when it came to the nude was lack of idealisation, for Bazille's courtesan looks like a portrait, much as Renoir's *Diana* had unabashedly identified its naked model

as an actual individual and Monet's *Le Déjeuner* showed his model Victorine (p. 23). In addition, Bazille's courtesan might have reminded jurors too much of Manet's *Olympia* (p. 219), which had been allowed into the temporarily liberalised Salon of 1865, then caused a scandal. Whereas Renoir's *Diana Huntress* was perhaps too egregiously staged, Bazille's picture calls forth

|Fig. a| Jean-Auguste-Dominique Ingres, *Odalisque with Slave*, 1839–40 Harvard Art Museums, Cambridge, MA

|Fig. b| Pierre-Auguste Renoir, *Diana Huntress*, 1867, National Gallery of Art, Washington, DC

ambiguity. Is the setting indeed a harem, or is it the artist's studio? Lise is dressed in the same sort of fashionable Parisian stripes as seen in Renoir's double portrait of her with Alfred Sisley (p. 47). Moreover, the silk robe she is preparing for the model is more of Japanese or Japanese-inspired design than North African. The oriental rug covering the back wall could be part of the decor in an artist's studio, although Bazille's space was not known for the clutter found in more established artists' ateliers. Another element of provocation relates to the significance of the action. The model seems being readied for

her master. After she has dried her following her bath, as indicated by the towel, it is hard to imagine the slave taking slippers off the model, and the second slipper is nowhere near the foot that would have worn it. It has yet to be put on. In other words, the picture implies that the harem woman will go to her master wearing only slippers and her caftan. While thus seeming to ingratiate himself with public taste and an acceptable Salon technique, Bazille subtly undermined it. Because of his unfortunate death in the Franco-Prussian War there are few examples after this work that allow one to decide whether he was ambivalent about his position, compromising or insubordinate.

Edgar Degas

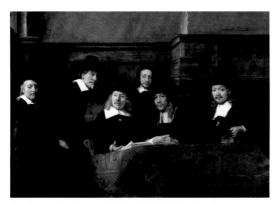

|Fig. a| Rembrandt van Rijn, *The Syndics of the Drapers' Guild*, 1662
Rijksmuseum, Amsterdam

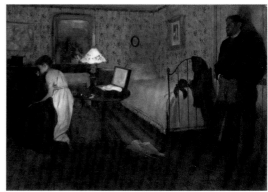

|Fig. b| Edgar Degas, *Interior: The Rape*, 1868 or 1869
Philadelphia Museum of Art, PA

How Dare You Interrupt!

A fashionably dressed young woman, presumably the harried banker's daughter, leans over towards the presumed father on the back of a chair. It is not a formal meeting; if it were she would be seated. Nor is it a welcome one, given the man's expression of avoidance. It is doubtful such postures or expressions would occur were she a client, or that she would be in his private office with the window above the shelf behind her closed for transactions. That is why when another person interrupts by entering – a *faux pas* that Degas wittily attributes to the viewer – the man cringes further and the lady barely hides her annoyance. This device, used by masters such as Rembrandt to simulate such an unexpected moment (Fig. a), was one of Degas's trademarks. It is another version of the theme of the ever-probing eye.

Ledger books are on shelves at the upper right. Below them on the wall is probably a calendar. Other than the papers and inkwell on the man's desk, the most prominent accessory is the large racing print behind him – *Steeplechase Cracks* of 1847 by the British artist J.F. Herring. It signifies the banker's prosperity and upper-class taste. Thoroughbred horse racing had come to France from England, and was available to only the rich and the gentry.

The models for Degas's picture have been identified as Edmond Duranty, whose interest in physiognomy was shared with Degas (p. 52), and Emma Daubigny, daughter of the Barbizon School landscape painter and friend of the Impressionists. Thus, *Sulking* is not a family portrait but a genre scene posing as one. Like Édouard Manet, Degas used friends for scenes of daily interactions in order to enhance the illusion of reality caught spontaneously. Yet that candid quality is what so piques the viewer's curiosity. Is she asking for money or to see an inappropriate suitor? Is that a bill or an

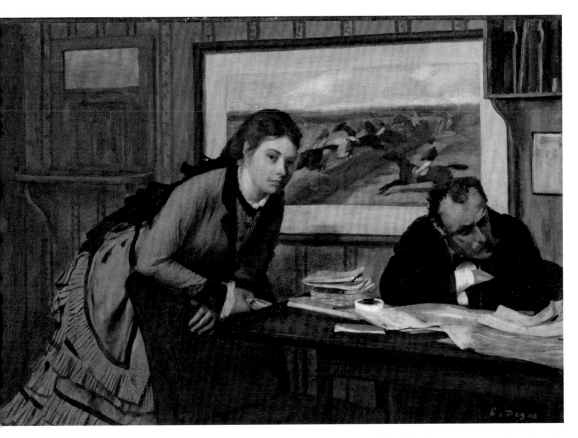

invitation in her hand? Scholars have sought to identify a literary source, so far without success. Another painting by Degas presents a similar conundrum. *The Rape* (Fig. b) really seems to contain a narrative, dramatised by the shadowy lighting and rapidly receding space. But what is the story that it tells? Is it really rape, as the usual title suggests? Is it prostitution? Does the open box with red interior stand for sex? Why else would the young girl in her undergarment turn away in shame? Her coat is on the bedrail and her hat is on the bed. Is she hesitating or undressing more? Is that a handkerchief wet with tears on the floor? Is the man a client, a lover or a father barring the door? It has been suggested that the scene bears resemblances to Émile Zola's murder novel *Thérèse Raquin*, in which case it would be a psychodrama of adultery, murder and guilt. Degas, a master of ambiguity, never let on which it might be. For that very reason, perhaps, *The Rape* was one of the pictures he treasured most.

Berthe Morisot

|Fig. a| Claude Monet, *Jean Monet in his Cradle*, 1867
National Gallery of Art, Washington, DC

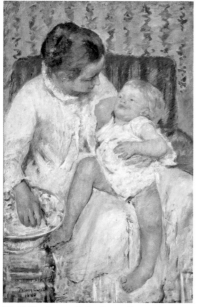

|Fig. b| Mary Cassatt, *Mother About to Wash Her Sleepy Child*, 1880, The Los Angeles County Museum of Art, CA

Cradle of Complexity

Edma Pontillon, Morisot's sister, gazes tenderly at her second child, six-month-old daughter Blanche. Morisot's delicate handling, of pinks and whites, with subtle blue-greys in the background, has few equals among Impressionist works. The baby sleeps; only the most muted pictorial means are appropriate.

Compared to the bold and brightly coloured brushstrokes of Claude Monet's picture of his son's cradle (Fig. a), Morisot's touch probably appears feminine. But true as it may be that the painting reflects what was expected of a woman in terms of technique, it also embodied the refinement and taste of her social class, as well as the quality of materials used for infants in such homes. The differences may be appropriate on other grounds as well, given the different futures for baby boys and baby girls, and nuances between the view of the proud father and the gentleness of an aunt and sister, even if tinged with ambivalence.

Normally pictures of parenthood pay equal attention to the child, as heir to the family's lineage and proof of male virility. In Morisot's *Cradle*, however, the child is virtually anonymous. The mother opens the protective net part way, shielding the baby from the outsider's view. Echoing the cradle, the curtain presses forwards, seeming to confine and compress the mother's shape. Edma had given up her artistic career when she got married (p. 82). One may wonder if Berthe's pictorial devices and the tenderness she records might not suggest those wistful memories of a once independent life.

Even if such thoughts were not on Edma's mind, they must have occurred to Berthe. She was pursuing her artistic career ever more ambitiously and was engaged in a profound artistic dialogue with the celebrated, if notorious, Édouard Manet. Yet she knew that she, too, would have to negotiate the same situation as Edma. She believed she was getting old, and marriage was inevitable. In the end, she was lucky enough to have her cake and eat it, by marrying Manet's brother Eugène, who supported her career.

This delicate image of motherhood and the artist's sensitivity to its ramifications compares to paintings by Mary Cassatt, who although never married and childless, had an amazing sympathy for the duties of child rearing. Her *Mother About to Wash Her Sleepy Child* (Fig. b) is a case study of a sincere devotion to a child's health and hygiene, as well as of the child's squirmy stretching when awakened from its slumber. Morisot's image shows motherhood as a complex affair and treats it with more psychological ambivalence. Yet in both, the seductions of the pretty innocent child are paralleled by seductions of paint. The rigorous compositional geometry and boldness of the picture's forms and devices reveal a push and pull that only another woman would be likely to understand – and only a major artist could translate into paint.

The Cradle, 1872

oil on canvas, 56 x 46 cm, Musée d'Orsay, Paris

Édouard Manet

|Fig. a| Édouard Manet, *Portrait of a Young Man (Léon Édouard Koëlla-Leenhoff)*, 1868
Museum Boijmans Van Beuningen, Rotterdam

The Human Still Life

As an image of boredom – or is it indecision? – Manet's *The Luncheon in the Studio* has few equals. One critic said it had 'little meaning'. Movement is suspended. Sportily dressed, Manet's presumed son Léon, who was also portayed in drawings by Manet (Fig. a), stretches his legs. Hat on head, will he take his leave for a stroll or is he going back to work at Degas's father's bank? Auguste Rousselin, a summer neighbour at Boulogne-sur-Mer, finishes his cigar. What can he be thinking? The atmosphere is sombre and contemplative. A servant looks out as if wondering what comes next.

The servant's coffee pot monogrammed with the family M indicates the place as Manet's. X-ray examination of the canvas shows that Manet covered up windows that would have made the studio location more explicit. To the left is a still life of helmet, sword and duelling pistol, accompanied by a black cat. Other inanimate elements of the picture are comprehensible: the Dutch-inspired arrangement of the remnants of the meal and the sectional Japanese painting on the wall are well within Manet's practice of art-historical allusions. The maid herself is reminiscent of works by Vermeer, recently rediscovered by the critic/historian Théophile Thoré-Bürger. Finally, the cat, Olympia's companion – so dear to Charles Baudelaire, Manet's friend Champfleury and Manet himself (p. 219) – was inspired by woodcuts by Hiroshige.

Many of Manet's figure paintings are accompanied by significant still lifes, as in his *Émile Zola* (p. 41). But here, rather than explicit commentary, they seem to represent themselves as studio props without further implications. Some interpretations, however, suggest that, like the cat, they allude to Baudelaire, whose funeral Manet had recently attended. Or perhaps as in Gustave Courbet's *Artist's Studio* (Fig. b) they refer to the kind of historical and romantic literary themes that the Realists had discarded. In that vein, the picture may propose a new kind of figure painting, in which the visual is more important than the narrative. Manet's earlier works, especially *Le Déjeuner sur l'herbe* (p. 23), to which this might seem an indoor sequel, engaged narrative painting through art-historical references in order to defeat it. *The Luncheon in the Studio* takes that victory for granted.

Luncheon was shown at the Salon of 1869 along with Manet's better-known *The Balcony* (p. 223). Even though the latter was painted in the studio, the two together signify Manet's movement

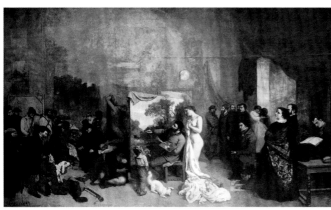

|Fig. b| Gustave Courbet, *The Artist's Studio*, 1854–5, Musée d'Orsay, Paris

The Luncheon in the Studio, 1868

oil on canvas, 118 x 154 cm, Neue Pinakothek, Munich

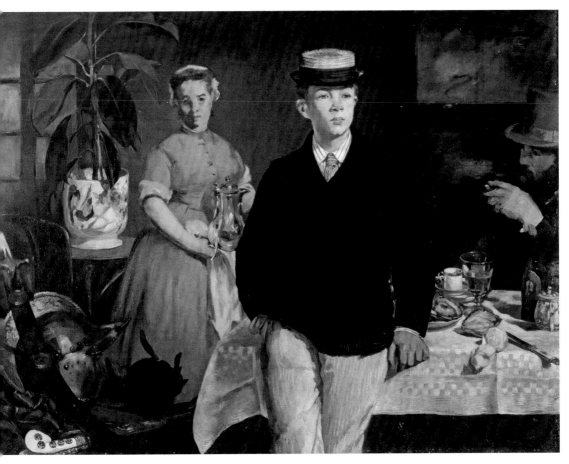

towards outdoor themes. What they share, other than the potted plant, is a static inscrutability that critics explained by comparing them to still life. Zola wrote that Manet treated figure painting without storytelling or philosophising, in the manner of still life. In 1869 this view dominated the thinking about Manet's work. One critic referring to *The Balcony* wrote:

[It would be futile to look for] the accentuation of a type, or the expression of a sentiment or idea … in this picture with no thought. Let us admit that it is about colour combinations and let us look at it as we would the wild arabesques of Persian pottery, the harmony of a bouquet, or the decorative imprint of wallpaper … His painting is no more interesting than a still life.

This statement could just as well apply to *The Luncheon*.

Gustave Caillebotte

Crystal Clear

Is Caillebotte's scene a still life of lead crystal or a family meal? Mother presides, waited on by her butler. Brother René concentrates on stabbing at his food. The painter's plate is empty, the meal is just beginning. His wine has been poured to the precise level in his massive glass. The others at the table apparently forgo its pleasures. Perhaps the bottle near Madame Caillebotte contains a fruit juice (or a laxative?). The oranges and lemons are untouched. Everything is still precisely in its place, laid out like a conscientious still life on a painter's table. A display of airless bourgeois luxury is itself a display of art. The crystal is no doubt the classic Harcourt design by Baccarat; cheaper imitations would not do in Caillebotte's world. Decanters on their fancy silver coasters, tureens, fruit dishes and knife supporters contribute to the layout. The ivory knife handle in the foreground is another sign of class. The table is a shiny, over-sized mass of precious wood, its exact shape, round or elliptical, obscured by optical distortion. The empty place to the left is where the younger brother, Martial, might have sat – or Caillebotte senior, were he still alive. The only sour note besides René's expression is his half-gnawed chunk of bread lying directly on the varnished surface.

The mealtime theme is common in Impressionism and art history. It records an everyday ritual and brings figures and objects together. For Caillebotte it allowed experimentation with the muted daylight coming through sheer muslin curtains, a variation on an effect he featured in *The Floor Scrapers* (p. 31). For other artists the main focus might have been human interaction, as in most Dutch or French genre painting. In François Boucher's *Luncheon* (1739, Musée du Louvre, Paris) the entire family, including kids, are present. At Caillebotte's house the opposite is true: a sense of absence is filled only by the tableware. A closer comparison is the Neo-Impressionist Paul Signac's image of

|Fig. a| Paul Signac, *La salle à manger, Opus 152*, 1886–7, Kröller-Müller Museum, Otterlo

INTERIORS AND STILL LIFE

bourgeois stuffiness (Fig. a), in which the pointillist technique and, as in the Caillebotte, calculated composition freeze both time and action in a parody of manners. Caillebotte's picture is less obvious than either of the other works. It might be an expression of the alienating materialism of modernity, but whether the painter so intended cannot be proven. That he was a product of its civilisation and devoted to rendering its image may be enough to make the point. His not entirely pleasant family image may not be his fault but it was a part of his experience, which he presumably rendered as he felt and saw it. Whether Caillebotte's stylistic idiosyncrasy or, to the contrary, his visual objectivity attained such authenticity will for ever remain debatable. Perhaps the answer was provided by Charles Baudelaire when he said that artists must lie in order to tell the truth. If Caillebotte's painting was a lie, its falsehood is skilfully disguised under the appearance of absolute optical veracity. And if that is idiosyncratic, then in art, truth and lie indeed converge.

Mary Cassatt

|Fig. a| Phillip Garrett, the Cassatt family tea set, c. 1813, Museum of Fine Arts, Boston, MA

Silver Lining

The viewer is seated at the tea table adjacent to two young ladies. One has finished her cup and has placed it on the tray; the other, identified as a visitor by her hat and gloves, seems to be gulping hers down quickly, as if she has to leave to catch a train. Yet her pinkie finger is held straight and proper, pointing up into the air. The scene is Cassatt's Paris drawing room, simple and uncluttered, but brightly wallpapered in fashionable stripes. It has a sculpted fireplace with a heavily gilt-framed mirror above it, which because of the picture's angled viewpoint does not significantly reflect the Chinese vase on the ledge before it. To the left, the main decorative motif is the floral-covered settee, shared by the two women.

The picture's chief feature is certainly the silver tea set (Fig. a). It is known that three pieces are marked with the initials of Cassatt's grandmother Mary Stevenson, after whom the painter was named. It therefore had special meaning to her as a very personal family heirloom. It was made in Philadelphia, which was home to several precious metal mining companies with which the Cassatts were financially involved. They had strong ties to the city, even though Cassatt was actually born in what is now part of Pittsburgh. Cassatt highlighted the centrepiece with white glints of light on the teapot and sugar bowl and their reflections on their silver support. The firmly drawn contours of the cup and saucer and the oval tray create a sense of sharper focus on the objects; most of the background and the two figures, except for their faces,

Five O'Clock Tea, c. 1880
oil on canvas, 64.8 x 92.1 cm, Museum of Fine Arts, Boston, MA

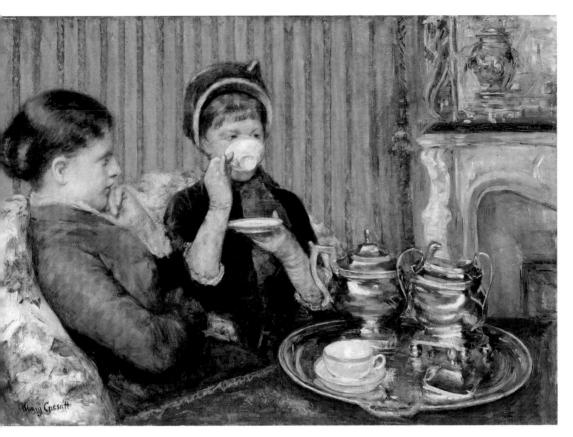

are more loosely rendered. The technique of less finished background that tends to set off the figures was often used in art, but here it might be interpreted as an element of photography's shallow depth of field. In that sense, it would be an effect of naturalism. The pouty girl to the left is surely Geneviève Mallarmé, sitting with Mary Ellison, who was visiting from Philadelphia. She had met Cassatt through Louisine Havemeyer, who with Cassatt's advice acquired a collection of Impressionist pictures that now forms the core of those at the Metropolitan Museum of Art in New York. Mallarmé and Ellison posed for Cassatt together in an opera loge around the same time (p. 122). Neither picture is dated, but Cassatt sold *Five O'Clock Tea* to Henri Rouart, the collector friend of Edgar Degas, in 1881.

Like Degas and Édouard Manet, Cassatt posed friends not for portraits *per se* but in genre scenes. Like them, too, she often left it to the viewer to imagine what was taking place. One critic found the canvas 'excellent', but another had harsh words for its central element, accusing Cassatt of cheapened realism with 'paraphernalia poorly drawn and misshapen … the wretched sugar bowl remains floating in the air like a dream'.

Camille Pissarro

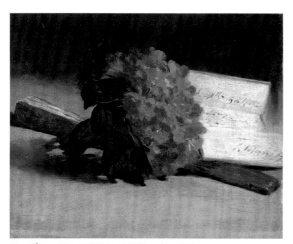

|Fig. a| Édouard Manet, *Still Life with Violets and Fan*, 1872
Private collection

|Fig. b| Paul Cézanne, *Still Life with Green Apples*, c. 1873–7
Musée d'Orsay, Paris

Simple Beauty

One of the most perfect still lifes in Impressionism, Pissarro's composition stuns by its ostensible simplicity. The geometry is clear: a round basket with a semicircular handle sits within a perfect yet natural-seeming rectangle made by the tablecloth's folds. The rosebud wallpaper's vertical stripes behind it add to the picture's feeling of rigour and stability. And yet a closer look shows variances with those symmetries that contribute to the sense of realism and life. For one thing, neither the wallpaper nor the folds across the linen are perfectly centred. The basket seems to lean forwards and to the right. It has stripes of its own that echo other verticals but those on the basket itself seem unevenly spaced. And the picture's glowing luminosity is achieved within a relatively limited palette.

The small, more or less regular squares of alternating grey and white over the off-white ground suggest a common sort of linen with a chequered weave, but the grey streak in the central section below the table edge cannot be explained except as relief to an otherwise less interesting uniformity. It also serves as a kind of frame for the basket of fruit. Within the basket the pears show a variety of colours corresponding to different stages of ripeness. They seem comparable to a palette for the colours of their surroundings. Standing or tipped in various directions, they perform an enlivening counterpoint. If the basket as a whole is slightly off centre, the protruding stem of the pear to the right seems to pull it back.

The subtle poetry of these relationships constitutes meaning within the picture.

Yet historical circumstances lie behind both the increased interest in the genre of still life and the kinds of subtleties Pissarro demonstrates. For one thing, Pissarro had trained with Jean-Baptiste-Camille Corot, who may rarely have practised still life but passed his belief in tonal unity on to his two closest followers in Impressionism, Pissarro and Berthe Morisot. More broadly, still life itself was enjoying a revival in the 1860s (p. 186), thanks to the presence of many paintings by Jean-Siméon Chardin in the La Caze collection, which many artists visited, and an exhibition at the independent Galerie Martinet,

Still Life: Pears in a Round Basket, 1872

oil on canvas, 46.2 x 55.8 cm, private collection

with which Édouard Manet was familiar, having shown there in 1862. The famous critic-novelists the Goncourt brothers were enthralled enough by what they called Chardin's 'magic' to write some of their most dithyrambic prose in their essays published as *Art of the Eighteenth Century* (1875).

Many of Manet's still lifes recalled the Dutch tradition and Chardin's understated elegance. Even when he portrayed ordinary objects, however, they were often symbolically charged (Fig. a). By contrast, Pissarro's composition of mere fruit focuses on the silent poetry of forms and colours. As such, he was part of still life's re-founding as a paradigm for modern pictorial practice. His example led Paul Cézanne, the most prolific still-life painter of the Impressionists, to forgo weighty compositions like *Still Life with Black Clock* (p. 193) and concentrate on the formal problems posed by simple objects, such as apples (Fig. b). Only in so doing could one really study the process of turning nature into art.

Édouard Manet

|Fig. a| Édouard Manet, *Peonies with Secateurs*, 1864
Musée d'Orsay, Paris

The Silent Poetry of Bouquets

It was traditional in theory of art to think of painting as silent poetry. The concept is summed up in a simple Latin phrase: *ut pictura poesis*, which means 'as is poetry, so is art'. Parallels between painting, poetry and music were made throughout Manet's time, with analogies between colours and sounds especially common late in the century, leading to the concept of synaesthesia. In a poem called *Correspondances*, Charles Baudelaire gave such notions spiritual overtones by calling nature a temple whose pillars (i.e. natural forms) speak a silent language the soul can understand without words.

Manet rarely painted flowers until late in his career, when he was ill with syphilis and, like his father, was sure to die. One exception was 1864, when he did a group of peonies, one of which showed them in a vase, another freshly cut and juxtaposed with secateurs (Fig. a). Together the pair suggests a parallel between art and the making of bouquets, the latter a pleasing arrangement of brightly coloured natural forms, like Impressionist art. There were even those, like Pierre-Auguste Renoir, who believed flower painting was not simply for women, as was most often thought the case in their time, but that it was a beneficial exercise for any painter. Henri Fantin-Latour, referring to his flower paintings, stated '… if one can paint [flowers] faithfully … one can paint the universe'. Yet most Impressionist flower still lifes are lush and full, like Edgar Degas's *Woman with Chrysanthemums* (p. 64) or Renoir's extraordinary *Flowers in the Greenhouse* (Fig. b). By comparison, Manet's are as ostensibly simple, yet equally subtle, as a single line of poetry by Mallarmé.

Sometimes flower paintings like Renoir's were demonstration pieces; sometimes they were commissioned to decorate a private home. Although most of Manet's large still lifes were done to be sold – their neutral subject matter giving less offence than his controversial figures – his flower pieces were mostly in small format. Manet often gave these away. When bedridden, he would make them based on flowers brought from his garden or by his friends. Such little pictures were tokens of his love and appreciation, images that preserved the cut flower otherwise destined like him to wilt and fade.

Few flower paintings in art are executed with the delicacy, skill and refinement of Manet's late flower pieces. In offering them to his friends it was not only to reciprocate their friendship and gifts, but as if he left them something of himself. These are not conventional bouquets in large bunches or ornate bowls. The crystal vase is as pure as the fresh colour of the paint, the flowers as unpretentious as if a child had picked them. And yet, because of Manet's circumstances, the feeling they convey could not be more profound. When the simplest pictures speak so eloquently, words can do no more; when one visits a dying man, words fail or are superfluous. It is the presence and the thought behind the visit that counts. That is the silent poetry of Manet's late bouquets.

Pinks and Clematis in a Crystal Vase, c. 1882

oil on canvas, 56 x 35.5 cm, Musée d'Orsay, Paris

fig. b| Pierre-Auguste Renoir, *Flowers in the Greenhouse*, 1864, Hamburger Kunsthalle

Vincent van Gogh

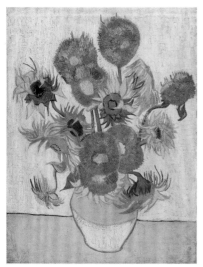

|Fig. a| Vincent van Gogh, *Sunflowers*, 1888
The National Gallery, London

The Eye of Nature

In the South of France the sunflower is ubiquitous, with its cyclopean face always turning towards the sun. Its name in French, *tournesol*, is more explicit than in English, meaning 'turn to sun'. Its flowers are a source of beauty, whether seen across a field or in a vase; the seeds a source of bounty for the healthy oil they produce when pressed. For Van Gogh, this flower became personal and symbolic. Like the artist, it depends on light, and the artwork produced from light and colour provides nourishment to the soul.

Van Gogh's first picture of sunflowers is a small study showing two dried specimens, one turned toward the viewer, the other turned away. The close-up makes it seem as if one is peering through the centre of the facing flower into a space beyond. That it might resemble an eye seems the more likely when the picture is compared to the sunflower paintings Van Gogh made in Arles, where he could observe the living species (Fig. a).

Van Gogh's spirituality and altruism were inspired by his preacher father and formed from his own experiences in religious training and work with the poor in Holland. These beliefs led him to subscribe to the utopian idea that art could teach and lead to social harmony. He was committed to representing ordinary people and everyday objects that would tell the story of both honest labour and the glories of natural surroundings. In the way he painted, direct from observation with a touch so physical that it calls attention to the artist's worker-like craft, he tried to embody those same principles himself.

Van Gogh had arrived in Paris in 1886, just as Impressionism was being questioned by the new generation led by Georges Seurat and Paul Gauguin. Stressed by the pressures of the city and the artistic debates swirling around him, he left to breathe fresh air in the south and clear his head. With the help of his brother Theo, who worked for an avant-garde art dealership, he rented the so-called Yellow House in the Provençal town of Arles where Theo had arranged for Gauguin to meet him (Fig. b). The idea was that the two painters would found a sort of monastic centre for art. Gauguin, however, revelling in his leadership of the

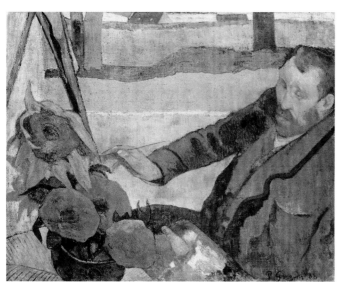

|Fig. b| Paul Gauguin, *Painting Sunflowers*, 1888, Van Gogh Museum, Amsterdam

Sunflowers, 1887

oil on canvas, 43.2 x 61 cm, The Metropolitan Museum of Art, New York, NY

group of artists in Brittany now called the School of Pont-Aven, took his time in coming, adding further to Van Gogh's frustrations. For the latter, then, painting acquired a therapeutic quality, which Gauguin's long-awaited arrival disrupted. They argued over principles, and eventually Van Gogh took refuge in a hospital in nearby Saint-Rémy. At first glance, Van Gogh's sunflowers seem far removed from these circumstances. But if one looks closely, each flower in the vase seems to have its anthropomorphic personality. One stretches its neck high up to get a better view. Or is it a kind of beacon or the captain of its team? Twists and odd positions enliven others, which are surrounded by the glowing, life-giving yellow of sunlight. There is both irony and awe in Van Gogh's ability to embody the vibrancy of joyful life in what the French call *nature morte* – literally 'dead nature' – their words for still life.

Paul Cézanne

|Fig. a| Paul Cézanne, *The Peppermint Bottle*, 1893-5
National Gallery of Art, Washington, DC

|Fig. b| Paul Cézanne, *Still Life with Apples and a Pot of Primroses*, c. 1890
The Metropolitan Museum of Art, New York, NY

The Cupidity of Art

The scene is not just a still life but a set-up in Cézanne's studio accompanied by elements such as a group of paintings leaning at different angles against a (real or imaginary?) wall. Dominating the composition is a plaster cast of Cupid, made from a 17th-century sculpture by Pierre Puget, like Cézanne a native of Provence. Its torso is contained within a canvas directly behind it, making sculpture merge into painting. Further back is an oil sketch of Puget's Michelangelesque *Flayed Man (Ecorché)*.
To the left is a still life with a blue cloth that appears in several compositions of the period (Fig. a). It seems to run out of the painting and merge with that on the table, whose reality disappears to an unfinished state at the edge.

The objects seem placed haphazardly, as if not in use. Cupid seems to be stepping on one apple. Although three are in a fruit bowl, others, plus two onions, are not. One pokes through the still life behind it, its stem conforming to the position of a table leg. An apple in the background would be the size of a football if the perspective were mathematical. Cupid's size is disproportionate too: if this were a still life alone, the composition would be awkward, but it is also a painting of an artist's studio. The final riddle is whether the floor is sky itself, a reflection from studio windows, or another tabletop.

Pictures of artists' studios had a long history. Sometimes the artist is present painting. His works are often pictured, and the scene comments on the creative process.
In Impressionism, some studio scenes assemble a group of painters in collaborative commitment to a certain kind of art (p. 38 and p. 44). Cézanne's conception is unique, by contrast, in its playful attitude towards three and two dimensions, reality and illusion, nature and art.

Most still lifes by Impressionist artists, including even Édouard Manet, are relatively straightforward. Cézanne's are more often complicated by his consciousness of the classical tradition of turning the flat canvas into a window onto space. There is a constant dialogue between depth and surface, the colour of things and the substance of paint. He follows the Impressionist ethos of working directly from observation to mark the canvas, but he understands that the mind orders raw perceptions into the world its

Still Life with Plaster Cast of Cupid, c. 1894

oil on paper, mounted on wood, 71 x 57 cm, The Courtauld Gallery, London

ig. c| Paul Cézanne, *Pyramid of Skulls*,
1898–1900, private collection

body knows. Indeed, some still lifes by Cézanne resemble landscapes, with apples or oranges interspersed among bumps and folds of drapery, like rocks or houses nestled in the land (Fig. b).

Cézanne was always thinking about death. In the 1870s he had a will naming Armand Guillaumin and Camille Pissarro as his executors. Early in his career he painted skulls, and around the same time as the *Cupid* he painted a still life with three skulls – a sort of triple play between life, death and legacy (Fig. c). Cupid, of course, refers to love, which Cézanne knew was fickle and sublimated to his art. Old and cantankerous in the 1890s, unknown except by fellow artists, Cézanne in *Still Life with Plaster Cast of Cupid* reflects on his love of art, life's work and legacy.

Gender and Sexuality

Édouard Manet

|Fig. a| Alexandre Cabanel, *Birth of Venus*, 1863, Musée d'Orsay, Paris

|Fig. b| Titian, *Venus of Urbino*, 1538, Galeria degli Uffizi, Florence

CHAMPFLEURY – LES CHATS

DEUXIÈME ÉDITION AVEC 52 DESSINS

DEUXIÈME ÉDITION AVEC 52 DESSINS

Un volume illustré, Prix 5 Francs
En Vente ici.

|Fig. c| Édouard Manet, *The Cats' Rendezvous*, 1868
New York Public Library, NY

Sex Scandal

Clearly, Olympia was a prostitute, and her lack of modesty is therefore no surprise. Her presence at all at the Salon of 1865 was enough cause for upset, but after the protests and the Salon des Refusés in 1863, the Salon had been liberalised, and a letter from a well-placed friend helped overcome the picture's initial rejection. Perhaps the most provocative element of the painting was the woman's domineering attitude, even though viewers who knew *Le Déjeuner sur l'herbe* (p. 23) could recognise Manet's favourite model, Victorine. She seems indifferent to the flowers brought from an admirer by a maid from one of France's West African colonies. She stares out at the viewer with her usual assertive gaze.

Unlike the voluptuous curves of Alexandre Cabanel's *Birth of Venus* (Fig. a), which had been accepted by the official Salon of 1863, Olympia's expression implies self-assurance rather than seduction and submission. Wearing her slippers, a velvet choker and a camellia in her hair (a reference to Alexandre Dumas's novel *La Dame aux camélias*, which inspired Verdi's later opera *La Traviata*), she exposes the parts of her body that are for sale, with the exception of the most important one, to which she calls even more attention by covering it with her firmly outlined hand. Its shape has been variously described as looking like a crab, a tarantula or Manet's signature initial M. Indeed, Charles Baudelaire compared artists to prostitutes, since both must use appearances to sell. That the bracelet Olympia wears was Manet's mother's and contained a lock of his baby hair, adds to the idea of Olympia as a metaphorical self-portrait. Baudelaire's fascination with appearances, make-up and fashion led him to theorise that *demi-mondaines* possessed the kind of beauty that most reflected human (male) desire, and since its satisfaction leads to happiness, it embodied a modern ideal. For him, the ideal always combined eternal and contemporary elements. Indeed, Manet's composition is an updated version of Titian's *Venus of Urbino* (Fig. b), which Manet copied on a trip to Florence. He no doubt knew that Titian

had idealised the Duke of Urbino's mistress. As a painter of modern life, he not only refused to do so for Olympia but changed Venus's lapdog, symbol of fidelity, into a cat. As in Champfleury's book on cats, for which Manet made an illustration and a poster (Fig. c), feline independence and reputed promiscuity made them appropriate companions for courtesans. They were Manet's, Baudelaire's and Théophile Gautier's favourite pet as well, and were thus associated with poetic licence and artistic freedom, as in the foreground of Gustave Courbet's *The Artist's Studio* (p. 202).

Reactions to Manet's subject matter and technique were predictably hostile. Critics wrote: 'What is this odalisque with the yellow belly, ignoble model dredged up from who knows where?' 'The flesh tones are filthy … Shadows are … strokes of shoe polish …' and 'There is an almost infantile ignorance of the basic elements of drawing [and] the painter's attitude is one of inconceivable vulgarity.' The government was forced to post guards.

Berthe Morisot

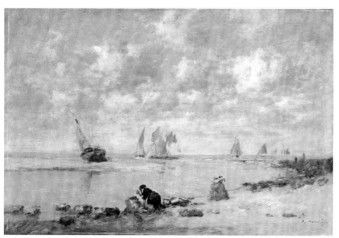

|Fig. a| Eugène Boudin, *Washerwoman near Trouville*, c. 1872–6, National Gallery of Art, Washington, DC

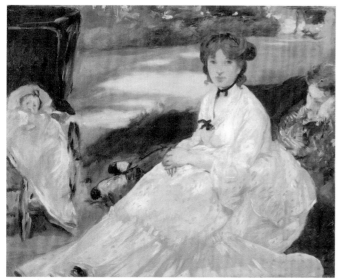

|Fig. b| Édouard Manet, *In the Garden*, c. 1870, Shelburne Museum, VT

Two Proper Ladies

The train service inaugurated in 1862 made the charming seaport of Lorient on Brittany's Atlantic coast accessible. In 1869 Morisot stayed with her sister and brother-in-law, the Pontillons.

Unlike in the industrial ports of Le Havre or La Rochelle, only pleasure craft and fishing boats, as opposed to ocean steamers and cargo ships, are seen here. Since proper ladies would not wander out into the open air alone, few female artists painted landscapes unless they were within their domestic domain, the so-called 'space of femininity'. So this image of the harbour and its boats, reminiscent of Eugène Boudin's pictures of Honfleur or Trouville (Fig. a), can only be explained by the presence of a companion, obviously Morisot's sister Edma, whom she included in the panorama. Nor would her sister have been sitting alone in such a place. One must conclude, therefore, that the picture posits two women here, even though only one is visible.

Is the painting a landscape or a portrait? The sister's position at the far edge might be the sort of location Edgar Degas would assign (p. 64) for a portrait. However, Edma's face lacks the detail and expression of portraiture, which are uncharacteristic for Morisot. Edma looks to our left and downwards, as if directing the viewer's eyes towards the water, which makes up most of the picture's foreground. The wall on which she is seated both leads the viewer towards her and yet leads back when one notices her gaze. It is from this relatively broad foreground that the view of the harbour opens, distant enough

The Harbour at Lorient, 1869

oil on canvas, 43 x 72 cm, National Gallery of Art, Washington, DC

that the picture reads as a general and anonymous tourist view rather than a detailed examination of either the place's pleasures or its commerce. In this way, too, Morisot keeps a demure distance from the presence of anyone other than her sister.

The delicate harmonies of the painting reflect Morisot's training with Jean-Baptiste-Camille Corot. Eighteen sixty-nine was relatively early in her relationship with Édouard Manet (p. 50) and this picture shows that she was a mature *plein-air* painter at the time, already working with a light touch and luminosity that would make her work mainstream in Impressionism. It is the sort of picture that could have encouraged Manet to do more pictures like hers, while from Manet she acquired bolder facture and more challenging attitudes towards aesthetic authority than she had previously held. The point is that the exchange between them was certainly not one-way, with Manet getting all the credit. In fact, Manet's first true *plein-air* painting (Fig. b) was done in Morisot's garden and depicted one of her friends. So when it came to painting in the open air, Morisot had the lead. Even so, one may ask whether Edma actually sat out on a wall or whether the composition was assembled from sketches. Proper ladies would never tell.

Berthe Morisot

|Fig. a| Berthe Morisot, *View of Paris from the Trocadéro*, 1871–2, Santa Barbara Museum of Art, CA

The World Beyond

The Morisot family lived, overlooking the Seine, on the hillside of Passy, a neighbour-hood annexed to Paris in 1862. Gazing outwards is Morisot's niece Jeanne, first daughter of sister Edma. Jeanne looks down towards the Trocadéro Gardens on the riverbank below, recently opened to the public, rather than towards the skyline, where, other than the Invalides' gilded dome, there are only a few landmarks and little detail. Edma leans over in a protective posture, as if the balcony railing were not enough security. The child's instinct is to crave the freedom represented by the world beyond the balcony and by nature, as in the gardens. Her mother, on the other hand, may think of the city as a place of danger and watches lest her daughter's gaze wander further. Focusing more on the relationship between mother and child than on the view, the picture demonstrates Morisot's sensitivity to child rearing.

The picture was not made from the Pontillons' own home as often thought, but nearby. The balcony's grand size, Edma's formal dress – black for the recent death of her father – and her parasol indicate a public place such as existed before construction of the first Palais du Trocadéro in the 1870s. The flowers in the planter to the right suggest a restaurant or possibly a hotel. The view is related to another from behind a fence that is actually further down the hill at garden level (Fig. a).

One is invited to share the child's innocent gaze. This device was not new in art: Édouard Manet had used it in different circumstances for his *Gare Saint-Lazare* (p. 158), where a little girl looks out to the industrial spectacle of the railway yards. Both pictures draw attention to the world beyond the railing. Morisot's doubles as a cityscape and is perhaps the closest she could get to urban views like those by Manet, Claude Monet and Pierre-Auguste Renoir. Like the opera or theatre, the world inside the railing is a protected environment, yet one that interfaces with the public realm. Morisot's picture obviously recalls Manet's *Balcony* (Fig. b), for which she had actually posed. Manet is said to have had the idea while vacationing at Boulogne-sur-Mer, and his

GENDER AND SEXUALITY

The Balcony at Passy, c. 1874
oil on canvas, 60 x 50 cm, private collection

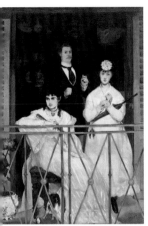

b| Édouard Manet, *The Balcony*, 1868–9
sée d'Orsay, Paris

c| Francisco de Goya (attributed to),
as on a Balcony, c. 1810–2
e Metropolitan Museum of Art, New York, NY

picture evokes taking the seaside air after a lunch with friends. It was assembled, however, in the Paris studio from individual posing sessions, and it overtly referenced a composition by Francisco de Goya of *majas* on a balcony (Fig. c), to which Manet's entirely proper figures provide an ironic contrast. Morisot's picture, on the other hand, like *The Harbour at Lorient* (p. 221), seems as if done from life, unburdened by the dialogue with past art. The angled viewpoint is part of her strategy to create a natural explanation for the placement of her figures. In the Manet no rationale explains the figures' stiff formality other than they know they are being viewed. Morisot's picture may be less portentous than Manet's, but its lighter touch reflects the delicacy of family relations observed from life.

Mary Cassatt

|Fig. a| François Boucher, *Jeanne-Antoinette Poisson, Marquise de Pompadour*, 1750
Harvard Art Museums, Cambridge, MA

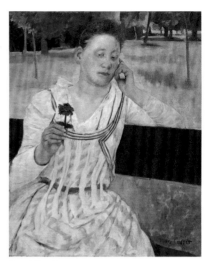

|Fig. b| Mary Cassatt, *Woman with a Red Zinnia*, 1891
National Gallery of Art, Washington, DC

What Women Know

One of Cassatt's masterpieces, this image of a homely girl doing her best to look pretty is famous on more than one account. It is said to be Cassatt's rejoinder to her friend Edgar Degas's sarcastic question 'What do women know about style?' Degas of course knew that women knew everything about fashion. But he seems to have believed that style was another matter, having to do with class and personal imprint. Cassatt responded on more than one level by showing what every Parisienne knew better than Degas: namely, that a beautiful arrangement can transform even an ugly creature like her model into a magnificent work of art.

The age-old theme of the mirror has many dimensions in the history of art (p. 226). It was especially popular in the 18th century, when women at court began to take an active role in patronage and cultural life (Fig. a). Indeed, in Impressionism, with a few exceptions such as Édouard Manet's *Nana* (p. 117), the theme was especially the domain of women painters. Their own lives and limitations dictated by gender brought them into close contact with it, unlike the confirmed bachelor Degas or others who were more interested in landscape. The intimacy of a girl's self-critical gaze and the complexity in balancing self-realisation with pleasing others, the social pressures and the tricks of illusion-making, are part of a woman's both personal and private experience. But they are all the more interesting and familiar because they are also at the heart of the making of art.

Cassatt set before herself the extreme challenge of making a beautiful picture from a girl with protruding teeth, a nose wide at the base and, above all, red hair – still mocked by some in France today as *rouquin*. Through skilful brushwork and combinations of colour – like the use of blues in the girl's nightshirt – and a rigorous composition, Cassatt made the picture a huge success. The step by step geometry of right angles going from the bamboo chair back to her dresser, hair, upraised elbow and the mirror

Girl Arranging Her Hair, 1886

oil on canvas, 75.1 x 62.5 cm, National Gallery of Art, Washington, DC

to the right give the picture firm structure, with which the freely painted wallpaper pattern forms its elegant contrast. The still life on the dresser echoes the counterpoint of straight and rounded forms of the girl's arms, head and torso, while alluding to the reflective surfaces one expects of the unseen mirror.

By contrast with Cassatt, Pierre-Auguste Renoir preferred non-professional models for their naturalism, but he made sure that they were pretty. Cassatt more than once chose common types as vehicles for artistic beauty. A late-career demonstration of this ability is *Woman with a Red Zinnia* (Fig. b). The theme of a woman with a single flower goes back to the Renaissance, transformed here into a demonstration of how, as in *Girl Arranging Her Hair*, simple geometry and a background with one dominant colour can set off the beauties, if not of an individual herself, of the image the artist makes of her.

Berthe Morisot

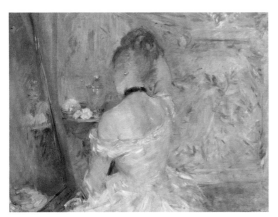

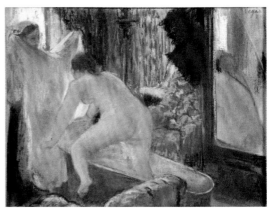

|Fig. a| Berthe Morisot, *Woman at Her Toilette*, c. 1875-80
The Art Institute of Chicago, IL

|Fig. b| Edgar Degas, *Woman Getting Out of her Bath*, c. 1877
Norton Simon Museum, Pasadena, CA

Reflections of the Soul

The mirror has multiple meanings in the history of art. One is the theme of worldly vanity; another is to symbolise art's reflection of the world. Its presence in views of women at their toilet, especially popular in the 18th century (p. 224), featured women as the object of their own gaze preparing to be the object of the gaze of men. In treating themselves as objects for the eye, like works of art, the women evoke the role of the artist, as the artist creates commodities for visual consumption.

For Charles Baudelaire a woman's desire to improve upon nature was proof of the human instinct for self-improvement, hence of a moral drive towards the ideal. For him the prosaic theme of fashion and practical use of make-up could lead to a fundamental understanding of what it is to be human. The word 'psyche', before it became part of the vocabulary of psychoanalysis, referred to the human soul. Psyche was the mythological girl loved by Cupid. Already it was used as a name for a full-length mirror, as if in reflecting the entire body it could capture the soul as well. In a psyche a person could submit to self-examination from top to bottom, and maybe through and through.

In 1875, Morisot's treatment of female grooming in *Woman at Her Toilette* (Fig. a) was relatively conventional, echoing her rococo predecessors with the model's three-quarter, turned-away *profil perdu*. In 1876 her take on the theme changed radically from the usual placement of a woman at her dressing table. The figure, said to be modelled by a young neighbour, is adjusting her dress at the waist rather than doing her hair, washing or putting on make-up. Trivial as such a slight gesture may seem, the tightening of the garment, combined with a gentle forwards thrust of the hips and the strap falling off her shoulder, suggests a private eroticism perhaps only a woman artist would notice. Although the girl's gaze seems directed discreetly downwards, her reflection reveals that she is looking exactly where the torso joins the pelvis, perhaps considering whether a corset would flatter her figure. How different from Edgar Degas's deliberately prosaic *Woman Getting Out of her Bath* (Fig. b)! One could guess that Morisot's *Devant la Psyché*, exhibited with the Impressionists in 1877, was her response.

GENDER AND SEXUALITY

Although it is doubtful Morisot directly considered the relationship between 'psyche' as the name of the mirror and the new science of psychology, notions such as art mirroring the soul were common. In this most gentle picture, seeming so breezily sketched and deftly painted, dominated by the summer dress's virginal white and the light of morning coming through gauze curtains, one could read the drama of a young girl's coming of age. Even the delicate floral patterns on the bedroom sofa and matching drapes allude to this flowering, with the window knob suggesting possibilities opening up, perhaps outside the home. Whether Morisot intended any such thoughts is not the point. That her painting is capable of suggesting them exemplifies her mastery.

Berthe Morisot

|Fig. a| Jean-Baptiste-Camille Corot, *Girl Reading in the Forest of Fontainebleau*, 1834
National Gallery of Art, Washington, DC

Life is an Open Book

In the 19th century women artists rarely painted landscapes because they were not free to wander the countryside unaccompanied. Morisot had trained with Jean-Baptiste-Camille Corot as a landscape painter, alongside her sister. As a pair, their independence appeared legitimate. As in *The Harbour at Lorient* (p. 221), *Reading Outdoors* involves two ladies, but in this case the scene appears more natural, less posed. A lady of means, as indicated by the private carriage waiting in the road, has taken to the countryside for peace, quiet and privacy, the perfect place for reading alone.

The idea of nature as a place of freedom was articulated especially in the writings of the French philosopher Jean-Jacques Rousseau. This is suggested in Corot's picture *Girl Reading in the Forest of Fontainebleau* (Fig. a), whose solitary figure with partly opened blouse makes clear it is a fantasy. The translation into practice of the Rousseauian concept of 'the return to nature', as a return to simplicity away from the constraints of society, had major limitations, depending on the availability of leisure, the affordability of transport and the proprieties of social class. And yet the notion of losing oneself in literature in natural surroundings is still powerful today, as people bring their books to the country or the beach.

Morisot's lady, probably her sister *sans* children, seems to be seated in a pleasant shady meadow, with a low fence behind her separating her grassy spot from a more open and sunlit field. She has kept on her hat with its trailing crêpe, and she is surrounded by the typical paraphernalia of the bourgeois lady, such as the parasol to the left and the fan behind her to the right. That she didn't just leave them in the carriage suggests how important they are to her identity. At least the shawl women wore over their dresses has served a purpose, protecting her pretty white summer dress from the ground. Morisot paints her as if catching her at the moment when she turns a page in her paperback, its blue cover indicating most likely a contemporary novel in a popular series. This detail also gives the picture the feeling of spontaneity, as if the lady is actually absorbed in reading, unaware or unconcerned about being painted.

|Fig. b| Gustave Caillebotte, *The Orange Trees*, 1878
The Museum of Fine Arts, Houston, TX

Reading Outdoors, 1873
oil on canvas, 46 x 71.8 cm, The Cleveland Museum of Art, OH

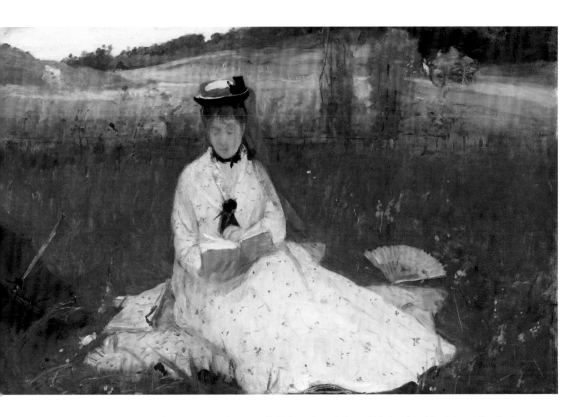

Compared to Gustave Caillebotte's painting of his brother Martial, reading in the manicured garden of their elegant country estate (Fig. b), Morisot's picture seems filled with fresh air. Caillebotte's obsession with structure, angled viewpoints and interesting postures makes for an altogether contrasting experience. Besides, Martial is hardly lost in fiction; he is reading the newspaper of the day. Cousin Zoé is in the middle ground, separated from Martial not only by the delightful geometry of the outdoor furniture, but also by her thoughts as she leans on one of the two box planters with orange trees that gave the painting its title. The family dog dozes in the sunlight, impervious to the heat of this brilliant summer's day. For Caillebotte the theme of reading affords an opportunity to show off his sense of rigour and design, as constricting as the steamy atmosphere of the season. For Morisot the occasion affords sisterly understanding and companionship, filled with the luxury of relaxation under shady trees.

Pierre-Auguste Renoir

|Fig. a| Raphael, *The Colonna Madonna*, c. 1508
Gemäldegalerie, Berlin

|Fig. b| Jean-Baptiste Greuze, *The Village Betrothal*, 1761
Musée du Louvre, Paris

Renoir's Anti-Feminism

Renoir represents his mistress and eventual wife Aline Charigot as a nurturing mother
in a Madonna-like pose (Fig. a). Their first child, Pierre – who became an actor and was
brother to the future cineaste Jean Renoir – displays his infant manhood in a way that
makes his father proud. Renoir's attitude towards motherhood is expressed by the cat,
attending to hygiene by licking her fur. This was a device adapted from earlier times, as in
Jean-Baptiste Greuze's *Village Betrothal* (Fig. b), where a mother hen tends to her brood in
the foreground. Both show the mother's child-rearing role as a natural instinct. For Renoir,
wives and mothers were defined primarily by their duties; the child is the father's trophy.
Renoir loved women as subjects for his art, and yet in memoirs about his father, Jean
reported a number of statements that even at the time must have seemed unflattering.
For example, Renoir believed that housework was good for women. Bending down
'to scrub floors, light fires or do the washing' was good exercise because 'their bellies
need movement of that sort'.

Feminism was afoot in the 1880s, and so both Renoir's remarks and his picture must
be seen in that context. There had been demands for equality by women during the
Commune and, following a brief pause after its defeat, they re-emerged. In 1878 the
first International Congress for Women's Rights was held, organised by the notorious
Maria Deraismes and her partner Léon Richer. In 1880 the French Republic under Léon
Gambetta's leadership instituted public education for girls. On hearing of a woman lawyer,
Renoir exclaimed, 'I can't see myself getting into bed with a lawyer … I like women best
when they don't know how to read and when they wipe their baby's behind themselves.'
Oddly, this kind of anti-feminist argument had been popularised by one of France's leading
liberals, the anarchist Pierre-Joseph Proudhon. And so Renoir, vulgar and narrow-minded
as his words certainly were, was taking sides in a debate that was far from settled.

The painting is stylistically unusual as well. It was painted at exactly the time when
Impressionism's loose technique, spontaneity and sense of the fleeting moment were
criticised by supporters of the Neo-Impressionists led by painter Georges Seurat (p. 330).

They were seeking a more permanent way to represent experiences of nature. Renoir, too, was questioning his previous work. In *Maternity* his contours are firmer than in earlier work and, following a trip to Italy, his allusion to the Renaissance is unmistakable. A psycho-biographical interpretation might argue that Renoir's modest origins made him socially insecure, and that his fear of female independence was linked to its usurpation of the last bastion of male privilege, the home. It is also likely that characterisations of Impressionism as soft, delicate and feminine may have aroused his assertion of a firmer (read: more masculine) style, based on the traditions of male artists. Colour, often associated with feeling and sensuality, needed to be contained by line, which was the rule of reason.

Pierre-Auguste Renoir

Rowing Alone

Regarded primarily as a figure painter, Renoir was capable of wonderful landscape paintings, too. Often, as here, they are settings for figures, in this case two women enjoying an outing on the river. Unlike so many of his scenes in which women are set in fields or flowers (Fig. a), the outdoors dominates the figures here, as if the environment enjoyed on this lovely day is at least as important as the ladies. The picture is painted in a softer version of Claude Monet's style of the mid 1870s and reflects Monet's interest in surroundings and atmospheric effects more than figures. Renoir was often inspired by Monet, with whom he painted at La Grenouillère in 1869 (p. 272) and visited frequently in the early to mid 1870s (p. 74).

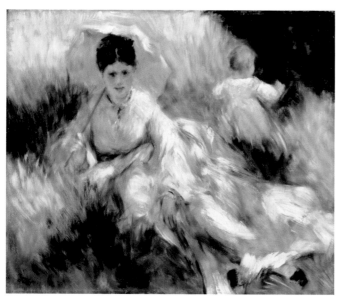

|Fig. a| Pierre-Auguste Renoir, *Woman with a Parasol and Small Child on a Sunlit Hillside*, c. 1874–6 Museum of Fine Arts, Boston, MA

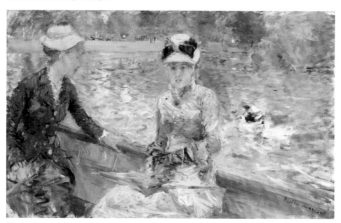

|Fig. b| Berthe Morisot, *Summer's Day*, 1879, The National Gallery, London

Although *The Skiff* has ties to Monet's scenes in Argenteuil (p. 278), it is set at Chatou and is one of many boating scenes Renoir did there (p. 280). The location is recognisable from the railway bridge to the right with a train approaching from the left. In addition, the riverside house in the background is present in *Oarsmen at Chatou*, which is set nearby (p. 280). Renoir's picture compares to one painted in the same year by Berthe Morisot (Fig. b). That they knew each other's work is likely since they were close friends, but they did not paint side by side as Renoir had done with Monet. Morisot's picture is set in one of the lakes of the Bois de Boulogne, the grassy expanse of which can be seen in the background. At the western edge of Paris, the Bois was easily accessible from the neighbourhood of Passy, where the Morisots resided.

It would have been a more protected spot than the open Seine, with no chance of encountering industrial river traffic or a strong current. Since Renoir's other pictures of boaters include men, and the boats in them are hired by couples, the two women rowing alone in *The Skiff* might be considered somewhat daring, even though one suspects that male companions are close by.

In the Morisot, by contrast, the ladies are either close to shore or the painter is in the boat with them. In any case, no one is

The Skiff (La Yole), 1875

oil on canvas, 71 x 92 cm, The National Gallery, London

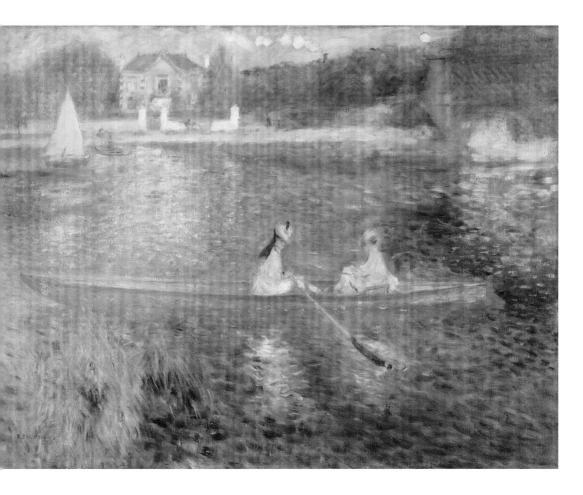

rowing, and their expressions rather than the landscape are of primary interest. One looks over at a pair of ducks. The other looks at the viewer as if caught by surprise. In the Renoir the rowers are far enough away and sufficiently generalised to be impossible to identify; in the Morisot they are recognisable, even though their names remain unknown, for they appear as models in other pictures. Perhaps they were professionals. Oddly enough, Morisot's painting is more like what one might expect from Renoir. One is forced to conclude that neither she, nor he, nor any of the Impressionists always stuck to what they are known for by posterity. They were in a constant state of experimentation and dialogue with one another.

Marie Bracquemond

|Fig. a| Félix Bracquemond, Copy after J.M.W. Turner, *Rain, Steam, and Speed*, c. 1871
Bibliothèque nationale de France, Département des Estampes et de la Photographie, Paris

A Family Quarrel

Few art historians are familiar with Marie Quivoron-Pasquiou, who married the printmaker Félix Bracquemond in 1869. They met while sketching at the Louvre; both were students of a follower of Jean-Auguste-Dominique Ingres, hence their training and draughtsmanship were traditional. Félix Bracquemond befriended the Impressionists, and is known for exhibiting an etching after J.M.W. Turner's *Rain, Steam, and Speed* at the first Impressionist exhibition (Fig. a). It suggests a link between Turner and Claude Monet during the latter's stay in London during the Franco-Prussian War. Marie became an avid supporter of the Impressionists and exhibited with them three times. The critic Gustave Geffroy once described her as 'one of the three great ladies of Impressionism'. The couple's son Pierre was born in 1870. His sickly infancy led the family to move to a house called the Villa Brancas on a hillside in Sèvres, a suburb just outside Paris, where the air was less foul. There is little trace of Marie's activity until she exhibited in 1879. In 1880 she showed *On the Terrace at Sèvres*, her masterpiece, which places figures dressed in the latest fashions outdoors in sunlight. Her design, draughtsmanship and the volumes of her figures reflect the rigour learned from traditional training, but her surfaces sparkle with Impressionist sensitivity to colour modulations made by shadows or reflections of nearby objects. The white dress in particular has a plethora of intermingled hues, with blues in shaded passages and pinks in the other dress and the floral covering of the cushion of her wrought-iron armchair. Remarkable, too, is a system of slanted parallel strokes for the landscape in the background. They suggest she might have been aware of Paul Cézanne's so-called 'constructive stroke' (p. 316).

GENDER AND SEXUALITY

On the Terrace at Sèvres, c. 1880

oil on canvas, 88 x 115 cm, Musée du Petit Palais, Geneva

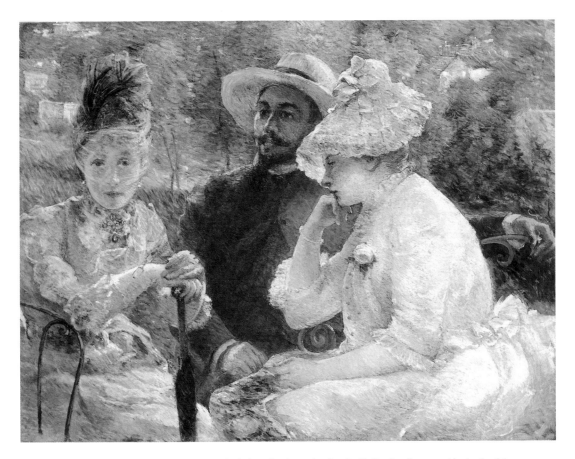

Marie's unmarried sister Louise, who lived with the family, posed for both of the women in the picture. The man has not been identified, unless he is a very clean-cut version of husband Félix. An etching by the latter (*Terrace of the Villa Brancas*, 1876, The Sterling and Francine Clark Art Institute, Williamstown, MA) shows Marie sketching her sister on the terrace from life, a *plein-air* process of which he ultimately disapproved. According to both Louise and Marie's son Pierre, her success brought her husband's limitations into focus, and by 1890 he forced her to stop painting. His own career had been in graphic art and porcelain design, yet despite the originality of, for example, his Rousseau service for the Haviland China Works at Limoges, competition from his wife led him to treat her badly.

Marie's combination of conservative framework and radical colouring and brushwork makes her appear to compromise between the Impressionisms of Gustave Caillebotte and Edgar Degas, with whom she was close, and Pierre-Auguste Renoir and Monet. Yet *On the Terrace at Sèvres* shows a distinct personality, and her middle way was prophetic: Renoir in the early 1880s would shift towards something similar (p. 280 and p. 328). Had Marie had more freedom, her name would certainly be better known. Even today almost all her work remains with her descendants.

Gustave Caillebotte

|Fig. a| Frédéric Bazille, *Fisherman with a Net*, c. 1868
Fondation Rau pour le Tiers-Monde, Zurich

Male Friction

Were Caillebotte's male nude not drying himself with a towel near his bathtub, the picture might seem worthy of a place alongside great academic nudes. Its observation of anatomy is impeccable, its masculine beauty fine. Having adopted the Impressionist ethos, however, Caillebotte places his figure in a domestic setting and everyday activity. The pose is striking and unusual, with the back turned, as in the male nudes of Frédéric Bazille (Fig. a) and Pierre-Auguste Renoir (Fig. b). On close examination, moreover, one notes Caillebotte's summarising simplifications. Hands and toes are barely articulated; there is no sign of veins or blood circulation within the chalky back. Caillebotte's main concern is musculature that defines the figure's masculinity, but his modelling is achieved by swarms of parallel hatchings that call attention to his technique. By comparison, the smooth surfaces and sharp outlines of Bazille's man look more conservative than Caillebotte's. And Bazille's model's pose, justified by the fishing net, seems contrived to display fine buttocks and broad shoulders.

Caillebotte's picture is no less contrived but appears more matter of fact than Bazille's, down to the hint of the figure's genitalia from behind. Wet footprints on the floor suggest the instant when he stepped out of the bath; Bazille's figure, by contrast, seems frozen, posing. As often the case, Caillebotte's palette was limited to accommodate muted, indoor light, as in *The Floor Scrapers* (p. 31) and *The Luncheon* (p. 205). Chalky, pastel-like blues signify subtle effects of shading. They are prominent on the discarded towel in the foreground, which echoes the coarse cloth in Cézanne still lifes (p. 193 and p. 214). They also unify the composition, while playing off the browns, blacks and copper tones that constitute the darker side of Caillebotte's palette.

It has been suggested for both Bazille and Caillebotte that such representations of masculinity indicate an element of homosexuality, even if repressed. It is true that neither married – Bazille died too young – but Caillebotte had a female companion. Caillebotte's emphasis on sport and his domineering rigour of design suggest an obsession with control, perhaps compensatory for sexual insecurity. One should recall, however, that Edgar Degas never married either, and he shared many pictorial characteristics with Caillebotte, while spending a lot of time in brothels. Still, the possibility is undeniable. Without proof either way, it can be said that Bazille's relationship with friends exemplified the male bonding among students or young professionals who go out drinking together, as when Bazille, Gustave Courbet and Claude Monet went out painting near Chailly (p. 16). In fact, Renoir's *Boy with the Cat* (Fig. b) is far more

|Fig. b| Pierre-Auguste Renoir, *The Boy with the Cat*, 1868, Musée d'Orsay, Paris

A Man Drying Himself, 1884

oil on canvas, 144.8 x 114.3 cm, Museum of Fine Arts, Boston, MA

cloying than either Bazille's *Fisherman* or Caillebotte's *A Man Drying Himself*. Male insecurity plays out in different ways. Speculations about same-sex relations may be the result of today's preoccupations rather than those of the 1870s. Until there is some documentation, one can only guess, and whether knowing for sure would change the significance of the artworks is hard to say. The confusion and ambiguity stems from Impressionist modernity, in which the male nude is de-idealised to become a naked man.

Pierre-Auguste Renoir

Venus with a Lapdog

Renoir's *Bather with a Griffon Dog* may be a pendant to *The Boy with the Cat* (p. 236), given its reversal of the figure's sex and the switch from cat to dog. It is one of a number of large figures that Renoir and other young Impressionists produced in the second half of the 1860s. They were inspired by pictures like Édouard Manet's *Mademoiselle V...* (1862, The Metropolitan Museum of Art, New York) and his *Olympia* (p. 219). They were also meant to attract attention at the Salon if the work were to be accepted. In 1867 Renoir had made the beautiful *Lise with a Parasol* (Fig. a), which won him praise at the Salon of 1868. Émile Zola included it among those he dubbed 'Actualist' (p. 38).

The twenty-four-year-old Renoir had fallen in love with Lise Tréhot, the sixteen-year-

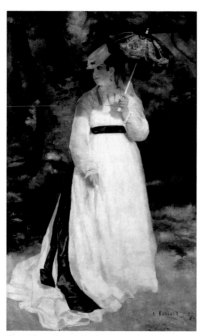

old sister-in-law of his friend Jules Le Cœur. He drew and painted her over a dozen times from 1865 to 1872. *Lise with a Parasol* is a portrait of her; his initials on the tree trunk behind her declare his love. Earlier she had posed nude for *Diana Huntress* (p. 196), which was rejected by the Salon of 1867. She posed again for *Bather with a Griffon Dog*, in which Renoir seemed less concerned than earlier about propriety. As in *Diana*, his reference to the ever provocative Courbet was explicit. A boat floating nearby and a woman lying behind Lise as if she might be spying allude to the latter's *Young Ladies on the Banks of the Seine* (Fig. b). In that painting, two courtesans, the nearest one in petticoats, are resting on the riverbank. Behind them is a rowing boat with a man's hat. Surely they have been up to no good.

Unlike the *Diana*, in which Renoir was trying to pass Lise off as a goddess, in *Bather with a Griffon Dog* he pulled no punches. She is a very contemporary lady, somewhat more ample than in 1867, and certainly more realistic than the idealised Capitoline Venus, goddess of love, whose pose she paraphrases (Fig. c). Renoir updated Venus to contemporary fashion: her dress has a bright red ribbon and shows the latest stripes. Adding to realism is the implication that Lise is undressing. Her red shawl and straw hat lie heaped carelessly on the ground, like Victorine's in Manet's *Le Déjeuner sur l'herbe* (p. 23). Her slim, almost cat-like dog relaxes comfortably on her dress.

|Fig. a| Pierre-Auguste Renoir, *Lise with a Parasol*, 1867 Museum Folkwang, Essen

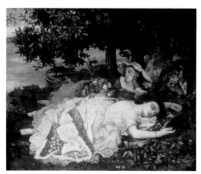

Lise looks demurely away, like the Medici Venus but in the opposite direction, thus avoiding any sense that she might be on the lookout or be a venal courtesan like Olympia. She seems slightly stooped as if uncomfortable in her contrapposto stance. If she posed reluctantly, it surely endeared her to the libidinous Renoir, whose gaze seems particularly attentive to her breasts. Such deference fits his concept of women as objects meant to serve their men, whether it be dinner or another appetite. Here she functions as a vehicle for the display of Renoir's skills in modern painting, complete with up-to-date fabrics, fashionable pet and seductive flesh.

|Fig. b| Gustave Courbet, *Young Ladies on the Banks of the Seine (Summer)*, 1857, Petit Palais, Paris

g. c| *The Capitoline Venus,* 4th century BC
pitoline Museum, Rome

Édouard Manet

Aristocrats of the Demi-Monde

Like Pierre-Auguste Renoir, Manet was a lover of female beauty, with the difference that he was never so obvious about it. He did few nudes, and seemed more interested in outward appearances – complexion, make-up, jewellery and clothing – than Renoir, whose preference for flesh grew increasingly obvious in his later works. Some of Manet's pictures of women make them seem devoid of psychology, as in his pastel portrait of Irma Brunner, called 'The Viennese Woman'. Her perfect profile seems without particular consciousness. Her lips don't even crack a smile.

Little is known about Brunner except that she was introduced to Manet by Méry Laurent, of whom the painter had already made several images. He so admired Méry's beauty that in 1881 he asked her to pose for *Autumn* (Fig. a) in a series of the four seasons. Each one portrayed a different model against a wallpaper background that evoked the appropriate time of year. In his pastel portraits, by contrast, Manet used a featureless background, coloured to set off the figure. That is the case for the greyish background for Brunner, in which an extraordinary brown hat, merging with her tied-back brunette hair, frames her face at the top, while the pink jacket with high collar provides a bold contrast to it in the lower register. The pink is just right to bring out the subtle colouring of Brunner's skin. The bold contrast of her pale face to her dark hair and hat makes it seem almost like a mask. With touches of pink to the ear and the pure white of her eye just behind the pupil, the close observer senses how the jacket brings out the flesh tones. The portrait was so stunning that in 1882 Manet made a comparable one in pastel on canvas for Méry (*Méry Laurent in a Black Hat*, 1882, Musée des Beaux-Arts, Dijon), except dominated by black in a way that only Manet could use it.

One of the most remarkable passages in the portrait of Brunner is where the hat curves just under her nose, thereby silhouetting its aquiline perfection. The curls of her hair give a little extra style to her coiffure. Manet's strokes of colour sometimes reach beyond the contour, as at the left shoulder, or, at the other extreme, they may fail to fill out the pre-established outline, as at the top of the hat. These are signs of the spontaneity of sketching, since in pastel one draws directly with pigment held together by a binding agent to make chalk-like sticks. Near Brunner's chin the pastel's pasty thickness seems to imitate a woman's make-up.

In the years just before his death it was difficult for Manet to paint, and he often had to do so seated. Working with pastel was easier, and between 1879 and 1882 his production was prolific. In addition, the popularity of pastel in the 19th century gave it aristocratic overtones. If one can assume that Brunner had as many lovers as Laurent, then the two of them were nobility in their *demi-monde*.

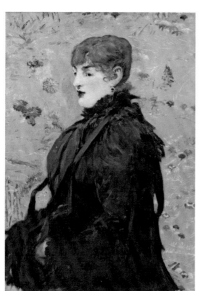

|Fig. a| Édouard Manet, *Autumn: Méry Laurent*, 1881
Musée des Beaux-Arts, Nancy

GENDER AND SEXUALITY

Portrait of Irma Brunner (La Viennoise), c. 1880

pastel on canvas, 53.5 x 44.1 cm, Musée d'Orsay, Paris

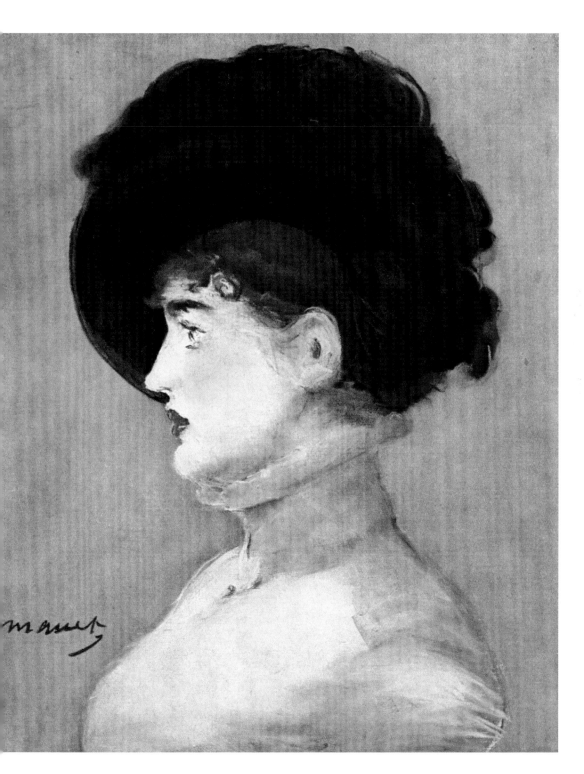

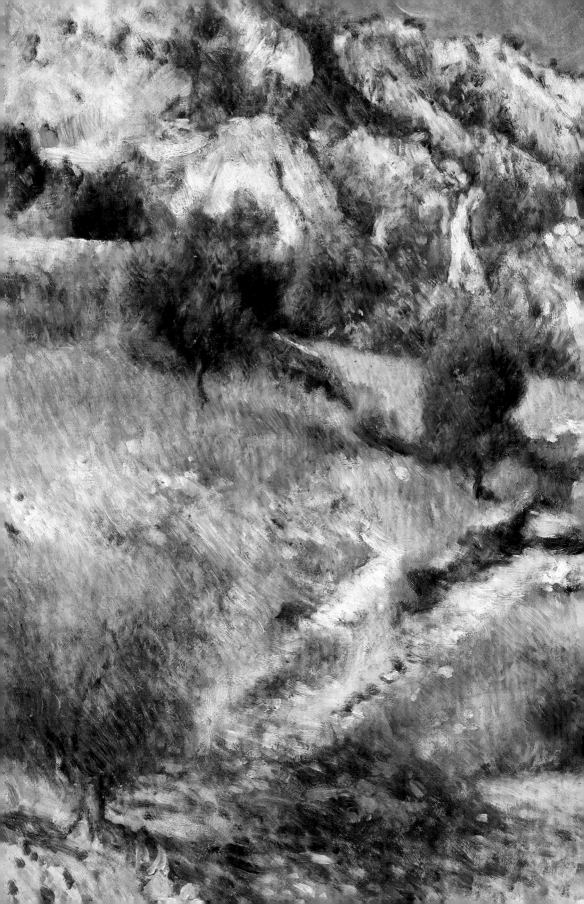

Promenades and Travel

Camille Pissarro

An Ideal Place

Pissarro's childhood in the multiracial community of the Caribbean and his Jewish background predisposed him to open-mindedness and liberal, even radical, political views (p. 182 and p. 186). Neither factories (p. 148) nor bourgeois newcomers seemed an intrusion on the countryside he loved. From the late 1860s until the early 1880s he lived for the most part in the small market town of Pontoise (meaning 'bridge on the river Oise'), not far from the Oise's confluence with the Seine. The Oise was frequented by the Barbizon-generation painter Charles-François Daubigny (p. 32), who was friendly with several of the Impressionists, but it was far more rural than Argenteuil, Marly or Chatou. In the late 1860s Pissarro lived in the hilly hamlet near Pontoise

|Fig. a| Camille Pissarro, *Jallais Hill at L'Hermitage*, 1867
The Metropolitan Museum of Art, New York, NY

called L'Hermitage. Its solid houses and neatly laid-out gardens (*Vegetable Garden at L'Hermitage*, 1867, Wallraf-Richartz-Museum, Cologne) offered quasi-classical compositions reminiscent of Jean-Baptiste-Camille Corot's Italian studies, against the background of the steep Jallais Hill (Fig. a). Most of the town's income was derived from the well-exposed fields visible in the distance, from which local farmers exported produce to the city. Pontoise was a place of relative well-being, served by both the railway and a small port on the river. One of a small group of large paintings Pissarro made at the time, hoping to exhibit at the Salon, *L'Hermitage* achieved a balance between the unity and clarity he had learned under Corot and the avant-garde brilliance and contemporary presence produced by Impressionist colour. Whereas *Jallais Hill* showed a bourgeois couple strolling along an open country road, *L'Hermitage* is located in the village. In the foreground, a prosperous mother out walking with her daughter, both dressed fashionably for summer, stop to talk with a village lady, possibly the mother of the two children sitting on the grass. Figures going to and from work or carrying errands are in the background. A man in a blue office clerk's smock stops to greet another who is behind his garden fence. The latter may be tending his roses, visible to the right. The smoke issuing from the neighbouring house might indicate lunchtime. There is no sense of either discord or social segregation, or that such issues might be significant, as they would be for the urban *flâneur*. Rather, Pissarro's modernity was aesthetic.

L'Hermitage at Pontoise, c. 1867

oil on canvas, 151.4 x 200.6 cm, Solomon R. Guggenheim Museum, New York, NY

Claude Monet's *Women in the Garden* (p. 115) was a powerful example, which Pissarro referenced through contrasting light and shade across much of his foreground. Even closer to Monet's effect is the bold patch of sunlight in *Jallais Hill*. There is also spatial compression, aided in both pictures by the hillside background, but offering slight echoes of Japanese prints. This was as close as Pissarro would come at this point in his career to the problems of figures in bright sunlight that Monet and Frédéric Bazille were confronting at the time. At the Salon of 1868, Émile Zola called a picture similar to *L'Hermitage* an example of 'the modern countryside', referring no doubt to the sense of workaday normality that defined Pissarro's harmonious vision of an ideal place to live.

Pierre-Auguste Renoir

|Fig. a| Camille Pissarro, *View from Louveciennes*, 1868–70
The National Gallery, London

|Fig. b| Jean-Baptiste-Camille Corot, *The Bridge at Narni*, 1827
National Gallery of Canada, Ottawa

Country Pleasures

One of Renoir's most exquisite early landscapes, *A Road* was painted at Louveciennes, where Camille Pissarro lived for a short time until the Franco-Prussian War, and to which he briefly returned after it was over. Renoir might have been visiting him there. It was not far from Marly, Bougival and Chatou, where Claude Monet, Alfred Sisley and Renoir often painted. Given that Pissarro painted a similar view (Fig. a), one might think the two painted side by side or at the same time. And yet differences abound. Pissarro's picture seems closer to the village and to the aqueduct built by Louis xiv than Renoir's, which is in the flowering countryside with only one house visible. They could have placed their easels at a distance from one another, or simply modified their perspectives to satisfy their different attitudes. Another difference is that Pissarro's picture still shows the strong influence of Jean-Baptiste-Camille Corot, whereas Renoir's sparkles with the lively delicate brushstrokes and bright colours for which he would be known.

In the Renoir, a fashionable couple with their daughter in what looks like their summer Sunday best stroll down a country road on a sunny day. Amid the delightful scramble of brushstrokes one discerns the father's straw hat and walking stick, the wife's black hat set off by her red parasol, and the daughter's white ribbon in her black hair and a wide red ribbon at her waist. The trees cast wonderful shadows in the foreground, leaving patches of sunlight, the motif first introduced by Monet that became a signature of Impressionist landscapes in the late 1860s and early 1870s (p. 244). Some of Renoir's brushstrokes in that area are quite broad, evoking Monet but with more pleasing liquidity to his paint.

Pissarro's view, on the other hand, is plainer. A solitary peasant with a kerchief on her head walks away – a motif often used by Corot. The shadows to the left echo Monet, as do the dabs Pissarro used for foliage. By comparison, Renoir used delicate little strokes. In Pissarro's picture the aqueduct looms large and echoes ancient Roman monuments such as one from a well-known painting by Corot, *The Bridge at Narni* (Fig. b). The motif thus gives Pissarro's view a more classical and timeless rather than specifically contemporary character. In Renoir's picture its function is more perfunctory, indicating simply the location and perhaps the purpose of his figures' trip to the country. An even closer look at Renoir's group of figures suggests another difference from Pissarro. Behind the bourgeois tourists, who are probably returning from a walk up

A Road in Louveciennes, c. 1870

oil on canvas, 38.1 x 46.4 cm, The Metropolitan Museum of Art, New York, NY

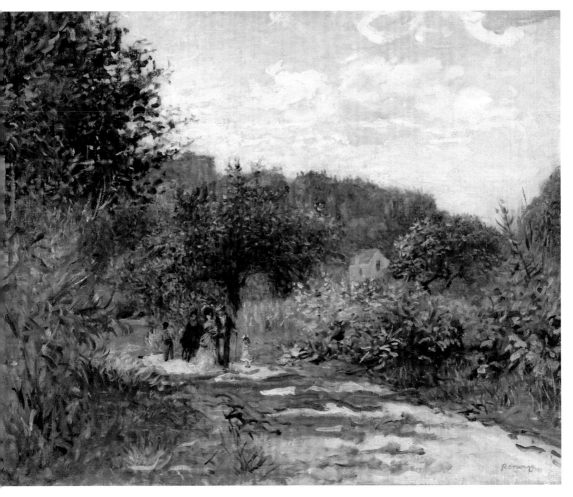

to the aqueduct, a boy with what looks to be a knapsack leads a donkey ridden by an older woman. They seem to pass without stopping, as if their worlds would never overlap, whereas Pissarro surely would have shown them in a cordial greeting, as in his earlier pictures at Pontoise (p. 245). The point is that Renoir's consciousness of class was related to a division between city folk and country peasants, a difference that Pissarro may have observed but treated in a positive manner. For Renoir, then, the countryside is a place for unfettered enjoyment by the city dwellers for whom he painted and to whose status he surely aspired. For Pissarro it was a place in which pleasure was grounded in the everyday experience of its habitual residents, whom he joined and never disdained.

Camille Pissarro

Impressionists in Exile

Pissarro's birth on the Caribbean island of Saint Thomas made him a Danish citizen without military obligations during the Franco-Prussian War. His residence in Louveciennes, southwest of Paris, was in the path of advancing Prussian soldiers encircling the city and laying siege. He fled to London in December 1870. When foreign troops were billeted at his studio, all but forty of some fifteen hundred pictures were destroyed.

Pissarro settled in Upper Norwood, south London since both his widowed mother and his brother Alfred were living nearby. There was a sizeable Jewish community there although Pissarro himself was not religious. In fact, in 1860, he had begun living with Julie Vellay, his mother's Catholic maid. They finally tied the knot in the Croydon Register Office in June 1871.

|Fig. a| Claude Monet, *Green Park, London*, 1870-1, Philadelphia Museum of Art, PA

Upper Norwood was a new suburb with simple but comfortable houses (many since destroyed to make way for public housing) next to the Crystal Palace, which had been relocated from Hyde Park, where the Great Exhibition of 1851 originally took place. It was a marvel of iron and glass construction (Pissarro, *The Crystal Palace*, 1871, The Art Institute of Chicago, IL) worth preserving for tourism. A special rail link called the High Line made it accessible from London, while facilitating Pissarro's commute to the city too. During that period he was in touch with Claude Monet, who also fled France, his family having paid for a military substitute. (By contrast, Édouard Manet, Edgar Degas and Gustave Caillebotte were National Guardsmen, Frédéric Bazille was killed and Pierre-Auguste Renoir trained warhorses in the Pyrenees.) It was also in London that they met Paul Durand-Ruel, the first dealer to support Impressionism.

Pissarro wrote that Monet was painting superb studies of London fog (Fig. a), whereas Pissarro painted only around where he was living. Yet the variety of views he obtained within that limited radius is impressive. In addition to the Crystal Palace and Lordship

Fox Hill, Upper Norwood, 1870

oil on canvas, 35.3 x 45.7 cm, The National Gallery, London

Lane train station (p. 160), both of which were buildings with special functions, he made many views of plainer places (p. 250). Among the earliest following his arrival were a few snow scenes. This one looks up Fox Hill in Upper Norwood, affording the viewer not only a view of the village but a sense of its hillside location, emphasised by the somewhat awkwardly rendered bend in the road at the picture's centre. The high vantage point suggests it was done from a window from the painter's room. Under the clearing clouds some prosperous residents out for a stroll in the new neighbourhood seem to appreciate the snowfall, rare in December in this part of England. The women have their heavy shawls, and the gentleman is wearing a scarf and boots. They engage in friendly greetings. Many of the houses have their fires going to keep them warm. The picture is most remarkable for its pleasing colour combinations. Although low-key, there is nothing dull about the browns, beiges and touches of red ochre, which are subtly complemented by the grass showing through the snow and muted green fence. Pissarro's picture exudes his pleasure in this new and sheltering, if temporary, home.

Armand Guillaumin

|Fig. a| Paul Cézanne, *View in Île-de-France*, c. 1876–9, private collection

|Fig. b| Camille Pissarro, *Street, Upper Norwood*, 1871
Neue Pinakothek, Munich

Plain and Colourful

Like Camille Pissarro, Guillaumin had an eye for
the ordinary, but unlike his friend, he used colour in
unprecedented ways. His most original works were
industrial views (p. 140), but *Plain of Bagneux* is
one of his most beautiful mainstream Impressionist
landscapes. The location is the suburb south of Paris
where Guillaumin painted several other pictures (p. 144
and p. 160). In the background are the Panthéon and
church towers that might be Notre Dame. Bagneux had
been the site of a bloody battle between the Prussians
and defenders of Paris, but unless the field to the right
is a burial ground, later to become Paris's third largest
cemetery, there is little reminder of such events.
Guillaumin was sometimes accompanied by Paul
Cézanne, who also chose plain, if compositionally
more interesting, motifs, such as a view framed by trees
(Fig. a). *Plain of Bagneux*'s gorgeous colours include
pinks and violets as well as an azure sky with puffy
white clouds. The shadows in the foreground are highly
adventurous, if not eccentric, with overtones of orange
and purple that Guillaumin would so accentuate later in
his career that he prefigured Fauvism. The picture shows
a bourgeois couple in a carriage and a worker travelling
towards the painting's left. This sharing of pictorial space
by members of different social classes was a motif
among those working in Pissarro's environment (p. 244),
but here they do so anonymously and without greeting.
The juxtaposition of modes of transport is a socially
conscious observation of such differences.

By 1874 these were well-known Impressionist themes
and pictorial devices (p. 246). But despite what might
seem an indictment of Guillaumin as a follower rather
than a leader and *Plain of Bagneux* as derivative,
one could say that it represents, so to speak, the
temperature of Impressionism at the time. Moreover,
there is no mistaking Guillaumin's particular take on
the Paris outskirts. Unlike most Impressionist scenes of
village streets with neat houses, bucolic views, flowery gardens, sailing boats and so
on, Guillaumin's landscape is chaotic and undeveloped. New housing is grouped to
the left, a field is to the right, and in between is a place where wild flowers grow freely.

Promenade on the Plain of Bagneux, 1874

oil on canvas, private collection

By contrast, Pissarro's *Street, Upper Norwood* (Fig. b) is colouristically more plain.
It is an ordinary cold and windy day: in the carriage, the couple are bundled up,
with scarves and a blanket on their knees. The women in the street have their woollen
dresses and shawls in muted colours. No buds are visible on mostly barren trees, only
old leaves from the previous season. The painting's beauty lies in its tranquil simplicity,
of which Pissarro is the master. His palette is dominated by browns, beiges and russet
tones, punctuated here and there by a spot of blue or red that provide focal points
while bringing out the other colour harmonies and calling attention to social distinctions
between inhabitants of recent homes and village natives. He and Guillaumin, therefore,
depict complementary sides of everyday reality.

Alfred Sisley

|Fig. a| Gustave Caillebotte, *The Bridge at Argenteuil and the Seine*, c. 1883
Private collection

|Fig. b| Hippolyte Collard, *Pedestrian Passage under the Viaduc d'Auteuil*, 1860s
Bibliothèque nationale de France, Département des Estampes et de la
Photographie, Paris

British Engineering

Two complementary aspects of British culture were of special interest to the French: industry and sport. During his visit to England under the patronage of the celebrated baritone Jean-Baptiste Faure (p. 58), Sisley made pictures related to both. While observing and painting the regattas on the Thames (p. 282), he had occasion to paint the third oldest cast iron-bridge in England, at Hampton Court. Its five spans of girders supported by paired brick and iron columns were designed in 1866 by the engineer E.T. Murray. The present bridge now bears his name. Not visible in this picture are posts at its ends that look like medieval turrets.

The composition is unique in Sisley's oeuvre, reminiscent of certain viewpoints chosen by Edgar Degas, except that the latter did few outdoor scenes. Even Japanese prints have nothing quite so bold. Gustave Caillebotte, who had joined the Impressionists in 1876, offers a later analogy (Fig. a), for he admired the picture when he saw it after Sisley's return. The only likely precedent is in photography, when photographers made records of new infrastructures. Some such images (Fig. b) adopt the aesthetic of architectural or engineering drawings from which the structures were built.

The initial shock of Sisley's apparent stringency is mitigated by several factors. One is that the perspective is slightly skewed at the left, another is that the outlines of its powerful piers and horizontal struts are painted by hand rather than with a straight edge, as they would be in an engineering drawing. Light and shade modulate the supports, to say nothing of their reflections in the water. The streamlined curves of the empty single scull near the foreground echo the arcs of the bridge's vaults, while also suggesting that our view is a privileged one, accessible only by water. If we count the visible bays, it seems there may be another one behind us. It is as if a painter-sportsman has introduced us to a world where only those like him have access.

On the river are scullers who are probably there for training, since the rowing competitions were contested in full gear. On the riverbank is the Mitre Inn and at the

Under the Bridge at Hampton Court, 1874

oil on canvas, 50 x 76 cm, Kunstmuseum Winterthur

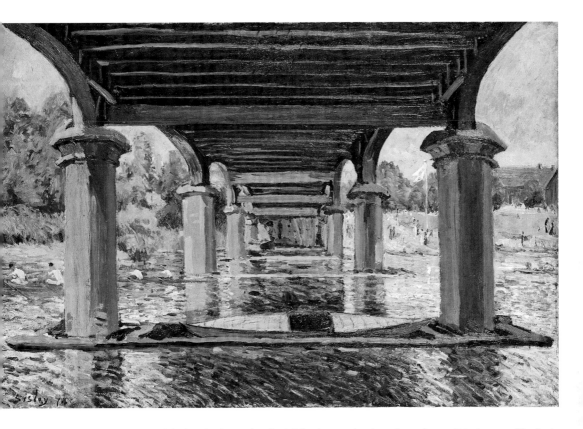

right-hand edge a pier. Certainly pleasure boaters abound as well, but many of the inn's guests, including many women, have come just to watch. By comparison, Caillebotte's view has industrial traffic on the river at Argenteuil and a factory in the distance.

Faure paid Sisley's expenses in exchange for six paintings, of which the artist ultimately made sixteen. Such groups were not unknown in Sisley's circle, but this one was more numerous than, for example, Monet's ten pictures of Le Havre harbour (p. 24 and p. 33), made over three or four years. Yet Sisley's group is not a series, since the latter is defined by more or less identical subjects and their simultaneous exhibition in a large number. Clearly time and opportunity led Sisley to make a relatively unified ensemble, looking ahead to a phenomenon Impressionism would make famous.

Pierre-Auguste Renoir

|Fig. a| Pierre-Auguste Renoir, *Ravine of the Wild Woman, Algeria*, 1881
Musée d'Orsay, Paris

|Fig. b| Paul Cézanne, *Rocks at L'Estaque*, 1882–5
Museu de Arte de São Paulo

Wild and Free

Flush with money from sales to the dealer Paul Durand-Ruel, Renoir decided to travel to North Africa and Italy, in that order. Both trips had an important impact on his work. In North Africa he discovered lush colours and blinding light; in Italy, he discovered the Renaissance with its simple outlines and solid forms (p. 230). On the way back, he visited Paul Cézanne in Provence. Together, they painted some landscapes of the rocky terrain behind the small Mediterranean port of L'Estaque, near Marseille (p. 142). Renoir's painting of the scene is fascinating for the changes and new ideas it embodies.

Travel allows both for escape and for discovery. Already in the early 1880s both Renoir and Claude Monet had begun to seek new motifs. Renoir was already fascinated by the so-called Orient when he did his *Woman of Algiers* in 1870 (p. 119), but he had not yet had a direct experience of the actual place. He must have found the women there less exotic than imagined – that is, if he was allowed to see them – for the landscapes he made were by far the most interesting result. One spectacular example shows the so-called Ravine of the Wild Woman (Fig. a), which recalls Western fantasies by its name, but in reality was an extraordinary stimulus for wild painting, so to speak. Although he worked directly from the motif, it is doubtful Renoir felt constrained by things he knew or what others' judgment. The picture is alive with colour and spreads attention all over the canvas surface in a kind of visual fireworks.

In Italy, on the other hand, Renoir had been impressed by the classical permanence of Renaissance forms. In his *L'Estaque* he attempted to combine the two experiences. Compared to Cézanne's far simpler composition (Fig. b), in which boulders and ledges seem powerfully constructed, as if sculpted in paint by his methodical brushstroke, Renoir's brush wants to encompass everything – trees, rocks, shrubs, dried grasses and sky – yet with a genuine feel for the rough terrain and the rocks' sharp edges. Historically all three paintings imply the beginnings of a turning point in Impressionism

Rocky Crags at L'Estaque, 1882

oil on canvas, 66.4 x 81 cm, Museum of Fine Arts, Boston, MA

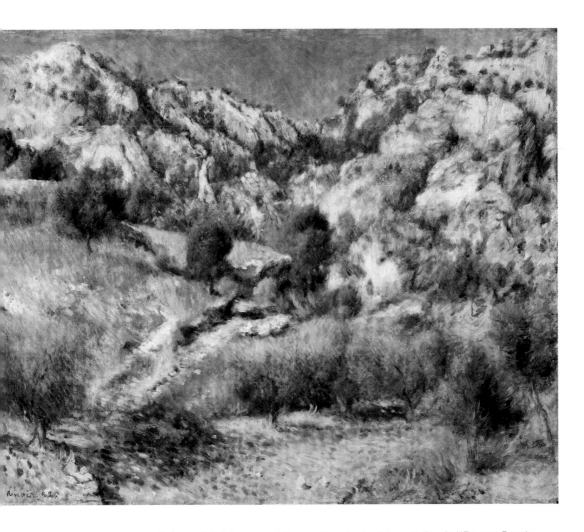

between faithful representation and imaginative interpretation. In *L'Estaque* Renoir shows a greater feel for non-decorative aspects of the environment than in *Ravine*, although the two pictures are equally exciting to the eye. The puffy, blurred quality of patterns of light and semi-transparent shadow produced by the North African sun has disappeared into crisper, more focused outlines under the dry winter light and air of the more arid land behind L'Estaque's rocky hills. The difference between Renoir's two pictures, done almost exactly a year apart, must be the trip to Italy, as well as Cézanne's own attempts to reconcile Impressionist technique with solid forms. Renoir, too, would eventually simplify, as in what he called his 'sour period' (p. 292 and p. 328). Here he feels the elation of new discoveries, however contradictory, and in the presence of an artist friend many would consider Renoir's opposite, he tried to bridge their differences.

Claude Monet

|Fig. a| Claude Monet, *Fisherman's Cottage on the Cliffs at Varengeville*, 1882
Museum of Fine Arts, Boston, MA

Diamonds and Parasol Pines

The 1880s was a period of searching for several of the Impressionists, most of all Monet. As he reached better exposure through Durand-Ruel, his finances improved and he was freer both to travel and choose his motifs. He returned often to the Normandy cliffs and beaches, but in 1884 he journeyed southwards to the sunny Mediterranean where the sun-lacking British, followed by the French, had already discovered ancient fishing villages and begun building villas, as in Monet's picture of a house designed by Charles Garnier, the architect of the Opéra, for a Parisian patron (*Villas at Bordighera*, 1884, Santa Barbara Museum of Art, CA). The Italian Riviera and the French Côte d'Azur were born as popular seasonal destinations.

On 17th January, Monet departed by himself for Bordighera, a town of about 2,000 inhabitants. Without his family, Monet cannot have intended the trip as a vacation. Workaholic that he was, he made some 40 paintings there. To read his letters to Alice Hoschedé, with whom he was living following the death of his wife, Camille, work was a constant battle: 'It's a fairy land, but very difficult; you need a palette of diamonds and precious stones.' He couldn't believe the colours he was 'forced' to use! The results were spectacular.

Bordighera has one of Monet's more unusual vantage points. The *città alta* (the historic centre perched up high) is flooded by intense early spring light. The bright blue water still seems cool from winter and the air is clear, at a time before the oppressive summer heat. The town is framed by delightfully rhythmic twisting tree trunks as the painter

looks out from a clearing above the dense forest of parasol pines below. A fuller range of colours and contrasts is demanded than in the north. There are few precedents in Monet's landscape pictures for the pastel pinks and yellows seen here.

An interesting recent development in Monet's work was the comma-like brushstroke prominent in the foliage. It responds both to the clump-like groups of pine needles and to the constant movement of the practically year-round breezes, so say nothing of the famous mistral wind when it blows. The technique also introduces a more animated response to new stimuli than the straight strokes, dabs and patches suitable for Paris and its environs. Monet had used the technique in some pictures of the Normandy coast made in the early 1880s, but more broadly and loosely, for the tall grasses and shrubs on top of the cliffs at places such as Pourville and Varengeville (Fig. a). It is as if not just colours but the air itself was more vibrant in the south.

Paul Gauguin

|Fig. a| Paul Gauguin, *Nude Study, Suzanne Sewing*, 1880
Ny Carlsberg Glyptotek, Copenhagen

Caribbean Creativity

Gauguin exhibited at all the Impressionist exhibitions from 1880 onwards. He had met Camille Pissarro in 1874 and later joined him, Armand Guillaumin and Paul Cézanne as part of the 'School of Pontoise' group within Impressionism. In 1881 he attracted particular notice with his *Nude Study* (Fig. a), which seems to combine effects from Édouard Manet, Edgar Degas, and even Pierre-Auguste Renoir's flesh tones, but with South American paraphernalia that testified to Gauguin's partly Peruvian origins and with glowing colour that would eventually become his trademark. Following the stock market crash of 1882 he left the lucrative position as an exchange agent that he had obtained through family friends. He decided to devote himself entirely to art.

Gauguin already had travel experience, as both a former expatriate and a sailor. In 1886, following a trip to Brittany, which was considered France's most remote and backward province, he left with his painter friend Charles Laval for Panama. He eventually landed in Martinique. Like Renoir's exposure to North Africa (p. 254) and Monet's to the Riviera (p. 256), Gauguin's experience of tropical light and vegetation was transformative. Already when in Brittany he had experimented with bold patches of colour, sometimes using the 'constructive stroke' he admired in Cézanne (p. 316), sometimes outlining his patches boldly as in Japanese prints (Fig. b). This particular Martinique landscape is unusual within the group Gauguin made because it deliberately combines a highly stylised foreground, exemplifying his new direction, and a more realistic background. Against the deep blue water and the active volcanic peak of Mount Pelée, the foreground looks like a flattened and abstracted patchwork tapestry. Its different shapes are distinguished from one another by parallel brushwork at different angles. Gauguin knew Cézanne's work and had even purchased a few of his paintings. His main difference from the latter was that his colours were contrasting rather than closely related, and they glowed with the soothing hues of a warm, enveloping tropical paradise. Pinks, blue-greens, chartreuse, lavender, yellows and oranges evoke exotic vegetation rather than describing specific plants. Gauguin had already told another comrade, Émile Schuffenecker, that the artist should 'close his eyes and dream before nature rather than copy it directly'. Hence the deliberate contrast between foreground and background stands for the process of reconstructing nature from memory, infusing it with the artist's own feelings and ideas. By 1887, in fact, Symbolism had become the latest current in literature, and Gauguin had begun adopting its principle of subjectivity as a critique of pure Impressionist naturalism. In this he was far from alone, as all sides began looking for

|Fig. b| Paul Gauguin, *Breton Landscape with Shepherdess*, 1886
Art Gallery, Newcastle upon Tyne

Martinique Landscape, 1887

oil on canvas, 115 x 88.5 cm, National Galleries of Scotland, Edinburgh

alternatives. For the Neo-Impressionists, Impressionism was not objective enough; its technique was too indebted to tricks of the hand. For the Symbolists, it was too impersonal, insufficiently informed by inner thought and emotion, which had to be conveyed through anti-naturalist devices. Although *Martinique Landscape* bears many traces of Impressionism, it marks Gauguin's confidence in his new Post-Impressionist formulation (p. 344 and p. 378).

Claude Monet

Never the Easy Way

The Creuse valley had attracted painters and poets since the 1830s. In 1889 a friend of Monet's, the critic Gustave Geffroy, invited him to Fresselines, where they joined the poet Maurice Rollinat. Monet was so excited by the steep valleys, deep woods and wild rivers that converged nearby that he rushed back to Giverny to get his equipment. He returned to stay there for three months, during which he produced twenty-three canvases, his first major series exhibited as such. Three untamed rivers, the Creuse and its tributaries the Sédelle and Petite Creuse, flowed freely at the time – a dam was built

|Fig. a| Claude Monet, *Antibes, Afternoon Effect*, 1888, Museum of Fine Arts, Boston, MA

in the 1920s – creating rushing sounds and driving water mills on their way to the Atlantic via the Loire. The region became especially well known when the writer George Sand took a house in Gargilesse in 1857, several kilometres downstream. Several years after Monet, Armand Guillaumin took up residence at Crozant (*The Sédelle Valley, near Crozant*, c. 1898, The Cleveland Museum of Art, OH), returning frequently almost to the end of his long career.

It was Monet's second trip to a dramatic landscape. After sun-filled Bordighera (p. 257) in 1884, he went in 1886 in the opposite direction, painting the jagged rock formations at Belle Île, off the Brittany coast (p. 264). As if alternating between the melodramatic and the idyllic, his next trip was to Antibes in 1888 (Fig. a), where the sun again dissolved forms such as the town's fortifications and where he rendered the Maritime Alps sketchily rather than in their powerful mass. In the Creuse valley pictures, Monet returned to the spectacular. The Creuse was dramatic in unusual ways. The Neo-Impressionists' obsession with geometry led Monet to see simpler, bolder shapes in nature than before, and Monet's surfaces, thicker and more heavily worked than in previous pictures, convey the interplay of sunlight and the inhospitably steep ravines through which the rivers flow. The rough white waters of rapids are indicated through horizontal strokes of white modulated by blues and pinks. Lavender-pinks are especially prominent, freely interpreting the raking light of early morning, exposing the harshness of the terrain and contrasting with the puffy clouds in the bright sky. Near the high horizon, houses and trees are barely distinguishable, engulfed it seems by prismatic effects of the sun.

Valley of the Creuse (Sunlight Effect), 1889

oil on canvas, 65.1 x 92.4 cm, Museum of Fine Arts, Boston, MA

Like Pierre-Auguste Renoir, Monet was a sponge, absorbing elements from other artists while never giving away his own originality. The glowing colours make one think of Paul Gauguin's Brittany and Caribbean scenes, and the small, fragmented, labour-intensive brushstrokes might be a response to Georges Seurat's pointillism. Yet these influences are so fully integrated and powerfully justified by topographic and atmospheric effects that one must be reminded that Monet's effort was not just to represent an amazing natural state of landscape, but also to remain at the cutting edge of modern painting. In order to do so, like his contemporaries, he would turn increasingly to personal interpretation conveyed through intensified colours and heightened effects of vibrancy. Yet he would never 'close his eyes and dream before nature', as Gauguin would have advised. For him, that would have been too easy.

Claude Monet

|Fig. a| Claude Monet, *Mont Kolsås (Rose Reflections)*, 1895
Musée d'Orsay, Paris

|Fig. b| Katsushika Hokusai, *Inume Pass in the Kai Province*, 1826–33

|Fig. c| Claude Monet, *Houses of Parliament, Fog Effect*, 1903
High Museum of Art, Atlanta, GA

Snowbound

In 1895, Monet spent two winter months in Norway with his stepson, Jean-Pierre Hoschedé. The latter had married a Norwegian woman and was going to Kristiania (now Oslo) for business. Scandinavian cultural figures such as Strindberg and Ibsen were much in vogue during the 1890s, and young painters such as Frits Thaulow and Edvard Munch came to France to experiment with Impressionism. Among several places Monet visited was Bjoernegaard, at the foot of Mount Kolsås near Sandvika, a village on the fjord, about ten kilometres west of Oslo. Monet revelled in painting snow scenes (p. 114), and Norway presented a new challenge he relished but probably never anticipated. Unlike Norwegian painters who had an established art colony in Sandvika, Monet insisted on working outdoors despite, according to his own account, icicles 'like stalactites' forming on his beard. Unable to ski, Monet painted mostly snowbound houses rather than more remote places of the kind he often sought.

Among the views Monet made of Mount Kolsås some are so abstract, flattened and summary they appear unfinished (Fig. a). For Monet, however, the mountain reminded him of Japanese prints of Mount Fuji (Fig. b), which he had been collecting, and so the effects of such pictures were deliberate enough for him to sign many of them. He would explore similar floating effects on later trips to London, as in *Houses of Parliament* (Fig. c) whose masses are dematerialised by ethereal renderings of mist. *Red Houses* is one of Monet's few Norway compositions with bold, bright colour. Signed with the signature stamp fabricated by his son Michel in order to authenticate works that remained in the studio at his death, the painting is probably not complete. Monet often finished, signed and dated pictures only when he was ready to exhibit or sell them. It is not that his process was based on commercial motivations alone, for by 1895 his success was secure. Rather it signifies that finishing touches could wait while the workaholic in him moved on to the next interesting motif.

Red Houses at Bjoernegaard, Norway, 1895

oil on canvas, 65 x 81 cm, Musée Marmottan Monet, Paris

These buildings form the courtyard of a farm. A cosy house stands to the left with stables and farm buildings to the right. No smoke rises from the house's chimney, but a pile of firewood is at the left edge. A few logs lie nearby in what might have been more a compositional choice for balance and framing than actually observed. The blue strip in the foreground indicates that Monet was working either from a window or with a building at his back. It is a pale echo of the blue background, which could be either darker shadow on snow or bright sky with clouds. Such confusion might explain why Monet never finished the picture, or, to the contrary, why he kept it and why it is appreciated today. For it plays with ambiguities that, beginning with Impressionism, are often characteristic of modern art.

Alfred Sisley

Water off a Rock's Back

After the 1870s Sisley's work was probably the least original among the Impressionists, but neither its quality nor his productivity ever flagged. Like Claude Monet and others, he sought new motifs, often following in their footsteps. For example, long before Sisley discovered Lady's Cove (now Rotherslade Bay), in south Wales, Monet had produced his group from Belle Île (Fig. a), where jagged rock formations and stormy seas provided him with novel inspiration. In letters to Alice Hoschedé and Gustave Caillebotte, Monet depicted himself heroically battling with the elements. Bold brushstrokes seem to lash the canvas as waves batter the coast, while certain rocks, animated by Monet's ever-active tones of light and shade, seem to rise up in defiant protest.

|Fig. a| Claude Monet, *Stormy Sea at Belle Île*, 1886, Musée d'Orsay, Paris

Sisley had neither a heroic view of himself, nor Monet's original vision. His compositions of the church at Moret (*Church at Moret after the Rain*, 1894, Detroit Institute of Arts), magnificently luminous and monumental as they are, have nothing of the path-breaking novelty of the Rouen Cathedrals (p. 380). Although born to a wealthy family, Sisley had no other resource than his painting after his father's silk business failed in 1870. Discouraged after many years of being attacked by critics or ignored, he finally had a retrospective at the luxurious gallery of Georges Petit in Paris in 1896. Only two critics reviewed it, and it failed financially.

A visit to England in 1897 promised a breath of fresh air. It was backed by the Rouen manufacturer François Depeaux, whose collection is now the core of the Rouen museum's Impressionist treasures. In declining health and poor spirits, Sisley had become difficult and irascible. A trip to Wales seems to have done him good. In Cardiff he finally married his long-time partner and the mother of his two children, the Breton Eugénie Lescouezec. They stayed at the Osborne Hotel, built over a cave with prehistoric remains at the edge of a cliff overlooking Lady's Cove at Langland Bay, a few miles to the west of Swansea and forty miles west of Cardiff on the Gower Peninsula. The beach is now one of British surfing's favourites.

At the seaside, the huge boulder called Storr's Rock captured Sisley's attention, and he pulled out the stops for views in which he set it against its surroundings. *The Wave*

The Wave, Lady's Cove, Langland Bay, 1897

oil on canvas, private collection

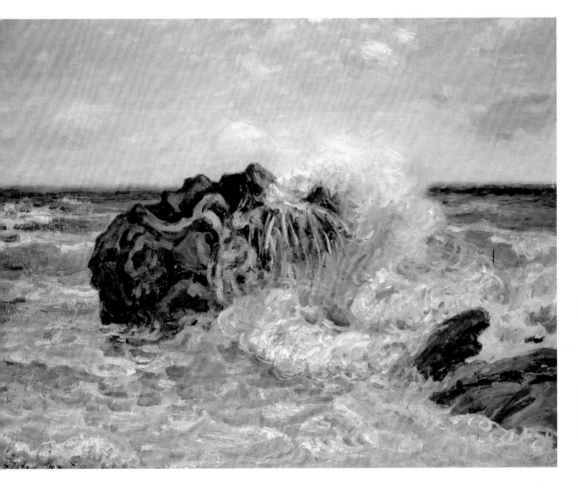

is undoubtedly the most spectacular, the most comparable to Monet, but also with the greatest interpretative possibility. For, since the boulder stands fast against the waves that batter it, there might be a bit of the self-portrait underlying the picture's conception. Sisley's brushstrokes come to life describing the pounding surf. Attacked by a huge wave from the right, Storr's Rock calmly stands its ground. Water rolls off its back as if it shrugged its shoulders. Purplish colours suggesting shadows cast by its rugged features mix with whites and blues of seawater draining from its surface before another wave hits. Swirling sand mixes with the water at its base. Given that Monet's views were taken from the cliffs above Belle Île, not since Gustave Courbet had a master so vehemently shown the power of the ocean directly at its shoreline.

Claude Monet

The Living Outdoor Still Life

Never has the art of gardening been represented so seductively as in Monet's paintings of his own garden at Giverny (situated between Paris and Rouen). In 1883 he rented what would become his permanent home in 1890, when the owner offered it to him for purchase. *Path in the Garden* shows the original garden before Monet added to it in order to create a lily pond. The view is down the main pathway leading to the steps of the house. The garden was designed as grid, a bit like in a nursery, so that access to each plot, whether for planting, viewing or strolling, would be easy. Over a number of years it replaced the original orchard behind the house. One imagines Monet as the relatively new gardener, who wants to include as many species as available.

Moreover, just as he was filling up his surfaces more and more, as in the Rouen Cathedral series (p. 380), where the sky hardly appears, paintings of his gardens look down pathways or onto flowerbeds, framed on three sides by vegetation, revelling in the beauties nature can produce when guided by the hand of man.

Painting and gardening are parallel activities. Paintings of man-made gardens are a bit like still lifes prearranged by the artist in his studio – hence works of art, so to speak, before they are painted. Monet's gardens are like living still lifes – the opposite of the French *nature morte* – set in the studio of the outdoors. Just as Monet was careful about his choice of colours for his palette, he was careful about the flowers he would choose. Many letters to his gardener demonstrate the degree to which he took an interest in various species and sought specific characteristics. Moreover, the range of colours, details and patches of light and shade are so varied that he could forgo the imaginative

|Fig. a| Claude Monet, *Grainstack (Sunset)*, 1891
Museum of Fine Arts, Boston, MA

colour and compositional interpretations of the pictures from the Creuse valley, the Haystacks (Fig. a) and the Rouen Cathedrals. There is plenty of visual stimulus and complexity without the liberties of the 1880s, 1890s or eventually the *Water Lilies* (p. 391).

Among the many types of flowers in the garden, roses were dominant. Monet had them in beds as well as growing up trellises, which in certain key locations formed arches over the paths. Other favourites were clematis (another climber), purple irises, peonies and chrysanthemums. With such choices, clearly the idea was that there would be flowers for as much of the flowering season as possible.

Yet, despite what seems a relatively straightforward description of his garden and his ostensible isolation at Giverny, Monet must have been conscious of artistic trends around him. Can it be an accident that Pierre Bonnard and Édouard Vuillard (p. 371 and p. 394) had been experimenting with decorative effects, whether outdoors in gardens or indoors with floral wallpapers and upholstery? Floral motifs are dispersed across many of their canvases to translate the popularity of fashionable overstuffed interiors.

Path in the Garden at Giverny, 1902

oil on canvas, 89.5 x 92.3 cm, Österreichische Galerie Belvedere, Vienna

Vegetal motifs were at the heart of Art Nouveau as well. If the overplanted gardens at Giverny differ radically from the austere parterres of Paris public parks or the traditional geometries of the French garden that originated at Versailles, it may be more than mere enthusiasm or a will to the natural and the free. The artistic context surely had a role as well, for Monet was never one to allow a trend to get ahead of him.

Sport and
Outdoor Leisure

Frédéric Bazille

|Fig. a| Gustave Courbet, *The Quarry (La Curée)*, 1856
Museum of Fine Arts, Boston, MA

|Fig. b| William Bouguereau, *Nymphs and Satyr*, 1873, The
Sterling and Francine Clark Art Institute, Williamstown, MA

Bathing with the Classics

On a bright summer day on the banks of the river Lez, which ran along the Bazille family's property (p. 62), seven youths frolic and swim. They are joined in the background to the right by an eighth, who drops his jacket on the ground and begins removing his shirt. In the foreground a bearded youth has already donned his trousers and is helping a friend out of the water. Another lounges in the shade while two boys wrestle in the sunlit clearing at the composition's centre. To the left, in a pose reminiscent of Gustave Courbet's presumed self-portrait in *The Quarry* (Fig. a), a young man leans dreamily against a tree. The wrestling pair, too, might allude to Courbet's famous picture on the theme (1852–3, Szépművészeti Múzeum, Budapest), except that the latter's fighters were professionals.

The variety of activities afforded Bazille the opportunity to study male anatomy in various positions, but the ostensible randomness through which he hoped to convey the naturalism of leisure resulted in an awkward pastiche. The effect is confirmed by poses reminiscent of old master paintings, a few of which have been identified from the Montpellier collections Bazille was fond of visiting. The reclining figure in particular was directly inspired by a painting of a shepherd playing the flute by the 17th-century painter Laurent de La Hyre, now in the Musée Fabre in Montpellier. The Courbet-like figure also suggests a martyred Saint Sebastian, which Courbet himself may also have had in mind (Fig. a). In Bazille's case, however, the only possible candidate for a resemblant self-portrait might be the figure extending a hand to his friend.

The popularity of bathing, holidays and leisure provides the context for the painting's effort to echo modern life. Moreover, the increasing mobility of urban dwellers thanks to railways made the balmy South of France accessible. Bazille exploits this trend by showing that for those who actually live there its pleasures are part of daily life. With the exception of Édouard Manet's *Le Déjeuner sur l'herbe* (p. 23), originally entitled *Le Bain (Bathing)*, where a woman is wading in the river, few beach or leisure scenes actually focused on a single figure in the water. So with its wrestlers added for good measure, Bazille's picture is as much about sport as leisure, in contrast to the *Déjeuner*. What they do have in common is classical poses appropriated to the contemporary realm.

Yet Bazille's style also shows the effects of outdoor study with Claude Monet and Courbet. Sunlight and shading effects as well as ripples on the water are reminders of developments since the Salon des Refusés scandal. Yet, following the success of *Family Reunion* (p. 63), Bazille's bodies are more crisply defined and tightly packed, and the landscape more finished than Monet's in what might be considered a more Salon-oriented male sporting version of Monet's twice-rejected *Women in the Garden* (p. 115). Compared to cloying academic versions of female water frolics (Fig. b),

Summer Scene, 1869

oil on canvas, 160 x 160.7 cm, Harvard Art Museums, Cambridge, MA

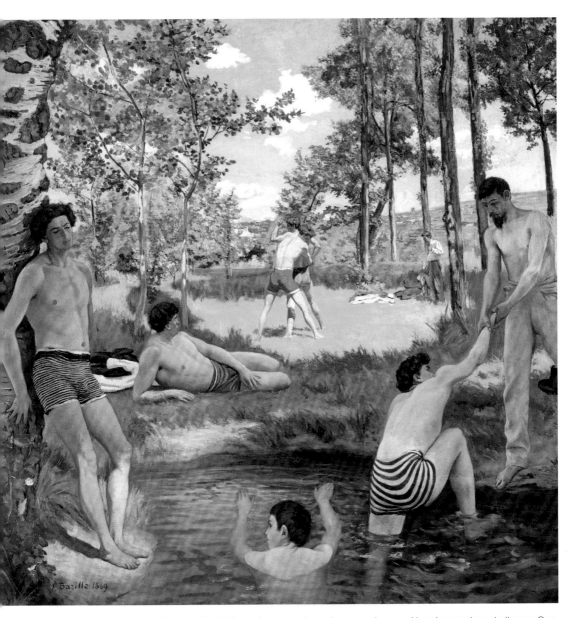

however, Bazille's study comes through as a serious and bracing modern challenge. One might observe, nevertheless, that at the same time as *Summer Scene*, Monet was making unprecedented and radical decisions about summer swims at La Grenouillère (p. 272). Bazille died in a Franco-Prussian War battle, so one can only wonder how the dialogue between the two friends would have continued.

Claude Monet

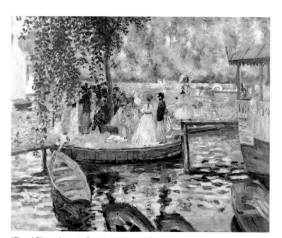

|Fig. a| Pierre-Auguste Renoir, *La Grenouillère*, 1869
Nationalmuseum, Stockholm

|Fig. b| Claude Monet, *Bathers at La Grenouillère*, 1869
The National Gallery, London

Frogland Frolic

In the summer of 1869, Monet and Pierre-Auguste Renoir (Fig. a) set up their easels side by side at the popular *guinguette* (outdoor bistro) and bathing spot at Bougival called La Grenouillère (literally, a place full of frogs). It was just upstream from Le Port-Marly, which as painted by Pissarro (p. 183) shows a far less bucolic environment. Both Monet and Renoir did a few paintings there, which if placed end to end might suggest a quasi panorama (Fig. b). Monet's intention was again to make a large composition suitable for the Salon, as he had tried with his *Le Déjeuner sur l'herbe* (p. 23) and *Women in the Garden* (p. 115). He found his large sketches more interesting, however, as well as worthy, and thus never carried out the project on a larger scale. Nor did he again work towards official exhibitions. In 1870, before the outbreak of the Franco-Prussian War, Monet, Frédéric Bazille and others were already planning an independent show. After the battles were over, the first one became reality in 1874. The restaurant built over the river is to the right, with boat rentals in the foreground. Some bathers are in the water, and at the centre on a circular jetty men and women socialise. Monet's geometry echoes his earlier *Terrace at Saint-Adresse* (p. 25), around whose circular parterre Monet staged figures, flowers and the views of ships outside the harbour. In *La Grenouillère*, too, what surrounds the jetty seems more important than interaction among the figures on it. Reflections shimmer, the rowing boats offer simple and colourful forms cut off in the foreground *à la japonaise*, and the sunlit poplar trees

|Fig. c| Jules Pelcoq, *A La Grenouillère*, 1875

along the opposite riverbank are painted so broadly that, unlike in the Renoir, there is more a sense of their ensemble as a limiting element to the space rather than of their individuality and delicate foliage.

Renoir, on the other hand, paid more attention to social interactions: he is closer to the jetty, and the murmuring figures are painted with finer brushes that allow for greater detail. For example, who would have guessed that the horizontal stroke of white in the foreground of Monet's

SPORT AND OUTDOOR LEISURE

La Grenouillère, 1869

oil on canvas, 74.6 x 99.7 cm, The Metropolitan Museum of Art, New York, NY

circle stands for a small dog resting, as the Renoir reveals! Renoir, by contrast, is less successful in making wider, more Monet-like horizontal brushstrokes convey rippling reflections. Some seem just to sit on the surface without participating in the illusion. La Grenouillère was so fashionable that Napoleon III and Empress Eugénie dropped in for a visit. However, it was in reality a place for more youthful and unattached members of the bourgeoisie, popular enough that it appeared in illustrated journals (Fig. c) and caricatures. In popular lingo, in fact, the word 'frog' came to stand for the kind of girl who might be looking for a friendly toad. In any case, this pleasure place was the source for Monet's increasingly fragmented brushstroke, appropriate not only for catching ripples on the water but for embodying the spontaneous vision for which Impressionism would be known. Allied with scenes of leisure, the technique connoted casual rather than serious, laboured effort. For its violation of professional decorum and work ethic when the same technique appeared in *Impression, Sunrise* (p. 32) or *Boulevard des Capucines* (p. 91), the new style would be attacked.

Claude Monet

Honeymoon with Flags

Monet and Camille Doncieux were wed on 18 June 1870, after which they holidayed in Trouville. The Roches Noires was one of the great luxury hotels overlooking the beach. Monet evokes its palatial architecture, framed by tower-like projections at either end, with balconies at every level so that residents, like those at the upper right, could take in fresh air along with views. The various flags indicate it as a favourite spot for international vacationers, but whether the Monets stayed there is doubtful, since at this point they were always short of money. Here, then, Monet reveals his admiration for the spectacle of wealth and fashion, which he would be able to satisfy in later years, when it no longer mattered to him as subject matter. It is also a brazen example of the new, sketch-like style he developed in Bougival (Fig. a) and at La Grenouillère (p. 273), as well as of his commitment to modern life.

Monet signed and dated the picture – hence the unfinished state of the American flag was not objectionable to him. His bold coloured strokes painted over grey ground may suggest it flapping in the wind. Perhaps the constant movement prevented him from counting its stars, and perhaps the royal blue square that should be there would have clashed with the lighter sky. Also, depending on how one counts them, there may be too few or too many stripes. Precision was unimportant in a painting with the look of spontaneity and outdoor freshness. Rather, the eye moves lightly from one form to another, like the brief gaze of the *flâneur*. That gaze, however, is skilled in evaluating its targets, as Monet deftly distinguishes figures and their gestures. The seated lady to the left frames the composition at the lower corner. Adjacent to her, a man doffs his hat as he is introduced by a woman, probably a mother, to her probably eligible daughter. In novels at the time, such introductions could be the stuff of romance whether they were suitable or not. Nor can one really know who is introducing whom to whom. A marquee in the distance is for tea or outdoor dining during the heat.

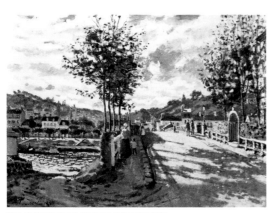

|Fig. a| Claude Monet, *The Seine at Bougival*, 1869
Currier Museum of Art, Manchester, NH

|Fig. b| Claude Monet, *The Beach at Trouville*, 1870
The National Gallery, London

The same marquee is in the background of a bold sketch of Camille (Fig. b) that Monet did directly on the beach – judging by the sand embedded in the paint. In both Trouville pictures shadows are prominent, especially that cast by Camille's parasol across her face, looking like a mask, in an echo of the reflection on her face in *Women in the Garden* (p. 115). The woman reading the newspaper to the right seems anonymous as she is partly cut off and dressed in dark clothing. She contrasts with Camille's white summer dress and flowery hat.

Hôtel des Roches Noires, Trouville, 1870

oil on canvas, 81 x 58.5 cm, Musée d'Orsay, Paris

As in *The Breakfast* (p. 194), the abandoned chair in the foreground indicates the artist's presence, as if he had just got up to catch the instant, like a snapshot. Since film exposures were not yet fast enough, nor cameras portable enough, it might be claimed that the idea of the snapshot came from Impressionism's concept of the moment rather than from photography.

Alfred Sisley

|Fig. a| Jean-Baptiste-Camille Corot, *The Bridge at Mantes*, 1868–70
Musée du Louvre, Paris

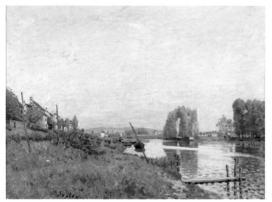

|Fig. b| Alfred Sisley, *The Île Saint-Denis*, 1872, Musée d'Orsay, Paris

A Quiet Modern Flow

Sisley's view of the bridge at Villeneuve at an acute angle from the side and below is unquestionably one of his finest works. The bridge connected Villeneuve, north of Paris where the Seine curves back on itself, to the industrial suburb of Saint-Denis. It was near the major access point of the Canal Saint-Denis, where barges could leave the Seine to head directly towards the Canal Saint-Martin, a waterway Sisley painted at least four times (p. 104) a couple of years earlier. The bridge also opened up the Île Saint-Denis, the island in the middle of the Seine across which it was built. In this picture, the island lies behind the viewer. Like La Grande Jatte, which Georges Seurat's painting would make famous (p. 188 and p. 330), the Île Saint-Denis attracted fishermen and weekend boaters, such as the two women in a hired skiff floating in the middle ground or the couple relaxing under the bridge's shadow on the village side. Small bars and restaurants flourished in the area, too.

Although not especially recent (1844), the bridge's stone and iron suspension structure exemplified engineering that was common in the 1830s and 40s and thus distinguishes it from the old-fashioned masonry bridges in the work of nostalgic predecessors such as Jean-Baptiste-Camille Corot (Fig. a). Sisley silhouettes the suspension cablework against the sky and brings the stone pier to the left-hand edge of his painting, implying an indefinite mass beyond the frame. The span itself cuts decisively across the composition, dominating its entire left side. Corot's bridge at Mantes is seen through a screen of trees, and its multiple arches slow down the eye's crossing; by contrast, Sisley's bridge advertises speed. His modernity is conveyed by angled viewpoint, brighter colour and novel handling, combined with the example of modern leisure.

Sisley's bright sunlight and patch-like, horizontal brushstrokes resemble those of Claude Monet, but Sisley has integrated them into the kind of unity one might expect from an Impressionist Corot. As other pictures from this period demonstrate (Fig. b), Sisley was as open to the latter's delicate harmonies and sense of unity as to Monet's more declarative contemporaneity. As in his picture of the temporary footbridge between Gennevilliers and Argenteuil (p. 170), where Monet lived, before

The Bridge at Villeneuve-la-Garenne, 1872

oil on canvas, 49.5 x 65.4 cm, The Metropolitan Museum of Art, New York, NY

the reconstruction of the road bridge (p. 170) was completed, Sisley deployed brushwork derived directly from his colleague while preserving a more limited palette consistent with his plainer views and duller days. Through such restraint he created a subtle alternative within mainstream Impressionism that placed him somewhere between Camille Pissarro and Monet. Before one thinks of Sisley's work as derivative from or inferior to either of the two, however, one must remember that the early 1870s was a time of searching for a combination of truthful and personal modernity. As yet unrecognised, with works virtually unexhibited, Sisley, Monet, Pissarro and others were on parallel tracks, trying out themes, colours, techniques and atmospheric effects that would satisfy each artist's commitment to painting from direct observation, modern subjects in a modern manner.

Claude Monet

The Philosophy of Water

In January 1872, Monet moved to Argenteuil, where until 1878 he and his small family rented a villa. It was only fifteen kilometres from Paris: a twenty-two-minute train ride from Saint-Lazare station. During his stay Monet produced so many pictures that no other single location is as typical of Impressionism in its formative years. The town's attractions were many: fresh air, open fields, new housing as well as old, picturesque streets. Its prosperity was both industrial (p. 150) and leisure-oriented. A wider than usual stretch of the Seine without a central island made it a popular spot for sailing and pleasure boating. Many pictures show boats for hire or in use for sport or leisure. Argenteuil's regattas and associated fêtes (p. 282) were popular, as were its leisurely promenades (p. 76).

Painted in the very year of the first Impressionist exhibition, *Road Bridge* is a balanced and harmonious composition executed at the height of Monet's mainstream Impressionist maturity. The taut, interlocked geometry of sailing boats and their rigging is counterbalanced by the new steel and stone structure of the rebuilt road bridge. Its vertical reflections both frame and provide a counterpoint to the boats' masts. Even the trees on the opposite bank play in rhythmic succession across the background, limiting depth, thus enhancing the sense of the image's contained self-sufficiency. Similarly balanced geometries framed by the highway bridge can be found in other pictures – Monet made seven in 1874 alone. Moreover, there are many, like this one, in which more attention, as witnessed by thicker paint, is paid to reflections than to the solid forms they echo (Fig. a). Monet's brush records visual effects rather than mass or volume, creating a fascinating interplay between presence and absence, representation and illusion.

Compared to an episode of contemporary courtship by Édouard Manet (Fig. b), for which Argenteuil is just the setting, Monet's pictures focus on water and atmospheric effects. Water is such a defining element in Monet that Manet's river background imitates Monet's style both as a homage to their friendship and a sign of the scene's location.

|Fig. a| Claude Monet, *Bridge over the River at Argenteuil*, 1874
Neue Pinakothek, Munich

|Fig. b| Édouard Manet, *Argenteuil*, 1874, Musée des Beaux-Arts, Tournai

The Road Bridge and Sailing Boats, 1874

oil on canvas, 60.5 x 80 cm, Musée d'Orsay, Paris

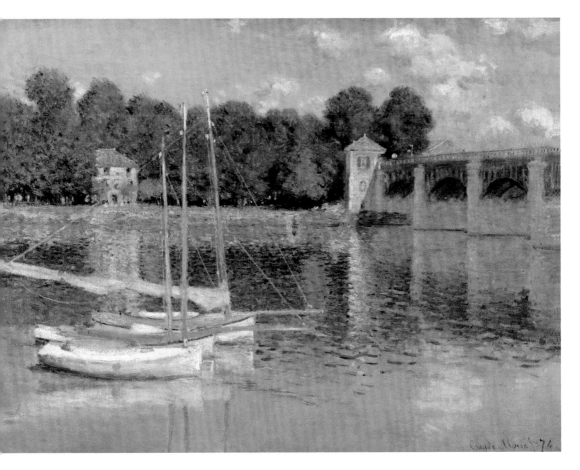

From Monet's emphasis on liquids and air rather than solid forms one might extrapolate a view of nature. In it, flux and flow are permanent features, unlike the classical belief in some underlying solid form that painters strive to evoke. Moreover, Monet's emphasis on surfaces seems to bear out the Positivist faith that reality is only what can be observed, and in which the presumption of duration has given way to the experience of change. That is not to say Monet read philosophy, but rather that on some level his painting fitted the ideas of his time. If the pleasures of his artistry are as great as those one experiences vicariously through it – here, the warmth and tranquillity of a sunny Argenteuil day – then it is as if the pleasure of the moment is the ideal goal of life. Such implications were obviously the key to Monet's eventual and long-lasting success.

Pierre-Auguste Renoir

|Fig. a| Pierre-Auguste Renoir, *Oarsmen at Chatou*, 1879
National Gallery of Art, Washington, DC

|Fig. b| Pierre-Auguste Renoir, *The Rowers' Lunch at the Restaurant Fournaise*, 1875
The Art Institute of Chicago, IL

Ravishing Repositioning

The Fournaise family had a popular restaurant in Chatou, not far from Renoir's parents. It was complemented by their boat rental business, so that after boating one could enjoy a relaxing meal, or vice versa (Fig. a). Chatou was a bit further down the Seine than Argenteuil. It was a slightly longer train ride from Paris (p. 232) but had less industrial development.

Since the mid 1870s, Renoir painted there on and off (Fig. b). Following his *Moulin de la Galette* (p. 135) and *Madame Georges Charpentier* (p. 57) he decided on a major composition, which he would use to reconsider both social and stylistic aspects of the *Moulin de la Galette*. It was the beginning of his re-evaluation of his position in the history of art and of his commitment to Impressionism, allied to repositioning himself in Parisian society as well. Rather than the popular setting of Montmartre in which the figures including Georges Rivière were relative unknowns, in *Luncheon of the Boating Party* Renoir showed the bearded son of the fashionable restaurant's owner to the left, his rich painter-friend Gustave Caillebotte with a cigarette to the right. Both are sleeveless as if their biceps might indicate Renoir's more muscular approach to art. Others include the actress Ellen Andrée, whom Edgar Degas used for *L'Absinthe* (p. 109), turning to a friend who has come to greet her, and in the background with top hat, Charles Ephrussi, a wealthy collector friend of Édouard Manet and Degas. Playing with her new puppy is Renoir's newest seamstress mistress, Aline Charigot, with whom he would eventually have children and marry. She flaunts her latest fashions, like the flowery hat more ornate than any of the others. Her upturned nose and lovingly painted puckered lips stand out against Fournaise's white boating T-shirt. Renoir's increasing status was

Luncheon of the Boating Party, 1880–1

oil on canvas, 130.2 x 175.6 cm, The Phillips Collection, Washington, DC

such that he and Aline now mixed with entertainers and patrons of the arts at a popular bourgeois establishment rather than with the working class at a less refined *guinguette*. Compared to *Moulin de la Galette*, Renoir's figures are larger and more solidly formed, even though his surfaces are still brilliantly covered in ravishing Impressionist colour. Faces and outlines are far sharper and precise than in earlier work, and the arabesque border of the awning to the left suggests a joy in draughtsmanship. Where such values are less important is the still life on the table, with bottles, glasses and abundant fruit suggesting the joy of consumption, both visual and gastronomic, as in the pastry-like evocations of his earlier *La Loge* (p. 125).

Shortly after completing *Boating Party* Renoir would travel to Italy to satisfy his yearning for a durable and historically legitimated style. Up to now, however, no Impressionist had painted successfully on this large a scale while remaining true to *plein-air* immediacy and yet sustaining the formal and compositional coherence necessary for monumental art.

Alfred Sisley

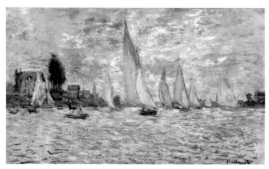

|Fig. a| Claude Monet, *Boat Races at Argenteuil*, c. 1872
Musée d'Orsay, Paris

|Fig. b| Alfred Sisley, *Along the Canal at Moret-sur-Loing*, 1892
Musée des Beaux-Arts, Nantes

On the Mark

Among the seventeen paintings Sisley made while visiting England (p. 252), three were of the annual regatta on the Thames at Molesey, attended by the rich and famous. It was one of the oldest sporting events in Great Britain, attracting crews from all around. It took place in July on an 850-metre course, but despite the summer season, the water here is choppy and the wind has picked up; dark grey clouds threaten rain.

The location is the starting line, with the colourful rowing-club ensigns flying on flagpoles along the banks and other flags suspended – one knows not exactly how. Four officials in white are monitoring the start, one of them with his arm raised to mark it, waiting for the hand on the watch he is looking at to reach the top of the dial. A fifth sits in a small boat on the river to the right. People wander across the lawn of the hotel on the opposite side of the river. Not all are paying attention. The real crowds and enthusiasts are not here but at the finish.

Two long sculls with their teams of rowers at the ready drift towards the starting line. Let the race begin! Rowing and especially sailing were popular subjects among the Impressionists. In Paris and the suburbs, waterways were an important presence and a convenient place for both sport and leisure. For Claude Monet, raised in Le Havre, where the Seine meets the Channel, there was an obvious predisposition to water scenes, but many others followed his lead. He painted races at Argenteuil (Fig. a) as soon as he moved there, always with an eye to the weather. In *Boat Races at Argenteuil* the sails are tightly trimmed to take best advantage of the wind.

Regatta at Molesey is an exception for Sisley, for when it came to the Seine or when in 1880 he moved to Moret-sur-Loing (on a tributary near Fontainebleau but on the opposite side of the forest from Barbizon), slow-moving barges were his speciality. Indeed, many pictures along the Loing and its canal show nothing but its calm and shimmering surface (Fig. b) and when there are figures they seem in the melancholy mood of Barbizon (p. 14). Even in pictures of the Seine, pleasure boats are rare. There is usually a Corot-like unity and tranquillity to Sisley's pictures, even when their colours are

Regatta at Molesey on the Thames, 1874

oil on canvas, 66 x 91.5 cm, Musée d'Orsay, Paris

brilliant. The marks made by his brush are rarely as artistically extroverted as Monet's, which so often celebrate both place and the painter's technique. Sisley's work is more low-key, his beauties glowing peacefully.

Since public events were not his pleasure one must assume *Regatta* was motivated by the patronage of Jean-Baptiste Faure. Yet the signs of discomfort one might expect from a painter of relatively empty places, from which he usually seems removed, are difficult to detect in his British pictures, even when, as here, there are crowds.

They seem unencumbered by psychology or ambiguity, and in that sense they are perfectly straightforward barometers of the middle-of-the-road Impressionism one finds so superbly exemplified in Sisley's other work.

Gustave Caillebotte

|Fig. a| Gustave Caillebotte, *Rower in a Top Hat*, 1877
Private collection

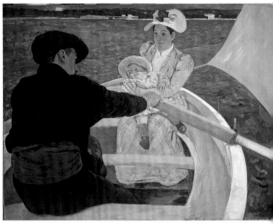

|Fig. b| Mary Cassatt, *The Boating Party*, 1893-4
National Gallery of Art, Washington, DC

Rowing Classes

Caillebotte had a passion for boats, perhaps more even than for art, since later in his career he devoted himself more to yacht design than to painting. He was a member of the Paris Sailing Circle, headquartered at Argenteuil, and purchased a small boatyard at Petit-Gennevilliers. He combined his love of sport and artistic innovation in several remarkable pictures done on the river Yerres (p. 307), which ran along his family's luxurious country estate in the town of Yerres, southeast of Paris.

Unlike his colleagues' pictures of relaxed boating figures in which the atmosphere is pleasant, Caillebotte's stress the physical effort of propelling a craft and put the viewer close enough to sense the rowers' sweat. In *Rowers on the Yerres* the figures are dedicated sportsmen, dressed alike in boating uniform with protective straw hats. The closer oarsman enjoys a cigar while exercising, a sign he has not yet reached his limit. By contrast, *Rower in a Top Hat* (Fig. a) is a hired oarsman, the facial hair suggesting his class, the hat an indication of his profession, like that of a footman or a carriage driver. Unlike the boat in *Rowers*, a two-man scull with each rower having one oar, a conventional rowing boat has oars worked in tandem. In the hired man's situation, formal attire shows respect towards the client, like that of a maître d'.

In both pictures Caillebotte brings one uncomfortably close to his subjects. But only in *Rower in a Top Hat* is there a character study, as if the painter's superior social class entitles him to scrutinise the other. All the picture's converging lines focus on the man's face. He seems a rough sort, with ruddy cheeks and a severe, if attentive, expression. Rowing is a job, for which he shows neither pleasure nor dislike. In *Rowers on the Yerres*, on the other hand, the bared arms with their muscles tell the tale. Sport is their pleasure, and they take it seriously. The figures are anonymous; the artist's domination

Rowers on the Yerres, 1877

oil on canvas, 81 x 116 cm, private collection

is achieved through art. The vantage point is like that in *The Floor Scrapers* (p. 31), exhibited the previous year. It is Caillebotte's way of distinguishing himself from the other outdoor Impressionists. The only painter with similar visual dramatics was his friend Edgar Degas, who rarely painted *en plein air* (p. 78).

Some years later, Mary Cassatt made a picture unusual for her (Fig. b) that seems a homage to Caillebotte, who died less than a year later, as well as to their mutual friend Degas. Caillebotte had been extremely generous to the Impressionists, financing their exhibitions after 1876, buying pictures and giving money. He left his collection to the Louvre, which after much debate would only accept it in part. Cassatt's boating scene off the coast of Antibes includes a mother and child, but the viewpoint set within the boat and rower seen from behind mainly recall Caillebotte. Cassatt was experimenting with Japonisme at the time (p. 369), as her bold, simple outlines and broad areas of local colour demonstrate. Since all these artist friends were inspired by Japanese prints, the reference was appropriate.

Edgar Degas

|Fig. a| Édouard Manet, *Races at Longchamp*, 1864, Harvard Art Museums, Cambridge, MA

Competitive Art

Horse racing was first a British sport, descended from the hunt. The first French horse race is said to have taken place in 1775. By Degas's time it was widespread in France and had evolved from a gentlemen's pastime to one with professional jockeys, breeders and importers. Unlike Gustave Caillebotte's love for boating (p. 284), in which he himself vigorously participated, Degas probably never mounted the saddle.

His exposure came through friends, especially Édouard Manet. His fascination was with the challenges of equine anatomy, the spectacle's traditional pageantry and its fashionable audience. Most of Degas's racing pictures show moments prior to the race, such as the colourful ceremonies where jockeys parade their colours before the tribune. By contrast, Manet went one better by picturing horses racing head-on towards the viewer at the finish (Fig. a). Even in art there could be racing competition …

The Longchamp Racecourse in the Bois de Boulogne was opened in 1857.

Its accessibility and manicured grounds made it a popular place for outings. With factory chimneys in the background, Degas's location is clearly urban; the angle in relation to the tribune indicates the industrial suburb of Puteaux on the other side of the river.

Degas has left out details of the jockeys' faces, and the colours he attributes to each

horse are vague enough to obscure their owners' identity. It is as if the overall spectacle is what interests him. One of the most interesting facets of the picture is how, while the horses and riders overlap and cut one another off, the series of shadows on the ground is clear and rhythmically regular. With the tension before the race, the last horse has broken ranks, affording Degas the opportunity to represent a horse in spontaneous motion.

Like the ballet, horse racing is based on predetermined rules and formats, and thus parallel to making art. And like the ballet, such subjects are a major proportion of Degas's work and a frequent vehicle for experimentation. In some cases, he reworked pictures years after first making them. *Parading the Colours*, done in oil diluted with turpentine to act like watercolour, was worked on twice and yet whether it is finished is unclear.

|Fig. b| Edgar Degas, *Scene from the Steeplechase: The Fallen Jockey*, 1866
National Gallery of Art, Washington, DC

Parading the Colours (Le défilé), 1866 and 1868

petrol painting on paper on canvas, 46 x 61 cm, Musée d'Orsay, Paris

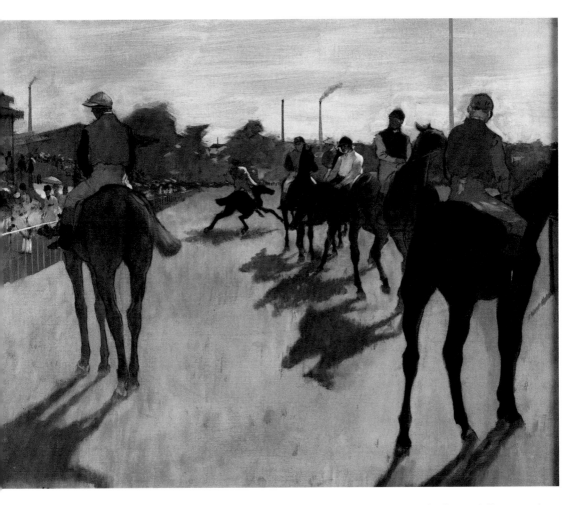

In 1863 a steeplechase organisation was formed, and shortly afterwards Degas made a large painting called *Scene from the Steeplechase: The Fallen Jockey* (Fig. b). At the Salon of 1866 it was attacked with these words: 'Like this jockey, the painter does not yet know his mount perfectly.' Enlightened later by Eadweard Muybridge's stop-motion photographs of a galloping horse, Degas admitted his ignorance. But the critic failed to see the tragic point. Whether the jockey is dead or just unconscious is hard to know, while the horse that threw him galloped off to freedom. The painting was also a response to *The Dead Toreador* (1864, National Gallery of Art, Washington, DC) that Manet painted in a bullfight picture two years earlier. In both pictures the artists declared their freedom from history painting, with which Degas had been engaged (p. 28) until he met Manet.

Claude Monet

|Fig. a| Claude Monet, *La Japonaise (Camille Monet in Japanese Costume)*, 1876
Museum of Fine Arts, Boston, MA

Return to the Figure

In 1886 Monet made two spectacular large-scale paintings of his stepdaughter Suzanne Hoschedé. She is standing on a wind-blown cliff in Normandy, probably at Pourville. In one she is turned to the left, in the other to the right (*Woman with Parasol Turned to the Right*, 1886, Musée d'Orsay, Paris). They are often called '*plein-air* studies' because, though large, they were not for sale; they never left Monet's studio, and as a pair they show attention to effects of light and air on figures posed towards and against the wind and sun. In both, Suzanne's scarf is blowing towards the left and her parasol is tilted to the right to protect her.

Seemingly identical in so many ways, the paintings become more interesting for subtle differences that reveal Monet's skills and perceptions. When turned to the left, Suzanne's face is obscured by the veil wrapped around her head to keep her hair in place and hold down her hat. Turned to the right, her features are less blurred but simplified, and one notices strokes of green for eyebrows, reflecting the lining of her parasol. In the first picture her scarf is blue and white, reflecting the colours of the clouds and sky. In the second it catches some green, as does her blouse. In the first, she casts a shadow; her dress billows to emphasise her shape heightened by sunlight; the red rose at her waist is more visible than in the second; the sun bleaches through the umbrella lining at the centre. These paintings, in other words, are about looking and seeing, and that is all Impressionism seems to demand. And yet it was in this very same year that Georges Seurat burst upon the scene with his *Sunday Afternoon on the Island of La Grande Jatte* (p. 331). At the eighth Impressionist exhibition a separate room was devoted to him and his new followers, who included Camille Pissarro and his son Lucien. Both the size of Seurat's painting and his monumental figures must lie behind Monet's experiments. Even Monet's brushstrokes, without coming near to Pointillism, are somewhat systematic, but they seem propelled by wind, that is, by nature, rather than by theory, as in Seurat.

In the late 1860s Monet exhibited figure paintings as part of the trend Émile Zola called Actualist. His *Women in the Garden* (p. 115), *The Breakfast* (p. 194) and two portraits (one of which is *The Woman in the Green Dress*; p. 48) were all Salon-sized. In 1876 Monet showed a large picture of his wife Camille dressed in a Japanese costume (Fig. a), his last major essay in the full-length genre. This precedent is a reminder that the full-length female figure was common in Japanese prints, although usually they represented courtesans. Whereas Monet's painting of Camille suggests almost a parody of this trend – she wears

Woman with a Parasol Turned to the Left, 1886

oil on canvas, 131 x 88 cm, Musée d'Orsay, Paris

a blonde wig to emphasise her European identity – Monet was a great lover of things Japanese. Although Camille's elaborate kimono is as unlike Suzanne's white summer dress as is possible, both show Monet's attention to fashion. Suzanne's walk on the cliffs, therefore, was more an exercise in art than a leisurely promenade.

Paul Cézanne

Solid State

Like a god astride the world, Cézanne's bather dominates the landscape. Like an ordinary youth, he is frail and unsure. Like a classical statue, he stands immobile. Like a little boy, he tests the water with his toe. These contradictions embody the universality of Cézanne's figure and the painter's ambitions. He wanted, he said, to make nature into 'something solid and durable, like the art of the museums'. Sharing the Impressionist commitment to direct observation, often working obsessively out of doors and walking miles to do so, he aimed to produce more than the record of an instant, but rather something authentic, and lasting too.

Among the most challenging themes in art traditions was the human figure in nature, for it expresses the relationship between man and the world of which he is a part. Édouard Manet's *Le Déjeuner sur l'herbe* (p. 23) had been a challenging example. Cézanne's picture captures the duality of the individual as self and the generality of man as part of the larger reality. How Cézanne achieves this fusion makes his work fascinating and sustains long looking. For example, his outlines contain both the general and the particular. The contours of the arm are simple, appearing boldly sketched with curves so subtle that they suppress unusual detail or individuation. Yet the limbs they describe are thin and their musculature unheroic. The large hands suggest a figure still developing. His gaze seems both introspective and attentive to his footing. Both possibilities remove him from our immediate world.

Bathing was a modern activity, driven by increasing leisure and claims of benefits to health. It was also an ancient topos, descended from the ancient gods and athletes. In the late 1860s, when the Impressionists did figure paintings aimed at the Salon, bathers, as in Frédéric Bazille's *Summer Scene* (p. 271) and Pierre-Auguste Renoir's *Bather with a Griffon Dog* (p. 239), updated the ancient theme to modern practices. Renoir's picture shows his girlfriend Lise Tréhot as a modern Venus. An earlier group of bathers by Cézanne himself (Fig. a) places them in a Provençal landscape, with the great landmark of the Montagne Sainte-Victoire in the distance. His poses mimic in the nude the beach scenes and picnics so familiar from many examples among his cohorts, while recalling his own youthful summer swims in the river Arc with Émile Zola, Antoine Fortuné Marion, Antony Valabrègue and other school chums. One of them foretells this single figure.

Cézanne's style demands patience, just as he patiently laboured. It is rewarded with a combination of awe and enlightenment. The technique consists of

|Fig. a| Paul Cézanne, *Bathers at Rest*, 1876–7, The Barnes Foundation, Philadelphia, PA

The Bather, c. 1885

oil on canvas, 127 x 96.8 cm, The Museum of Modern Art, New York, NY

thin patches and deliberate strokes that convey both economy and care. Every stroke is thoughtfully placed without seeming forced. Patches of colour that sometimes look like lines operate through colour relations to produce a natural kind of modelling rather than following academic formulae. Although rooted in observation, Cézanne's method reveals its cogitation over time. The result is an image of permanence forged forcefully from a contemporary moment, an image packed with the energy and intensity that was necessary to produce it.

Pierre-Auguste Renoir

|Fig. a| Pierre-Auguste Renoir, *Nude* (study for *The Large Bathers*), 1886, The Art Institute of Chicago, IL

|Fig. b| Pierre-Auguste Renoir, *Dance at Bougival*, 1883
Museum of Fine Arts, Boston, MA

Sweet and Sour

Renoir's trip to Italy (p. 254) had a profound impact (p. 328). He had begun to question Impressionism, wondering if he still knew how to draw. It is true that with the exception of those allied with Edgar Degas, the Impressionists rejected traditional draughtsmanship in favour of rendering forms exclusively through colour. Renoir had been among the foremost in this trend, except that he tended to use long, light and sometimes feathery brushstrokes like those associated with sketching rather than the more patchy version adopted by Édouard Manet, Claude Monet, Camille Pissarro and Alfred Sisley. His misgivings were surely reinforced by Georges Seurat's example (p. 330), in which figures were sharply defined and sculptural, however depersonalised.

In Italy, Renoir admired fresco wall paintings, where pigments were applied to wet plaster, fusing with the white ground when it dried to achieve both luminosity and permanence. He viewed *Bathers* as a 'trial' or probably a demonstration piece 'for decorative painting', hoping perhaps to rival the success of the popular classicising decorative painter Pierre Puvis de Chavannes (p. 188). As in Renaissance and academic works, Renoir prepared his composition through preliminary studies (Fig. a), which in their linear purity resemble those of the conservative stalwart Jean-Auguste-Dominique Ingres. His poses echo Ingres's odalisques (p. 196) and, to the right, the latter's *Valpinçon Bather* (p. 352), which was owned by the father of Degas's friend Paul Valpinçon. Such references remind one how closely Renoir's fantasies about female bodies coincided with Orientalist assumptions regarding women's sexual availability. Compared to other Impressionist paintings, the figures have an academic polish, the sort of effect the Impressionists usually disparaged. And Renoir shows them – all of which were posed by Suzanne Valadon, a favourite model – from a variety of viewpoints: front, profile and three-quarter rear. Similar combinations were common in academic painting in order to demonstrate the artist's skill at representing the figure from all angles.

This phase of Renoir's development is often called his 'sour period'. Renoir may have tried to preserve a sense of spontaneity through his figures' playful attitudes, but the result is unconvincingly contrived. His background is freely painted, but in juxtaposition to the figures it seems merely incongruous or a poorly integrated backdrop – unless that is what he was seeking in order to set off the careful execution of his

The Large Bathers, 1884–7

oil on canvas, 117.8 x 170.8 cm, Philadelphia Museum of Art, PA

figures' shapely forms. Renoir's dealer, Paul Durand-Ruel, disliked the picture so much that he refused to show it, so Renoir turned to the more upmarket Galerie Georges Petit, whose stock of academic painters gave the dealer a more elite clientele. It is worth noting that Renoir's composition as a whole had its source in a relief sculpture by François Girardon from the fountains of Versailles – a supremely aristocratic reference. Many of Renoir's paintings from the period have a newfound solidity. In *Dance at Bougival* (Fig. b), for example, Paul Lhote and Suzanne Valadon form a monumental full-length couple 'in the round', with Lhote's arm wrapped around Valadon's curvaceous body as if to show off Renoir's ability to combine Impressionism and the three-dimensional. This and similar resolutions of Impressionism and the classics are far more successful than the Philadelphia *Bathers*, and Renoir eventually backed away from the extreme this work embodied. Later in his career he would find other ways to evoke the grand tradition (p. 388).

Light and Air

Camille Pissarro

|Fig. a| Jean-François Millet, *Winter, The Plain of Chailly*, 1862–6, The Burrell Collection, Glasgow

Cold Reception

After inventing the name 'Impressionism' (p. 32), Louis Leroy's fictive interlocutor Monsieur Vincent came upon Pissarro's *Frost*. 'What!' he exclaimed:

But this is nothing but palette scrapings posed uniformly on a filthy canvas. There's neither head nor tail, nor front nor back!

Leroy was responding to the relatively dry and fragmented facture of Pissarro's painting, whose tactile and laboured surface corresponded both to the feel of terrain hardened by frost and to the manual toil of ploughing; that is, a pictorial equivalent of physical effort required to furrow the field into clods of earth through which the soil will be refreshed. With a figure dressed in worker's blue carrying a load of dead branches on his shoulder, one knows immediately that thematically one is in the world of Jean-François Millet. However, Millet's handling, when not matter of fact, could be ingratiating in its Delacroix-like freedom and liquidity (Fig. a). Pissarro's brushwork here seems constricted and workman-like, without frills; it is what led Émile Zola to call Pissarro an 'honest man' and a 'worker' (p. 186). The picture was one of five Pissarro submitted to the first Impressionist exhibition, held in 1874. In addition to its effects of weather and atmosphere, the painting was most remarkable for its striped pattern of light and shade created by the furrows, and for the hints of the canvas surface that add to the coarse quality of the rustic scene. Pissarro's dabs of related browns, beiges and ochres, with hints of orange and green as the eye approaches the horizon, do not always cover the canvas or mask its threads. Only the figure is painted more thickly.

Frost (Gelée blanche), 1873

oil on canvas, 65 x 93 cm, Musée d'Orsay, Paris

The location is near the road towards Ennery, outside Pontoise. This was prime farming country and any passer-by would notice the neat geometric rows into which ploughed or crop-bearing fields are groomed. Such designs express order, patience, effort and efficiency learned over generations, even if their only impact at first glance is of pleasing picturesque patterns. In Millet's picture an abandoned plough is the only sign of human effort, and the ploughman's absence allows a swarm of crows to devour as much seed as they can hold. In other words, Millet's picture alludes to the constant struggle man must wage in order to draw forth his sustenance from nature.

Pissarro's view, on the other hand, is less dramatic and less allegorical, although it is hardly devoid of feeling. Yet that feeling is about the everyday, unromantic life of the countryside, which offers unsuspecting beauties to the eye such as the comparison between the frosted field as yet unexposed to morning sunlight and adjacent strips where frost has melted. A lover of bold patterns that structure pictures into bold perspectives paralleling Japanese prints without imitating them, Pissarro could find compositions in as yet unflowered nature that fascinate with their starkness and simplicity as much as flowery garden scenes are seductive for just the opposite.

Alfred Sisley

Calm Over Troubled Waters

Although Sisley usually preferred quiet, ordinary views, few artists could resist spectacular natural events when they involved the phenomena and places they had been studying for years. Sisley moved to Marly-le-Roi in 1874 and often painted at its associated port. He was well placed when a huge flood in spring 1876 led him to make a group of six pictures, several of which are considered to be among his best.

All were taken from almost a single location, with some of them nearly identical. Some may have been meant to be viewed as pairs or as a sequence. Differences are subtle, including slight shifts of angle and atmospheric variations, with dark clouds giving way to blue sky, all rendered with supreme skill and sensitivity.

The À St-Nicolas inn stands just across the flooded road. The rooms are above a wine merchant. From another view several metres further back from the corner (Fig. a), we know that Sisley was on the other side of the street with the Lion d'Or inn to his back. In the later view the sky has cleared and the waters have begun to recede. Figures come out of the buildings to stand on the muddy street as they survey the scene. In the first picture there is the greater sense of stillness, as in the immediate aftermath of a storm. Some blue sky has begun showing through the clouds, in contrast to certain views that show the sky still very dark and rainy. A

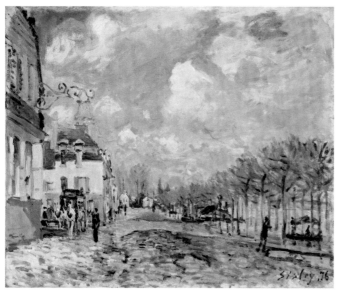

|Fig. a| Alfred Sisley, *Flood at Le Port-Marly*, 1876, Museo Thyssen-Bornemisza, Madrid

few men have boats that help them move about without solid ground or perhaps ferry guests at the two inns. Planks on barrels, almost obscured, do service as temporary pavements in front.

Tall telegraph poles are at intervals, following the road along the river. With the hotel, a bulky compositional anchor to the left, the pole closest to the foreground provides a counterpoint and framing element. The river's normal limits are delineated by pruned trees closely aligned, which lead the eye into the painting. At the centre is a wash house with a rudimentary roof. Skilful reflections enhance the picture's geometric balance.

One suspects that Sisley made his several views not only because he found the subject

Flood at Le Port-Marly, 1876

oil on canvas, 60 x 81 cm, Musée d'Orsay, Paris

challenging and unique but also because he thought them saleable. In recording the newsworthy event he was in full accord with the Impressionist ethos of specificity of time and place. Photographers might be documenting real events and places, too, but none could equal painting's authenticity in rendering both naturalist vision and feelings produced through colour. Despite critics who compared Impressionist specificity to photography, seeing it as little more than copying nature, painting's techniques had the ability to soften the sharp edges of photography and create more than a frozen mechanical imprint. In Sisley's picture, ripples and varied reflections endow the picture with a sense of living reality, even though there is little other movement.

Alfred Sisley

Winter Harmonies

Paintings of the seasons were a long-established tradition. In classical art they were usually done in sets of four to express the cycle of life from the springtime of birth to the winter of mortality. They were allegories of transience and renewal. In the 19th century, seasonal, temporal (for example, sunset) and atmospheric references were among the effects (*effets*) painters found picturesque even in the plainest of settings. Barbizon landscape painters in particular often used *effets* both to create emotional resonance and to offset the repetitiveness of their locations. In Impressionism, the term survived in titles to many pictures, especially those of the countryside. Effects of season, light and weather concentrate, as the term '*plein air*' itself suggests, on expressing the direct contact with nature that was their sign of authenticity. Claude Monet's *Impression, Sunrise* (p. 33) might be classified as an *effet*.

Almost all Impressionist landscape painters produced winter scenes, but none did so many as Sisley. *Snow at Louveciennes* is extraordinary for its limited palette and its melancholy rendering of atmosphere. Its harmonies in grey and white, with almost imperceptible overtones of blue, suggest experiments by James Abbott McNeill Whistler (Fig. a), the expatriate American who associated with the future Impressionists in the 1860s, then later settled in England. Born in England, Sisley might well have been thinking of not only Whistler but John Constable, J.M.W. Turner and Richard Parkes Bonington, whose works were known through travel or their presence on French soil. To emphasise the subtle range of colour relations in low light, Whistler often called his paintings *Harmonies* or *Nocturnes*. Sisley's sensibility was similar, though he never used such terms. *Snow at Louveciennes* manifests the sort of quiet and distance characteristic of so many of Sisley's pictures. One thinks of the example of Jean-Baptiste-Camille Corot, whose figures in his more naturalistic landscapes are moving away from the viewer and at a distance (p. 12). They are often solitary, as in this Sisley, and there is a tranquil sense of melancholy, related to the quieting effect of deep snow. By comparison, Sisley's *Early Snow at Louveciennes* (c. 1870–1, Museum of Fine Arts, Boston) records that sensitive point when snow first arrives, announcing the transition to winter ahead.

First snow usually melts quickly. In places like Île-de-France and Normandy, it rarely forms the heavy blanket of *Snow at Louveciennes*. In *Early Snow*, indeed, Sisley remains true to form in evoking, other than the snow itself, the normality of the day, as individual villagers go about their business, taking everything in their stride. His inclination is to capture the

|Fig. a| James Abbott McNeill Whistler, *Chelsea in Ice*, 1864, Colby College Museum of Art, Waterville, ME

Snow at Louveciennes, 1878

oil on canvas, 61 x 50.5 cm, Musée d'Orsay, Paris

sense of the ordinary that eventually follows even notable atmospheric events, as men and women simply accommodate themselves to them. There is not the feeling, as in Romantic landscapes, that man is dwarfed by nature's power and grandeur. Nor does it seem that Sisley's attitudes were overly coloured by his own hardships. While he might suggest the constancy of human perseverance, his pictures also find a subtle beauty in the way life simply continues on.

Armand Guillaumin

Winter Spectacular

In an extraordinary combination of winter, sunset and industrial atmospherics, Guillaumin added a uniquely modern twist to the temporally determined effects pioneered by the Barbizon School and followed by Impressionism. It is hard to say which dominates his sky: factory smoke, clouds or sunset, and of course their subtle reflections over the snow. Instead of the blue-grey reflections in Claude Monet's countryside (Fig. a), it is as if Guillaumin responded by urbanising the snow scene motif. At first glance, indeed, one might confuse the last flames of Guillaumin's sunset effect and the fires of industry themselves.

Snow effects were common during the 1860s and 70s, in part as a leftover from Romantic landscape, which the Impressionists rendered less melodramatic (p. 300). In part they were demonstrations of the Impressionist artists' commitment to painting out of doors under any and all conditions. With its dramatic clouds and sunset, Guillaumin's picture might be more comparable to the approach of earlier generations. Yet its industrial content is unprecedented in a snow scene, except in his own earlier work (p. 140). Rather than a compromise between two tendencies, however, a closer look reveals the painting's stark contemporaneity. The empty foreground with a single figure, others being smaller and more distant, is a formula that Alfred Sisley employed in many paintings. But logs and debris lying on Guillaumin's riverbank have nothing to do with the nostalgia of the solitary countryside; and the figure's cap and short winter jacket clearly indicate his worker status. The picture's foreground shares the anti-picturesque quality one finds in some of Sisley's plainer views, such as *The Seine at Grenelle* (Fig. b). A small port (called Port de Grenelle or Port de Javel) and a bridge were built at Grenelle in 1825. The loading area is rudimentary, with a single steam-powered crane.

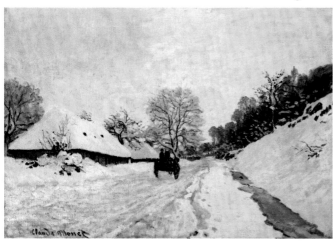

|Fig. a| Claude Monet, *The Cart. Road in Snow at Honfleur*, c. 1867, Musée d'Orsay, Paris

|Fig. b| Alfred Sisley, *The Seine at Grenelle*, 1878, Denver Art Museum, CO

Snow at Ivry, c. 1873

oil on canvas, 52 x 73 cm, Musée du Petit Palais, Geneva

River traffic leaves white puffs of vapour behind. Sisley framed the scene with the railing in the foreground, but its effect on compositional coherence is weak; rather a sense of emptiness and randomness prevails. Without an overriding or too wilfully selected structural principle, that plainness endows the scene with naturalistic credibility. Guillaumin and Sisley seem in sympathy at this point of their careers. Indeed, Guillaumin made a few pictures and prints at sites nearby.

It may be that for both Guillaumin and Sisley staying faithful to a setting required a certain distance. Focusing close up on details removes them from explanatory contexts and transforms them into aesthetic objects, as in Sisley's own, more Monet-like *Piles of Sand* p. 147). The distance that so often deprives Sisley's views of strong aesthetic focus and emotional interest reflects his commitment to a self-evident realism. For Sisley, the eye can linger over gentle effects of subtle lighting from a grey sky reflected on rippled waters. For Guillaumin, the nondescript foreground is the setting for the picturesque drama in the sky as well as for the factoryscape, a theme for which, in Impressionism, he was the originator. His picture combines conservative *effet* with a radically modern cause.

Paul Gauguin

|Fig. a| Paul Gauguin, *Cail and Co. Factories along the Seine at Grenelle*, 1875
Private collection

Winter Colours

Following his mother's death in 1867 Gauguin lived with his guardian, the collector Gustave Arosa, who was well versed in contemporary art, possessing works by Eugène Delacroix, Jean-Baptiste-Camille Corot and Jean-François Millet. Gauguin took up painting as a hobby, and in 1874 Arosa introduced him to Camille Pissarro. Gauguin subsequently joined the group of artists who worked together with Pissarro around Pontoise, including Paul Cézanne and Armand Guillaumin. His lucrative job with the money-changing firm of Bertin, obtained through Arosa's influence, made it also possible for him to buy works painted by his cohorts and to paint at his leisure. Economic troubles, however, resulted in his being fired or leaving voluntarily (he claimed) in 1882, to pursue his passion for painting.

Gauguin painted his earliest scenes in the unexceptional territories that aligned with Pissarro's seriousness about and preference for rendering the ordinary. Within the limitations of geography and technique acquired from Pissarro, however, Gauguin sought some exceptional challenges. Snow was one of them, as in his picture of the Rue Carcel in the winter of 1883. Gauguin had been renting the house at No. 8 of this tiny street in the 15th arrondissement since 1880. It still overlooks a garden, which was the location for Gauguin's picture. Beyond the wall are chimneys of the Vaugirard gas works. Factories were sprouting up in the still relatively undeveloped neighbourhood. Indeed, when Gauguin first moved to the 15th arrondissement he made several pictures of the Cail Company factories (Fig. a) along the Seine at Grenelle that resemble compositions by his cohort Guillaumin. Gauguin was surely encouraged by the fact that Cézanne, whom he much admired, regarded Guillaumin's work highly enough to copy one of

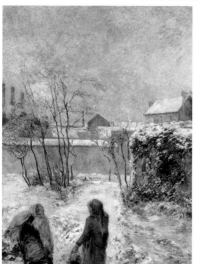

|Fig. b| Paul Gauguin, *Snow in the Rue Carcel*, 1883
Private collection

Guillaumin's paintings (p. 308). In the informal 'School of Pontoise', of the mid 1870s to mid 1880s, factories were part of the modern environment. This picture is a smaller, preparatory version of a larger, signed composition (Fig. b), in which the three chimneys frame the composition to the left with relatively little interference from trees. The wall offers a powerful horizontal, framed by a house to the right. It was from his association with Pissarro and Cézanne, no doubt, that Gauguin acquired his penchant for structural clarity, and although later on he would modify the rectilinear scheme to more original, often curving patterns, he would never forget the importance of compositional geometry. Two large women Gauguin added to the foreground of the larger picture are cut off *à la japonaise*, like the peasants Pissarro was painting at the time (p. 184).

Snow in the Rue Carcel, 1883

oil on canvas, 60 x 50 cm, Ny Carlsberg Glyptotek, Copenhagen

The most remarkable achievement of the painting is a colouristic complexity and subtlety under grey skies. Small touches of green and brown mix with the snow in the foreground, with a few touches of orange to the right and in some bushes near the base of the trees to centre left and along the wall. Faintly similar tones on the house to the right echo them. The sky is painted in diagonal strokes of mixed blues and greens with hints of pink. Although the picture is otherwise quite derivative, its overall quality reveals considerable skill and a sharp eye for colour, the latter to become the outstanding characteristic of Gauguin's artistic maturity.

Gustave Caillebotte

|Fig. a| Edgar Degas, *Dancers Practising at the Barre*, 1877
The Metropolitan Museum of Art, New York, NY

|Fig. b| Claude Monet, *Fishermen on the Seine at Poissy*, 1882
Kunsthistorisches Museum, Vienna

Circling in the Rain

If one picture alone could demonstrate Caillebotte's originality, this one would be it. The river Yerres ran along the border of the Caillebotte family's country estate in the town of Yerres, around twenty kilometres southeast of Paris, next to Montgeron, where Ernest Hoschedé was playing host to Claude Monet (p. 54). The location was a noble one, near the Château de la Grange, built in the time of Louis XIII and owned successively by the Duchesse de Guise and the Maréchal de Saxe and recently purchased by the Bonapartist legislative deputy Napoléon Gourgaud. At around the same time or a few years later than *Rain on the Yerres*, Caillebotte, ever the sportsman, made a group of paintings (p. 284) of rowers along the river. Caillebotte's focus on the water's surface is already unusual for its time, anticipating Monet's water-lily pond by many years. Even the circular ripples of raindrops on its surface seem to look ahead to Monet's floating lily pads. Although that may be a backwards reading of history, forced upon us by the lack of precedent for Caillebotte, it does say something about his relationship with Monet, which quickly became very close. Indeed, the only antecedents for Caillebotte's dramatic simplicity can be found in his own work: for example, *The Floor Scrapers* (p. 31), in which reflections of light and the patterns formed on an extended surface embody similar compositional principles and fascination with geometry. In the latter, however, both setting and surfaces are man-made, and patterns are created by human labour. In *Rain on the Yerres* nature itself provides the surface on which natural forces are the geometer.

In a harmonious contrast with the circles – rendered as ellipses, of course – are the vertical shapes of trees, which are also reflected in the water. The effect is in the spirit of Edgar Degas, whose *Dancers Practising at the Barre* (Fig. a) dates from around the same time, and would later be taken up in a more closely related composition (if not theme) by Monet (Fig. b). The diagonal cutting off of the foreground can be found in Japanese prints, which all three artists knew and loved. The interplay of vertical/horizontal right angles, prominent in the Degas, is a pleasing counterpoint to the floor or river's sweeping slant. In the Degas in particular, given how dancers are subject to certain formal rules as well as manipulation by the choreographer, the parallel to artistic planning is explicit. Like a telling footnote, the relationships are summarised by the watering can that frames the picture to the left. By contrast, by locating his effects in an entirely natural realm,

Rain on the Yerres, 1875

oil on canvas, 81 x 59 cm, Indiana University Art Museum, Bloomington, IN

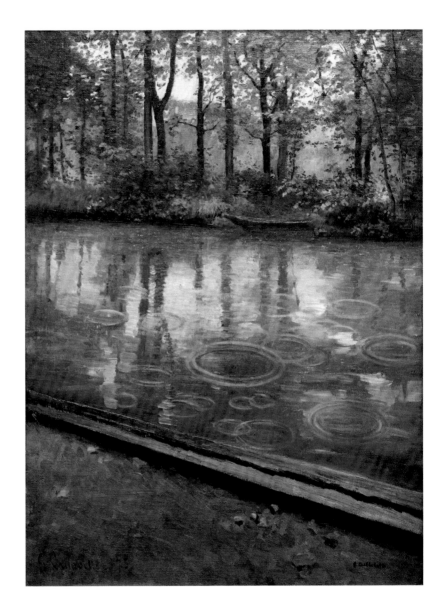

quite beautifully painted in the background, Caillebotte shows that such effects are found in nature. The function of art, thanks to an original viewpoint, is to pay attention to them. One might take the architecture of the house barely seen through the trees to embody the principle of geometric structure lying behind nature's surfaces. But to imply that that was actually Caillebotte's intention would be going too far, were it not for his interest in architectural shapes and how they interplay with their environment.

Armand Guillaumin

|Fig. a| Paul Cézanne, Copy after Guillaumin, *Quai de Bercy*, 1876–8
Hamburger Kunsthalle

|Fig. b| Vincent van Gogh, *Fishing in the Springtime*, 1887
The Art Institute of Chicago, IL

A Pivotal Role

Until recently Guillaumin has been regarded as a second-rate painter, and indeed the undeniably fluctuating quality of the later work done over his long career hurt his overall reputation. (He lived until 1927, a year after the death of Monet.) Yet, as the concept of Impressionist modernity broadens to include industrial views, of which he was the master, and as his works gradually emerge from private collections, it is evident that he made many beautiful and influential pictures. It is especially during the early part of his career, when he worked with Camille Pissarro and Paul Cézanne, with whom he was extremely close, and then later with Paul Gauguin and Vincent van Gogh. In fact, since Cézanne and Van Gogh never actually met (although it is said they crossed paths at the shop of Père Tanguy), Guillaumin may have served as a kind of intermediary between the two.

This role is exemplified by *Épinay-sur-Orge*, a picture of farmhouses in the lush terrain of the village about twenty kilometres south of Paris. Guillaumin often painted in the southern suburbs (p. 140), an area little frequented by Impressionist artists except when Cézanne accompanied him (p. 160 and p. 250). It seems inevitable that Guillaumin would eventually travel further south to an area with easy train access but not yet transformed into suburbia. With its peasant woman in front of the group of houses, there is a sense that the painting emulates Pissarro's farms and peasant women (p. 182). However, Guillaumin's fresh and even daring colours make the picture uniquely his – the bright blue shadows on the background hills, the bright red spots on the orange tile roofs, and the turquoise in the sky carried over to the foliage on the left. In addition, in the same area are echoes of Cézanne's 'constructive' brushstroke. Guillaumin knew this aspect of Cézanne's work well, since the latter had used it systematically to copy one of Guillaumin's compositions (Fig. a).

When Van Gogh came to Paris one of the first artists he met was Guillaumin, along

with Pissarro. Cézanne had already left, but it is evident that Van Gogh systematised his own bold brushstroke through contact with the Pissarro group. More than Pissarro himself, however, Van Gogh would have found Guillaumin interesting because of his brilliant colour. Before switching to evocations of Neo-Impressionist pointillism, which was emerging in 1886 at exactly the time of his arrival – as Pissarro and Paul Signac (also part of the later Pontoise group) were doing – Van Gogh seems to have adopted Guillaumin's colour and his response to Cézanne, strengthening both by his expressionist boldness (Fig. b). Gauguin, too, may have been stimulated by Guillaumin's use of colour (p. 304). Guillaumin, then, was a pivotal figure, even though quickly overtaken by those he influenced. That he could have had such a position must force one to re-evaluate the status of his works, for, as *Épinay-sur-Orge* clearly demonstrates, he was capable of producing pictures of the first order.

Édouard Manet

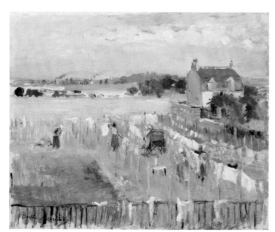

|Fig. a| Berthe Morisot, *Hanging the Laundry out to Dry*, 1875
The National Gallery of Art, Washington, DC

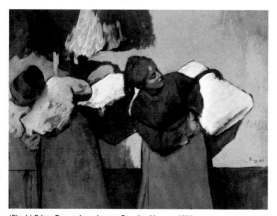

|Fig. b| Edgar Degas, *Laundresses Carrying Linen*, c. 1878
Private collection

'mobile daubs of paint dissolving into ambient space'

Both Manet's *Laundry* and *The Artist, Portrait of Marcellin Desboutin* (p. 108) were rejected by the Salon of 1876. He was forced to show them in his studio. The Impressionists got far more press than Manet, yet the longest single essay of that year about Impressionism was entitled 'The Impressionists and Édouard Manet' – published in English only – and hailed Manet as the group's leader. Its author was Stéphane Mallarmé (p. 80).

Painted in 1875, *Laundry* thus immediately followed the first Impressionist exhibition and may be seen as a response to it. Manet might also have been thinking of his friend Berthe Morisot's painting of laundry of the same year (Fig. a). Done from her house in the Paris suburb of Maurecourt, it shows the city in the distant background. Both artists differed in their naturalism from Edgar Degas's version of the theme (Fig. b), which poses laundresses balancing their baskets on their hips and mirroring each other as if they were part of a dance review. All three make art from the contemporary obsession with cleanliness and hygiene.

For Mallarmé, *The Laundry* exemplified why Manet was the leader of the group. It was a full-figure painting, which in the minds of most still had higher status than the landscapes dominating Impressionism. At the same time it exemplified painting done out of doors. So Mallarmé took it to be the ultimate example of modern painting in its highest aspirations. He wrote:

The young woman's body is entirely bathed and seemingly absorbed by light, which leaves her with nothing but her appearance [aspect]*, both solid and vaporous, as is demanded by the plein-airism everyone is aiming for in France today.*

The French word '*aspect*' refers to the optical, as distinct from the architectonic and psychological, properties of form. Mallarmé believed Manet had achieved a turning point in history, for by concentrating on the purely visual, he made art more democratically accessible than ever before.

It is doubtful Manet executed a picture the size of *Laundry* outside the studio, but as far as Mallarmé was concerned, the painting's simplicity and broad-brushed technique enhanced its claim to spontaneous *plein-air* naturalism. It looked unposed; few could have known the yard was the same as in *The Railway* (p. 158) and that the models were the daughter of Alphonse Hirsch's concierge and Alice Legouve, the painter Alfred Stevens' mistress. The previous year, critics had acknowledged Manet's *Argenteuil* (p. 279), a clearly structured studio composition, as exemplifying the *plein-air* school.

Laundry (Le Linge), 1875

oil on canvas, 145.4 x 114.9 cm, The Barnes Foundation, Philadelphia, PA

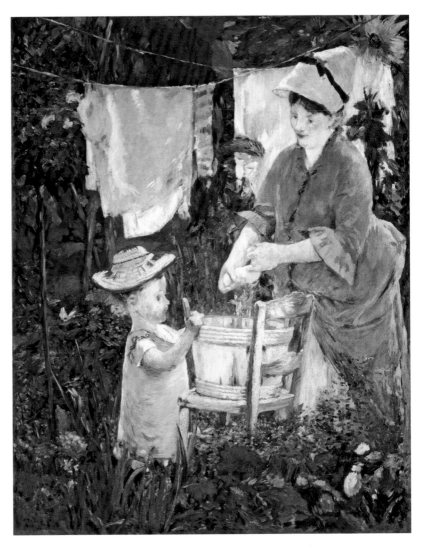

Light and air, Mallarmé argued with considerable eloquence, are the medium for existence and perception, which, though they cannot themselves be rendered by a colour, preside over nature by their effects and are the conditions for awareness of our surroundings. Manet's art thus embodied the presence of objects as a dynamic process rather than stasis, a dialogue with light and the perceiver rather than a separation. His painting was of its time by corresponding to science, by which Mallarmé meant what empirical observation reveals. The artist's ostensibly incomplete touches and immanent forms produce an active effect, rather than a static image, and are thus, Mallarmé claimed, a truthful expression of lived experience.

Édouard Manet

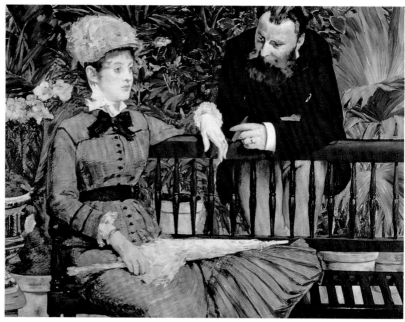

|Fig. a| Édouard Manet, *In the Conservatory*, 1879, Alte Nationalgalerie, Berlin

Art and the Modern Condition

Manet's visits with Claude Monet at Argenteuil (p. 75) coincided with *Boating*, one of the most exemplary pictures of *plein-air* leisure ever made. It seems as if painted from an adjacent boat, a conceit paying homage to Monet's floating studio (p. 74 and Monet, *The Studio Boat*, 1874, Kröller-Müller Museum, Otterlo), which Manet of course knew. The picture also exhibits Manet's more broadly brushed version of Monet's style. With its glorification of sport and relaxation, along with up-to-date fashions, brilliant colour and loose brushwork, Manet's picture at first glance exemplifies the Impressionist attitude towards modernity and enjoyment of nature.

But there is more. Unlike the Impressionists, whose preoccupation with the visual is ostensibly innocent and uncomplicated, Manet was still mulling over issues associated with the narrative traditions that he had worked to engage and then transcend earlier in his career. He knew that juxtaposing two figures inevitably raised the question of a relationship between them. Yet he gave no clues to their inner thoughts or the content of their communication. *Boating* and the painting with which it was exhibited at the Salon of 1879, *In the Conservatory* (Fig. a), display a sense not only of detachment – already a characteristic Manet had perfected – but estrangement.

In *Boating* the woman's mind seems as suspended and adrift as does the sailing boat. Shielding her complexion from the sun, her veil also adds to the sensation of her distance. Her companion may be wary of a nearby boatman's curiosity; clearly his sail fastened by a rope needs little watching, while his rowing gloves, indicated by a few amazing strokes, are tossed over to the picture's right. *In the Conservatory*'s domestic interior is more appropriate to a married couple, whose vows are confirmed by the placement of their hands with wedding rings on the bench's back. Yet this detail

Boating, 1874

oil on canvas, 97.2 x 130.2 cm, The Metropolitan Museum of Art, New York, NY

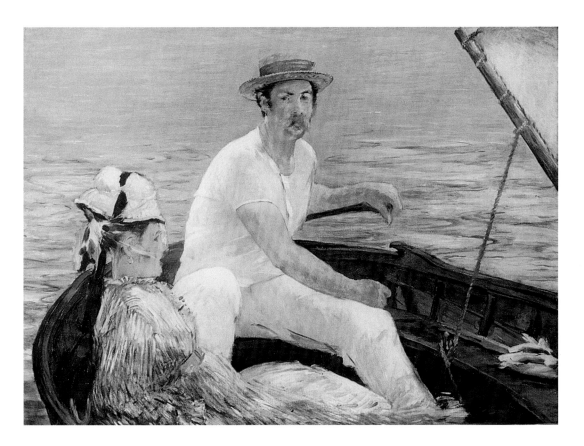

renders interpretation even more difficult than for *Boating*. Is the couple waiting for their coach to take them out? – she is equipped for a promenade with matching ostrich-feather hat, yellow gloves and parasol. Is she leaving without her husband, whose cigar is far from finished? He is the one behind the railings; his wife has an open space before her. Manet was certainly attracted to Madame Guillemet, at least to her lovely legs, for he drew them several times in watercolour in a letter addressed to her (p. 110). Was she an available *femme du monde*?

In both *Boating* and *In the Conservatory* women's fashions are a focal point, giving rise to some of Manet's most exciting facture. It might also be said that Manet dresses his images with reminders that they are aesthetic objects, like the women they portray. Their effect corresponds to the aesthetics of modern leisure: the painted river Seine in *Boating* and the hothouse plants of the conservatory provide pleasures for the viewer paralleling those of the settings enjoyed by Manet's painted figures. But an unsettling question remains: is detachment a sign of modern alienation, an emptiness only art and leisure can fill, or, to the contrary, are such narcissistic and consumer indulgences the source of social indifference and isolation, to which art is both a pleasurable and necessary antidote?

Camille Pissarro

|Fig. a| Paul Cézanne, *A Corner of the Woods, Pontoise*, c. 1875–6
Museum of Fine Arts, St Petersburg, FL

Dialogues on the Hill

In 1877 Pissarro made two pictures that are among his best: *Red Roofs, Corner of a Village, Winter* (1877, Musée d'Orsay, Paris) is horizontal, *Côte des Bœufs* vertical, the latter less common for landscapes, but frequent during this period of experimentation and dialogue with Paul Cézanne (Fig. a). In all three pictures, trees, houses and sky seem compressed into a flat surface and woven together into a pattern that brings together space, understood as three-dimensional, and matter, embodied by the pigments on the planar physical surface. The vertical format adds pressure from the sides to be pictorially concise. In Pissarro's picture there is a veritable screen of trees in the forward middle ground through which one views the landscape. And a second row in the background to the right might be said to frame the architectonic elements between them. The effect is less pronounced in *Red Roofs*, which shows the same houses to the left but viewed from the right, where the tall trees are only hinted at. More houses are allowed by the horizontal view, but there is a greater sense, towards the canvas centre, of compression and overlap between houses and limbs as they seem fused by the materiality of their pictorial representation. These effects stem directly from a dialogue Pissarro was engaged in with Cézanne. The two met at the studio of Charles Suisse in 1861. As outsiders to Parisian circles, they formed an immediate friendship, and were introduced to other future Impressionists by Frédéric Bazille in 1863. The real exchange between them, however, began when Cézanne moved to Pontoise in 1872 and they, along with Armand Guillaumin, frequented the home of Dr Paul Gachet (p. 160) at Auvers-sur-Oise, where Cézanne settled in 1873. It was then that Cézanne concentrated seriously on landscape. He called Pissarro 'humble and colossal' and Pissarro made an affectionate portrait of his friend (p. 187). Although it is often said that Pissarro acted as an older mentor to Cézanne, who was nine years younger, close examination shows that Cézanne held his own, and that the flattening and rigorous structuring adopted by Pissarro in these paintings are effects that probably emerged from their mutual experimentation, since they characterise Cézanne's work more than Pissarro's from this point on in time (p. 316). A witness who observed the two said that Pissarro worked in dabs, while Cézanne worked in slabs. Compared to Pissarro's picture, Cézanne's is flatter and more schematic; Cézanne goes further when exploring new techniques and principles. (Despite differences in their titles the paintings show the same place.) In this case, the goal was to integrate forms perceived in nature to a tight visual image in order to reconcile naturalist

The Côte des Bœufs at L'Hermitage, 1877

oil on canvas, 114.9 x 87.6 cm, The National Gallery, London

illusionism with the intellectual and physical labour required to produce it on the canvas. This process required an emphasis on compositional conception and material brushwork. The result is a less spontaneous, more planned and thoughtful image than those of fellow Impressionists more concerned with the instant. In Pissarro's picture, in particular, two immobile figures at centre left stare out at the painter while he was working, mirroring with their gaze the artist's prolonged concentration on creating an image rather than merely 'copying' it, as critics believed, without creative input.

Paul Cézanne

|Fig. a| Paul Cézanne, *The House of the Hanged Man, Auvers-sur-Oise*, 1873
Musée d'Orsay, Paris

Constructive Abstractions

Despite *The Turn in the Road*'s simple subject, Cézanne produced a masterpiece of early maturity, combining elements acquired through his dialogue of the 1870s with Camille Pissarro, while adding a level of system and abstraction that would characterise the rest of his career. In earlier paintings, such as the famous *The House of the Hanged Man* (Fig. a), exhibited at the first Impressionist exhibition, Cézanne chose a sharp curve on a steep hillside to produce an illusion of space and volume through sheer observation of surfaces rather than the artifice of perspective or traditional modelling. The result was powerful but awkward – an example of the limited but lightened palette from Pissarro, but heavy-handed with its dabs and jarring in its intersecting axes. In *The Turn in the Road* Cézanne resolved these features into an elegant reconstruction of nature, revealing the cerebral, step by step, development of his composition.

The eye follows the road's hooking penetration into the setting, the rightward curve of which is picked up by the stone wall. A row of houses emerges from behind trees, moving in what seems like a deliberate procession across the field of vision. There is a sense of mapping based not on momentary but protracted observation, including from what seem like different angles. In addition to this systematic approach, Cézanne displays his relatively new 'constructive' system of short, juxtaposed parallel strokes, often changing in hue, and usually positioned at angles to surrounding areas with a patch-like result. Playing off one another, these patch-ensembles imply planes in space while producing simplifications that call attention to design. Their derivation from hatching marks reminiscent of those used in drawings, reinforces a sense of the artist's direct contact with natural form, as in sketching, while at the same time their reference to hand movement emphasises the artifices of technique. They are a graphic device that implies the artist's control and method.

The effect of the flattened road penetrating the composition is paralleled in the foreground of certain still lifes of this same period (Fig. b and p. 192). Cézanne's structural interests may thus be compared across both genres, even though landscape differs in that primary objects, such as the houses, are part of a larger context, namely their setting. Conversely, even in his simplest still lifes Cézanne often took pains to integrate the elements of his set-up to the studio or home environment.

Unlike in *The House of the Hanged Man*, one notices this integrating effort in *The Turn in the Road*. Following the effects observed in Pissarro's and his own pictures of the Côte des Bœufs (p. 315), Cézanne made the overlapping and merging of forms on the surface more elegant and clear. There are many instances throughout

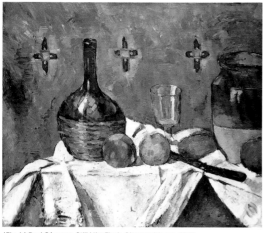

|Fig. b| Paul Cézanne, *Still Life: Flask, Glass and Jug*, c. 1877
Solomon R. Guggenheim Museum, New York, NY

The Turn in the Road, Pontoise, c. 1881

oil on canvas, 60.6 x 73.3 cm, Museum of Fine Arts, Boston, MA

the picture, but at its centre, framed by the white side of the most prominent house, is a paradigmatic example, where broken lines of branches allow the house to show through. Cézanne thus emphasises a fundamental truth in painting: that it is an artificial construct derived from observation. For him, the emphasis on that constructive element must now be equal to the naturalist effect, for instead of nature merely seeming to impress itself on the artist, it expresses a dialogue between the two.

Georges Seurat

Rock of Ages

Seurat's work on the Normandy coast from summer 1885 seems a rebuke to Claude Monet's coastal images from the early 1880s (Fig. a and p. 256). Rather than the instantaneity of waves crashing, wind blowing or sun brilliantly shining, Seurat suggests the permanence of a rudely shaped rock across airless space and time. The bizarre geological formation – now pockmarked by World War II bomb craters – is like a huge beak (*bec*), its tip reaching just beyond the virtually flat horizon of the Channel. This virtual intersection's emphasis on geometry is seconded by the meeting of the promontory's base at the canvas's lower left corner. Some whitish wavelets and distant sailing boats play a light-hearted counterpoint to the cliff's huge continuo. Five birds above the point seem frozen in their flight formation; by inversion, they echo the picture's basic geometric design. Although the term 'Neo-Impressionism' was yet to be coined, this painting along with two others from Grandcamp was part of the eighth and final Impressionist exhibition (1886), which included *La Grande Jatte* (p. 331). Thus, landscapes such as *Le Bec du Hoc* contributed to defining Seurat's novelty. It displays a regularised, though variable, pre-pointillist technique through which Seurat tried to depersonalise the image, banning the tricks and bravura of the Impressionists' highly personal technique and skill in favour of a method universally available and legible to all. The critic Félix Fénéon explained the aim as 'to synthesise the landscape in a definitive aspect that perpetuates the sensation', rather than the Impressionists' habit of seizing 'fugitive appearances'. For the latter to capture 'the landscape in a single sitting' they had to distort nature, resulting in mere 'anecdotes'. By contrast, Neo-Impressionism sought to transcend the moment in favour of a common denominator among moments that would express the enduring character of a place, hence a 'superior, sublimated reality', corresponding to a deeper intellectual truth than the superficiality of the instant.

However powerful the Bec's form, Seurat still dominates nature through his mechanistic technique, which varies only by surface (water, rock or grass), by his high viewpoint and by cutting off the motif in the foreground as in Japanese prints. The outline of the shaded area is also more emphatic, hence artificially imposed, than in other areas where different surfaces are juxtaposed. In contrast to Monet's tiny figures, dwarfed by the grand arch of the Manneporte, Seurat thus maintains a rational

|Fig. a| Claude Monet, *The Manneporte (Étretat)*, 1883
The Metropolitan Museum of Art, New York, NY

|Fig. b| Georges Seurat, *Sunday at Port-en-Bessin*, 1888
Kröller-Müller Museum, Otterlo

Le Bec du Hoc, Grandcamp, 1885

oil on canvas, 64.8 x 81.6 cm, Tate Modern, London

control – the opposite of sublime awe conveyed by Romantic landscape.

The image's artifice and isolation from reality is underlined by the painted border, which Seurat added later in pointillist dots and colours echoing the picture's central shadow. At this later time he was painting man-made harbours and their new, concrete breakwaters with almost cartoon-like simplicity (Fig. b). Their obvious, poster-like effects are a gesture towards the legibility of popular advertising imagery, ostensibly supporting the social claims that his art made for democratic accessibility and impersonality. And yet few styles are as identifiably individual as Seurat's, backed by sophisticated theories, to the point where most of his followers would have trouble distinguishing themselves as anything but imitators.

Renewal and Revival

Paul Cézanne

|Fig. a| Paul Cézanne, *A Modern Olympia*, 1873–4, Musée d'Orsay, Paris

|Fig. b| Paul Cézanne, *Apotheosis of Delacroix*, 1890–4, Musée d'Orsay, Paris

The Gaze of the Artist Returned in Blood

Throughout his career Cézanne stuck to the Impressionist ethos of direct engagement with nature. Yet he never lost touch with figure painting, whether portraits or the theme of bathers. In spite of his discomfort with nude models – he used drawings of nudes from his student days as a substitute – one of his obsessions, especially in his early years, was to respond to the nudes in Édouard Manet's *Le Déjeuner sur l'herbe* (p. 23) and *Olympia* (p. 219). He did some early picnic scenes and at the first Impressionist exhibition he exhibited *A Modern Olympia* (Fig. a). These pictures had in common the presence of a figure whose beard and balding head unmistakably show the artist himself. In *A Modern Olympia* the nude prostitute is dramatically staged in a lavish setting. *The Eternal Feminine* is a development from this theme recast into public space, like a circus fair or outdoor theatre.

In the centre foreground is the bald head of the artist, accompanied by various figures, some more or less identifiable by their costumes. To the upper right with a canvas is a painter generally identified as Eugène Delacroix. Cézanne much admired the Romantic painter, as did other Impressionists (p. 26 and p. 119). To the left is a Napoleonic soldier, at the centre a mitred bishop, and to the right trumpeters who herald the nude woman in the centre. All focus their offerings and attention on her, while she stares out with bleeding eyes. If the picture illustrates a literary theme, it has yet to be discovered. On the other hand, it may be allegorical, for the eyes, the bishop's crozier and Cézanne's head form a highly suggestive axis.

It reads like a puzzle, possibly explained by Charles Baudelaire's claim in 'The Painter of Modern Life' that woman is 'a stunning and enchanting idol … who holds wills and fate suspended in her gaze'. She is an object of both worship and sacrifice.

The Eternal Feminine was one of the first compositions to which Cézanne applied his constructive brushstroke (p. 316), which in this case might be said to suppress the emotion conveyed by the cruder and more intuitive facture of his earlier, especially figurative work, in favour of dominance and control. Not that Cézanne was especially fond of allegories, but he had planned a homage to Delacroix since the 1860s (Fig. b), and as one can tell from the intellectual aspects of his still lifes and landscapes, he was

The Eternal Feminine, c. 1877

oil on canvas, 43.2 x 53.3 cm, The J. Paul Getty Museum, Los Angeles, CA

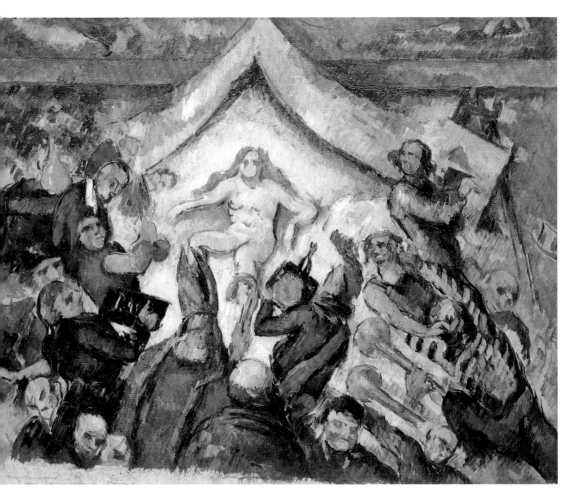

deeply concerned with the processes of art and how to reconcile objective nature and subjective perception. Expressing his personal temperament was always a point of pride for him, seconded by Émile Zola's claim that what he himself sought in artwork was the man behind it. It is this element of masculinity, determination and interaction between man and nature (defined as woman) that Cézanne emphasises in this otherwise enigmatic work. One might also recall Zola's definition of art as 'a corner of nature seen through a temperament'. Although set in the modern topicality and technique of Impressionism, *The Eternal Feminine* recasts these as self-conscious rumination on that definition's meaning.

Vincent van Gogh

An Outsider's Response to the Avant-Garde

As an outsider abruptly introduced to the Parisian avant-garde in March 1886, the year of the Neo-Impressionist transformation, Van Gogh's reactions to the Impressionist exhibition of that year are informative. He had been painting in the dark tradition of the Dutch, when brother Theo, who worked for a Parisian art dealer, arranged for Vincent to join him. Van Gogh quickly lightened his palette and changed his brushstroke in response to Impressionism and Neo-Impressionism. The urban scene had already fascinated Van Gogh in Antwerp, and from his room in Montmartre he made several views of Paris. One of them (Fig. a) suggests the dramatic lighting of *Setting Sun at Ivry* by Armand Guillaumin (p. 141), who was among artists Van Gogh met in the group around Camille Pissarro. He also met Paul Signac (p. 204), the follower of Georges Seurat, in early 1887, and they painted together along the Seine that spring.

One of Van Gogh's most important pictures from this campaign was the *Bridges across the Seine at Asnières*, in which he mediates between Impressionism, as in Claude Monet's work (Fig. b), and the newer generation. The location is Asnières, one loop of the Seine closer to the city than Argenteuil, and where railway and road bridges cross the river from industrialised Clichy within easy sight of one another. It was the place where Monet had gone for industrial views in the mid 1870s (p. 156). Here, factories can be seen in the distance. Van Gogh juxtaposed bourgeois figures on the riverbank and rowing boats for hire to the right – sure signs of leisure typical of Impressionism – with the massive railway bridge, with a train lumbering over it. Although his brushstrokes are Impressionist rather than pointillist in shape, their regularity and the intensity of the picture's complementary blues and oranges reveal the effect of recent pictorial innovations and presage his expressive use of colour. The same is true of the picture's powerful geometry, with its clear allusion to Neo-Impressionism's compositional strategies (p. 376).

Although Van Gogh's work is to a degree derivative at this time, it reveals a powerful personality hungry for new ideas that seemed to be coalescing within a group of like-minded practitioners. Although industrial imagery had disappeared in Monet's work, the group around Pissarro, Signac especially, reflects not only the revived significance of such themes but their appropriateness for artistic aims in which modernity in handling, colour and modern imagery were inseparable. In Van Gogh's case, the unique physical imprint of his pictorial handling

|Fig. a| Vincent van Gogh, *Factories Seen from a Hillside in Moonlight*, 1886
Van Gogh Museum, Amsterdam

|Fig. b| Claude Monet, *The Promenade with the Railway Bridge, Argenteuil*, 1874
Saint Louis Art Museum, MO

Bridges across the Seine at Asnières, 1887

oil on canvas, 53.5 x 67 cm, E.G. Bührle Collection, Zurich

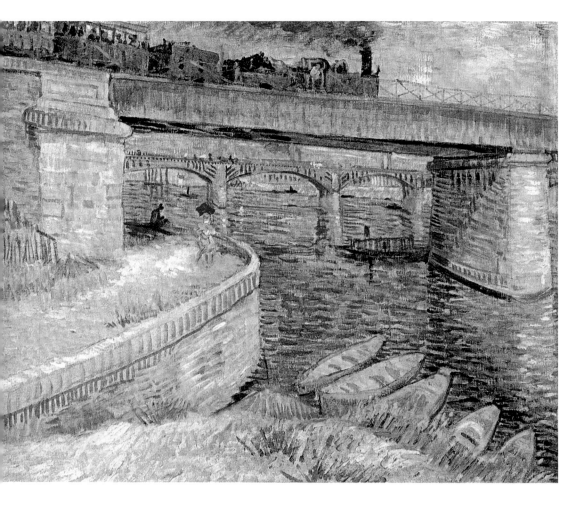

maintained an insistence on individual artisanal productivity rather than the impersonal or scientific-technological evocations of the pointillist dot. It is easy to understand how the leftist sympathies for the working man Van Gogh had acquired while ministering to potato farmers and labourers in the Netherlands led to his interest in urban and industrial imagery and common elements of everyday life. At the same time, the admiration for pre-modern labour he expressed in many of his letters and early Dutch period works helps explain his resistance to the depersonalising anonymity of modernisation, which Signac and Seurat's pointillism implied.

Paul Gauguin

Searching for Self

Rooftops had been an interesting topic for artists since the first *plein-air* studies, some of which were made from artists' studios, which were often on high floors not only because the rent was cheaper but because the light was better. At the 1879 Impressionist exhibition – the first in which Gauguin participated – Gustave Caillebotte attracted attention with two dramatic views made from his newer Haussmann-period building looking out over the older, lower buildings just below (Fig. a). Caillebotte's interest in engineering and spectacular viewpoints gave such views a special attraction for him, but Paul Cézanne had also experimented with their geometry, though in the context of a suburban village landscape (p. 316).

At the end of 1883, having either lost or quit his job in the money market, Gauguin decided to give up finance for good and pursue painting full time. In January 1884 he moved with his Danish wife Mette and family to Rouen, where he could live more cheaply than in Paris. Camille Pissarro was in Rouen at the time making pictures of the port, although he was living at Eugène Murer's hotel and had no plans to stay much longer. Gauguin thought that various Impressionist connections there, including Murer and Monet's brother Léon, might lead to clients. He found a place in Rouen's northern outskirts, where he did most of his paintings until lack of money eight months later forced him to live with Mette's family in Copenhagen.

In 1880 Gauguin must have been stung by criticism that his work was 'watered down Pissarro'. As for many artists, it took time to find himself, and that searching continued in Rouen, where his style hovered between those of Pissarro, Armand Guillaumin and Cézanne. In *Blue Roofs* he combines them most successfully, forging something that verges on his own. The steep hill and flattening are reminiscent of numerous paintings by Pissarro of L'Hermitage (p. 244), while the geometry makes one think more of Cézanne. Indeed, the picture seems like a spin-off from his two colleagues' paintings of the Côte des Bœufs (p. 314). The brushwork, on the other hand, is less refined, pasty or systematic than Pissarro's, yet it is not yet an imitation of Cézanne's 'constructive stroke'. It looks more like Guillaumin's, and certain colouring effects, such as violets and oranges, are comparable only to the latter's (p. 308).

The cut-off figure in the left foreground was already something of a Gauguin trademark. Pissarro had used it only in crowded market scenes (p. 184) he painted

|Fig. a| Gustave Caillebotte, *Rooftops in the Snow (Snow Effect)*, 1878
Musée d'Orsay, Paris

|Fig. b| Paul Gauguin, *Haystacks in Brittany*, 1890
National Gallery of Art, Washington, DC

before temporarily leaving Pontoise for Rouen. One could find the motif in, for example, Gauguin's picture of the Rue Carcel from the previous year (p. 304). Moreover, the blue colour of the slate roofs and the yellows and oranges of the houses represent a considerable brightening of Gauguin's palette, and their geometry signals the simplifications and patterning called Synthetism that he would eventually develop in Brittany (Fig. b) and Martinique (p. 259) to claim his independence from Impressionism. *Blue Roofs* represents both the last phase of Gauguin's Impressionism and the first glimpse of his future.

Pierre-Auguste Renoir

|Fig. a| Marie Bracquemond, *The Three Graces*, 1880
Musée d'Orsay, Paris

|Fig. b| Pierre-Auguste Renoir, *La Promenade*, 1875–6
The Frick Collection, New York, NY

Drawing in the Rain

Among the consequences of Renoir's trip to Italy in 1881 – financed by sales, such as that of *Luncheon of the Boating Party* (p. 281) to Durand-Ruel – was a reassessment of his relationship to Impressionism and his overall place in art. He began studying Renaissance writings and later confessed to the dealer Ambroise Vollard that he 'had reached the end of Impressionism' and was no longer sure whether he could paint or draw, by which he meant in the traditional manner. Like the conservative painter Jean-Auguste-Dominique Ingres, he became an admirer of Raphael (p. 231), and he began drawing in Ingres's linear style (p. 292). His claim that artists had lost touch with nature raised questions about whether *plein-air* painting had achieved that goal. More than any other painting, *The Umbrellas* traced this development because it was painted at different times, with a marked change of style from the first to the second. It was conceived like *Luncheon of the Boating Party* as one of several large paintings of modern life, more specifically everyday than the posed and symmetrical *Three Graces* by Marie Bracquemond (Fig. a) that surely inspired it. The mother and her two daughters in the right half of the foreground are painted in Renoir's rich, blended style of around 1880-1, and are highly reminiscent of the charming *Promenade* (Fig. b), which he exhibited with the Impressionists in 1876. The rest, finished four years later, is modelled in a drier, tighter manner with far greater emphasis on volume and geometry. Scientific analysis has shown that he even used different pigments. The wonderfully playful crowd of umbrellas is unlike anything else in Renoir's work, with overlapping and cutting-off reminiscent of Japanese prints. It might be a fun-loving answer to Gustave Caillebotte's archly serious *Paris Street, Rainy Day* (p. 101). In spite of *Umbrellas'* so-called 'sour style', which was unpopular with Paul Durand-Ruel – he said it would ruin Renoir's career – there is no absence of sentiment and seduction. The little girl with the hoop gazes out at the viewer with typical child-like innocence, while her mother watches to make sure she doesn't wander. In the group to the left, the servant out shopping, posed by Suzanne Valadon, grocery basket as yet unfilled, is followed by a clean-cut young admirer whose top hat is cut off by his umbrella. Hers is by far the shapeliest figure, clearly outlined by the artist; she is also the only adult unprotected from the rain, as if to reveal her more fully.

Partially cut off behind the mother is another woman: looking at the sky as if wondering whether to open or close her umbrella, she contributes to the Impressionist feeling of the moment. To the upper right is a man holding his umbrella high, fighting his way against the flow of the crowd. His raised arm blocks out the face of a woman moving in the opposite direction. One is forced to conclude that whatever charm Renoir's new style might lack is compensated for by inventive wit, and however static its sharply outlined figures seem, a plethora of detail contributes to the feeling of city hustle.

The Umbrellas, c. 1881–6

oil on canvas, 180.3 x 114.9 cm, The National Gallery, London

Georges Seurat

|Fig. a| *Procession of the Peplos Bearers*, Fragment from the Parthenon Frieze, 445–438 BC, Musée du Louvre, Paris

Weekend Rituals

The most powerful and lasting challenge to Impressionism came at their 1886 exhibition. A room was devoted to work by Seurat, Paul Signac, Camille Pissarro, who temporarily adopted Seurat's style, and Pissarro's son Lucien. With Paul Cézanne, Pissarro had been developing more systematic brushwork than those Pissarro now called 'romantic' Impressionists.

It was Seurat who in 1886 took the undisputed lead in this direction with his large painting of La Grande Jatte. Its theme of outdoor bourgeois leisure was typically Impressionist, as were its luminosity and suburban location on an island running down the middle of the Seine between Asnières and Courbevoie on one side, and Neuilly on the other. (It is now called simply Île de la Jatte.) But the sense of depersonalised anonymity and time frozen, rather than the fleeting instant, produced by its pointillist technique – actually dots and many small dashes – was entirely new.

A painting of its size could only have been produced in the studio, and indeed it was preceded by many studies of groups and figures, as for academic paintings. Many of them, however, were done in a far more intuitive, Impressionist-like style than the finished work. In addition, Seurat had become interested in optical theories, from Michel-Eugène Chevreul's writings on interaction of colours and Hermann von Helmholtz's differentiation between additive and subtractive colour relations, to Columbia University professor Ogden Rood's *Modern Chromatics* (translated into French in 1881). Shadows containing dots of their complementary colours were one way to display Seurat's relationship to science. Another was to evoke Helmholtz and Rood by juxtaposing colours rather than blending them, believing they would be more luminous when their rays mixed in the eye rather than on the canvas.

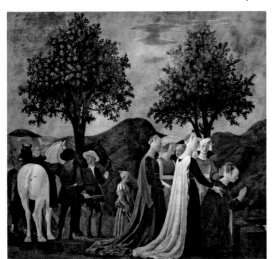

|Fig. b| Piero della Francesca, *Adoration of the Sacred Piece of Wood and Meeting between King Solomon and the Queen of Sheba* from *The Legend of the True Cross*, c. 1432, Church of San Francesco, Arezzo

The son of a successful engineer, Seurat was respectful of both science and tradition: he trained at the Academy and attempted to preserve many of its values.

He compared his work to the Parthenon Frieze (Fig. a), which represented a generalised version of a ritual held by Athenians every four years. For Seurat, Sunday outings were a ritual performed by Parisians.

Another important context for his picture were ambitions like those of Pierre-Auguste Renoir to evoke Renaissance art and its decorative traditions (Fig. b).

Sunday Afternoon on the Island of La Grande Jatte, 1884–6

oil on canvas, 207.6 x 308 cm, The Art Institute of Chicago, IL

This effort was encouraged by the young, charismatic, so-called psychophysicist Charles Henry, who explained the endurance of classical Egyptian, Greek and Renaissance art by their 'harmony', which he could measure mathematically. His standard was the golden section, a proportional relationship (p. 374). Beginning with *La Grande Jatte*, and increasingly thereafter, Seurat used it to organise his compositions. The effects of the new style and method were described by the critic Félix Fénéon as 'Neo-Impressionism', although Seurat's follower Signac (p. 378) preferred the more scientific term 'chromo-luminarism'. The former, however, implied both a revival, in the sense of Impressionism's original goal of objective observation, and a reassessment of how best to achieve it. The new generation's claim was that rather than expressing a single moment viewed by an individual, a more truthful approach was to 'synthetise' in order to create the pictorial equivalent of a more lasting, underlying truth (p. 318).

Camille Pissarro

|Fig. a| Camille Pissarro, *The Shepherdess*, 1881
Musée d'Orsay, Paris

The Points of Politics

In 1886 Pissarro exhibited in the same room as Georges Seurat, signalling his solidarity – temporary, it turned out – with the new generation (p. 330). The Impressionists' friend the Irish novelist George Moore said that without knowing Pissarro well he would have been unable to tell his work from others, including Paul Signac and Pissarro's son Lucien. In one sense, that was the point of exhibiting together. The new pointillist style was aimed at eliminating bravura effects of pleasing handwork, such as in works by Claude Monet and Pierre-Auguste Renoir. It was one that anyone with patience could master. A painting's quality would depend on the painter's 'vision' rather than the 'tricks' or skills of his hand. Among reasons underlying this effort were democratic ideals of accessibility to all, meaning that both artists and viewers would practice and understand a modern, objective language based on science, a work ethic that the casual, sketch-like technique of the 1870s seemed to disdain, and a desire for more than a mere moment's truth about the world. As revealed in numerous letters, moreover, Pissarro had great respect for intellectual rigour and careful physical labour in art-making.

Pissarro's work is nonetheless distinguished from his cohorts' by its rural and agricultural setting. *Apple Pickers* was begun in the early 1880s and shows farm women like those of paintings finished during those years at Pontoise (Fig. a). The pointillist style is undoubtedly an overlay on the original composition. The bold shadow, presumably of a house just outside the picture, was probably added to correspond to what Pissarro perceived as Neo-Impressionism's demand for overall geometric coherence.

View from My Window (Fig. b), by comparison, was begun in 1886 entirely under the new spell and finished in time for the exhibition. Its ostensibly mathematical design and stippled vision pushes Neo-Impressionist principles to their extreme. In 1888, however, Pissarro reworked the picture, adding more foliage in the foreground and softening the colours to mitigate its simplistic harshness and stridency, hoping perhaps that it would be more saleable. It is also possible that he saw the pointillist system as counter-productive, its screen of dots tending to poeticise rather than politicise the work.

For Pissarro's attraction to Neo-Impressionism certainly had a political basis. Although his views emerged explicitly only later (p. 385), he was a long-time anarchist, judging by his understanding of the Impressionist organisation as cooperative, and his brief flirtation with

|Fig. b| Camille Pissarro, *View from My Window, Éragny-sur-Epte*, 1886–8
Ashmolean Museum, Oxford

Apple Pickers, 1886

oil on canvas, 128 x 128 cm, Ohara Museum of Art, Kurashiki

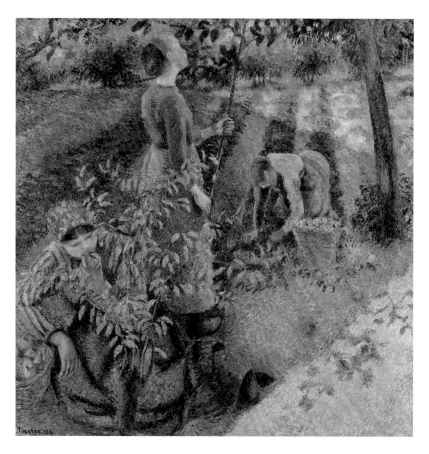

an artist's union organised by one Alfred Meyer in the later 1870s. Seurat's first exhibited works were with a group of Independents whose connections to some leftist city councilmen led to their use of the post office across from the Louvre. The point was that it was a public space, in opposition to several Impressionists, who had begun showing in private galleries. Although Pissarro did not exhibit with the new group, he understood that Neo-Impressionism's combination of modern subject matter and classicising generalisation corresponded to aspirations of utopian imagery. It was he who invited Seurat to join the Impressionists in 1886. Pissarro later did illustrations for Jean Grave's anarchist magazine *La Révolte* and a series of anti-capitalist caricatures. He may have felt that the Neo-Impressionist style got in the way of its utopian message.

Mary Cassatt

Like many of the Impressionists, Cassatt's style developed into what passed for greater rigour in the 1880s; namely, firmer outline and more traditional modelling to escape the flattening effects of earlier Impressionism. She produced what seems an ideal fusion of colourist modernity and illusionistic presence that satisfied both the taste of her time and her own principles. She had been trained in academic style in Philadelphia and Paris before being invited to join the Impressionists by Edgar Degas, who was himself similarly trained. This painting, often known as *The Oval Mirror*, frames the mother and child in a shape that recalls Renaissance Madonnas in oval or tondo form. Like the long-deceased

|Fig. a| Praxiteles, *Hermes with the Infant Dionysos*, c. 343–330 BC, Archeological Museum of Olympia, Ilia

Jean-Auguste-Dominique Ingres, the defender of the classical tradition, her work evokes Raphael, and indeed many of Ingres's followers were producing overtly retrograde religious images at the time. Unlike them, however, Cassatt preserves the absolutely contemporary feeling of her work through the woman's fashionable housedress and coiffure. Moreover, her young son's absent gaze as his mother holds him tenderly seems based on observation rather than on standardised formulas. Despite the physical attachment and tenderness between mother and son, there is no mistaking *The Oval Mirror*'s evocation of Greek *ephebes*, as if the young man's future is to be an ideal demigod. This is a clever take on Madonnas in which the young Christ Child seems aware of his tragic destiny on the Cross. The child's contrapposto stance paraphrases Praxiteles's *Hermes with the Infant Dionysos* (Fig. a), perhaps combined with elements from another of the sculptor's contrapposto figures. It contrasts with earlier works in which Cassatt shows mothers engaged in more practical tasks, like bathing their little ones (p. 200).

Although Cassatt herself neither married nor had children, she was an exquisitely sensitive observer of mothering. Much of the second half of her career was devoted to this theme, but without the anti-feminist slant of Pierre-Auguste Renoir's *Maternity* (p. 231). For Cassatt, evoking the Madonna implied the sanctity of motherhood. The invariable absence of the father, even in groups like *The Family* (Fig. b), suggests a reconfiguration of the family unit around the mother – a sort of soft feminism. In the latter the goofy gesture of the baby, interacting with his older sister, foretells the sister's destiny. The mother's love is apparent through her expression, head leaning attentively forwards and supporting, rather than actively restraining the boy, who reaches out to the flower his sister holds. His instinct is to reach for beauty, just as the woman's is to find bliss through child-rearing.

|Fig. b| Mary Cassatt, *The Family*, 1893
Chrysler Museum, Norfolk, VA

Mother and Child (The Oval Mirror), c. 1889

oil on canvas, 81.6 x 65.7 cm, The Metropolitan Museum of Art, New York, NY

The quasi-erotic attachment between the two is signalled by the reddening of the mother's hands where she holds the child's body. Similarly, one can hardly avoid the erotic potential in *The Oval Mirror* of the exposure of the boy's youthful genitalia, but the mother gazes elsewhere, as an indication that their liaison goes beyond the flesh, regardless of his having issued from hers and his future role in perpetuating the family.

Paul Cézanne

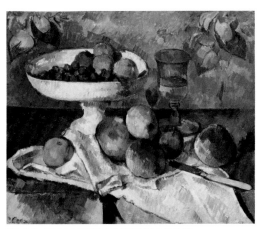

|Fig. a| Paul Cézanne, *Still Life with Compotier*, c. 1879–82
Private collection

|Fig. b| Gustave Caillebotte, *Fruit Stand*, c. 1880
Private collection, Paris

Looking is the Point

Cézanne's majestic still life is one of his most compelling mid-career achievements. Its sturdy pots, like soldiers at attention, backstop the slightly tilted fruit bowl perched on a strangely bunched-up table cloth, made of stiff, seemingly freshly laundered and starched cotton. The pots themselves make interesting comparisons, with different shapes, finishes and functions; the delicately decorated sugar bowl contrasts with the large Provençal vase, which is painted flatly, with a schematic patch of yellow looking both like a flat lid and its hollow interior. Its shiny surface bears traces of the parallelism of Cézanne's constructive brushstroke, although more blended than in earlier works like *Still Life with Compotier* (Fig. a) (which was purchased and imitated by Paul Gauguin). Irregular reflections this brushwork produces on the vase's green glaze suggest its rustic artisanal handwork and parallel Cézanne's own constructive process.

Behind the table to the right, a chest of drawers provides a geometric framework of verticals and horizontals as a foil to the arrangement on the table itself. Compare it to Gustave Caillebotte's *Fruit Stand* still life (Fig. b), in which Caillebotte found a motif outside the studio, yet set up with equal care. Cézanne's choices are more self-consciously arbitrary. The commode is of course an architectonic construction, but more functional than the studio still life. It affords the artist playful contrasts between darkened keyholes and protruding knobs, whose round surfaces are concavely modelled, just as fruits in crates and baskets do for Caillebotte. Unlike Caillebotte's persistent illusionism, however, Cézanne's commode below the right-hand knob, where another is vaguely indicated, fades into thin air that echoes the light colour of the tablecloth.

The Impressionist's fascination with wallpaper design is present at the upper left. It is hard to determine if the large pot stands against the side of the commode or a wall, and the corner of the table blocks a view of where floor and wall begin.

Still Life with Commode, c. 1883–7

oil on canvas, 73.3 x 92.2 cm, Neue Pinakothek, Munich

Below the wallpaper one cannot tell if the horizontal strips are moulding, skirting board or floor. This confusion – or rather, this invitation to look harder – is more ambiguous than the background of *Still Life with Compotier*, in which wallpaper becomes almost illusionistic and is near to merging with the water glass.

A notable element is the tilted table, contrasted with the relatively perspectival open drawer. It proffers the still life to the eye by pushing forwards. The flattening effect is a known phenomenon in Impressionism encouraged by emulating Japanese prints. However, the French philosopher Maurice Merleau-Ponty's ingenious explanation holds that since the knowledge vision provides is inseparable from memories of touch and the body's situation in space, Cézanne's imagery expresses 'lived perspective'. Working from careful observation in order to, as Cézanne said, 'realise his sensations' approximates a psychological experience in which the eye projects the mind/body into space to unconsciously experience it from within space, including the potential for different simultaneous viewpoints. Cézanne's works are thus both uncanny and familiar – he 'defamiliarises' the world as if deconstructing by analytical reason, but in order to gain it back through sensation via its artistic reconstruction.

Vincent van Gogh

|Fig. a| Vincent van Gogh, *Noon*, after a wood engraving by Jean-François Millet, 1889–90, Musée d'Orsay, Paris

The Peasant Lullaby

La Berceuse shows the pensive Augustine Roulin, wife of the postman Joseph Roulin, holding the cord of her infant Marcelle's cradle. Her large breasts and hips suggest the role of motherhood and her harmonious surroundings that of homemaker. The picture's title refers to rocking the cradle but also means 'lullaby', a term Van Gogh acknowledged in a letter. One imagines the flowery wallpaper as a rhythmic and harmonic form of musical writing, while also suggesting the mother's reverie, as she watches her baby sleep. Rather than rock the cradle, she simply holds the yellow rope with the gnarled peasant hands Van Gogh so admired for their evocation of manual labour.

Before arriving in Paris, Van Gogh had been attracted to rural and worker themes. Through his brother Theo, who worked for the Goupil gallery, issuer of many reproductive engravings, he became especially interested in the works of Jean-François Millet, and while at the hospital in Saint-Rémy he made a series of painted copies of Millet prints (Fig. a). Earlier, on arriving in Paris, he had quite naturally gravitated to the circle around Camille Pissarro, whose leftist political leanings and less bourgeois subjects were compatible with his ideals. Paintings such as Pissarro's *Café au Lait* (Fig. b) set an example for how one might treat such themes in a modern style, but Pissarro himself was moving towards more systematic forms of brushstroke.

La Berceuse's bold patterns and contrasts of broad, relatively flat areas of contrasting colours reveal the presence in Arles of Paul Gauguin, who after long delays had finally arrived in late October to share Van Gogh's Yellow House. The two came into conflict, however, with the violent result that Van Gogh cut off the lobe of his right ear, defiantly mailing it to a prostitute he had probably been involved with. (In the Netherlands he had lived with a prostitute named Sien, hoping to save her from misery.) Mystery surrounds this incident, but there is no doubt that Gauguin's theory and Van Gogh's commitment to work directly from nature were in conflict. Gauguin believed, as he wrote to his friend the painter Émile Schuffenecker, that one should not copy nature directly but 'dream before it', and think 'more of the result than of the model'. For Gauguin, the image retained and shaped by the mind through memory and imagination was more important than reproducing one's observations. For *La Berceuse* Van Gogh did not abandon draughtsmanship – as in the wallpaper or the bold outlines of Madame Roulin's body. For most other areas, however, he did suppress his systematic hatchings in favour of long, broad, partly blended strokes. The result was a

|Fig. b| Camille Pissarro, *Young Peasant Woman Drinking Her Café au Lait*, 1881, The Art Institute of Chicago, IL

Augustine Roulin ('La Berceuse'), 1889

oil on canvas, 91 x 72 cm, Kröller-Müller Museum, Otterlo

Gauguin-like abstraction. The flat red areas framing Mme Roulin's chair heighten the impact and richness of the painting's complementary greens. Van Gogh was highly conscious of colour interactions and had used red–green contrast expressively in other compositions of the same period. He thus turned Gauguin's often ostentatious formal simplifications and sometimes gratuitous wit into powerfully expressive devices, still anchoring them primarily in observation. The result was to suggest the humanity of ordinary folk, their deep emotion and their deserving of respect.

Vincent van Gogh

|Fig. a| Caspar David Friedrich, *Two Men Contemplating the Moon*, 1819-20
Galerie Neue Meister, Dresden

Universal Clockworks

By 1888 Van Gogh had developed the thickly brushed, brightly coloured style for which he would become famous. Today he is considered a Post-Impressionist, having passed rapidly through a period in which his style was closer to Impressionism itself (p. 324).

The Post-Impressionists are a diverse group that includes the Neo-Impressionists, Paul Gauguin and the mature Paul Cézanne. Unlike the term 'Impressionism', coined at the time, 'Post-Impressionism' was invented well after the fact. It implies a continuing relationship to Impressionism, like an aftermath or critique – and different practitioners may have different rationales. Unlike his contemporary Gauguin, who claimed to paint from memory and imagination (p. 258 and p. 338), Van Gogh remained committed to painting directly from observation, but with intense feeling rather than Impressionism's frequent anomie. Van Gogh's brushstrokes and colour both derive from Impressionism but are redeployed for expressive purposes.

In several letters, Van Gogh expressed the desire to paint a night-time scene with stars. *The Starry Night* overlooks the sleepy town of Saint-Rémy at the foot of the Alpilles mountains. Van Gogh found shelter there from what appears to have been a bout with depression after his conflicted residency with Gauguin in Arles. Although most pictures painted during Van Gogh's stay were done from his room or from the hospital grounds, this one seems to have been made after he left. The church's steeple at the centre is dwarfed by the large, twisting cypress tree in the left foreground. Van Gogh knew that cypresses were associated with death because they were often found in cemeteries, and it is supposed that he might have painted the picture from such a location.

The tree's pointed top and its ascending rhythmic shapes draw the eye upwards, as if reaching for the sky. One witnesses a sky teeming with stars, a brilliant crescent moon balancing the composition at the upper right.

|Fig. b| Vincent van Gogh, *Pietà* (after Delacroix), 1889
Van Gogh Museum, Amsterdam

With its swirling shapes and reverberations, attributed by some to effects on vision of some drugs he might have been taking for his illness, Van Gogh suggests the mysterious silent clockwork of the universe, which never stops but becomes more visible upon contemplation at night when the sun goes down and most people are asleep. The comparison between the natural form of the tree and the church steeple echoes earlier north European symbolism, as in the work of Caspar David Friedrich (Fig. a), in which nature was understood to be permeated by divine presence, which the artist aimed to express.

The Starry Night, 1889

oil on canvas, 73.7 x 92.1 cm, The Museum of Modern Art, New York, NY

In hindsight, Van Gogh's picture might foretell the sense of desperation and need for relief that would drive him to suicide in 1890. It is possible that the galaxies of spinning light represent a world of comfort and knowledge beyond the sufferings of man. Van Gogh often saw himself as victim, comparing himself to Christ (Fig. b), whose Crucifixion promised salvation to the rest of the world. Van Gogh's education and first inclinations had been religious, but he came to believe in the social and spiritual vocation of art. Although this painting seems so deeply personal, it might also have explanatory value in its reminder of living energies available only to artistic vision.

Paul Cézanne

Art in Play

The theme of card players occupied Cézanne greatly in the early 1890s. Statements that he wanted to 'make of Impressionism something solid like the art of the museums' or 'redo Poussin after nature' lie behind *The Card Players*' monumental scale, balance and serious mood. Cézanne's ambition evolved from 'realising his sensations' to seeking a durable classical equivalent taken from the world around him. Raising the genre of ordinary men ritualistically concentrating on their daily card game at the local bar to something approaching the classics was a *tour de force*. However different-looking from the work of his contemporaries, it embodies ambitions not unlike those of Pierre-Auguste Renoir in the mid 1880s (p. 328), though without the reactionary solutions, or Georges Seurat (p. 330), though without abandoning the commitment to direct observation.

The curtain to the right evokes old master portraits. The blue cloak of the nearby player has the weight and mass of the High Renaissance – one thinks of the mature Raphael

|Fig. a| Jean-Siméon Chardin, *The House of Cards*, c. 1736–7
The National Gallery, London

|Fig. b| Paul Cézanne, *The Card Players*, 1890–5, Musée d'Orsay, Paris

or Fra Bartolommeo. They are balanced by the man to the left, smoking his pipe while watching. The table, its shape emphasised by its drawer, and the man in the middle form the central axis of a triangle with the other players' backs. These are compositional features of artists such as Leonardo and Raphael. It is impossible to decide whether the cut-off picture hanging at the triangle's peak is significant. A pipe rack above the little boy punctuates what would otherwise be an empty area. In traditional art, as in pictures by Jean-Siméon Chardin (Fig. a), the theme of cards was a lesson in morality about how children innocently fritter away time on trivial games compared to the fragility of the life ahead, subject at any moment to collapse. By contrast, Cézanne's painting is as solidly built as any he ever made, and the engagement of players wizened by experience gives the game its dignity and seriousness. The same can be said of Cézanne's preparation, for which there are over a dozen sketches and studies of models from among the local farmers. Of five more or less finished card-player compositions, there are two types. After completion of two more finished and complex examples, Cézanne did three others in which the background is simpler and the number of players reduced to two, without spectators. Only a bottle of wine has been added (Fig. b). These three are less

The Card Players, 1890–2

oil on canvas, 135.3 x 181.9 cm, The Barnes Foundation, Philadelphia, PA

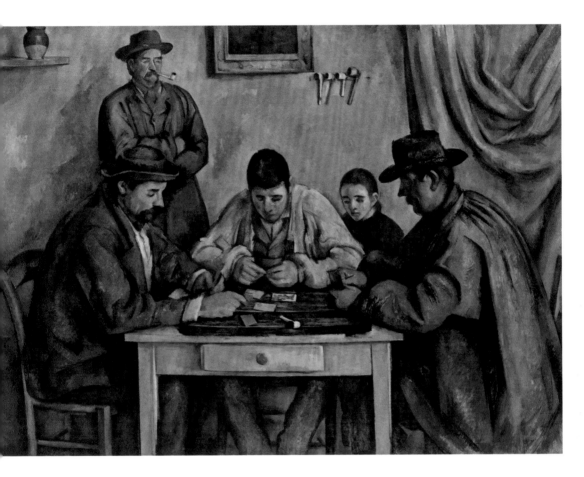

clearly finished, with more visible and summarising brushstrokes. Yet the reduction to two men, one of whom smokes his pipe, enhances the viewer's concentration as a parallel to the players'. Smokers, of course, have a history in art associated with inner thought and creativity (p. 80).

The rules of card games are the framework for the players' moves. Cézanne seems to compare them to rules of art, at least of old master painting, which he ostentatiously evokes in the earlier versions. He demonstrates how the most ordinary scene can be invested with a philosophical dignity that provokes thoughts about the sources, language and processes of art. The almost quasi-religious reverence of his figures for the game suggests how any activity – card-playing or art-making – can be probed for insights into the meaning of life itself.

Armand Guillaumin

Fierce Colours

By 1886 Guillaumin had earned a reputation as 'a furious colourist'. The critic Félix Fénéon, who at the same time supported Georges Seurat, wrote in that year with considerable rhetorical flourish:

Here we are before the Guillaumins. Immense skies: overheated skies, where clouds jostle in a battle of greens, purples, mauves and yellows; others, crepuscular, where from the horizon arises a huge amorphous mass of low vapours strung out by the raking winds. Under heavy, sumptuous skies, violet hunchbacked countryside with alternating furrows and pastures, painted with violent impasto; the trees cringe …

In 1892 Guillaumin won 100,000 francs in a lottery, allowing him the freedom to travel and paint as he pleased. From that time onwards he painted regularly on the Mediterranean and Atlantic coasts and in the Creuse valley (p. 260). He regularly visited the Esterel Massif near Saint-Raphaël, where the red rocks at Agay were a favourite subject, giving rise to some of his most intensely colourful works. Although colour had always been one of his strong points, in the 1890s and through the early 1900s his paintings began to look expressionist and Fauve. They appeared so violent and crude, ostensibly defying classification, that Guillaumin became discredited. And yet his farms were based on Impressionist observation and remained easily recognisable. Although Paul Gauguin had been using intense colour, too, he combined it with witty, abstracted compositions, as in *Beach at Le Pouldu* (Fig. a), in which the compositional and formal inspiration was clearly Japanese despite the Breton location. Gauguin called this style 'Synthetism' due to its combination of the real and the imaginary (p. 326).

Guillaumin could not count on similar wit or abstraction to give his work an avant-garde look. However, its unrealistic colour departed so much from Impressionism so early that he did not seem to belong any longer with that movement either.

Guillaumin and Vincent van Gogh became friends after 1886, when Van Gogh moved from the Netherlands to Paris. It is likely that both benefited from a dialogue, but unlike Van Gogh's brushstroke that systematically evoked weaving or other kinds of labour, Guillaumin continued painting intuitively, while using heavier brushstrokes and thicker paints. In *Rocks at Agay* the red-violet rocks jut out into the bright turquoise ocean with white waves churning at their base. The background of hills, high cliffs to the right and mountains in the distance shows a range of stunning

|Fig. a| Paul Gauguin, *Beach at Le Pouldu*, 1889, private collection

greens, blues, pinks and violets. Such pictures so aggressively detach themselves from their gallery or living room surroundings that one responds to them with trepidation. Guillaumin repeatedly returned to Agay, painting the bay from different viewpoints but always with colouristic daring. Whether his work actually was a source for Fauvism, however, is hard to say, since he worked more or less in isolation. On the other hand, some of his paintings had already been appearing on the art market. Disdained by museum curators, Guillaumin is only now being recognised for the thematic originality of his early industrial views (p. 140) and the expressive, pre-Fauve daring of this later work.

**Techniques and
Other Media**

Edgar Degas

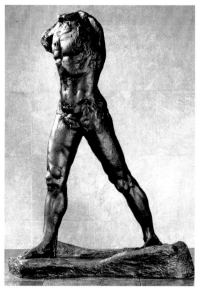

|Fig. a| Auguste Rodin, *The Walking Man*, before 1900
The Metropolitan Museum of Art, New York, NY

|Fig. b| J.J. Grandville, *Man descending into animality*, 1843

Impressionism in the Round

Impressionism received its name from painting, and the notions that so often define it as an art of light and air rather than solid form seem inherently antithetical to sculpture. Yet through a combination of realism and the use of variegated surfaces that play with light, the sculptor Auguste Rodin (Fig. a) is often associated with Impressionism.

Rodin was friendly with many of the Impressionist artists – indeed in 1889 he and Monet exhibited together at the Galerie Georges Petit. Paul Gauguin also did sculpture, but his sits less easily within the Impressionist aesthetic. By contrast, Camille Claudel, the poet Paul Claudel's older sister, became Rodin's pupil, mistress and sometime muse. Her work compares stylistically with Rodin's.

Among the Impressionists themselves, Degas, who was always the most technically experimental, was the only one to make sculpture an important element in his work. He did many models of horses and dancers, but the piece that had the greatest impact was his *Little Fourteen-Year-Old Dancer*, based on the Belgian ballet student Marie Van Goethem, which he exhibited with the Impressionists in 1881. It was a fragile piece, made of wax and a mixture of materials including a ribbon and an actual tutu, which enhanced both its contemporary and realistic effect. It created a small sensation.

One critic wrote: a 'blossoming street urchin' with a 'pug-nosed, vicious face' and 'brutish insolence'. 'Why is her forehead, like her lips, so profoundly marked by vice?' Such opinions are surprising, even shocking, today. Compare it to the journalist Christopher Lydon's dithyrambic fantasy, written in 2003: 'Degas's bronze dancing girl was all about dawning Eros. At 13 or 14, I had a crush that chokes me up to this moment on that lithe, springy compact little dancer. She was the personification of rapture, girlishness centred and self-confident, ready to spring, blissfully aware that she is irresistible. She was my dream girl; maybe still is.'

Ballet dancers usually came from the lower classes, and Degas's relentless naturalism had him represent her in a way that left no doubt as to these origins. Even before Charles Darwin a form of evolution theory existed – one that included the notion derived from Enlightenment physiognomy that character can be read from the shape of the head and facial characteristics (Fig. b). In *The Song of the Dog* (p. 131) and *Vicomte Lepic and his Daughters (Place de la Concorde)* (p. 173) Degas could be seen comparing humans to animals. In his *Dancer* he gave his subject simian characteristics he associated with less developed humans. It was believed their inferior social position was due to their more animalistic instincts and lesser intelligence.

There are cracks and fingerprints on Degas's maquette that show he bent the girl's head backwards in order to have the ears and mouth line up more closely along a horizontal axis and make the forehead look flatter, which in Degas's time were considered signs

The Little Fourteen-Year-Old Dancer, c. 1880

bronze, partly tinted, with cotton skirt and satin hair ribbon, on a wooden base, 104.8 cm

The Metropolitan Museum of Art, New York, NY

of stupidity. Moreover, he exhibited her in a glass case that clearly evoked scientific specimens in a natural history museum. The figure's finish lacked the smoothness of academic sculpture, hence was not out of place in an Impressionist exhibition. But Degas's manipulation of the figure far outstripped the choreographer's, and his Impressionist commitment to observation of the modern acquired an element of cruelty.

Camille Pissarro

|Fig. a| Berthe Morisot, *The Sisters*, 1869, National Gallery of Art, Washington, DC

A Fancy Format

Fans were less an oddity among Impressionist productions than they may seem at first. Thanks to the fashion for things both Spanish and Japanese, as well as the revival of taste for 18th-century rococo, many fans were exhibited at the official Salon during the 1870s, the number reaching over forty late in the decade. As early as 1868–9, Edgar Degas made a few fans, one of which he gave to Berthe Morisot (Fig. a), and he resumed the practice in 1878, no doubt encouraged by their popularity at the official Salon. At the fourth Impressionist exhibition (1879) Degas contributed five fans (Fig. b), and Pissarro, who was often as experimental as Degas, contributed twelve. Degas even imagined a separate room where he and Pissarro, along with Morisot and the Bracquemonds, could exhibit them separately.

Degas's ballerinas and dance themes seem appropriate for the novel format because fans were so commonly used by ladies in places like the Opéra. In diametric contrast were Pissarro's farm scenes. Yet almost none of the Impressionist fans was made to be used; many collectors purchased them for their beauty as decorative objects, a market the Impressionists hoped to exploit. At the time, the French economy was at the bottom of a recession, and both Degas and Pissarro were looking for new sources of income. At this time, too, they began

|Fig. b| Edgar Degas, *Fan Mount: Ballet Girls*, 1879, The Metropolitan Museum of Art, New York, NY

Fan Mount: The Cabbage Gatherers, c. 1878–9

gouache on silk, 16.5 x 52.1 cm, The Metropolitan Museum of Art, New York, NY

experimenting with prints and eventually planned to collaborate with a few other artists, including Mary Cassatt, on an edition to be called *Jour et Nuit* (Day and Night). Neither Pissarro nor Degas made their compositions wrap around the fan's semicircular shape. For Pissarro, the format seems almost to have been an inconvenience he tried to ignore by representing a scene that is simply cut off where the fan's shape intervenes. The same view could have been planned for a rectangle. It is as if he simply transferred a conventional composition to the new shape. Degas, on the other hand, clearly enjoyed cutting off figures, much as he would crop them in his regular canvases. It almost seems as if his view of ballet dancers, who are here seen from above, is taken from behind a fan at the opera, as in the pastel *Ballet from an Opera Box* (p. 126).

Degas also revelled in his unusual materials: gold, silver and watercolour. He may have suspected that they would not last very well, since watercolour on silk was quickly absorbed and likely to be fragile. For him, in other words, the fan may have been an ephemeral decorative object, whereas for Pissarro it was as straightforward as any of his productions. Indeed, Pissarro's use of gouache, which has a certain thickness to it, would be far less susceptible to wear, as the survival in relatively good condition of many of his fans confirms. He was probably less interested than Degas in displaying artistic wit or self-conscious blurring between decorative and high art, preferring to assert his kind of plainness for the latter. Thanks to skilled draughtsmanship, sensitive colouring and care, his fan became an object of great beauty rather than a relic.

Edgar Degas

|Fig. a| Jean-Auguste-Dominique Ingres, *The Valpinçon Bather*, 1808
Musée du Louvre, Paris

|Fig. b| Maurice-Quentin de La Tour, *Jean Le Rond d'Alembert*, 1754, Musée du Louvre, Paris

The Scrub

In the 1880s Degas began a series of pastel pictures of nudes at their bath, several of which he exhibited at the eighth Impressionist exhibition in 1886. The female nude was a traditional theme in the history of art, and women grooming at their *toilette* became especially popular in the 18th century. Degas combined both traditions by choosing the first stage of the activity, namely the bath. In aristocratic culture, women bathed with their chambermaids, who knew all their secrets. It might even be said that the ritual of the *toilette* was meant to hide certain secrets under make-up while accentuating compensating assets. However, Degas was not interested in ordinary rituals, for his were located in bordellos. This particular version of the bathing ritual was meant to guarantee proper hygiene between the succession of clients – a quite heretical twist on the purifying theme of baptism.

Where else could one encounter the nude naturally? The positions from which Degas represented some of his bathers suggest voyeurism, like looking through a keyhole. Evoking such a vantage point could help a pose seem candid and unselfconscious. Yet Degas's housekeeper told of the excruciating effort he required from his models. So although he may have observed young women in the *maison close* – a legal house of prostitution (p. 364) – the works themselves were executed in the studio. Degas had been working in pastels for some time, often in combination with other media and in smaller formats. In this picture, almost a metre wide, pastel was the only medium. There were both ironic and historical references associated with pastel. Popular in the 18th century for refined portraits and exquisite drawings, it was used here by Degas for themes that, if not shocking in themselves, represented women of low station, much like his ballet dancers or laundresses. Yet what Degas made of the ostensible lack of suitability of his technique to his subject matter was precisely the point. His implication was that the great and skilful artist could draw forth beauty from dross. Charles Baudelaire had discussed the idea in his 'The Painter of Modern Life' (1863) when he spoke of the beauties and fashions of the *demi-monde*. Degas was like a Velázquez or a Manet making beautiful pictures out of the most ordinary subjects, except Degas took the notion to its extreme by depicting women most

The Tub, 1886
pastel on card, 60 x 83 cm, Musée d'Orsay, Paris

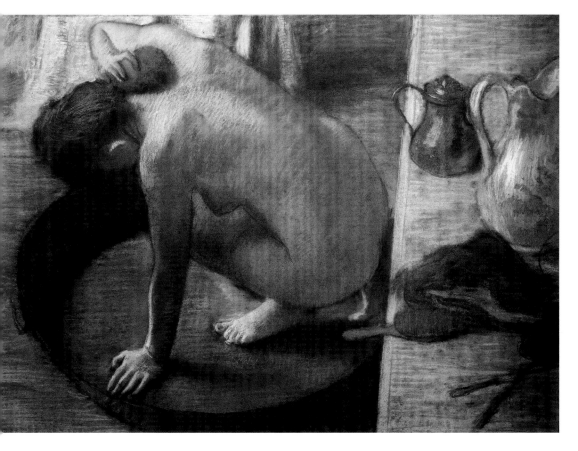

people would neither have wanted to encounter socially nor even talk about.
Pastel was like drawing directly with colour – a sort of synthesis or third way that mooted the traditional conflict between line, associated with abstract reason and championed by the conservative Jean-Auguste-Dominique Ingres (Fig. a), and colour, associated with the material world and its emotions, championed by Eugène Delacroix, Édouard Manet and most of the Impressionists. Degas certainly knew Ingres's *Bather*, owned by his friends the Valpinçons, whom he represented in a number of pictures.

The Tub evokes such pictures with their clean outlines and three-dimensional forms, while rendering them through pure, coloured lines. Indeed, rather than the gentle, muted blending of 18th-century pastels (Fig. b), Degas's vigorous parallel lines, as if he has scrubbed the surface with his pastel sticks, call attention to his skills as the performer of the image. However domineering Manet's prostitute Olympia (p. 219) may have seemed, Degas powerful draughtsmanship places this commercial creature under his dominion by transposing her to the realm of art.

Mary Cassatt

|Fig. a| Eugène Delacroix, Drawing for *Death of Sardanapalus*, 1826-7, Musée du Louvre, Cabinet des dessins, Paris

|Fig. b| Armand Guillaumin, *In the Boat*, 1867

Impressions are in Colour

Although pastel might hark back to a time of aristocratic elegance and ostentatious technique, it also had practical functions. After all, the reality of nature was neither the black on white of traditional black chalk or graphite drawing, nor other traditional techniques of draughtsmanship. A more authentic approach would be to sketch in colour. Yet for those Impressionists working directly on the spot in oils, preparatory sketches or studies were generally unnecessary. Edgar Degas, Édouard Manet and Gustave Caillebotte, by contrast, often did preliminary drawings because their compositions were usually meticulously planned. They often filled sketchbooks, too, continuing to use pencil or black chalk. Even Camille Pissarro was among them.

For those who wanted to sketch or prepare in colour, watercolour was a technique much practised in the 19th century, but other than with Paul Cézanne it was never too popular among Impressionist painters. Pastel was the technique of choice when, as in Cassatt's case, she wanted to combine sketching with planning in colour. In the 19th century the Impressionists were not the first to use pastel either. Eugène Delacroix, the predecessor they so admired for his colour, had practised both. For his famous *Death of Sardanapalus*, the highlight of the so-called Romantic Salon of 1827, Delacroix had carefully prepared with a combination of sketches in ink and others in pastels (Fig. a). The latter allowed him to study effects of colour before he approached his canvas directly. Since, unlike the Impressionists, he still painted on a dark ground, he used coloured paper for a middle ground, against which both white, red and blues would relate to one another. Impressionists such as Claude Monet in his early years, and Armand Guillaumin throughout his career, used pastels, but in the latter's case it was more to sketch from nature (Fig. b) than to produce a finished work.

Cassatt shared her apartment with her sister Lydia, and the two were often together, thus allowing Cassatt slightly freer range than other women. For example, Degas made a famous print of the two sisters at the Louvre (p. 356). It was also often the case that artists took their friends and family as models. Lydia, ostensibly at the theatre, was the vehicle for a pastel so spectacular one wonders why Cassatt used it as the basis for a painting (Fig. c) at all! The criss-crossing of blues and yellows on Lydia's dress, the reds of her seat and their reflections on her hair, the subtle blue-green tints of the edges of shapes in the crystal

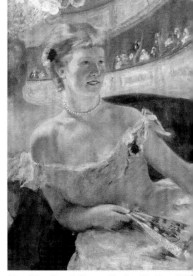

|Fig. c| Mary Cassatt, *Woman with a Pearl Necklace*, 1879 Philadelphia Museum of Art, PA

Lydia Cassatt at the Theatre, c. 1879

pastel on paper, 55.5 x 46 cm, The Nelson-Atkins Museum of Art, Kansas City, MO

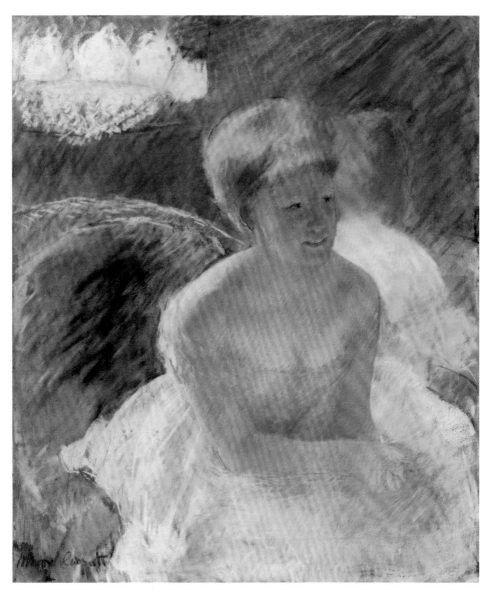

chandelier: all these spectacular effects are unified by the dominant diagonal of Cassatt's coloured strokes. Compared to the painting, indeed, it is the boldness of Cassatt's system and sureness of her choices, despite the far more generalised forms and tentative outlines, that make the preparatory pastel even more fascinating than the finished work. One barely thinks about Lydia's peaceful and contented expression, hands clasped, even though she was chronically ill. (She died in 1882.)

Edgar Degas

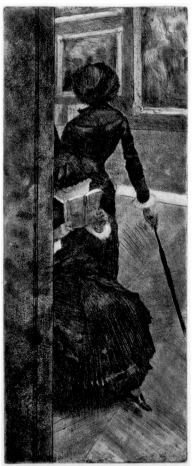

|Fig. a| Edgar Degas, *Mary Cassatt at the Louvre: The Paintings Gallery*, 1879–80, Brooklyn Museum, New York, NY

Mary's Many States

Degas's friendship with Mary Cassatt made her the subject of several of his pictures. In 1879 he and Cassatt, along with Camille Pissarro (p. 362) and Félix Bracquemond, planned to produce a portfolio of etchings called *Jour et Nuit* (Day and Night), an allusion to the black and white medium of the most common form of prints. During the 1860s the Société des Aquafortistes (Etching Society) had revived the practice of etching. It included several artists from the Barbizon School, as well as Édouard Manet, who like his friend Degas had a career-long interest in printmaking (p. 360). But unlike Manet, who more or less stuck with etching or lithography even when being experimental, Degas and Pissarro loved to combine different tools and techniques, seeking various pictorial effects they could derive from the copper plate, which was traditionally etched with lines. In fact, at the Impressionist exhibition of 1880 Degas exhibited several different states of his etching of Cassatt, the earliest having the blurry quality of soft-ground etching, the later ones showing the vigour of deep drypoint gouges that boldly caught the viscous ink. The example from the Metropolitan Museum of Art corresponds to a pastel Degas made that shows Cassatt in the Museum's painting galleries, and yet the print shows her viewing an Etruscan sarcophagus. It was not unusual for Degas to change backgrounds at will. In a second use of the same figures (Fig. a), he changed to a narrow vertical format, with the two figures now overlapping, Mary still observing while sister Lydia still has her face buried in what is presumably a guidebook. In this experiment, the narrow format was daring, as was the compressed repositioning of the two figures, especially for those intimates of Degas who might have witnessed the print's evolution. Finally, a wonderfully simple pastel at the Philadelphia Museum of Art (Fig. b), probably done after the print or during its progress, shows only Cassatt herself. In some ways this is the most satisfying image of all, for it focuses without distraction on the elegant form and confident bearing of an independent woman, regardless of her setting. Little squiggles of colour call attention to Cassatt's subtle, understated sense of fashion, as well as to Degas's own sophisticated ability to suggest rather than to outline forms as carefully as in the later states of his prints. Although *Jour et Nuit* never came to fruition, several prints that were destined for it, especially this one, have become famous examples of the innovative Impressionist vision and technical skills.

|Fig. b| Edgar Degas, *Mary Cassatt at the Lou* 1880, Philadelphia Museum of Art, PA

Mary Cassatt at the Louvre: The Etruscan Gallery, 1879–80

softground etching, drypoint, aquatint, and etching, third state of nine, 26.8 x 23.2 cm
The Metropolitan Museum of Art, New York, NY

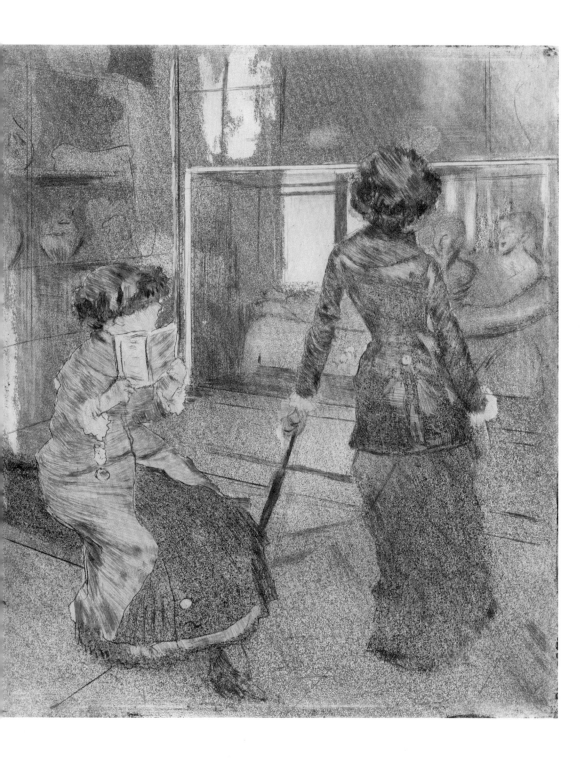

Edgar Degas

|Fig. a| Eugène Cuvelier, *Fontainebleau Forest*, early 1860s
The Metropolitan Museum of Art, New York, NY

|Fig. b| Martial Caillebotte, *Unidentified Buildings*,
c. 1880–90, private collection

Is there Impressionist photography?

Photography had a pervasive presence in the visual culture of the Impressionist period, setting an unimpeachable standard for naturalism and making new ways of seeing and original vantage points into conventions. Indeed, Impressionism was compared by certain critics to photography, over which they said it had the advantage only of colour. Usually the comparison was negative, since photography was not considered an artistic form; as the product of a mechanical device it seemed to lack creativity and imagination. Although the famous photographer Nadar contested that point of view successfully in court, winning the exclusivity of his name and the equivalent of copyright in his photographs, that decision did not change general opinion. Indeed, photography was often practised by failed artists or business-oriented craftsmen. Painters, including Eugène Delacroix, Gustave Courbet and Degas, were known to use photographs to substitute for models. Degas, always fascinated by new techniques, sometimes made photographs of models, which he then used as the basis for paintings or pastels.

As early as 1859 the French government opened a Salon of Photography. It was situated next to the Salon of Art, but with a separate entrance. There were three principal kinds of photography. Portrait photography, for which Nadar was celebrated, was often a poor man's substitute for painted portraiture. Landscape photography tended towards the romantic (Fig. a). Documentary photography recorded travels to places near and far, and was used by railway companies and the French public works department to celebrate as well as to provide a record of progress in the construction of national infrastructure (p. 160, p. 176 and p. 252).

Among the Impressionists, Degas was the only one who seems to have made photographs, although Gustave Caillebotte's brother Martial was an avid amateur photographer whose work (Fig. b) certainly became a resource for Gustave himself (p. 100). Degas's photograph of Stéphane Mallarmé and Pierre-Auguste Renoir (seated) is one of his most interesting works because in the mirror before which his two friends are posing is reflected the photographer himself, his head under the black cloth that allows him to see the viewfinder clearly, without interference from ambient light. In addition, Degas was using the artificial light of flash powder. The latter explains both the image's harsh contrast and the explosion of light in the mirror. Given what one knows about Degas's self-consciousness as performer, his experimentalism and his love of mirrors, the set-up was

|Fig. c| Edgar Degas, *Édouard Manet, Seated*, c. 1866–8, The Metropolitan Museum of Art, New York, NY

TECHNIQUES AND OTHER MEDIA

Stéphane Mallarmé and Pierre-Auguste Renoir, 1895

gelatin silver print, 39.1 x 28.4 cm

Bibliothèque nationale de France, Département des Estampes et de la Photographie, Paris

certainly deliberate and enjoyed by all. Indeed, it was probably a pleasurable irony that his medium resulted in self-effacement while at the same time he is present in the picture. Degas's interest in photography was compatible with his love of and practice of drawing. A pencil drawing of Édouard Manet (Fig. c) shows the precision and care he could bring to likeness and pose in portraiture. Both qualities are found in photography, but in the double-portrait photograph they were combined with unpredictable effects introduced by technique in ways that parallel those of his pastels and monotypes (p. 364). In that sense, one could call Degas not only an Impressionist who made photographs, but a practitioner of Impressionist photography.

Édouard Manet

A Printmaking Society

Since the invention of the lithograph, prints had become ubiquitous in 19th-century society. Lithography, in which the artist could draw directly on a smooth, prepared stone and which could make large numbers of positive images (though reversed), became an element in popular culture for illustrations of all kinds, from political caricature, as in the work of Honoré Daumier (p. 168), to fine-art prints. In 1862, attempting to give a boost to fine-art printmaking, the publisher Alfred Cadart and the printer Auguste Delâtre founded the Société des Aquafortistes (Etchers Society) as a way to encourage etching, a medium more identified with fine-art limited editions and practised by great historical masters including Rembrandt. Certain French artists, such as members of the Barbizon School, had been using etching, often to reproduce their own compositions. Manet met others, including James Abbott McNeill Whistler, Alphonse Legros and Félix Bracquemond, probably through Charles Baudelaire, who was an admirer of the graphic arts. Manet became a member of the Society at its founding.

Manet's first prints were free reproductions of his painted compositions. He published a group of eight in an album sponsored by Cadart and company. For its cover he experimented with three different compositions, all of which contained motifs that alluded in different ways to the prints inside as well as to the artist's role as their producer. In the second trial frontispiece (Fig. a), Manet self-consciously alluded to the artist as an entertainer by suggesting a stage set and the clown figure Polichinelle. This notion fell within the concept of the artist articulated by Manet's friend Baudelaire, of whom he made an etching at around this same time (p. 20). Other motifs refer to specific paintings as well as to his lithograph of the balloon.

At the same time as Cadart encouraged etching, which had a history of original compositions as well as reproductive prints, he tried to make lithography a vehicle for serious high-art prints. Manet's image of the launching of a Montgolfier balloon corresponded to that effort.

The scene is framed by two tall poles, each with a crossbar near its top, as if to evoke the Crucifixion on Golgotha. Does he mean that such public entertainments are the religion of modernity or that they are some kind of atrocity? On the latter, more sombre note, dead centre in the composition is a cripple. It is thought that the event may have taken place on 15 August, which at the time was the Fête Nationale, now on 14 July and called Bastille Day. Might Manet's figure embody those left behind by bourgeois society, or perhaps a man wounded in one of the Second

|Fig. a| Édouard Manet, Second Trial Frontispiece for an Album of Etchings, 1862, New York Public Library, NY

|Fig. b| Édouard Manet, *Émile Olivier*, 1860 Bibliothèque nationale de France, Département des Estampes et de la Photographie, Paris

The Balloon, 1862
lithograph, 40.3 x 51.5 cm
Bibliothèque nationale de France, Département des Estampes et de la Photographie, Paris

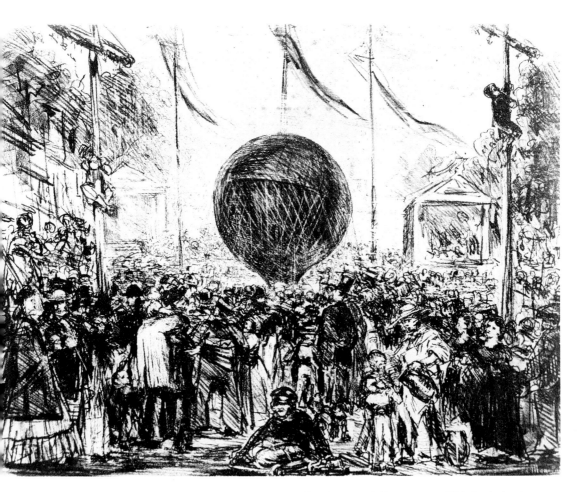

Empire's military campaigns, which Manet would have opposed? Modernity has its costs.
The Balloon was, in any case, a freely drawn image of modern life, executed as if
sketching a bustling crowd straining to get a look at the event. It was done in the
same year as his painting of another crowd, *Music in the Tuileries Gardens* (p. 21).
That Manet's style was deliberately intended to show off the artifice of the medium is
demonstrated by comparison to an earlier lithograph, a political caricature, which he
executed in the much tighter style of conventional lithography (Fig. b). *The Balloon*
was so different that it may have been considered insulting to the lithographer's art. In
any case, Manet used only one of the three stones Cadart had given him. It was never
published and exists in only five proofs.

Camille Pissarro

The First Haystack Series

The most famous group of haystacks (actually wheat stacks) in painting is certainly the series (p. 266) produced by Claude Monet near his house in Giverny.

However, Pissarro's interest in rural labour led him to make many pictures that included the same motif, beginning in the 1870s (p. 185). Moreover, through his experimentation in printmaking, he actually became the first artist to produce images of haystacks in what might be called a series.

A series, of course, refers to multiples. In painting, a series is a group of closely related views of the same subject, conceived as an ensemble and exhibited as such. In printmaking, multiples are duplicates of one another, except that the plate can be modified between printings, or states, as was the case for Edgar Degas's *Mary Cassatt at the Louvre* (p. 357), of which Degas exhibited several varied examples in 1880. Pissarro's proofs of *Twilight with Haystacks* duplicate one another, except that he printed them in different coloured inks – green, brown and blue, with the name of the ink colour written by hand at the lower right-hand margin. That variation made them a series rather than mere duplicates.

The plate was first worked with aquatint, a technique that produces a smudging and mottled effect. It was then reworked with etching and drypoint, the latter a tool that digs into the copper and leaves burrs that catch the ink, slightly blurring the line and resulting in rich blacks or colours. A related composition (Fig. a), which itself has variants, was done in black ink, with diagonal streaks across it signifying rain. Some of them were made with the engraver's gouge-like tool turned upside down, making parallel streaks that look like a single stroke empty in the middle.

Pissarro's printmaking embraced themes as broadly as his painting. His painting of the Île Lacroix in Rouen (p. 162) was preceded by a group of prints that might be considered a series. For him, printmaking could be a separate experimental enterprise as for *Twilight with Haystacks* and *Rain Effect*, or it could be part of a group of images mixing prints and paintings. Rouen was one

|Fig. a| Camille Pissarro, *Rain Effect*, 1879, The Los Angeles County Museum of Art, CA

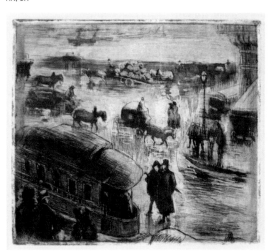

|Fig. b| Camille Pissarro, *Place de la République with Tramway, Rouen*, 1883
New York Public Library, NY

Twilight with Haystacks, 1879

aquatint with etching and drypoint in green ink on laid paper, 12.6 x 20.3 cm

National Gallery of Canada, Ottawa

place where such mixing was probably due to novel choices of subject matter, such as his etching *Place de la République with Tramway* (Fig. b). At the time, he was staying at a hotel owned by his friend and patron of the Impressionists Eugène Murer. It was one of his first views taken from a hotel window, a practice that would become his norm in his several series of modern urban views (p. 162) in late career. His paintings of the subject and his prints were often preceded by free pencil sketches, unlike the majority of his colleagues. Although one might take easel and canvas outdoors, etching was an indoor activity, with its copper plate, precision tools and acid etching baths.

Even lithography, which is drawn directly on stone, was limited because of the latter's weight. The smudging, blurring and softening effects are unique to the multi-stage process of etching.

Edgar Degas

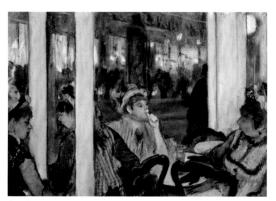

|Fig. a| Edgar Degas, *Women on a Café Terrace, Evening*, 1877
Musée d'Orsay, Paris

Beauty and the Brothel

In his celebrated essay of 1863, 'The Painter of Modern Life', Charles Baudelaire held that prostitutes had a kind of beauty characteristic of a contemporary fashionable ideal, since their profession was to attract the gaze of potential clients. He also implied a parallel with artists in their need to attract patrons through appearances, as in their artworks. Art is partly a game of seduction. The theme of courtesans and prostitutes was well entrenched in contemporary avant-garde literature of the so-called Naturalist school. Émile Zola was its declared leader, and his 1880 novel *Nana* (p. 116) exemplified the theme's importance.

Other writers, especially the Goncourt brothers, also dealt with the topic, and Degas's close friend Ludovic Halévy published a series of stories about a fictional low-class family ironically named Cardinal, which overlaps scenes of young girls encouraged by their mother to join the ballet with clandestine prostitution.

Degas's scenes, however, take place in legal houses of prostitution called *maisons closes*, a term that translates best as 'protected houses'. The concept underlying them was a supposed guarantee of hygiene, thanks to bathing before every client (p. 353).

Most of Degas's fifty-odd brothel or related scenes (with the exception of many bathers) were done using the monotype technique. The prefix 'mono' indicates a single proof, unlike other kinds of prints that were made in multiples. Instead of permanently etching lines or marks into a copper plate with an acid bath, Degas would simply draw or paint on the plate's surface with ink. He would then take an impression with paper to which most of the ink would adhere, although in many cases he would make a second, very incomplete impression to take up what ink remained. The first proof was generally of

good enough quality to stand on its own, whereas Degas usually went over second impressions with pastel or other media in order to add colour and/or detail to the faint image, as in the image of prostitutes at a café (Fig. a). In either case, the resulting work was unique, and Degas had a special name for them: printed ink drawings.

The Name Day of the Madam is an especially large and impressive work, thanks to its colouring and its story. Until recently the only first or given names to be legal in France were those of saints or combinations thereof. Each day in the calendar is devoted to one particular saint, so that when the saint's day corresponds to a person's name that day is celebrated like a birthday, including gifts, with the advantage of avoiding discussions of age. In Degas's image, the matronly madam accepts flowers from her naked workers, in a wry mockery of bourgeois ritual.

In another (Fig. b) the line of ladies in various poses recalls not only the way Degas contrasted ballerinas' various positions, but ironically evokes the academic practice of demonstrating the artist's skill in depicting anatomy by putting his figures in contrasting poses (p. 293).

|Fig. b| Edgar Degas, *Waiting*, 1876–7
Musée Picasso, Paris

The Name Day of the Madam, 1876–7

pastel over monotype, 26.6 x 29.6 cm, Musée Picasso, Paris

One can wonder whether the blurriness and lack of definition often found in these monotypes embodies some sort of reserve, discretion or misgivings that a man of Degas's social class might have had at such brazen displays of intimate body parts. It is as if delicacy and unpleasantness combine in a sort of refined heavy-handedness. Of course, the number of frontal, onanistic and grotesque postures and gestures may hint at Degas's own sexual preferences. He never married, but an account of an early visit to a brothel suggests he was not celibate. Whether such scenes reveal his own sexual proclivities or his voyeurism, the fact is that he felt entitled to enter such premises with the clinical eye of the detached observer. A friend of the Impressionists, the Irish novelist and dandy George Moore, explained that Degas liked to work from models unaware that they were being observed, as if looking through a keyhole (p. 353). Indeed, Degas's 'discretion' prevented him from exhibiting any of his explicit prints, sharing them only with his friends. At the painter's death his brother guaranteed the late artist's privacy by destroying approximately half of them.

Paul Cézanne

|Fig. a| Paul Cézanne, *La Montagne Sainte-Victoire*, 1905–6, Tate, London

|Fig. b| Paul Cézanne, *Still Life with Apples on a Sideboard*, 1900–6
Dallas Museum of Art, TX

The Father of Modern Art

Cézanne was among the Impressionist minority who made many drawings, sketches and other studies preparatory to or along with paintings, as well as independently of them. He was the only one, however, to use watercolour extensively. It was a means to work in pure colour far more transparent than pastel. Moreover, one generally drew or shaded with pastel, which came bound in chalk-like sticks, whereas watercolour is pigment floating in water, which dries off, leaving a patch of pigment behind without a stroke or a line being necessary or always visible. More than pastel, watercolour could also more closely approximate the patchwork of fragmented colour strokes at the heart of the Impressionist style. But because of the unpredictable flow of water into and over paper, one has less control than in oils, nor can one scrape away and try again.

For all those practical reasons, Cézanne's watercolours are almost always made over a lightly sketched armature of pencil lines. The same reasons may explain why the technique, practised by Eugène Delacroix, whom Cézanne much admired, held little interest for other Impressionist painters. Cézanne, on the other hand, used it with increasing frequency and fluency over the course of his career. It is even possible that Cézanne appreciated watercolour's slightly random effects, like those of nature itself or the imprecision of the instantaneous impression.

Certain watercolours are clearly studies for paintings (Fig. a), whereas others, such as the luminous and shimmering *Still Life with Apples on a Sideboard* (Fig. b) are complete enough that they can be considered independent compositions regardless of how they may resemble another, oil-painted one. It happens that *Rocks near the Caves above Château Noir* is neither. The so-called Château Noir is still a private property on a rocky hill with a stone house, not a castle, once painted black, where Cézanne rented an outbuilding to store his equipment in order not to have to carry it the 6.5 km down the road to the village of Le Tholonet from his studio in Aix-en-Provence. Through the watercolour one is intimate with his creative process, derived from direct and solitary observation, yet tentative and fragile, as intuition must be when faced with the evidence

Rocks near the Caves above Château Noir, 1895–1900

oil on canvas, 54 x 65 cm, The Museum of Modern Art, New York, NY

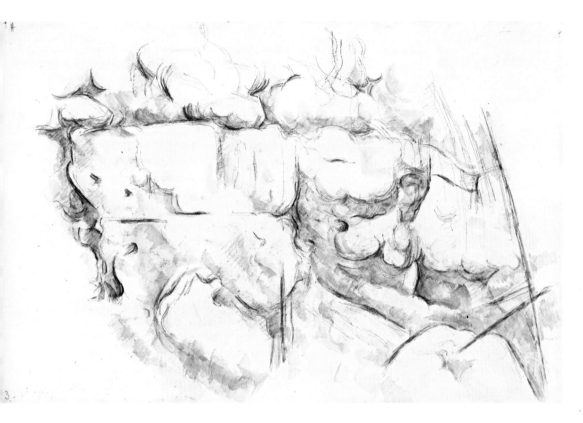

of the ageless earth. Certain forms, possibly anthropomorphic, invest the mass – both its physical reality and its artistic recreation – with vitality, almost a psychic sense of or communion with an indefinable energy tied to the immediacy of sensation.

Works such as these, to which Cézanne attributed only personal and artistic value, are among those most prized by collectors today, not for what they represent objectively – that is, their subject matter – but for the combination of intense attentiveness and economy of means – a difficult combination but one that lies at the essence of modern art, of which Cézanne is often seen as the father. Their sparseness and simplicity can be considered the source of modern representation, just as their emotional concentration can be considered the source of modern psychological sincerity and expression. Restraint coupled with sensitivity and hard-won skill exemplify values much admired today – as in Cézanne's day when, just as now, they seemed increasingly rare.

Mary Cassatt

|Fig. a| Pierre Bonnard, *The Square at Evening*, 1899
The Phillips Collection, Washington, DC

|Fig. b| Henri de Toulouse-Lautrec, *La Goulue at the Moulin Rouge*, 1891

The Japanese Reoccupy Paris

Cassatt was a well-practised printmaker, like her friends Edgar Degas and Camille Pissarro, with whom she had worked on the unrealised project for *Jour et Nuit* (p. 356). Among her most original and popular works is the album of ten colour aquatint etchings to which *The Letter* belongs. Cassatt made twenty-five proofs of each of the ten etchings. When exhibited at the Durand-Ruel galleries, they were a considerable success.

Beginning with Édouard Manet, Impressionists had been emulating pictorial aspects of Japanese *ukiyo-e* ('pictures of the floating world') prints since the 1860s, when they were first discovered (p. 41). An exhibition of Japanese prints at the École des Beaux-Arts in 1890 renewed their popularity and was Cassatt's direct inspiration. Indeed, the prints in Cassatt's Japanese album almost look like they could have been done by a Japanese artist. Bold areas of colour, angled viewpoints, cut-off figures defined by strong edges and simplifications – all of which were directly inspired by the Japanese print aesthetic – give these works their powerful impact and modern look. As in *The Letter*, Cassatt's themes were the same as in her paintings, but the coloured print medium gave them an unexpected look that shifts attention from the intimate domesticity of their subject matter to their expansive and extroverted forms.

The aquatint technique allowed for solid areas of more or less uniform colour, emulating with greater density the flat areas of colour in Japanese prints. Whereas the Japanese print was printed from a woodblock with ink applied to its flat, un-carved-out surfaces, in the aquatint process a granular resin allows some acid to pass through to the plate, creating a mottled effect that holds more ink because a textured surface can hold more than a flat one. Many aquatints have a highly visible grain, but Cassatt's was very fine, apparent only on close observation, and was probably etched very briefly. As in many of her paintings, the wallpaper of the interiors Cassatt represented became an important aesthetic element as well. Similarly, the kimono-like house robe of her lady subject adds to the decorative surface pattern that tends to dazzle the eye and disperse attention across the image.

Cassatt was far from alone in her 1890s Japanese phase. Although vastly different from Cassatt's borrowings, Pierre Bonnard's emulation of Japanese flattening and juxtapositions is obvious in his colour lithograph *The Square at Evening* (Fig. a). Another example is Édouard Vuillard's *Pastry Shop* (p. 370). Henri de Toulouse-Lautrec, too, was much enamoured of Japanese effects, which he used to advantage for advertising posters meant to grab the attention of passers-by when they were pasted on walls and kiosks. The now famous Moulin Rouge had opened in 1889 and was building its reputation. Toulouse-Lautrec's well-known poster (Fig. b) of the dancer La Goulue (literally 'The Glutton') flipping up her skirt to show her bloomers as the finale of her cancan dance act is a cartoon-like parody of the Japanese style. In some proofs the silhouette of the gentleman in the foreground is so grainy that it seems like a humorous take on Neo-Impressionism as it could be found in Seurat's *Le Chahut* (p. 375).

The Letter, 1891

drypoint and aquatint on laid paper plate, 34.6 x 22.8 cm

Bibliothèque nationale de France, Cabinet des Estampes et de la Photographie, Paris

The bold colours and original compositions encouraged via Japonisme, combined with the affordable and democratically dispersed media such as lithography, helped make the aesthetic discoveries and practices of Impressionism mainstream standards for progressive art.

Édouard Vuillard

|Fig. a| Édouard Vuillard, *The Pastry Shop*, 1899
The Museum of Modern Art, New York, NY

|Fig. b| Édouard Manet, *Jeanne* or *Springtime*, 1882,
New York Public Library, NY

Interior Landscapes

Even more than his friend Pierre Bonnard (p. 368), Vuillard was a leader in the flowering of colour printmaking at the end of the 19th century. His album of twelve colour lithographs called *Landscapes and Interiors* (*Paysages et intérieurs*), published by the art dealer Ambroise Vollard, mixes landscapes and interior scenes with an interchangeable aesthetic of coloured spots – echoing Neo-Impressionism, too – that scintillate in the eye, confusing spatial perception and often obscuring the subject matter that was the vehicle for his aesthetic effects. The group is dominated by interior scenes, including three different views called *Interior with Pink Wallpaper*. Exterior views are mostly urban, with only one genuine landscape. In one view, of a pastry shop (Fig. a), it is hard to tell whether one is indoors or not.

What Vuillard's interiors and landscapes have in common is their creation of environments. His interiors use motifs from landscapes to produce their effect, which is why they are more original than his landscapes themselves. In *Interior with Pink Wallpaper* more than half the image is filled with pattern, the pink rose print on the wall most prominently, but also the red checked tablecloth to the left, a painted vase and a matching goblet. Unlike the two other views with pink wallpaper, this one has no figures. Indeed, the compositions are different enough that they might refer to separate rooms with the same wallpaper design. This viewpoint looks up towards the enormous hanging lamp that dominates the left side. One sees over a table towards an archway into a neighbouring room where there is perhaps a door or a window.

Although Vuillard was of a later generation than the Impressionists, his work responded to and shared many characteristics of Impressionism. In fact, the basis of Impressionism as an art of colour meant that its destiny in printmaking was to use colour in the process itself, rather than added to it as in Edgar Degas's monotypes heightened with pastel (p. 364), or Camille Pissarro's pioneering monochromatic colour prints (p. 362). Colour lithography was a challenging medium, for each colour must be printed separately. Coordinating and aligning them demanded great precision.

Vuillard's cluttered and flowery interiors pick up from Impressionist motifs, as in Édouard Manet's aquatint and etching of *Springtime* (Fig. b), based on a painting of Jeanne de Marsy that was part of a group of four that used women friends of the artist to represent the four seasons (p. 240). It also echoes wallpaper patterns seen in many Impressionist paintings (p. 72 and p. 208) and especially loved by Vincent van Gogh (p. 338) and Mary Cassatt (p. 368). Although in a different spirit from Vuillard, in a suite of woodblock prints published with Vollard the same year

Interior with Pink Wallpaper II, from Landscapes and Interiors, 1899

colour lithograph (second state of two), 39.2 x 31 cm, The Museum of Modern Art, New York, NY

Fig. b| Paul Gauguin, *Human Miseries*, 1898–9
National Gallery of Auswtralia, Canberra

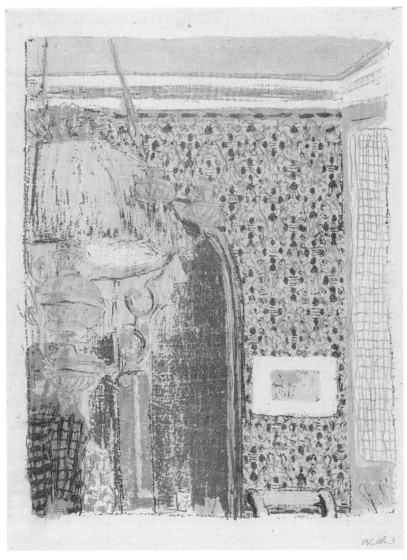

(Fig. c) Paul Gauguin also used abstracted, quasi-floral designs as backgrounds and filler in ways meant to imitate the so-called naive patterns of Tahitian carvings or fabrics. Comparing Gauguin to Vuillard, however, it is obvious that Vuillard's work retained far more Impressionist content in his Post-Impressionist response to Impressionism than Gauguin's, even though, as we know (p. 258), Gauguin began his career firmly anchored in Impressionism itself.

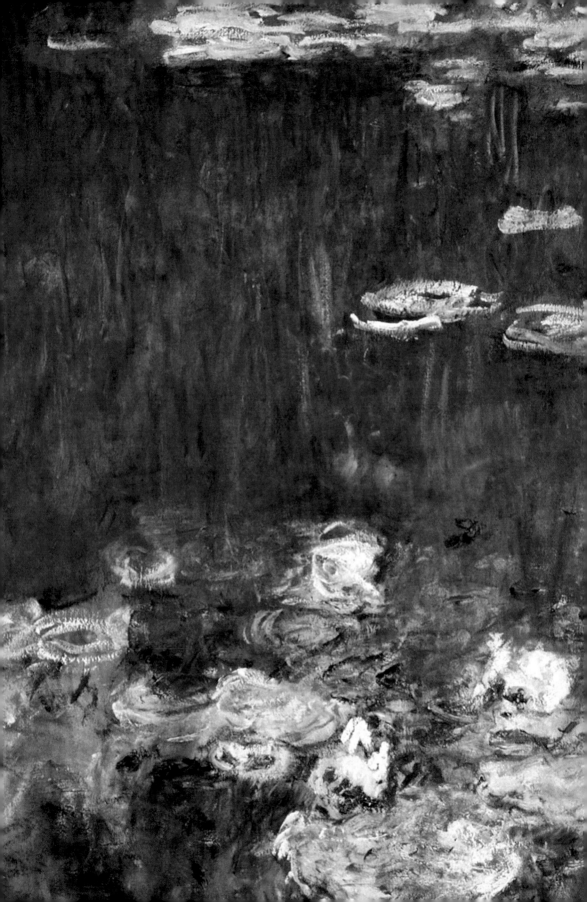

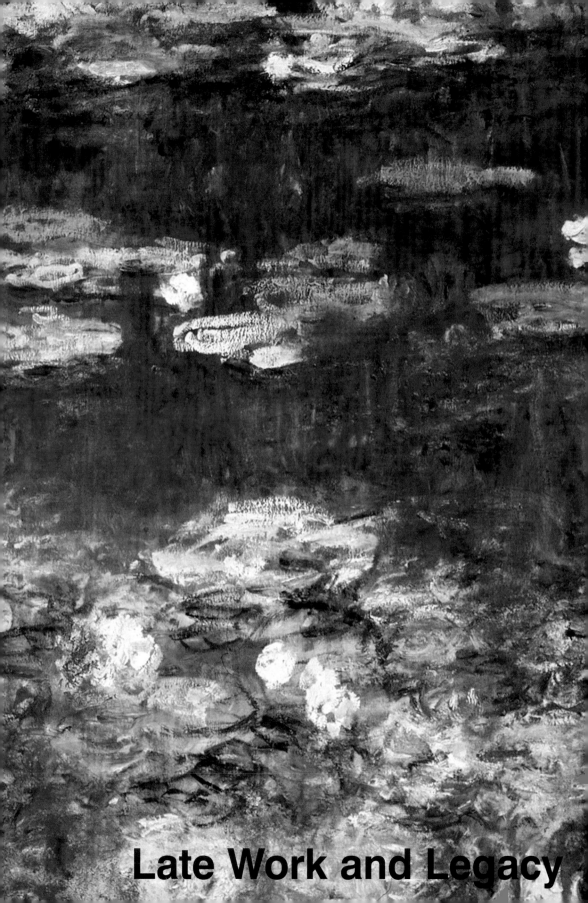
Late Work and Legacy

Georges Seurat

|Fig. a| Georges Seurat, *La Parade de Cirque*, 1887–8, The Metropolitan Museum of Art, New York, NY

|Fig. b| Georges Seurat, Letter to Jules Christophe

Calculated Hilarity

Although Seurat had won praise for his *Grande Jatte* (p. 331), with its indisputable luminosity, he was challenged to apply his system to indoor scenes and other forms of lighting. In *Le Chahut* he represents a popular Montmartre nightclub called the Divan Japonais (literally 'Japanese Divan'), the name of which evokes avant-garde relaxation, with a possible pun on the notion of its entertainments being divine. Its figures are so simplified and cut off at the bottom edge that in keeping with this name a Japanese aesthetic is one of the picture's prominent features.

Seurat's previous major picture, *La Parade de Cirque* (Fig. a), showed a crowd gathered on the pavement in early winter dusk outside the entrance to the Cirque Corvi. A band is playing in order to attract attention and proffer a foretaste of the fun inside. Ordinary folk have paused in their evening errands or on the way home from work in order to take in a bit of pleasure. The painting is so blatantly structured along geometric lines, most of which can be accounted for by the golden section (see below), that it seems ridiculously artificial, hence part of the amusing entertainment. Just as the circus 'parades' its pleasures for the public, Seurat displays the pleasures of artistic artifice for his audience. The 'psychophysicist' Charles Henry claimed in lectures attended by the Neo-Impressionists that the art that survived historically with the greatest reputation was that which provided society the greatest pleasure thanks to its harmonious structures. These could be determined scientifically. Among the measures he recommended was the golden section proportion, in which in a rectangle the ratio of the shorter length (A) to the longer (B) is the same as that of the longer to the sum of the two (A/B = B/A+B). One could use a pair of compasses to divide a given length, like the edge of a painting, into segments following that proportion. Another of Henry's principles was summarised by Seurat in a letter to his friend Jules Christophe (Fig. b). It was that upward directions were pleasurable, as indicated by upward moving lines or forms – assuming the Western habit of reading from left to right – and downward directions were the opposite. In the dim, almost monochromatic atmosphere of Seurat's nightclub – note the gaslights on the wall and at the top – every shape is directed upwards, from the conductor's baton, to the ribbons on the dancers, their kick-steps, their smiles and so on – one can barely count the different ways. The enjoyments of the nightclub extend to

Le Chahut, 1889–90

oil on canvas, 66 x 55 cm, Kröller-Müller Museum, Otterlo

the hilarity of the painting as a parody of urban entertainments. The curved shape of the painting at the top suggests both the top cornice of a stage and an altarpiece frame – just one more pun on modern ritual. As in *La Parade*, art and pleasure are juxtaposed. Indeed, the vertical shape of *Le Chahut* echoes the popular art of advertising posters. In so doing, Seurat evokes a graphic medium designed for commercial purposes, thus referencing a form that issues from the modern economy and aims at attracting the greatest numbers. His irony is the double game of democratising his art through popular forms on the one hand, and making a wry critique of capitalism on the other.

Paul Signac

|Fig. a| Paul Signac, *Gasometers at Clichy*, 1886
National Gallery of Victoria, Melbourne

|Fig. b| Georges Seurat, *Port-en-Bessin, Entrance to the Harbour*, 1888
The Museum of Modern Art, New York, NY

Musical Geometry and Decorative Abstraction

Sardine Fishing is one of five paintings Signac did as a series called *La Mer* (*The Sea*). He was already designating his pictures with opus numbers, like musical compositions – a practice that lasted until 1893. In this series he added musical subtitles like *Adagio*, *Scherzo*, *Allegro* and so forth. He also distinguished them by different dominant colours corresponding to different times of day. In earlier work, such as *Gasometers at Clichy* (Fig. a), Signac was attentive to powerful industrial geometries, taking his cues from Georges Seurat's early work (p. 318) and friends of Camille Pissarro, like Armand Guillaumin (p. 140), with whom he painted. In the 1890s he moved away from urban locations, following the lead of Seurat's Normandy harbour paintings (Fig. b), in which colouristic subtlety and refined pointillism combine with compositions *à la japonaise* to produce exquisite poems of the seashore.

Overshadowed by Seurat, whose large paintings were done for public exhibition, Signac, with few exceptions (p. 378), specialised in seascapes. His creativity may have been released by Seurat's untimely death in 1891. Having done a first *La Mer* series of three scenes from the bay of Cassis, east of Marseille on the Mediterranean, he expanded to five pictures of the fishing harbour of Concarneau on Brittany's Atlantic coast, not far from where Paul Gauguin had been at Pont-Aven. *Opus 221* is one of the most refined in the second series, its subtle plotting of fishing boats across the painting reading like a counterpoint of notes on a musical staff parallel to the horizon.

The theory comparing painting to music dated from Romantic times, summed up by Charles Baudelaire's claim, based on E.T.A. Hoffmann, that 'in colour, one finds harmony, melody and counterpoint'. It had received its most recent refinement in the Symbolist poet Jules Laforgue's 1886 essay on Impressionism in which he compared the artist to a keyboard on which nature plays its music, each 'keyboard' being differently tuned for each individual. Signac repeated this metaphor in a later theoretical treatise on colour (*From Eugène Delacroix to Neo-Impressionism*, 1899), but he, Gauguin and others had long since incorporated such ideas into their art. For Signac, the reality expressed through pictorial musicality was more 'authentic' than what mere observation could convey. As understood by Félix Fénéon (p. 378):

Setting Sun. Sardine Fishing. Adagio. Opus 221, 1891

oil on canvas, 65 x 81 cm, The Museum of Modern Art, New York, NY

Signac was able to create exemplary specimens of an art of great decorative development, which sacrifices anecdote to arabesque, nomenclature to synthesis, the fleeting to the permanent, and in its celebrations and its magic, confers on Nature, which at last grew weary of its precarious reality, an authentic Reality.

For Fénéon, as others at the time, 'decorative' meant harmonising reality through imagination into aesthetically independent forms expressing the essentials of their subject. A key feature was abstraction of reality into bold patterns, like those of Signac's visual counterpoint or of Gauguin's so-called Synthetism (p. 326 and p. 344). Abstraction meant to simplify, to take the essential from a form. No one yet imagined what is now called abstract art – that is, non-figural or non-objective – but works like these laid the foundations for it.

Paul Signac

|Fig. a| Paul Gauguin, *Self-Portrait with Portrait of Émile Bernard (Les Misérables)*, 1888
Van Gogh Museum, Amsterdam

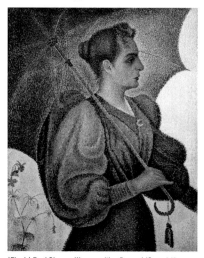

|Fig. b| Paul Signac, *Woman with a Parasol (Opus 243, Portrait of Berthe Signac)*, 1893, Musée d'Orsay, Paris

Swirls of Aesthetic Emotion

Félix Fénéon was a multifaceted character whose eccentricity and dandyism were typical of his time. He was a friend of the Symbolist group, which included Jules Laforgue (p. 376), Stéphane Mallarmé (p. 80) and Charles Henry (p. 380 and p. 374). Henry's theories on colour are suggested by the portrait's kaleidoscopic evocation of his colour wheel in the background. A civil servant in the War Ministry, Fénéon had time for contributions to Symbolist publications and for art criticism. The most famous instance of the latter is his anthology *The Impressionists in 1886*, which defended the new generation and coined the term 'Neo-Impressionism'. Beginning in that same year, he became involved in anarchist activities; he was arrested for hiding detonating materials in 1894, but then acquitted at the so-called 'Trial of the Thirty'. Signac's pointillist portrait profile, showing Fénéon's goatee and his aristocratic dress and bearing – even though he was in fact the son of a travelling salesman – suggests that Fénéon modelled himself on Jean Des Esseintes, the decadent hero of Joris-Karl Huysmans's first Symbolist novel, *À rebours* (*Against the Grain*, 1884). Des Esseintes was so disgusted by bourgeois society that he left Paris for the countryside, where he withdrew into the world of art and literature. This move paralleled Huysmans's sudden rejection of his own naturalist writing, like Symbolism's rejection of Impressionist pictorial naturalism. Fénéon stayed in Paris, however, and was engaged with many literary and artistic projects. He and Huysmans shared many tastes and ideas as part of the intellectual circle around *La Revue blanche*, founded in Belgium by the rich art patrons Alexandre, Louis-Alfred and Thadée Natanson in 1889 and relocated to Paris in 1891. Following Fénéon's acquittal, he was hired to be editor and secretary of the review.

Fénéon holds a flower in his right hand, symbolising on the one hand his love of nature but also his aestheticism. Flowery wallpaper, often used by Vincent van Gogh and Paul Gauguin to suggest imaginings (Fig. a), or flowers themselves, as in still lifes such as Van Gogh's *Sunflowers* (p. 213), were popular in Symbolist art for beauty and brilliant colour appealing to the senses while also embodying a natural process of 'flowering'. The latter evoked the natural growth of art, stemming from nature, but blooming in

Opus 217. Against the Enamel of a Background Rhythmic with Beats and Angles, Tones and Tints, Portrait of M. Félix Fénéon in 1890, 1890

oil on canvas, 73.5 x 92.5 cm, The Museum of Modern Art, New York, NY

the artist's imagination. Juxtaposed with the background, Fénéon's flower can be understood as the object of contemplation, the pinwheel behind him suggesting the turbulent artistic experience growing in his mind.

The background's segmented shapes might be compared to the colourful motif of the parasol held by fashionable women in many Impressionist pictures, of which Signac's portrait of his new wife (Fig. b) is a wonderful example. The patterns made by the umbrella's edges – echoed by the crescent-shaped pin on her blouse – combine with the billows of her chemise to produce an extraordinary counterpoint. Signac has remembered to include a flower, abstracted as if pasted on the canvas surface, to suggest the organic flowering of his own artistic imagination when contemplating the natural beauty of his beloved. It is a less mystifying use of devices similar to those in the portrait of Fénéon.

Claude Monet

|Fig. a| J.M.W. Turner, *Rouen: the West Front of the Cathedral*, c. 1832
The British Museum, London

Floating Stones

Among the most celebrated of Monet's many famous paintings is the series of thirty façades of Rouen's Notre-Dame of the Assumption Cathedral, with its towering late-gothic architecture bathed in light at various times of day. A major tourist attraction in the 19th century, the cathedral became famous through illustrations made by earlier artists, both French and travelling foreigners, mostly British (Fig. a), as well as through guidebooks and illustrated compendiums of medieval architecture. Monet had already painted in Rouen in the early 1870s when he stayed with his brother, Léon, who managed a chemical dye factory there. At that time, however, Monet concentrated almost exclusively on the harbour, relegating the cathedral to the background when he included it at all (Fig. b).

Having already done a few series on the same motif, such as twenty-five *Grainstacks near Giverny* (p. 266), of which ten were already sold when he showed fifteen of them at Durand-Ruel's in 1891, Monet was more or less assured that the more complex and historical motif of the cathedral would be at least as successful. He painted from rooms above the square across from the cathedral, beginning in 1892 and then in 1893–4. Unlike other artists, who worked from street level at enough distance that the urban setting and the cathedral's solid footing were included, Monet paid virtually no attention to its surroundings. Its massive piers are framed so closely and the stonework occupies the field of vision so completely that the architecture almost seems congruent with the canvas surface. In choosing to focus so exclusively on the façade's surfaces, Monet created an entirely different effect from any of his predecessors.

While the light seems to dematerialise the cathedral's lace-like architectural ornament, the latter seems to re-materialise through pigment. Monet's surfaces were becoming increasingly complex and heavily worked, as if to express both the dazzling visuality of the object of vision and the enormous effort to create its equivalent in art through both productive imagination and technical labour. The result seems, as in Symbolist art, to be a poetic vision of a reimagined world rather than the far more 'accurate' representation of it he would have made in the 1880s or earlier. Indeed, during the

|Fig. b| Claude Monet, *The Seine at Rouen*, 1874
Staatliche Kunsthalle, Karlsruhe

1890s Monet had been painting pictures of reflections in mist along the Seine and in the year following the cathedral series he began the earliest versions of his *Water Lilies* (p. 390). The cathedrals seem to be a turning point towards inward experience and general luminary effects or atmospherics, as opposed to the concern in earlier work to register details. Even though little twists or dabs of the brush might evoke a carved motif on the cathedral's face, they are generalised enough not to be specifically identifiable. As in the poeticising fragmentation and optical diffusion of Neo-Impressionist pointillism, Monet's all-over effects seem to isolate and bathe the viewer in reveries of light and colour – browns, pinks, yellows, blues and whites – for which the cathedral becomes no more than a support.

Rouen Cathedral, West Façade, Sunlight, 1894

oil on canvas, 100.1 x 65.8 cm, National Gallery of Art, Washington, DC

Paul Cézanne

|Fig. a| Paul Cézanne, *Montagne Sainte-Victoire*, c. 1904-6
Philadelphia Museum of Art, PA

Pride in Provence

Montagne Sainte-Victoire is the highest peak in the Provence region of southern France, where Cézanne's home town, Aix-en-Provence, is located. As the most prominent feature in the surrounding area, visible from most high points around the city, its presence in many of Cézanne's landscapes is quite natural (p. 290). In addition, named after the victory of the Roman-led Gauls over Teutonic invaders in 102 BC, it was especially revered during the revival of regional pride that coincided with Cézanne's years there. It served as an image of strength and bravery, compared to Paris's capitulation to the Prussians and its temporary takeover by the Commune. The mountain's evocation of endurance through time was enhanced by fossils discovered on its limestone slopes by Cézanne's boyhood friend the naturalist geologist Antoine Fortuné Marion. It also held personal memories for them and other friends, including Émile Zola (p. 26 and p. 40), who spent youthful summers swimming in the river Arc in the adjoining valley.

In general, except for his scenes with bathers (p. 290), Cézanne's landscapes have no figures. Pictures of Sainte-Victoire in particular have a timeless, unchanging quality, distanced by the absence of immediate foreground. The chequered crossing of roads through fields dotted with occasional houses is abstracted enough to seem without incident and impersonal. The great mountain above the fields closes off the panorama so that the world represented seems self-contained and self-sufficient. In Cézanne's late work the landscape is completely abstracted, formed out of patches whose relationships become dynamic (Fig. a).

The latter's powerful impact when viewed by younger artists at the dealership of Ambroise Vollard certainly led to Cubism (Fig. b).

Unlike Monet, who conceived repetitions of the same motif as series, meant for commercial exhibition as part of a group, Cézanne's many encounters with Sainte-Victoire had no motivation other than to capture something of the mountain's grandeur and the landscape's permanence without straying from observed reality. The sequences and repetitions are simply more frequent in the later versions.

The reality included a modern stone railway viaduct crossing the valley to the south, and in certain views the tracks of a spur line (p. 142) in the immediate foreground.

|Fig. b| Pablo Picasso, *Portrait of Ambroise Vollard*, 1910
The Pushkin State Museum of Fine Arts, Moscow

Montagne Sainte-Victoire and the Viaduct of the Arc River Valley, 1882–5

oil on canvas, 65.4 x 81.6 cm, The Metropolitan Museum of Art, New York, NY

Cézanne achieved what some have called his 'classicising effect' through simplification, such that the viaduct evokes ancient Roman spans, with which its continuous arches are comparable. Unlike artists who celebrated modernity, Cézanne showed no train running along the tracks. In addition, he integrated various elements through pictorial markings – not only his 'constructive stroke' (p. 316), but also breaks in branches or in the mountain's outline. The latter technique, sometimes called *passage*, allows sky or cloud to come through to the foreground, not only unifying the picture as a planar pattern but revealing the artifice of Cézanne's representational process. Cézanne also had the uncanny ability to balance the sense of careful method with marks of spontaneous observation, such as indicated by the blue outline of the tree at the New York picture's centre. It is as if the viewer is reminded that the painted canvas is not the mountain itself but a thoughtful approximation of it in art.

Paul Signac

|Fig. a| Camille Pissarro,
Cover of *Turpitudes sociales*, 1889
Private collection

|Fig. b| Anonymous, Caricature of
Pierre-Joseph Proudhon, 1850s

Art and Anarchism

Signac was an anarchist in politics, like his friend and supporter Félix Fénéon (p. 378), as well as Camille Pissarro, who had briefly been his mentor. The idea that the pointillist technique allowed anyone with true and original vision to be an artist without the Impressionist sleight of hand or academic training attracted them for its ostensibly democratic aspirations. Although the Third Republic's conservative leader Patrice de Mac-Mahon had been replaced by Léon Gambetta in 1879 and its rhetoric was progressive, the Left objected to the government's continuing ties to the business and financial elite. Many anarchists believed violence was the way to achieve change; others realised that bombings and assassinations were counterproductive, but one must nonetheless gradually destroy the old order in order to build the new. Signac's painting conveys the concept of methodical destruction.

Like many idealists, Signac's background was bourgeois. Sailing on the Mediterranean in his yacht *Olympia* in the early 1890s, he discovered Saint-Tropez, which he used as the setting for harmonious views intended to provide ideal pleasures through scenes of leisure in bright colours. At the 1895 Salon des Indépendants – an avant-garde successor to the Impressionist exhibitions – he exhibited a picture called *In the Time of Harmony* (p. 394), where Saint-Tropez is the location for utopian imagery. Signac believed that 'harmony in art' would lead to 'harmony in society', extrapolating a sociopolitical function for art from Charles Henry's analysis of historical art (p. 374) and articulated as early as 1846 by Charles Baudelaire, though without the overt politics. Signac, Pissarro and their Neo-Impressionist friend Maximilien Luce were drawn to the circle of Émile Pouget, publisher of the anarchist weekly *Le Père peinard*, and Jean Grave, publisher of the anarchist newsletter *La Révolte* and later *Les Temps nouveaux*. In the cover to a series of illustrations Pissarro made for his British nieces, called *Turpitudes sociales* (Fig. a), he represented what appears to be himself as Father Time with a scythe – which might also indicate the agrarian bias of his ideal – looking out over the corrupt industrial city towards a rising sun labelled 'Anarchism'.

He was also a reader of the Russian anarchist Peter Kropotkin, and in the later 1890s he contributed illustrations to *Les Temps nouveaux*. Signac's *Demolition Worker*, however, looked further back to a caricature of Pierre-Joseph Proudhon (Fig. b), the originator of anarchist theories, whose writings Signac also knew and admired.

It seems likely that Signac was following the lead of his friend Luce, whose background was genuinely working class. Like Fénéon, Luce was arrested but acquitted in 1894. From his days in the Mazas Prison he made a series of illustrations of prison life. Shortly afterwards he was invited to Belgium, where he discovered the industries of Charleroi. There, Luce began a series of large paintings celebrating the contributions made to society by steelworkers and their fiery furnaces (Fig. c). Signac's *Demolition Worker* was a more direct appeal to the working classes than his earlier, more utopian imagery, suggesting it will take heroic effort to dismantle the entrenched institutions, including the Louvre, represented in his background. The poster-like format and bold, cartoon-like figure, a semi-disguised self-portrait, have the directness of propaganda rather than being a generalised image of the future.

Demolition Worker, 1897–9

oil on canvas, 250 x 152 cm, Musée d'Orsay, Paris

Fig. c| Maximilien Luce,
The Steelworks at Charleroi, 1895
Musée du Petit Palais, Geneva

Camille Pissarro

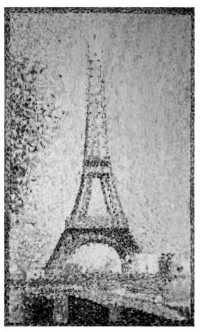

|Fig. a| Georges Seurat, *The Eiffel Tower*, c. 1889
Fine Arts Museums of San Francisco, CA

City Sights and Symbols

At the Exposition Universelle of 1889, which was the centenary celebration of the French Republic, the Eiffel Tower became the symbol of a healthy, progressive and creative France, with Paris at its centre. More than ever, tourists thronged the city's streets and overflowed its cafés. Georges Seurat, always fascinated by geometry, made a small study (Fig. a) of the new structure, which had no utilitarian purpose. To emphasise the tower's height, he shows its tip seeming to dissolve in atmospheric perspective. No doubt he believed that the pointillist style, embodying progressive and scientific principles, was suitable, and he would surely have made a larger version had he not died unexpectedly in 1891.

Celebrations of modern Paris had begun with Claude Monet's urban landscapes (p. 88 and p. 90) and were an important aspect of Impressionism during the 1870s. As the first generation of Impressionists took increasingly to the countryside, Neo-Impressionist painters revived the subject, often emphasising less bourgeois environments than their predecessors. Maximilien Luce, a Parisian by birth, did several night views (Fig. b) in which the crowds and traffic crossing the Pont du Carrousel emit a glow that, celebratory or not, fell within the interests of all Impressionist generations.

Pissarro's engagement with the activities of the modern city was manifest in the series of works he did visiting industrial harbours such as Le Havre and Rouen (p. 162), as well as in views of the relatively new Opéra – sometimes called the Palais Garnier after its architect Charles Garnier – seen in the background from a hotel room at the Place du Théâtre Français opposite the Comédie Française. Begun under Haussmann as part of the new boulevards and city plan, and inaugurated in 1875, the Opéra was the most recent expression of French cultural glory. With the Louvre behind him, Pissarro looked down what might be considered the city's main cultural axis, going from the famous classic museum and theatre to Paris' newest, most contemporary stage. Although he had reverted to a more Impressionist style from his brief flirtation with pointillism, Pissarro's pictures retain the diffusion of light and dispersion of attention associated with that technique. One reason for his switch to urban views and multiples was that his eyes began

|Fig. b| Maximilien Luce, *The Louvre and the Pont du Carrousel, Night Effect*, 1890
Private collection

Avenue de l'Opera, Sunshine Winter Morning, 1898

oil on canvas, 73 x 91 cm, Musée des Beaux-Arts, Reims

to bother him when overly exposed to outside air. This problem happily coincided with the market for views of Paris celebrating its modernity. Pissarro's representation suggests the city as an atomistic assemblage of tiny, scurrying individuals framed by architecture. His personal situation, isolated in a hotel room producing pictures in series, may have enhanced the sense of psychological distance, but the viewpoint from above and relatively limited palette imply a kind of uniformity despite the aimless diversity of movement that corresponds to hectic and random city life. It seems almost as if a lack of focus characterises the urban experience. In response the eye seeks closer contact with individual forms, while their generalisation through Impressionist technique resists giving up specifics. Pissarro thus achieves a dynamic balance between the implacable generalisations of pointillism and the call to anecdotal detail of Impressionism.

Pierre-Auguste Renoir

|Fig. a| Peter Paul Rubens, *The Judgement of Paris*, c. 1632–5
The National Gallery, London

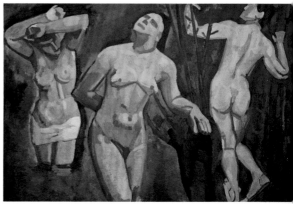

|Fig. b| André Derain, *Bathers*, 1907, The Museum of Modern Art, New York, NY

Elder Fantasies

Although many regard Renoir's late paintings as the clumsy and self-indulgent erotic fantasies of an ageing would-be Romeo, they have deep roots in his career and important echoes in the art of his contemporaries. Inspired by Raphael and Peter Paul Rubens, Renoir was looking back to the beginnings of his artistic activity. The mythological subject shows his admiration for Renaissance classicism, dating from his Italian trip of the 1880s (p. 292). Raphael's lost composition was known through the same engraving from which Édouard Manet took the river gods for *Le Déjeuner sur l'herbe* (p. 23). Renoir's interpretation is closer to that of Rubens (Fig. a), however, which he knew from an engraving, too, the composition being reversed. Rubens's brilliant colour stood at the head of a tradition perpetuated by Eugène Delacroix and the Impressionists (see p. 118), to say nothing of Renoir's sharing Rubens's predilection for fleshy women.

For years Renoir had been living in the South of France. His last studio can be visited at Le Cannet, above Cannes. Suffering from arthritis and confined to a wheelchair, he continued to work relentlessly. The choice of the Judgement of Paris as a subject was self-conscious testimony to Renoir's desire to be included in what he believed was still the grand tradition of art. Although Paris is a mythological figure bearing no relation to the French capital (in French his name is Pâris in order to make the distinction), Renoir certainly had the city in mind, for it was the undisputed art world centre, whose favourable endorsement he always coveted.

Paris, a Trojan prince, was to judge a beauty contest between the goddesses Hera, Athena and Aphrodite. The prize was a golden apple from the Garden of the Hesperides, inscribed 'For you, the Fairest'. Paris is shown as a shepherd with his crook, wearing a Phrygian cap that indicates his humble origins. Hermes, with his winged hat and sandals, leads the three goddesses before their judge. They have disrobed as seductively as possible, and each tries to bribe Paris with various rewards. Paris hands the apple to Aphrodite, who wins by promising him the most beautiful

The Judgement of Paris, c. 1913–4

oil on canvas, 73 x 92.5 cm, The Hiroshima Museum of Art

woman in the world, Helen, wife of the Greek King Menelaus, and soon to be known as Helen of Troy – 'the face that launched a thousand ships'. Thus began the Trojan War, whose many events are recounted in Homer's *Iliad*.

The story of the judgement of Paris attracted artists because physical beauty, so often represented by the female body, is its central motivating factor. It was an ideal vehicle for displays of artistic skill and the beauties of art. Renoir's generalised Mediterranean setting corresponds to his location and vision of ancient Greece. But his idealisations and brilliant colours also echoed the fantasies of the Fauves (Wild Beasts), a group of young painters known for their brilliant colours and brash handling (Fig. b). Renoir was surely competing with them, but as a wiser elder, maintaining roots in the classical tradition and subduing his brushwork to harmonise the sensuality of his forms through his caressing technique rather than the Fauves' ostensible violence.

Claude Monet

|Fig. a| Claude Monet, *Water Lilies, Green Reflections*, c. 1918–22
Musée de l'Orangerie, Paris

Water Landscapes

In 1890 Monet bought the property he had been renting since 1883 in the Normandy village of Giverny, near the Seine. Gardening was his passion (p. 266), along with painting, and in 1893 he added a new parcel of land on which he made a lily pond with meandering paths of willows, irises and other flowers. This new garden was far less formal than the geometric layout immediately behind the house. In the pond he put colourful exotic lily species, and by 1895 he made his first paintings of the pond, which also featured the Japanese-style footbridge he had built over it (p. 397).

By 1903 Monet began concentrating on the pond's surface, its reflections and transparencies framed by overhanging branches. After long preparations, in 1909 he exhibited at the Durand-Ruel gallery a series begun in 1905 called '*paysages d'eau*' (water landscapes). From that point onwards water lilies became his principal subject – about 250 paintings constituting two-thirds of his late work, about one seventh of his career production. In a letter he complained of the difficulty of capturing 'impossible things, water with vegetation that undulates in the depths'. Yet, despite the challenge, his deft brushstrokes, quick elliptical outlines, multi-layered surfaces and heavy gobs of paint for flowers manage to suggest both the subtlety and the visual excitement of his experiences. The variety of effects is amazing, from the most subdued and blended modulations to brash and brilliant colours, as well as different formats – vertical, horizontal, square and circular.

A long-time friend of the Impressionists, Georges Clemenceau, the French political and military hero of World War I, became President of the Council of Ministers in 1917. He persuaded Monet to make a gift of water-lily paintings to the French state, a project for which Monet built a special studio. After much negotiation, broad panoramas, consisting of long rectangular paintings, each one measuring 200 x 425 centimetres,

|Fig. b| Henri-Edmond Cross, *Les Îles d'Or*, 1891–2
Musée d'Orsay, Paris

with many bound together in groups of two or three (Fig. a), were inaugurated in 1927 in two elliptical galleries of the Orangerie of the Tuileries Gardens, near the Place de la Concorde. One could hardly have chosen a more central or prestigious location for contemporary art. By immersing the viewer in the calm and beauty of the water-lily pond, the paintings can be said to celebrate the return to France's love of nature after the violence of war. Monet's dispersion of attention in what would later be called 'all-over composition' renders with convincing naturalism effects of almost pure abstraction tried by contemporaries, such as an unusual picture by Henri-Edmond Cross (Fig. b). Monet's painterly gestures and brilliant colours so seductively attract the eye to

the painting's surface that they induce a soothing forgetfulness of one's surroundings, thus fulfilling something like the social function of art as a balm of harmony and pleasure for a disharmonious society that many artists and writers of his generation had sought (p. 384). Today Monet's *Water Lilies* are among the artistic wonders of the world for the way they so beautifully capture nature's ever-changing light and motion.

Childe Hassam

|Fig. a| John Singer Sargent, *Claude Monet Painting by the Edge of a Wood*, 1885, Tate, London

|Fig. b| William Merritt Chase, *Near the Beach, Shinnecock*, c. 1895, Toledo Museum of Art, OH

American Impressions

Outside France, the best and most avid practitioners and collectors of Impressionism were Americans. Thanks to Mary Cassatt, who introduced her wealthy collector friend Louisine Havemeyer to the movement, the Impressionists received enough exposure that Durand-Ruel organised a successful exhibition in New York in 1886 and subsequently opened a gallery there. A prominent Bostonian woman, Lilla Cabot Perry, met Claude Monet in 1887 and introduced others to him. Young Americans discovered Impressionism on their trips to Paris and several of them, beginning with Theodore Robinson, moved to Giverny. One, Theodore Earl Butler, married Monet's stepdaughter, Suzanne Hoschedé, after whose death in 1899 he eventually married her sister, Marthe. John Singer Sargent, best known for brilliant society portraits, made a painting of Monet at his easel at the edge of a wood (Fig. a). Sargent's fame was based on his sophisticated interpretation of the summary and sweeping brush-strokes he saw in works by Monet and Édouard Manet.

Childe Hassam's career was typical of foreign Impressionists. Following traditional training (in Boston), he travelled to Europe in 1883, where he was impressed by European artists' studies of light and atmosphere. After marrying, Hassam decided to return to Europe, where he lived from 1886 to 1889 and developed his own Impressionist style. Returning to the United States, he settled in Manhattan at 17th Street and Fifth Avenue, which he considered as beautiful as any Parisian boulevard. Among his best-known works are urban landscapes. When in Boston, he exhibited pictures of Boston Common, that city's public park. His view of New York's Union Square in snow was probably done from the Fifth Avenue studio window. Its deft Impressionist handling captures the subtle, attenuated atmospherics of a snowy day, with the ostensibly random crossing of two horse-drawn trams, carriages and pedestrian traffic creating the authentic feel of place and time. Square or vertical formats contributed to the unique sense of height characteristic of New York City buildings.

Winter in Union Square, 1889–90

oil on canvas, 46.4 x 45.7 cm, The Metropolitan Museum of Art, New York, NY

Among other American Impressionists, William Merritt Chase stands out for his flamboyant lifestyle, his teaching and his luminous scenes of Long Island and other seashores. Instead of Paris, Chase studied in Munich, but in 1886 he saw the Impressionists at Durand-Ruel's in New York. He had established a school in Shinnecock Hills on Long Island, where his views (Fig. b) of fashionable summer visitors picnicking or strolling across the grassy dunes give his Impressionist work a particularly American feel. Their luminosity, subtle colours and confident Impressionist handling place them among his best works, rivalling the French. His wide, horizontal formats suggest the great open spaces of America. Chase and Hassam both contributed to national pride by combining progressive technique with uniquely American locations. Painters with similar ambitions founded art colonies, where they worked in solidarity with one another, in places such as Cos Cob (Connecticut) and Provincetown (Massachusetts). Along with other American disciples of Impressionism, they founded a society called Ten American Painters, or The Ten, in order to distinguish their *plein-air* practices from those of the still conservative American academies. Painters from other countries too followed a similar pattern. They range from the British William Sickert and the Norwegian Frits Thaulow to the Ukranian Mikhail Tkachenko.

Henri Matisse

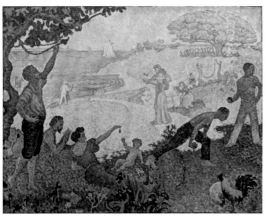

|Fig. a| Paul Signac, *In the Time of Harmony*, 1894–5

Prophecies of Light and Colour

The Joy of Life offers an imaginary escape from the trials of modernity, for which it substitutes a vision of harmony in a future world. The Third French Republic had a succession of unstable governments and was rocked by economic failures and increasing unemployment beginning in the late 1870s. Its worst crisis was the affair in which the Alsatian Jewish army captain Alfred Dreyfus was convicted of spying in 1894 and, despite proof to the contrary and the true villain's confession, was reconvicted at a new trial based on forged documents, cover-up and virulent anti-Semitism. These were countered by the most distinguished politicians, such as Georges Clemenceau, and writers, such as Émile Zola, whose famous pamphlet 'J'Accuse' was published in 1898 and helped to publicise government hypocrisy. Dreyfus was not exonerated until 1906.

The Impressionists were divided about the affair: Pierre-Auguste Renoir and Paul Cézanne sided with the army, with Edgar Degas in particular defending the institution, still dominated by aristocratic officers, and revealing his anti-Semitic feelings; Claude Monet and others clearly sided with the captain. The Jewish Camille Pissarro felt uneasy about appearing in public during part of the time of *l'affaire Dreyfus*. A common artistic reaction to such conflict was to find refuge in the aesthetic, with some painters creating utopian scenes as not simply an escape but as allegories for feelings a new society could introduce.

In his early years, Matisse associated with a group of artists who called themselves Nabis – a Hebrew word for 'prophet'. Their simplifications, following Paul Gauguin's Synthetism (p. 326 and p. 344) and the notion of art as a religion, were meant to create reveries of aesthetic joy. At the same time, Paul Signac's Neo-Impressionist *In the Time of Harmony* (Fig. a) proposed a utopian vision of society based on classicising Golden Age imagery transformed by pointillism and bright colours. Through Signac and Maximilien Luce, pointillism by this time was associated with a socialist (p. 384) as well as an aesthetic avant-garde.

Pierre Bonnard and Édouard Vuillard (p. 368) were among the Nabis' founders. Bonnard's *Game of Croquet* (Fig. b) transforms an Impressionist theme of bourgeois leisure into a clever patchwork derived from Scottish tartans and Japanese fashions, such that the subject is almost unrecognisable compared to the pictorial experience. Its aestheticised environment transforms

|Fig. b| Pierre Bonnard, *Twilight or The Game of Croquet*, 1892
Musée d'Orsay, Paris

The Joy of Life (Le Bonheur de Vivre), 1905–6

oil on canvas, 175 x 241 cm, private collection

and parodies Impressionist naturalism, which the younger generation rejected because they believed it was unrealistically limited to bucolic bourgeois pleasures. By 1906 Matisse became a partisan of utopian visions, following Signac, and formal abstractions, based on the Nabis, but purified into simpler patterns expressed through bold areas of strident colour. This style earned him and others, such as André Derain (p. 388), the epithet 'Les Fauves', which meant 'Wild Beasts'. Yet Matisse's aim was anything but wild; rather, he called forth tranquil pleasures for which he imagined society would be grateful if only it would take the time. Echoing long-standing avant-garde notions of art's social function, he once said that painting should be like 'an armchair', in which stressed and conflicted man could find comfort. *The Joy of Life* is not simply an artistic reverie alternative to Impressionist naturalism, then, but a visionary alternative to contemporary politics as well.

Jackson Pollock

|Fig. a| Claude Monet, *The Japanese Bridge*, c. 1923–5
Minneapolis Institute of Arts, MN

|Fig. b| Édouard Vuillard, *Public Gardens*, 1894
Musée d'Orsay, Paris

Impressionism Abstracted

By the end of his career, Claude Monet's paintings were becoming so full of colour and abstract that many believe they led directly to the New York School of Abstract Expressionism, exemplified by Jackson Pollock. If that is true, one must account for its transmission through intermediaries, since Monet's latest work was little known, especially among artists who had never travelled to Europe. Yet most research has shown that Pollock's resources were American and that where they were not, they owed far less to Impressionism than to Surrealism, which was brought directly to North America by émigrés such as Marcel Duchamp and Arshile Gorky. At best, then, the relationship to Impressionism is indirect, related to effects created by colour and painterly gesture rather than direct influence.

Certainly one element that Monet's later work (Fig. a) perpetuated was the dispersion of attention all over the large canvas surface. Art historians characterising Pollock's work referred to its 'all-over composition', which Pollock created by dripping paint on canvases lying flat on his studio floor. In Impressionism certain elements are accidental or experimental, and in Monet's late work this element becomes especially visible. So in that sense, Pollock's technique, in which chance becomes a prominent factor, can be considered an extension of Impressionism.

Pollock's early works created environments in which figures were suggested, but which relate to the Surrealist emphasis on the unconscious. In the skeins of lines and colour of Pollock's celebrated mature work, spatiality is still implied despite the absence of figural objects. The submergence of the viewer in an aesthetic environment stems directly from both Impressionism itself, as in Monet's *Water Lilies* (p. 391) and in reactions to Impressionism, like Matisse's *Joy of Life* (p. 395). Pollock's large-scale canvases, especially when horizontally conceived, recall Monet's and Pierre-Auguste Renoir's attempts to envelop the viewer, as well as those, for example, of the Nabi painter Édouard Vuillard, who made nine large panels (now split among different museums) representing public gardens (Fig. b), which seemed to melt away the walls of his patron Alexandre Natanson's Paris living room. Even when depicting no more than the surface of the ground, Vuillard's ever-active brush fills it with visual incident. Whether Pollock's efforts are utopian or escapist can be judged by their historical background in World War II, to which they might be considered a universally renewable alternative world of subjective creativity, away from human evil, death and destruction.

The point, then, is not that abstraction stems from the direct influence of Impressionism, but rather that Impressionism introduced principles whose consequences led to modern art. Those principles are the emphasis on progressive and original personal

vision, along with the novel painterly techniques that convey it, both of which are grounded in modernity. In accepting these premises, artists measure their feelings and styles against those of the immediate past, producing the constant critique and renewal we call modernism.

From Manet to Monet, the Impressionists instituted the never-ending cycle of renewal and search for personal expression – sociopolitical or private – that we call modern art today.

Selected Bibliography

Few movements in the history of art have been studied and exhibited as much as Impressionism. The following list emphasises essential works and recent studies, including many relatively recent exhibition catalogues that have added enormously to our knowledge of Impressionism while helping to popularise an already popular movement. Excellent illustrations have also been a factor in these choices.

Kathleen Adler and Tamar Garb, *Berthe Morisot*, Oxford, 1987.

Sylvain Amic et al., *Éblouissants reflets,* exh. cat., Musée des Beaux-Arts de Rouen, 2013.

Carol M. Armstrong, *Odd Man Out: Readings of the Work and Reputation of Edgar Degas*, Chicago, 1991.

Carol M. Armstrong, *Manet/Manette*, New Haven and London, 2002.

Nina Athanassoglou-Kallmyer, *Cézanne and Provence: The Painter in His Culture*, Chicago, 2003.

Colin Bailey, *Renoir's Portraits: Impressions of an Age*, exh. cat., The National Gallery of Canada, Ottawa, 1997.

Colin Bailey, *Renoir Landscapes, 1865-1883*, exh. cat., The National Gallery, London, 2007.

Charles Baudelaire, *The Painter of Modern Life and Other Essays*, translated and edited by Jonathan Mayne, London, 1965.

David Bomford, Jo Kirby, John Leighton and Ashok Roy, *Art in the Making: Impressionism*, exh. cat., The National Gallery, London, 1990.

Richard R. Brettell, Scott Schaefer et al., *A Day in the Country: Impressionism and the French Landscape*, exh. cat., Los Angeles, 1984.

Richard R. Brettell, *Pissarro and Pontoise: The Painter in a Landscape*, New Haven and London, 1990.

Richard R. Brettell, *Painting Quickly in France, 1860-1890*, exh. cat. The Sterling and Francine Clark Art Institute, Williamstown, 2000.

Richard R. Brettell, *Gauguin and Impressionism*, exh. cat., The Kimbell Art Museum, Forth Worth, 2005.

Norma Broude and Mary D. Garrard (eds.), *The Expanding Discourse: Feminism and Art History*, New York, 1992.

Marilyn Brown, *Gypsies and Other Bohemians: The Myth of the Artist in Nineteenth-Century France*, Ann Arbor, 1985.

Marilyn Brown, *Degas and the Business of Art: A Cotton Office in New Orleans*, University Park, Pennsylvania, 1994.

Françoise Cachin et al., *Manet, 1832-1883*, exh. cat., The Metropolitan Museum of Art, New York, 1983.

Anthea Callen, *Techniques of the Impressionists*, London, 1982.

Anthea Callen, *The Spectacular Body: Science, Method and Meaning in the Work of Degas*, London and New Haven, 1995.

Kermit Champa, *Studies in Early Impressionism*, New Haven, 1973.

Timothy J. Clark, *The Painting of Modern Life: Paris in the Art of Manet and his Followers*, New York, 1985.

Hollis Clayson, *Painted Love: Prostitution in French Art of the Impressionist Era*, New Haven, 1991.

Hollis Clayson, *Paris in Despair: Art and Everyday Life under Siege (1870-1871)*, Chicago, 2002.

Bradford Collins (ed.), *Twelve Views of Manet's Bar*, Princeton, 1996.

Philip Conisbee, Denis Coutagne et al., *Cézanne in Provence*, exh. cat., The National Gallery, Washington, D.C., 2006.

Denis Coutagne et al., *Cézanne à Paris*, exh. cat., Musée du Luxembourg, Paris, 2012.

Jonathan Crary, *Techniques of the Observer: On Vision and Modernity in the Nineteenth Century*, Cambridge, MA, 1990.

Anne Distel, *Impressionism: The First Collectors*, transl. by Barbara Perroud- Benson, New York, 1990.

Anne Distel et al., *Gustave Caillebotte: Urban Impressionist*, exh. cat., Chicago, 1995.

Ann Dumas et al., *The Private Collection of Edgar Degas*, exh. cat., The Metropolitan Museum of Art, New York, 1997.

Tamar Garb, *Women Impressionists*, Oxford, 1986.

Tamar Garb, *Sisters of the Brush: Women's Artistic Culture in Late Nineteenth-Century France*, London and New Haven, 1994.

William H. Gerdts, *American Impressionism*, New York, 1984.

Nicholas Green, *The Spectacle of Nature: Landscape and Bourgeois Culture in Nineteenth-Century France*, Manchester, 1990.

Gloria Groom et al., *Impressionism, Fashion, and Modernity*, exh. cat., The The Art Institute of Chicago, 2013.

Annette Haudiquet et al., *Pissarro et les Ports*, exh. cat., Musée d'Art moderne André Malraux, Le Havre, 2013.

Robert L. Herbert, *Neo-Impressionism*, exh. cat., The Guggenheim Museum, New York, 1968.

Robert L. Herbert, *Impressionism: Art, Leisure, and Parisian Society*, London and New Haven, 1988.

Robert L. Herbert et al., *Georges Seurat, 1859-1891*, exh. cat., The Metropolitan Museum, New York, 1991.

Robert L. Herbert, *Monet on the Normandy Coast: Tourism and Painting, 1867-1886*, New Haven and London, 1994.

Anne Higonnet, *Berthe Morisot: A Biography*, New York, 1990.

Anne Higonnet, *Berthe Morisot's Images of Women*, Cambridge, Mass., 1992.

John G. Hutton, *Neo-Impressionism and the Search for Solid Ground*, Louisiana, 1994.

Joel Isaacson, *The Crisis of Impressionism, 1878-1882*, exh. cat., The University of Michigan Museum of Art, Ann Arbor, 1979.

Richard Kendall and Griselda Pollock, *Dealing with Degas: Representations of Women and the Politics of Vision*, New York, 1992.

Serge Lemoine, *Dans l'intimité des frères Caillebotte, peintre et photographe*, exh. cat., Musée Jacquemart-André, Paris, 2011.

Eunice Lipton, *Looking into Degas: Uneasy Images of Women and Modern Life*, Berkeley and Los Angeles, 1986.

Christopher Lloyd (ed.), *Studies on Camille Pissarro*, London, 1986.

Henri Loyrette, *Degas*, Paris, 1991.

Laurent Manœuvre, *Eugène Boudin*, exh. cat., Musée Jacquemart-André, Paris, 2013.

Kenneth McConkey, *British Impressionism*, Oxford, 1989.

Michel Melot, *Impressionist Prints*, London and New Haven, 1996.

Charles S. Moffett, et al., *The New Painting: Impressionism 1874-1886*, exh. cat., The Fine Arts Museums of San Francisco, 1986.

Nancy Mowll Matthews, *Mary Cassatt: A Life*, New York, 1994.

Linda Nochlin, *Women, Art, Power and Other Essays*, New York, 1988.

David H. Pinkney, *Napoleon III and the Rebuilding of Paris*, Princeton, 1958.

Joachim Pissarro, *Camille Pissarro*, New York, 1993.

Joachim Pissarro, *Monet and the Mediterranean*, exh. cat., The Kimbell Art Museum, Fort Worth, 1997.

Diane Pittman, *Bazille: Purity, Pose and Painting in the 1860s*, Penn State Press, 1998.

Griselda Pollock, *Mary Cassatt*, London, 1980.

Griselda Pollock, *Vision and Difference: Femininity, Feminism, and Histories of Art*, London, 1988.

Theodore Reff, *Degas, The Artists Mind*, New York, 1976.

Theodore Reff, *Manet and Modern Paris*, exh. cat., The National Gallery of Art, Washington, D.C., 1982.

Jean Renoir, *Renoir, My Father*, London, 1962.

John Rewald, *The History of Impressionism*, Fourth revised edition, New York, 1973.

John Rewald, *Cézanne: A Biography*, New York, 1986.

John Rewald, *The Paintings of Paul Cézanne: A Catalogue Raisonné*, New York, 1996.

Joseph Rishel et al., *Cézanne*, exh. cat., The Philadelphia Museum of Art, 1996.

Jane Mayo Roos, *Early Impressionism and the French State (1866-1874)*, Cambridge University, 1996.

James H. Rubin, *Courbet*, London, 1997.

James H. Rubin, *Impressionism*, (Art and Ideas), London, Phaidon Press, 1999.

James H. Rubin, *Impressionism and the Modern Landscape: Productivity, Technology and Urbanization from Manet to Van Gogh*, Berkeley and Los Angeles, University of California Press, 2008.

James H. Rubin, *Manet: Initial M, Hand and Eye*, (English edition), Paris, Flammarion, 2010.

Laurent Salomé, *Rouen, A City for Impressionism; Monet, Gauguin, and Pissarro in Rouen*, exh. cat., Musée des Beaux-Arts de Rouen, 2011.

Meyer Schapiro, *Paul Cézanne*, New York, 1962.

Meyer Schapiro, *Modern Art: 19th and 20th Centuries: Selected Papers*, New York, 1978.

Richard Shiff, *Cézanne and the End of Impressionism: A Study of the Theory, Technique and Critical Evaluation of Modern Art*, Chicago, 1984.

Richard Shone, *Sisley*, London, 1992.

Paul Smith, *Seurat and the Avant-Garde*, London, 1997.

MaryAnne Stevens, *Alfred Sisley*, exh. cat., The Royal Academy, London, 1992.

MaryAnne Stevens, *Manet: Portraying Life*, exh. cat., The Royal Academy of Art, London, 2013.

Jean Sutherland Boggs et al., *Degas*, exh. cat., The National Gallery of Canada, Ottawa, 1989.

Richard Thomson, *Camille Pissarro: Impressionism, Landscape, and Rural Labour*, New York, 1990.

Richard Thomson et al., *Claude Monet, 1840-1926*, exh. cat., Grand Palais, Paris, 2010.

Gary Tinterow and Henri Loyrette, *Origins of Impressionism*, exh. cat., The Metropolitan Museum of Art, New York, 1994.

Mary Tompkins Lewis, *Cézanne's Early Imagery*, Berkeley, 1989.

Paul Hayes Tucker, *Monet at Argenteuil*, New Haven and London, 1982.

Paul Hayes Tucker, *Monet in the 90s: The Series Paintings*, exh. cat., The Museum of Fine Arts, Boston, 1989.

Paul Hayes Tucker, *Claude Monet: Life and Art*, New Haven and London, 1995.

Paul Hayes Tucker et al., *Monet in the Twentieth Century*, exh. cat., Museum of Fine Arts, Boston, 1998.

J. Kirk T. Varnedoe, *Gustave Caillebotte*, New Haven and London, 1987.

Martha Ward, *Pissarro, Neo-Impressionism, and the Spaces of the Avant-Garde*, Chicago, 1996.

H. Barbara Weinberg et al., *American Impressionism and Realism: The Painting of Modern Life, 1885-1915*, exh. cat., The Metropolitan Museum of Art, New York, 1994.

Daniel Wildenstein, *Claude Monet,* 4 vols, Cologne, 1996.

Juliet Wilson-Bareau, *The Hidden Face of Manet: An Investigation of the Artist's Working Processes*, London, 1986.

Juliet Wilson-Bareau, *Manet, Monet: The Gare Saint-Lazare*, exh. cat., The National Gallery of Art, Washington, D.C., 1998.

Nina Zimmer et al., *Renoir Between Bohemia and Bourgeoisie : the Early Years*, exh. cat., Kunstmuseum, Basel, 2012.

Michael Zimmerman, *Seurat and the Art Theory of his Time*, Antwerp, 1991.

Émile Zola, *Mon Salon, Manet, Ecrits sur l'art*, Antoinette Ehrard (ed.), Paris, 1970.

Index of Proper Names

Page numbers in bold refer to illustrations

Ambre, Émilie 167

Ando, Kaigetsudo 40, **41**

Andrée, Ellen 108, 110, 280

Arosa, Gustave 304

Astruc, Zacharie 38, **40**, 41

Baldus, Édouard **102**

Baudelaire, Charles 20, 21, 22, 26, 36, 40, 48, 58, 80, 88, 96, 106, 114, 115, 123, 202, 205, 210, 218, 219, 226, 322, 352, 360, 364, 376, 384

Bazille, Frédéric 14, 16, **17**, 20, 38, 42, 43, **43**, 44, **44**, 62, 63, **63**, 90, 92, 196, 197, **197**, 236, **236**, 237, 245, 248, 270, 271, **271**, 272, 290, 314

Bazire, Edmond 120

Bellelli, Laura 28, 29, 64

Bertin, Louis-François 52, 304

Blanc, Charles 40

Bodmer, Karl 14

Bonington, Richard Parkes 10, 11, 300

Bonnard, Pierre 266, 368, **368**, 370, 394, **394**

Boucher, François 121, 181, 204, **224**

Boudin, Eugène 10, 11, **11**, 18, 220, **220**

Bracquemond, Félix 234, **234**, 235, 350, 356, 360

Bracquemond, Marie 234, **234**, 235, **235**, 328, **328**, 350

Brunner, Irma 240, 241

Bruyas, Alfred 17, 62

Cabanel, Alexandre 218, **218**

Cabot Perry, Lilla 392

Cadart, Alfred 360, 361

Caillebotte, Gustave 30, 31, **31**, 82, 90, 92, **92**, **93**, 94, **94**, 95, **95**, **96**, 100, **100**, 101, **101**, 136, **136**, 148, **148**, 154, 158, 159, **159**, 204, 205, **205**, **228**, 229, 235, 236, 237, **237**, 248, 252, **252**, 253, 264, 280, 284, **284**, 285, **285**, 286, 306, 307, **307**, 326, **326**, 328, 336, **336**, 354, 358

Callias, Nina de 120, 121

Carolus-Duran (Charles-Émile-Auguste Durand) 30, **30**

Carré, Albertie-Marguerite 122

Cassatt, Mary 66, 67, **67**, 68, **68**, 69, **69**, 78, 79, **79**, **122**, 123, 126, **127**, 137, 200, **200**, 206, 207, **207**, 224, **224**, 225, **225**, **284**, 285, 334, **334**, **335**, 350, 354, **354**, 355, **355**, 356, 362, 368, **369**, 370, 392

Castagnary, Jules-Antoine 140

Cézanne, Paul 6, 26, **26**, 27, **27**, 32, 40, 48, **48**, 49, **49**, 57, 70, **71**, 72, **72**, 73, **73**, 98, **98**, 99, 104, 142, **142**, 143, **143**, 144, 152, 160, **160**, 186, **186**, 187, 188, 192, 193, **193**, **208**, 209, 214, **214**, 215, **215**, 234, 236, 250,

250, 254, **254**, 255, 258, 290, **290**, 291, **291**, 304, 308, **308**, 309, 314, **314**, 316, **316**, 317, **317**, 322, **322**, 323, **323**, 326, 330, 336, **336**, 337, **337**, 340, 342, **342**, 343, **343**, 354, 366, **366**, 367, **367**, 382, **382**, 383, **383**, 394

Champfleury (Jules-François-Félix Fleury-Husson) 116, 202, 219

Chardin, Jean-Siméon 208, 209, 342, **342**

Charigot, Aline 230, 280

Charpentier, Georges 56, 57, 134, 280

Chase, William Merritt **392**, 393

Chevreul, Michel-Eugène 330

Choiseul, Comte de 18, 19

Choquet, Victor 57

Christophe, Jules 374

Clemenceau, Georges 390, 394

Collard, Hippolyte **160**, 176, **176**, **252**

Constable, John **148**, 149, 300

Corot, Jean-Baptiste-Camille 12, 13, **13**, 14, 46, 50, 82, 144, 145, 194, 208, 221, 228, **228**, 244, 246, **246**, 276, **276**, 282, 300, 304

Courbet, Gustave 14, 16, 17, 18, 19, **19**, 30, 32, 36, **36**, 38, 39, 42, 46, 62, **62**, 141, 186, **186**, 196, 202, **202**, 219, 236, 238, **238**, 265, 270, **270**, 358

Cross, Henri-Edmond **390**

Cuvelier, Eugène **358**

Daguerre, Louis 176

Darwin, Charles 130, 348

Daubigny, Charles-François **32**, 33, 244

Daubigny, Emma 198

Daumier, Honoré 168, **168**, 360

Degas, Edgar 6, 28, **28**, 29, **29**, 30, 31, 32, 52, 53, **53**, 64, **64**, 65, **65**, 66, 67, 68, 70, **70**, 78, **78**, 79, 92, 106, **106**, 107, **107**, 108, 109, **109**, 110, 123, 124, **124**, 126, **126**, 128, **128**, 129, **129**, 130, **130**, 131, **131**, 132, 133, **133**, 135, 136, 137, 172, 173, **173**, 178, **178**, 179, **179**, 180, 185, 194, 198, **198**, 199, **199**, 202, 207, 210, 220, 224, 226, **226**, 235, 236, 248, 252, 258, 280, 285, 286, **286**, 287, **287**, 292, 306, **306**, 310, **310**, 334, 348, 349, **349**, 350, **350**, 351, 352, 353, **353**, 354, 356, **356**, **357**, 358, **358**, 359, **359**, 362, 364, **364**, 365, **365**, 368, 370, 394

Delacroix, Eugène **10**, 11, 26, **26**, 39, 47, 57, 58, **118**, 119, 124, 168, **168**, 169, 196, 296, 304, 322, 340, 353, **354**, 358, 366, 376, 388

Delâtre, Auguste 360

Depeaux, François 264

Derain, André **388**, 395

Deraismes, Maria 230

Desboutin, Marcellin 108, 310

Diderot, Denis 40, 58

Doncieux, Camille (Camille Monet) 46, 48, 114, 274

Doré, Gustave 152, **152**

Dreyfus, Alfred 178, 394

Duchamp, Marcel 396

Dumas, Alexandre 56, 58, 218

Durand-Ruel, Paul 14, 54, 59, 188, 248, 254, 256, 292,
 328, 368, 380, 390, 392, 393

Duranty, Edmond 52, 130, 198

Duret, Théodore 25

Eakins, Thomas 66

Ellison, Mary 123, 207

Emperaire, Achille 48, 193

Ephrussi, Charles 280

Fantin-Latour, Henri 38, **38**, 39, **39**, 44, 50, 210

Faure, Jean-Baptiste 58, 59, 252, 253, 283

Fénéon, Félix 318, 331, 344, 376, 377, 378, 379, 384

Fielding (brothers) 10, 11

Figuier, Louis 170

Fiquet, Hortense 72

Flachat, Eugène 154

Flaubert, Gustave 56, 68

Forain, Jean-Louis 108, **108**

Fragonard, Jean-Honoré **180**

Franc-Lamy, Pierre 134

Friedrich, Caspar David 340, **340**

Gachet, Paul 160, 186, 314

Gambetta, Léon 174, 230, 384

Garnier, Charles 90, 128, 256, 386

Gauguin, Paul 72, 84, 189, 212, **212**, 213, 258, **258**, 259,
 259, 261, 304, **304**, 305, **305**, 308, 309, 326, **326**,
 327, **327**, 336, 339, 340, 344, **344**, 348, 371, **371**, 376,
 377, 378, **378**, 394

Gautier, Théophile 20, 36, 219

Geffroy, Gustave 234, 260

Giorgione 22

Girardon, François 293

Goeneutte, Norbert 134

Gogh, Vincent van 58, 70, **70**, 92, **134**, 135, 212, **212**,
 213, **213**, 308, **308**, 309, 324, **324**, 325, **325**, 338,
 338, 339, **339**, 340, **340**, 341, **341**, 344, 370, 378

Goncourt, Edmond and Jules de 121, 209, 364

Gonzalès, Eva 50

Gorky, Arshile 396

Goya, Francisco de 40, 120, **120**, 166, **166**, 167, **223**

Grandville, J.J. 130, **348**

Grave, Jean 333, 384

Greuze, Jean-Baptiste **106**, 107, 230, **230**

Guillaumin, Armand 32, 98, 99, **99**, 104, 105, 140, **140**,
 141, 144, **144**, 145, 146, 147, 148, **150**, 151, 160, 161,
 161, 162, 176, 177, **177**, 182, **182**, 186, 215, 250, 251,
 251, 258, 260, 302, 303, **303**, 304, 308, 309, **309**,
 314, 324, 326, 344, 345, 354, **354**, 376

Guys, Constantin **20**, 21

Halévy, Ludovic 128, 178, 364

Hassam, Childe 392, 393, **393**

Hauser, Henriette 116, 117

Haussmann, Georges-Eugène 20, 88, 90, 92, 100, 176,
 182, 386, 392

Havemeyer, Louisine 207, 392

Helmholtz, Hermann von 330

Henry, Charles 331, 374, 378, 384

Herring, J.F. 198

Himmes, Ferdinand-Henri 122

Hiroshige, Utagawa **64**, 202

Hirsch, Alphonse 311

Hoffman, E.T.A. 376

Hokusai, Katsushika **262**

Holbein, Hans the Younger 28

Hoschéde, Alice 54, 76, 256, 264

Hoschéde, Ernest 54, 195, 306

Huysmans, Joris-Karl 378

Ibsen, Henrik 262

Ingres, Jean-Auguste-Dominique 28, 48, **52**, 53, 68, **68**,
 70, 84, 119, 196, **196**, 234, 292, 328, 334, **352**, 353

Jongkind, Johan Barthold 18, **18**, 19

Jouvin, Hippolyte 94, **94**

Juárez, Benito 166

Keynes, John Maynard 176

Kropotkin, Peter 384

La Bédollière, Émile de 152, 156

La Hyre, Laurent de 270

Lacan, Jacques 137

Laforgue, Jules 376, 378

Lamy, Auguste **158**

Laurent, Méry 137, 240

Le Brun, Charles 130

Le Coeur, Jules 36, 238

Lecadre, Marie-Jeanne 24

Legouve, Alice 310

Legros, Alphonse 360

Lejosne, Madame 20

Lepic, Vicomte Ludovic Napoléon 172, 173

Leroy, Louis 32, 33, 90, 296

Lescouezec, Eugénie 264

Lhote, Paul 134, 293

Livaudais, John 178

Lopez, Nini 124

Louis XIII 306

Louis XIV 94, 144, 246

Louis XV 88, 172, 181

Louis XVI 102

Luce, Maximilien 384, **385**, 386, **386**, 394

Mac-Mahon, Maréchal Patrice de 168, 174, 384

Maître, Edmond 38, 44

Mallarmé, Geneviève 123, 207

Mallarmé, Stéphane 80, 81, 84, 210, 310, 311, 358, 378

Manet, Édouard 6, 11, 14, 15, 18, 19, 20, **20**, 21, **21**, 22, 23, **23**, 24, 25, 26, 29, 32, 36, 38, **38**, 39, **39**, 40, **40**, 41, **41**, 42, 44, 46, **46**, 48, 50, **50**, 51, **51**, 58, **58**, 59, **59**, 63, 66, 67, 74, **74**, 75, **75**, 80, **80**, **81**, 82, 84, 90, 100, 102, 108, **108**, 110, **110**, 111, **111**, 114, 115, 116, **116**, 117, **117**, 120, **120**, 121, **121**, 122, 126, 134, 135, 136, **136**, 137, **137**, **158**, 166, **166**, 167, **167**, 168, **169**, 171, 174, **174**, 179, 180, 186, 188, 192, **192**, 193, 194, **194**, 195, 196, 198, 200, 202, **202**, 203, **203**, 207, **208**, 209, 210, **210**, **211**, 214, 218, **218**, 219, **219**, **220**, 221, 222, 223, **223**, 224, 238, 240, **240**, **241**, 248, 258, 270, 278, **278**, 280, 286, **286**, 287, 290, 292, 310, 311, **311**, 312, **312**, 313, **313**, 322, 352, 353, 354, 356, 359, 360, **360**, 360, **361**, 368, 370, **370**, 388, 392, 397

Manet, Eugène 50, 179, 180

Manet, Julie 85, 180

Marion, Antoine Fortuné 290, 382

Marsy, Jeanne de 137, 370

Martelli, Diego 52

Masaccio 185

Matisse, Henri 394, 395, **395**, 396

Maximilian, Emperor 166, 167

May, Ernest 178

Merleau-Ponty, Maurice 337

Meurent, Victorine 22

Meurice, Paul 58

Meyer, Alfred 333

Michallon, Achille Etna 12

Michelangelo 184

Millet, Jean-François 11, **184**, 185, 296, **296**, 297, 304, 338

Monet, Claude 6, 10, **10**, 11, 12, 14, **14**, 15, **15**, 16, **16**, 17, 18, **18**, 19, 24, **24**, 25, **25**, 29, 32, 33, **33**, 36, 38, 42, 43, 44, 46, 48, **48**, 54, **54**, 55, **55**, 62, 74, 75, 76, **76**, 77, **77**, 88, **88**, 89, **89**, 90, **91**, 96, 102, 104, 114, **114**, 115, **115**, 140, 143, 146, 148, 149, 150, **150**, 151, **151**, 152, **152**, 153, **153**, 154, **154**, 155, **155**, 156, **156**, **157**, 160, 162, 163, 170, 171, **171**, 174, **175**, 179, 182, 186, **188**, **194**, 195, 200, **200**, 222, 232, 234, 235, 236, 245, 246, 248, **248**, 253, 254, 256, **256**, 257, **257**, 258, 260, **260**, 261, **261**, 262, **262**, 263, **263**, 264, **264**, 265, 266, **266**, 267, **267**, 270, 271, 272, **272**, 273, **273**, 274, **274**, **275**, 276, 277, 278, **278**, 279, **279**, 282, **282**, 283, 288, **288**, 289, **289**, 292, 300, 302, **302**, 303, 306, 306, 308, 312, 318, **318**, 324, **324**, 326, 332, 348, 354, 362, 380, **380**, **381**, 382, 386, 390, **390**, 391, **391**, 392, 394, 396, **396**, 397

Montejo, Eugénie de 166

Monticelli, Adolphe 26

Moore, George 108, 332, 365

Morisot, Berthe 12, 32, 50, 74, 82, **82**, **83**, 84, **85**, 122, **123**, 179, 180, **180**, 181, **181**, 194, 195, **195**, 200, **201**, 208, 220, 221, **221**, 222, **222**, 223, **223**, 226, **226**, 227, **227**, 228, 229, **229**, 232, **232**, 233, 310, **310**, 350, **350**

Munch, Edvard 84, 262

Murer, Eugène 162, 326, 363

Murger, Henri 36

Murray, E.T. 252

Musson, Michel 178

Muybridge, Eadweard 287

Nadar (Félix Tournachon) 90, 120, 358

Napoleon I 48, 102, 118

Napoleon III 48, 166, 168, 186, 373

Natanson (Alexandre, Louis-Alfred and Thadée) 378, 396

Nittis, Guiseppe de 52, **52**

Péreire (brothers) 90

Perrault, Claude 88

Petit, Georges 188, 264, 293, 348

Picasso, Pablo 51, **382**

Piette, Ludovic 184

Pissarro, Camille 12, **12**, 13, 32, 99, 104, 148, 149, **149**, 160, **160**, 161, 162, **162**, 163, **163**, 181, 182, **182**, 183, **183**,

184, **184**, 185, **185**, 186, 187, **187**, 188, 208, 209, **209**, 215, 244, **244**, 245, **245**, 246, **246**, 247, 248, 249, **249**, 250, **250**, 251, 258, 272, 277, 288, 292, 296, 297, **297**, 304, 308, 309, 314, 315, **315**, 316, 317, 324, 326, 330, 332, **332**, 333, **333**, 338, **338**, 350, 351, **351**, 354, 356, 362, **362**, 363, **363**, 368, 370, 376, 384, **384**, 386, 387, **387**, 394

Poe, Edgar Allan 80

Poiré, Paul 170

Pollock, Jackson 396, **397**

Pompadour, Madame de 181

Pontillon, Adolphe 82, 220, 222

Pontillon, Edma 194, 200, 220, 222

Pouget, Émile 384

Prestidge, James 178

Proudhon, Pierre-Joseph 186, 230, 384

Puccini, Giacomo 36

Puget, Pierre 214

Puvis de Chavannes, Pierre **188**, 189, 292

Raimondi, Marcantonio 22, **22**

Raphael 18, 22, **230**, 328, 334, 342, 388

Regnault, Henri **118**, 119

Rembrandt van Rijn 18, 198, **198**, 360

Renoir, Pierre-Auguste 6, 16, 30, 32, 36, 38, **42**, 44, 46, **46**, 47, **47**, 48, 56, **56**, 57, **57**, 58, 62, **74**, 75, **78**, 79, 84, **84**, 96, **97**, 102, 103, **103**, 118, 119, **119**, 121, 122, **122**, 124, **125**, 132, **132**, 134, 135, **135**, 136, 137, **146**, 147, 154, 163, 179, 186, **196**, **210**, 222, 225, 230, 231, **231**, 232, **232**, 233, **233**, 235, 236, **236**, 238, **238**, **239**, 240, 246, 247, **247**, 248, 254, **254**, 255, **255**, 258, 261, 272, **272**, 273, 280, **280**, 281, **281**, 290, 292, **292**, 293, **293**, 328, **328**, 329, **329**, 330, 332, 334, 342, 358, 388, 389, **389**, 394, 396

Richer, Léon 230

Rivière, Georges 134, 154, 280

Robinson, Theodore 392

Rodin, Auguste **348**

Rollinat, Maurice 260

Rood, Ogden 189, 330

Rouart, Henri 30, 179, 207

Roulin, Augustine 338, 339

Roulin, Joseph 338

Rousseau, Théodore 14, **14**, 15, 228, 235

Rousselin, Auguste 202

Rouvière, Philibert 58

Rubens, Peter Paul 388, **388**

Samary, Jeanne 56, 58

Sand, Georges 260

Sargent, John Singer 392, **392**

Scholderer, Otto 38

Schuffenecker, Émile 258, 338

Seurat, Georges 132, **132**, 162, 188, 189, **189**, 212, 230, 261, 276, 288, 292, 318, **318**, 319, **319**, 324, 325, 330, 331, **331**, 332, 333, 342, 344, 368, 374, **374**, 375, **375**, 376, **376**, 386, **386**

Signac, Paul 162, **204**, 309, 324, 325, 330, 331, 332, 376, **376**, 377, **377**, 378, **378**, 379, **379**, 384, **385**, 394, **394**, 395

Sisley, Alfred 16, 32, 36, 38, 44, 46, 104, **104**, 105, **105**, 144, **145**, 146, 147, **147**, **170**, 196, 246, 252, 253, **253**, 264, 265, **265**, 276, **276**, 277, **277**, 282, **282**, 283, **283**, 292, 298, **298**, 299, **299**, 300, 301, **301**, 302, **302**, 303

Sisley, Marie 46

Stendhal (Marie-Henri Beyle) 40

Stevens, Alfred 311

Stevenson, Mary 206

Strindberg, August 262

Suisse, Charles 314

Thaulow, Frits 262

Thiers, Adolphe 186

Thoré-Bürger, Théophile 202

Titian 22, **22**, 218, **218**

Toudouze, Anaïs **114**

Toulouse-Lautrec, Henri de 368, **368**

Tréhot, Lise 46, 47, 118, 124, 196, 238, 290

Turner, Joseph Mallord William 149, 234, 300, **380**

Valadon, Suzanne 134, 292, 293, 328

Valenciennes, Pierre-Henri de 12

Valladon, Emma (Thérésa) 130, 131

Valpinçon (Mr and Mme Paul) 64, 65, 180, 292, 353

Velázquez, Diego 40, **40**, 58, **58**, 352

Vellay, Julie 248

Verdi, Guiseppe 218

Vermeer, Johannes 202

Vinci, Leonardo da 130

Vollard, Ambroise 72, 328, 370, 382

Vuillard, Édouard 266, 368, 370, **370**, 371, **371**, 394, 396, **396**

Wartenberg, Francisca and Angelina 132

Watteau, Antoine **134**, 135

Whistler, James Abbott McNeill 300, **300**, 360

Zola, Émile 26, 36, 38, 40, 41, 44, 48, 56, 62, 80, 96, 102, 116, 117, 120, 141, 142, 166, 167, 178, 186, 187, 192, 193, 199, 202, 203, 238, 245, 288, 290, 296, 323, 364, 382, 394

Photographic Credits

Every effort has been made to trace copyright holders. If, however, you feel that you have inadvertently been overlooked, please contact the publisher.

bpk/Gemäldegalerie, SMB/Jörg P. Anders 46 (top), 230 (left)

The Bridgeman Art Library 10 (left), 11, 26 (bottom), 27, 28, 37, 48 (top), 56 (bottom), 69, 79, 82, 83, 85, 93, 94 (bottom), 108 (top), 132 (top), 151, 154 (right), 156 (top), 193, 210 (bottom), 221, 224 (right), 225, 228 (top & bottom), 229, 231, 232 (top), 238 (top), 239, 245, 263, 265, 270 (bottom), 271, 272 (top left & top right), 274 (top), 278 (top & bottom), 280 (right), 282 (bottom), 284 (left), 286 (bottom), 290, 302 (top), 304 (bottom), 310 (left), 311, 313, 324 (bottom), 326 (bottom), 333, 336 (right), 343, 356 (top & bottom), 361

Christie's Images/The Bridgeman Art Library 178

Chrysler Museum of Art, Norfolk 334 (bottom)

Colección Carmen Thyssen-Bornemisza en depósito en el Museo Thyssen-Bornemisza/Scala, Florence 298

The Dallas Museum of Art 366 (bottom)

DeAgostini Picture Library/Scala, Florence 119, 319, 332 (bottom), 338 (bottom)

Digital Image Museum Associates/LACMA/Art Resource NY/Scala, Florence 200 (bottom), 362 (top),

Digital Image, The Museum of Modern Art, New York/Scala, Florence 348, 357, 376 (bottom), 377, 379, 388 (right)

Gaspart/Scala, Florence 326 (top)

Les Héritiers Matisse 395

High Museum of Art, Atlanta 262 (bottom)

Hiroshima Museum of Art 389

Kröller-Müller Museum, Otterlo 204

The Metropolitan Museum of Art/Art Resource/Scala Florence 15, 57, 64 (top), 68 (bottom), 75, 118 (bottom), 123, 199, 214 (right), 244, 247, 277, 318 (top), 335, 349, 351, 358 (bottom), 383, 393

Michele and Donald D'Amour Museum of Fine Arts, Springfield, Massachusetts. The James Philip Gray Collection. Photography by David Stansbury 149

Mondadori Portfolio 307

Mondadori Portfolio/AKG Images 19, 41 (right), 46 (bottom), 49, 53, 76 (bottom), 88 (top), 92, 95, 96, 105, 106 (top left), 111, 116 (top), 122 (right), 143, 160 (bottom), 171, 174, 178 (top), 180 (top), 181, 194 (bottom), 195, 203, 205, 208, 212 (bottom), 214 (top left), 215, 240, 248, 253, 254 (left), 256, 257, 258 (bottom), 262 (top), 273, 284 (right), 285, 286 (top), 287, 306 (top), 307, 323, 327, 328 (bottom), 332 (top), 340 (top), 350 (top), 352 (top), 354 (bottom), 359, 367, 374 (top), 378 (top), 380 (bottom), 386 (top), 392 (top & bottom), 394 (top)

Mondadori Portfolio/Album 13, 25, 280 (left), 344

Mondadori Portfolio/Electa/Laurent Lecat 29, 31 (top), 43, 55, 76 (top), 114 (top), 115, 121, 128 (left), 170 (bottom), 187, 201, 210 (top), 211, 276 (bottom), 279, 282 (top), 289, 299, 301, 338 (top), 342 (bottom)

Mondadori Portfolio/Leemage 17, 73, 101, 117, 179, 236 (top), 254 (right), 258 (top), 316 (top), 322 (top)

Mondadori Portfolio/Picture Desk Images 70 (top), 77, 153, 175, 188 (right), 196 (left), 275, 353

Museo Thyssen-Bornemisza/Scala, Florence 227

Museum of Fine Arts, Boston. All rights reserved/Scala, Florence 65, 127, 166 (left), 207, 237, 255, 260, 261, 266, 288, 292 (bottom), 317

The National Gallery, London/Scala, Florence 50 (top), 133, 189, 232 (bottom), 233, 249, 274 (bottom), 315, 329

National Gallery of Art, Washington 200, 220 (top)

National Gallery of Canada 363

The Nelson-Atkins Museum of Art, Kansas City, Missouri. Photo Jamison Miller 355

Norton Simon Art Foundation 107, 226 (left)

Photo Art Media/Heritage Images/Scala, Florence 218 (top)

Photo Scala, Florence 16, 18 (bottom), 39 (top), 42, 52, 54, 63, 84, 120 (bottom), 135, 146, 264, 267, 283, 291, 297, 382 (bottom), 394 (bottom), 396 (bottom)

Photo Scala, Florence/BPK, Bildagentur fuer Kunst, Kultur und Geschichte, Berlin 250 (bottom)

Photo Scala, Florence/courtesy of the Ministero Beni e Att. Culturali 330 (bottom)

Photo The Philadelphia Museum of Art/Art Resource/Scala, Florence 24 (left), 97, 150 (top), 162 (bottom), 198 (right), 293

Photo The Print Collector/Heritage-Images/Scala, Florence 241

Photography © The Art Institute of Chicago 18 (top), 192, 226 (left)

RMN, Paris, Gérard Blot 52 (bottom)

RMN, Paris, Hervé Lewandowski 30, 345, 390 (top)

RMN, Paris, Jean-Gilles Berizzi 108 (bottom)

RMN, Paris, Martine Beck-Coppola 385 (right)

RMN, Paris, Patrice Schmidt 328 (top)

RMN-Grand Palais (musée d'Orsay)/Christian Jean/Jean Schormans 32 (bottom)

RMN-Grand Palais (musée d'Orsay)/Hervé Lewandowski 81

Tate, London 380 (top)

Wadsworth Atheneum Museum of Art/Art Resource, NY/Scala, Florence 74 (bottom), 106 (top right)

White Images/Scala, Florence 38 (left), 44, 51, 136 (top right), 145, 147, 183, 185, 197, 236 (bottom), 296, 306 (bottom), 352 (bottom), 364 (top & bottom), 365, 378 (bottom), 390

Yale University Art Gallery/Art Resource, NY/Scala, Florence 120 (top)

4114